MOTHERLODE

Legacies of Women's Lives and Labors in Butte, Montana

MOTHERLODE

Legacies of Women's Lives and Labors in Butte, Montana

Edited by
Janet L. Finn and Ellen Crain

CLARK CITY PRESS

All inquiries should be addressed to:
Clark City Press
Post Office Box 1358
Livingston, Montana 59047
(406)222-7412

Book design and editor photograph by Russell Chatham.

Production by Sally Epps O'Connor, with technical
assistance from Cody Redmon.

First Edition

Library of Congress Control Number: 2005931946

ISBN-13: 978-0-944439-57-9 [hardcover]
ISBN-10: 0-944439-57-8 [hardcover]
ISBN-13: 978-0-944439-58-6 [paperback]
ISBN-10: 0-944439-58-6 [paperback]

We dedicate this book to our mothers, who taught us lessons in strength and resilience, and our fathers, who instilled in us the love of a good story; to Gordon, Julia, Sarah, and Patrick Crain, who were influenced by good Butte women; to Jennifer Malone, Megan Malone Olson, and Olivia Grace Olson, who carry a touch of Butte with them; and finally, with love and appreciation, to the generations of spirited Butte women who lived the stories told here.

PREFACE

Mother lode (*n*.) 1. The main vein of ore in a region. 2. An abundant or rich source.

This book draws its title from a key term in mining. In its original usage the term "mother lode" is written as two separate words. It has also come to be used as a single word when naming anything from lodges of the Rocky Mountain West to websites on the Internet. Like the mother lode, the women of Butte have been a rich, if hidden, resource. We have chosen the single word—*Motherlode*—in the title to represent the fusion of gender, labor, and abundant resource, which lies at the heart of this book. In the stories that follow we bring that abundance to the surface to be recognized and honored.

Motherlode began with a series of conversations between the editors regarding the wealth of untapped holdings in the Butte-Silver Bow Public Archives and the stories of women's lives contained there, just waiting to be explored. In the winter of 2003 we discussed the book idea with Andrea McCormick, who had written a series of inspiring profiles about women of Butte for the *Montana Standard* in the mid-1970s. Andrea shared our passion for women's stories and fanned our enthusiasm for the book idea. She supported the project as a contributor and interviewer, revisiting stories she had written a quarter century ago and adding new voices to the chorus of women heard on these pages. We are grateful for her participation in *Motherlode.*

During the spring of 2003 we began to identify both community and university scholars who shared our passion for Butte and the lives of Butte women, and we invited them to contribute to the project. Some contributors took this opportunity to revisit and expand upon their earlier research on Butte women, and others explored new terrain. We are honored to have such a diverse and talented group of contributors join us on this journey. Likewise, we are deeply grateful to the women who were willing to open their homes and hearts to us and share their stories with us. We will forever treasure those special moments of bearing witness and the chance to laugh and cry together.

Motherlode took her next steps forward with the award of a research grant from the Redd Center for Western Studies, Brigham Young University, and a fellowship from the Montana Committee for the Humanities in 2003. This funding made Janet Finn's many trips to the archives and residency in Butte possible, and we are thankful for this essential support.

We also extend our heartfelt thanks to Judy Strand, Shain Wolstein, Mollie Riordan,

Sam Schultz, and James D. Johnson of the Butte-Silver Bow Public Archives for their ongoing assistance and support; Brian Holland for his generous professional guidance and advice; Tracy Thornton of the *Montana Standard* for her detective work in locating several of the photos that appear in the book; Susan Mattson at the World Museum of Mining for her assistance in locating photos of Butte women; Darci Jones, Sue Polich, and Sarah Schwanfelder Shae of the University of Montana School of Social Work for their sharp editorial and research assistance matched by their buoyant enthusiasm that fueled the project through some grey Missoula days; Julia Crain for her research assistance and keen eye for a good story; Gordon Crain for serving as our guide on the trek to Bear Gulch in search of Alma Higgins' Shangri-la; and John Taras and folks at the Finlen Hotel for the hospitality and humor that not only kept us going, but kept us from taking ourselves too seriously. Finally, we thank Russell Chatham for his belief in this project and his commitment to crafting a book worthy of the women whose stories it bears and Sally Epps O'Connor of Clark City Press for the dedication, skill, enthusiasm, and humor she brings to the editorial process. We are privileged to work with such a team.

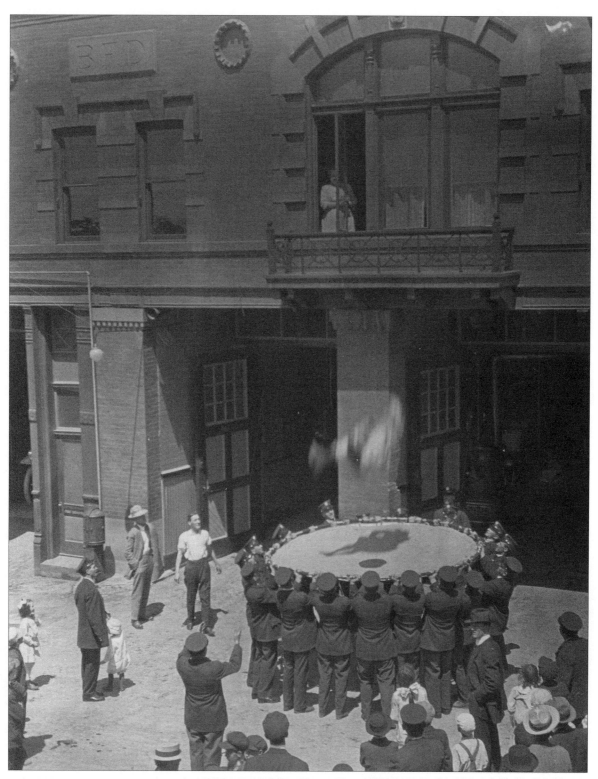

Butte Fire Department, currently home to Butte-Silver Bow Public Archives.

CONTENTS

Preface

A Note from the Publisher

PART ONE • INTRODUCTION

Motherlode: An Introduction 1
Janet L. Finn and Ellen Crain

Highlights and Sidelights on the Cosmopolis of the Rockies: A Pen Picture of Butte 27
Mary Brennan Clapp

PART TWO • WOMEN'S WORK

Sisterhood is Powerful: The Labors of the Butte Women's Protective Union 34
Marilyn Maney Ross and Janet L. Finn

Nun rethinks our education 53
Sr. Seraphina Sheehan

A Taste for Butte: Lydia Micheletti 57
Andrea McCormick

A Penny for Your Thoughts: Women, Strikes, and Community Survival 61
Janet L. Finn

Virginia Salazar: Crafting Everyday Life in Butte 77
Janet L. Finn

PART THREE • IN SICKNESS AND IN HEALTH

Caroline McGill: Mining City Doctor 85
Connie Staudohar

The Sisters of Charity: Mining City Health Care Pioneers 107
Sr. Dolores Brinkel, SCL

Butte's Cadet Nurses: Commitment to Country, Community, and Caregiving 123
Ellen Crain and Andrea McCormick

Rose Monahan: Nursing as a Way of Life 138
Andrea McCormick

PART FOUR • WOMEN OF THE CLUB

The Pearl Club: Black Women and Community Building in the Mining City 142
Loralee Davenport

The Butte *Kolo*: Circle of Serbian Sisters 154
Kerrie Ghenie

Homeless Children . . . In Butte, Montana 170
Margaret Hickey

PART FIVE • VISIONS OF POSSIBILITY

Elizabeth Davey Lochrie: A Well-Ordered Life 184
Mary Murphy

The Nevada Street School of Art 197
John McGinley

Seeing the Forest through the Trees: The Green Legacy of Alma Higgins 204
Janet L. Finn

Sara Godbout Sparks: Clean Up is Women's Work 224
Ellen Crain & Janet L. Finn

The Art of Life 229
Andrea Stierle

PART SIX • FOR LOVE AND JUSTICE

Butte's Women Warriors: Taking a Stand Against Poverty and Violence 236
Janet L. Finn and Ellen Crain

Making a Difference: Corinne Shea and Gert Downey 252
Andrea McCormick and Ellen Crain

Naomi Longfox and the Power of Native American Women in Butte 256
Janet L. Finn

"We're All *Familia*": The Work and Activism of Lula Martinez 268
Laurie Mercier

PART SEVEN • INSPIRING GENERATIONS

The Legacies of Our Grandmothers 280
Carol and Pat Williams

Pearls from Butte 292
Bill Macgregor

Teaching Inspiration: Building the Butte Teachers' Union 302
Kitte Keane Robins

Dorothy and Lucile Hannifin: Gems of Butte 312
Tracy Thornton

Afterword 317
Janet L. Finn and Ellen Crain

About the Editors 319

About the Contributors 321

About the Design 327

Photo Credits 329

Index 333

A NOTE FROM THE PUBLISHER

The idea of publishing an edition of Richard K. O'Malley's classic, *Mile High Mile Deep*, illustrated by contemporary photos, occurred to me because I had heard there was a Butte Historical Society, and that's just how sketchy my information was. I was soon to learn however, that it is the venerable Butte-Silver Bow Public Archives, located in an old fire station at 17 West Quartz Street, in Butte, America. On my first visit there, I met Ellen Crain, the Executive Director since 1990. She could not have been more cooperative, open, and friendly, and her assistance became a very meaningful element in successfully completing that project.

At a point during our research association, Ellen asked if I'd like to have lunch one day with her and her friend, Janet Finn (author of *Tracing the Veins*, a history of the connections between Butte and Chiquicamata, Chile—central to the power strategies of Anaconda Copper Company). Ellen said there was something they wanted to propose to me. Naturally I agreed, and before long we were sitting down to salads and sandwiches at the Acoma in Butte. They started their story in a minor key I thought, no doubt doing this as a water testing tactic. The gist of it quickly became clear though, which was that they had been working for some time on an alternative history of Butte as told entirely by women. Right away this sounded like a damn good idea to me, and I said so. They were pleasantly but cautiously surprised by my quick positive response, and I'm sure that was because they had come prepared to sell me a well known public bridge if necessary, that's how much they believed in their work. Common sense told me to shut up and listen the minute I realized they were not hawking a ware as it were, but rather describing a work of serious cultural value, and I came to understand then and there, I was dealing with two very bright, no nonsense women, each well armed with her own fine-tuned bullshit detector. The book they were telling me about was this one, now called *Motherlode*.

While I thought I recognized the value of a feminine approach to Butte's history, the fact is I did not have the faintest idea what that might be. All the books I'd read, such as *The War of the Copper Kings*, and *The Battle for Butte*, to name but two of the most obvious ones, were largely chronicles of aggression, by and about white males anxious to mix it up fair or dirty, in order to accumulate greater and greater wealth. *Mile High Mile Deep*, one of the best, most sensitive, and certainly most literate books ever written about Butte, is still nevertheless, told from a strictly male point of view. And while it definitely grows dark as it goes, its storytelling structure dictates its job is to entertain rather than probe into the bowels of an impossibly troubled society. (I did not discover until

later, Mary Murphy's extensively researched *Mining Cultures*. Her piece about Elizabeth Davey Lochrie is one of the chapters in *Motherlode*.)

It isn't easy to pigeonhole this book. *Motherlode* is at once a historical textbook, a scholarly paper, a collection of biographical sketches, and an oral history. Yet it is quite entertaining, even while its primary function is to inform and enlighten. That said, it's important to point out this is far from a litany of accusations or complaints about how men ruined everything, and then women had to step in and figure out not only how to take responsibility for the very survival of themselves and their families, but fix it all as well. Although, come to think of it, that is about what happened. Yes, this book does project a necessarily strong sense of solidarity, but more importantly, it is a call for sympathy and understanding for what happened, a testament to the vision and strength of the early stalwarts, and a cry for a more intelligent and humane future, one built upon equality and mutual trust.

Although *Motherlode* succeeds in a number of ways, perhaps the most important is in its presentation of the larger view, the view which sternly points out the true price of avarice by tracking through intergenerational relationships the human cost of underpaid life-threatening work, unemployment from that same work due to imperative strikes, lack of education, racism, poverty, alcoholism, and abuse. And while the specific subject of this work is Butte, all the tenets apply to any locale where there is such a dominant industry. The writing is clear, incisive, sometimes brilliant—and sometimes heartbreaking. I never expected to be moved to tears by this book, but I was, and not just once. In their acknowledgments, the editors have this to say, and it is everything: "We are grateful for the opportunity to bear witness to these stories and to make them part of the public record."

And, at last, it has come to pass that these truths are now readily available for all to consider, understand, and appreciate. And, even though most women already comprehend this material through gender intuition, if not experience, this book is a valuable tool for women because hard copy matters by providing in black and white, a validation of what was suffered, accomplished, and mended. Silence kills, recognition heals. Men need this recorded perspective as well, because the whole picture of human history is required to appreciate the real truth which ultimately builds authentic manhood.

Russell Chatham
Livingston, Montana

A NOTE ABOUT THE HISTORIC ESSAYS

The historic essays reprinted in *Motherlode*, are exactly as they appeared originally. We point this out because there are sometimes obvious spelling and grammatical errors, and we thought it important not to correct these, but rather maintain the integrity of the original texts.

PART ONE
INTRODUCTION

MOTHERLODE

LEGACIES OF WOMEN'S LIVES AND LABORS IN BUTTE, MONTANA

Janet L. Finn and Ellen Crain

Motherlode shares the stories of women's lives and labors in Butte, Montana throughout the twentieth century. Contributors to this collection take readers on a journey through three generations of women's lives, from Butte's early days, to the struggles of the Depression era, and to the post-war boom and bust, as Butte played out its mining wealth. The collaborative effort brings a chorus of women's voices to life on the page. Women's perspectives on and contributions to labor, family, and community are at the forefront, providing a gender lens through which to appreciate continuity and change in Butte. Contributors to *Motherlode* explore women's contributions as paid and unpaid laborers; as advocates for health care, education, civic improvement, conservation, and social justice; and as molders and shapers of family and community life. The collection addresses the value of women's work; the interplay of love and justice; feminine wit, wisdom, and visions of possibility; intergenerational ties and influences; and the power of women as makers of change. The contributors provide diverse accounts of women—mothers, grandmothers, neighbors, teachers, caregivers, and visionaries—who have influenced their lives and Butte history. *Motherlode* includes stories of women who were pioneers in their fields and leaders in social and political organizations as well as stories of unsung heroines who made a difference in their families and neighborhoods. It is our hope that this rich tapestry of women's lives will deepen respect for women's efforts in molding twentieth-century Butte and inspire a new generation of women and men shaping the twenty-first century.

The story of Butte has been told many times. It has been told as a story of copper kings vying for control of the "richest hill on earth," of the Gibraltar of Unionism, and of the cyclical rise and fall of hard rock mining.[1] In these masculine stories of Butte women are often cast in cameo roles as matrons of the boarding houses or madams of the bordellos. One is hard pressed to find fiction or history of Butte that does not feature a feisty widow who feeds, houses, and mothers scores of grown men and who has a soft spot for the boy in the man. Likewise, Butte's notorious red light district has been the subject of endless storytelling that usually features at least one tough, business-minded madam with a heart of gold. She, too, nurtures the boy in the man. Both images romanticize womanhood rather than reflect a more complicated reality.

A few eccentric characters known throughout the community have also become part of the local lore regarding women. For example, the stories of "Crazy Mary," "Nickel Annie," and "Shoestring Annie" were immortalized in *Copper Camp*, the mythic history of Butte published as part of the Federal Writers' Program of Montana in 1943.[2] Crazy Mary, a young Syrian woman, allegedly wandered Butte's streets and occasionally entered homes unannounced seeking tea and company. Shoestring Annie, a woman of considerable girth encased in a housedress, took an aggressive approach to shoestring sales in front of the miners' pay office each week. According to local legend, miners who were tight with their money and local law enforcement officers were the regular targets of her formidable wrath. She could be heard yelling, "Buy a pair of shoe laces, you God Damned cheap skate!" and pummeling reluctant buyers with blows from her crutch.[3] Nickel Annie, in contrast, made forlorn appeals for a mere five cents as she shuffled her delicate frame through Butte's streets. These images continue to capture the imagination of many writers seeking to craft a caricature of Butte women. In contrast, the faces of women who ran hospitals and schools, organized for the rights of workers, and created beauty from the raw materials of everyday life remain largely invisible.

Some would argue that any story of women in twentieth-century Butte should start with Mary MacLane. A precocious and provocative writer, MacLane advocated sensual pleasures and women's sexual freedom and chafed against the constrained gender roles of Butte in 1900. MacLane turned her personal journals and private angst into public consumption in her first book, *The Story of Mary MacLane,* published in 1901. The book was written over a three-month period when MacLane was just nineteen years old and recently graduated from Butte High School. Her vivid depictions of lusts and longings were matched only by her description of the physical and cultural barrenness of Butte. MacLane was variably revered and reviled for her iconoclastic view of turn-of-century gender and propriety. Her work struck a chord with many young women who shared her frustrations and her desire to break through stifling constraints. MacLane sparked controversy among other readers for her "shocking" proclamations such as her view that marriage was unnecessary for two people in love.[4] In the wake of her book publication, she was a fleeting sensation and the talk of Butte, New York, and Chicago. MacLane dabbled in theater and silent screen movies (most famous for her leading role in *The Men Who Have Made Love to Me*, filmed in 1917), lived the high life, returned to Butte for a time, and continued to write even as her health and fortunes declined. Acclaimed by some as Butte's first feminist, MacLane was a remarkable woman and arguably a necessary subject in any discussion of women in Butte. But the story of Mary MacLane has been told—by Mary herself and by a number of other writers.[5] Likewise, the accounts of street characters, madams, and boarding

house matrons have been written time and again. Unfortunately, they appear more like paper-doll cutouts to be inserted when "adding women" to the story was called for, rather than flesh-and-blood women with histories, memories, and identities. Their stories reveal little of the stuff and substance of women's lives.

Women's joys and sorrows, and their critical, creative contributions to the making of community, have too often been overlooked. In response, *Motherlode* places real women on center stage. We feature reflections by scholars and community residents, intergenerational perspectives, and the images, words, and wisdom of Butte women. *Motherlode* draws inspiration from scholars who have challenged the silences and gaps in our record of historical knowledge resulting from neglect of gender and women's experiences. Particularly relevant to this project is the growing body of literature that documents women's work as laborers, caregivers, and community builders. This project has been inspired by writers who have addressed the importance of women's histories and personal stories, by labor history that is inclusive of women, and by accounts of social life that take women seriously.[6]

This project is informed by and builds on the work of historians Mary Murphy and Laurie Mercier who have brought a gender lens to our understanding of twentieth-century Montana and western history.[7] The book's emphasis on the twentieth century, personal stories, and the diversity of women's labor and social experience in the mid-to-late twentieth century covers new ground. *Motherlode* is also informed by Ellen Crain's wealth of archival knowledge regarding women in Butte and Janet Finn's previous comparative study of gender, culture, and community in Butte and Chuquicamata, Chile and her ongoing work with women building community from the Rockies to the Andes.[8] *Motherlode* furthers our understanding of women's contributions to community building, our knowledge of twentieth-century Montana social history, and our capacity to engage with and learn from women's stories. The book is organized in seven parts: Introduction, Women's Work, In Sickness and in Health, Women of the Club, Visions of Possibility, For Love and Justice, and Inspiring Generations. Contributions include original essays, profiles of individual women, and historical pieces that capture women's experiences at particular moments in time. In the following paragraphs we provide an introduction to Butte and the stories of women's lives and labors.[9]

ARRIVAL

Like many towns in the Rocky Mountain West, Butte began as a mining camp, with the first strike of gold along Silver Bow Creek in 1864. A rush of hopeful miners and merchants followed. By 1867 the Butte City townsite had been laid out, and in 1879

Butte was incorporated as a city.[10] In 1878 the Butte Workingman's Union was established, marking a key historical moment that would come to define Butte as the "Gibraltar of Unionism" in the U.S.[11] With the arrival of the Northern Pacific Railroad in 1883, the discovery of rich veins of copper in Marcus Daly's Anaconda mine, and the opening of a copper smelter in 1885, Butte boomed. Although it was known as a magnet for a transient workforce of young men, Butte soon drew increasing numbers of women.[12] Some came with their husbands and fathers, some came on their own seeking work in the burgeoning service industry that accompanied mining booms, and some came naively or knowingly to make their living in a particular niche of the service industry—as sex workers.

Working men and women traveled to Butte from the Eastern Seaboard, the mining camps of Michigan, Colorado, Nevada, and California, the British Isles (particularly Ireland and Cornwall), and the European continent in search of a living wage and a better life. By 1884 more than three hundred mines were in operation in Butte, and five thousand miners were bringing Butte's riches to the surface.[13] As the kings of the copper industry battled over control of the Butte Hill, working men and women were building a town, a community, and a way of life on harsh terrain. They struggled to survive mining's booms and busts and to adapt to the challenges of this new urban life. Immigrants flooded to Butte, and a vibrant patchwork of ethnic neighborhoods blanketed the rugged hill, each with its own character, sounds, smells, and rules of social life. Women and men brought practices and traditions with them from their homelands. They were also inspired by the sense of freedom of a new place, where old-fashioned strictures might be cast aside and new possibilities imagined and invented. It seems that women, perhaps more than men, had something to gain in these possibilities as they played with, challenged, and reinvented the rules and roles of gender at the turn of the twentieth century.[14]

BECOMING BUTTE

Butte was becoming a major city. By 1890 it was a raucous and bawdy place—pulsating with life and labors twenty-four hours a day. The wealth of the city drew a diverse business and service sector—restaurants, theaters, dance halls, boarding houses, and religious, fraternal, and ethnic organizations. Initially, Butte City's population was young and largely male. In 1900, 88 percent of the population was under twenty-five, and there were nearly 150 men to every 100 women.[15] But women were making their mark as well. While prostitution was certainly a prominent profession in Butte, women were carving out other niches in economic and social life, particularly in the service sector.

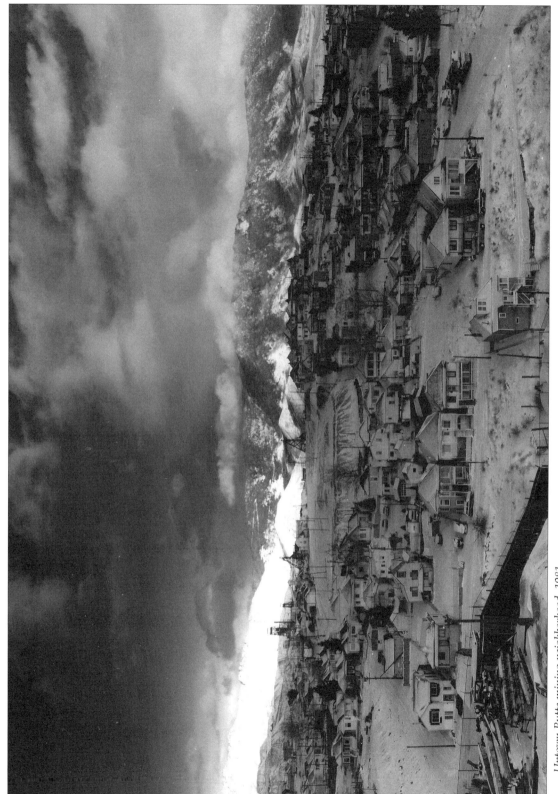

Uptown Butte mining neighborhood, 1981.

For working-class women, that meant low-wage labor in restaurants, laundries, boarding houses, and domestic service.[16] For middle-and upper-class women, service implied volunteer labor that contributed to charity work and the social and cultural life of the community. Mary Brennan Clapp offers a vivid depiction of her impression of Butte in 1916, when she arrived with her husband, a new professor at Montana School of Mines. Excerpts from her essay, originally published in the *Anaconda Standard* in 1923, appear in Chapter Two.

Working-class women experienced a different reality of service work from that of upper-class women. Infused with the labor consciousness of Butte's early union movement, working women, like their male counterparts in the mines, began to organize. For example, women service workers founded the Butte Women's Protective Union (WPU), an all-woman labor organization representing the interests of service workers, in 1890. The WPU championed the rights of women working in Butte's many service industries. Marilyn Maney Ross and Janet Finn tell the story of the WPU in Chapter Three. As women were moving into service jobs they also moved into emergent professional positions in health care and education. In Chapter Nine Sister Dolores Brinkel chronicles the Sisters of Charity of Leavenworth, an early and defining female influence in Butte, from their arrival in the mining camp in 1881 to their long-standing commitment to professionalizing and democratizing health care in the Mining City. A profile of Sr. Mary Xavier Davey, originally published in 1975 and reprinted in Chapter Four, speaks to the tenacity and talent of the Catholic sisters, pioneer educators who taught many a lesson in Butte.

The late nineteenth and early twentieth centuries witnessed the development of numerous women's social clubs, such as the Homer Club, founded in 1891, which brought middle-and upper-class Butte women together to read the classics, study philosophy and art history, and practice oratory. Through other clubs, such as the West Side Shakespeare Club and the Marian White Arts and Crafts Club women came together to pursue the arts, sciences, and literature.[17] In 1897 the Women's Club of Butte was organized, with over twenty charter members.[18] While the organization sought an inclusive, broad-based membership, it drew largely middle-class women with the leisure time to pursue liberal arts interests. Some of these women's organizations also engaged in civic improvement work and advocacy on behalf of poor women, mothers, and children.

At the turn of the twentieth century, Butte boasted a population of nearly 60,000 and a reputation for scintillating culture and nightlife. The miners' workforce garnered the world's largest payroll, with 15,000 men earning a monthly payroll of $1,500,000 dollars.[19]

Women's work of feeding, cleaning, teaching, and healing this human engine of mining saw much more modest compensation. However, men and women alike were putting down roots and creating a world bonded to and beyond mining. By 1905 Butte was home to forty-two churches, twenty-five public schools, and seven parochial schools.[20]

From 1900 to 1920 domestic service was the most predominant labor opportunity for women.[21] The majority of Butte women's lives were defined in terms of their relationships as wives and daughters of mining men. Women were also income producers, taking in boarders, doing laundry, and working as domestics in private homes and maids in hotels. Mining was notoriously dangerous work, leaving many women in the precarious status of widow, often with the responsibility for rearing several children. In his book *The Butte Irish* historian David Emmons writes:

> The mines created more Irish widows—fifty to one hundred per year from accidents alone—than Irish fortunes. Census statistics tell a part of the story. In 1900 there were 153 Irish widows under fifty years of age with a combined total of 392 children living at home; in 1910 the figures were 434 and 1,117. A closer look at what these numbers meant can be had by considering the 100 block of East La Platta Street in 1910. There were ten homes on the block, eight of them occupied by Irish widows. The women ranged in age from thirty-two to fifty-five; six had been born in Ireland, two in Michigan of Irish parents. Four of them rented rooms to single miners; three had working children; one sold milk and eggs; and two were without visible means of support. A combined total of forty-eight children had been born to the eight; thirty-four of them were still living, and thirty-two of those, ranging in age from two years to twenty-four, were living at home.[22]

Widows engaged in a vast array of informal labor and made subsistence livings as midwives, cooks, and domestic servants. Meager widows' pensions, funded first through the county and later through the state, provided them a flimsy safety net.

In 1910 the most common occupations for women in Butte were servant, teacher, prostitute, dressmaker, and boarding house keeper. By 1916 Butte had fifty-three boarding houses, countless private homes that took in boarders, and 379 buildings offering furnished rooms.[23] Some boarding houses, such as The Florence—or The Big Ship as it was better known—housed up to 300 men and ran on the round-the-clock labors of women. Boarding house matrons exerted a powerful social influence on Butte's working men. Andrea McCormick describes one such matron:

Mary Buckley left a life of poverty in County Cork Ireland in the early 1900s, making her way directly from New York to Butte . . . Her realm was a two-story frame house at 526 N. Wyoming where, with Irish brogue and iron will, she bore and reared six children and provided room and board to 17 miners and feed for 30 more . . . Mary ran her domain according to two rules: You didn't eat meat on Friday or miss Mass on Sunday.[24]

WOMEN'S WORLDS

Women's position was not static. Like men and mines, they were staking claims to new spaces and opportunities. By 1920 women had made significant inroads into the world of business, bookkeeping, and clerical work, formerly identified as male domains. Young women were enrolling in the Butte Business College to train for careers as stenographers, cashiers, and bookkeepers.[25] Young businesswomen in Butte formed the Business Girls' Club in 1920. The organization was renamed the Women's Commercial Club in 1925, and it later became the Butte Business and Professional Women's Club (BPW), an affiliate of the national BPW organization.[26] Butte BPW remains a vibrant force among working women today.

Women bore, birthed, and nurtured Butte's first generation of U.S. citizens. They passed down knowledge and skills of midwifery and turned to the Sisters of Charity for additional medical support. They found Butte's first woman physician, Dr. Caroline McGill, who arrived in 1911, a welcome addition to the community. Connie Staudohar recounts the life and times of Dr. McGill and her remarkable career as a health care provider and advocate in Chapter Eight. Women also concerned themselves with the public health and well-being of Butte's citizenry. They took issue with copper king William Andrew Clark's claim that arsenic fumes produced through smelting enhanced the lovely porcelain complexions of Butte women.[27] Poor and working-class women struggled daily with the toxic conditions of housing and sanitation that belied the wealth of the mines. A 1912 report on sanitation and housing conditions in Butte documented the atrocities that Butte women coped with on a daily basis.[28] While men suffered the vagaries of underground mining, women bore the challenges of surface survival, where the safety, dignity, and well-being of mining families were not corporate priorities.

Women continued to expand their civic roles on a number of fronts. For example, the City of Butte hired its first police woman, Amanda Pfieffer, in 1913. Pfieffer blended Christian ministry and law enforcement as she patrolled the red light district, dance halls, noodle parlors, and bars seeking to bring wayward girls back on the path of

gender propriety.[29] Women's political participation was also expanding. Montana women gained the right to vote in 1914, and Butte women voted in municipal elections for the first time in 1915. Within three years three women were elected to public office in Butte.[30]

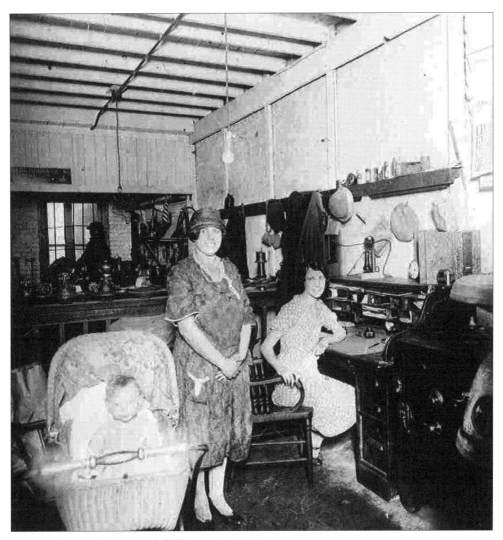

Juggling employment and child care, circa 1930's.

As the country entered into World War I in 1917, some Butte women filled men's shoes in the workforce and others came together to organize war support efforts. For example, as John Astle describes, women could be found clad in overalls and working alongside men at the Northern Pacific Railroad yards during World War I. According to the railroad foreman, "They do as well as the men and a lot better than the boys we would

hire otherwise."[31] In Chapter Twelve Loralee Davenport describes how women of Butte's small but significant African American community played a key role in organizing support efforts for U.S. soldiers during World War I. The women continued their organizing efforts beyond the war, combining their dual commitment to racial uplift and civic improvement. They inspired their daughters to continue the struggle against racism and for civil rights.

Butte women saw the connection between personal and political concerns, especially as they played out in terms of food security and community subsistence. As Butte and the mining industry grew, so did the profiteering impulses of some businesses. For example, in 1919 a state investigation into the high cost of living in Butte revealed the price-gouging practices of businesses that had grown accustomed to taking advantage of Butte's relatively well-paid workforce.[32] While working men fought battles over relations of production, women assumed responsibility for consumption. It was women, not men, who had to put food on the table for Butte's 15,000 miners and expanding numbers of offspring. Food was an everyday, real-life concern for women, and when they saw themselves exploited by the local market, they took matters into their own hands. Elizabeth Kennedy, the wife of a shift boss in the mines and a formidable organizer, did not stand idly by as the prices of food in Butte challenged her ability to put dinner on the table. In 1919, as President of the Butte Housewives' League, Kennedy spearheaded the movement against Butte's high food prices. The League arranged for producers to sell their goods directly to consumers, and they organized the Butte Women's Council to wage a "domestic war for food conservation and lowered prices."[33] They investigated price gouging and corrupt practices, such as dumping food rather than selling it to consumers for affordable prices. The women also took direct action, chasing down and confronting those engaged in dumping, setting up a neighborhood watch to patrol potential offenders, and organizing boycotts to force accountability of local merchants.[34]

The post-World War I years brought a downturn in the copper industry, and Butte experienced more hard times. Butte's population peaked in 1917 at 93,000 then began to drop.[35] While Butte's male workforce declined dramatically in the post-World War I era, the female workforce grew slightly as it expanded into the business sector. Despite the difficult times, women promoted and protected their interests as women and workers. For example, in 1920 the WPU organized a strike that resulted in a union contract with every café and restaurant in the city. And as their labors offered them a modicum of discretionary income, women were becoming patrons as well as servers in Butte's cafés and clubs.[36] Throughout the 1920s women expanded their claims to public spaces and challenged the boundaries of gendered worlds. As Mary Murphy

notes, women were making, selling, and drinking liquor, dancing to jazz in Butte's cabarets, and enjoying Butte's twenty-four-hour social life.[37] In Chapter Five Andrea McCormick profiles legendary restaurateur Lydia Micheletti who came to Butte from Italy and, at age thirteen, began her career as a cook in the city's booming night clubs.

Women also sought to beautify Butte's public spaces and address the city's dearth of public parks and recreation. In Chapter Seventeen Janet Finn recounts the story of Alma Higgins and her lifetime dedication to conservation and city beautification. A consummate gardener and advocate, Higgins sought to make conservation, the greening of Butte, and gardening broad-based public activities shared by men, women, and children. Higgins left a legacy of reclamation and beautification on Butte's battered landscape that continues to be carried out today by strong, committed women such as Sara Godbout Sparks. A profile of Sparks, the Environmental Protection Agency's Remediation Project Manager for the Butte area Superfund site, appears in Chapter Eighteen.

Some women found artistic inspiration on Butte's raw terrain. Butte became home to Elizabeth Davey Lochrie in 1903, when she was a teenager. Over the ensuing years Lochrie became a prolific painter, deftly juggling the demands of art and motherhood. Well-known for her portraits of Montana's Native American people, Lochrie also captured the harsh beauty of Butte. Mary Murphy takes readers on a journey into Lochrie's creative world in Chapter Fifteen. Lochrie's creativity resonates through the work of Andrea Stierle, a research scientist and artist who captures the beauty of the West in her paintings and finds possibilities for medical breakthroughs in the murky waters of the Berkeley Pit, Butte's defunct open pit mine. A profile of Stierle appears in Chapter Nineteen.

HARD TIMES AND HOPEFUL ACTIONS

The Depression hit hard in Butte. The price of copper dropped from eighteen cents a pound in 1929 to five cents a pound in 1933. Employment in the mines dropped by 84 percent in that time, and families turned first to charities then to the state for relief. Butte (Silver Bow County) had nearly 6,000 residents on relief, and it was using the lion's share of the state child welfare resources in 1931.[38] The U.S. Congress authorized the Federal Emergency Relief Act (FERA) in 1933. In his opening address to a special session of the Montana Legislative Assembly in 1933, Governor F. H. Cooney described the widespread unemployment, economic stagnation, and drought that plagued the state. He called on the legislature to take action that would allow Montana to take

advantage of the National Recovery Act and the FERA.[39] By 1935, more than eight thousand people in Butte were unemployed and, thanks to FERA and the Civil Works Administration (CWA), nearly half of the families in Butte were receiving relief. *The Eye Opener*, Butte's pro-labor newspaper, described Butte in 1935 as a "poor city atop the richest hill on earth" with the second highest percentage of people on relief in the country.[40] The Montana Relief Commission, established in 1933, expanded its mission in 1935 to "provide means for the sustenance of life, shelter, and the relief of distress among people of the state whose economic conditions, industrial inactivity, old age, unemployment, or other causes over which they have no control have deprived them of support"[41] The Works Progress Administration (WPA) was also instituted in 1935, and Butte men and women benefited from the federal dollars for work relief projects that began to flow into the city.

As was typical throughout the country, relief work was divided along gender lines. While men worked on construction crews for public infrastructure, building roads, bridges, and buildings, women stuffed mattresses and labored in sewing rooms. State welfare officials saw the sewing room projects as "particularly meritorious; they give employment to a great number of women sorely in need of this employment, and the clothing and household articles produced are distributed to relief clients throughout the state."[42] Silver Bow County received nearly one-third of the state disbursements for Mothers' Pensions in 1937 and one-quarter of the state appropriation for sewing room projects. Ninety-seven percent of sewing room workers were women. The Butte sewing room became the location where all garments for statewide distribution were cut in order to "ensure uniformity and cost containment."[43] The sewing rooms came under the management of the newly formed Montana Department of Public Welfare in 1937, and it retained the sewing rooms until 1943. The Department of Public Welfare reported that during the fiscal biennial—1940-42 alone—the clothing program distributed 629,074 garments with a retail market value of $694,447.[44] Butte women cut the garments that clothed men, women, and children across the state.

One Butte family's story illustrates the personal impact of the Depression. Margaret Cunningham lived in Butte during the Depression, and she remembers the positive parts of life in spite of the hard times. During the summer her family joined several others who moved north of Butte and lived in tents. As Margaret recalls, they played games and had lots of fun. There was no work, but the Cunninghams were getting by mining gold in Missoula Gulch. However, work in the mine slacked off by 1932. Margaret's husband secured work as a blacksmith with a WPA project. The family eked out a living with the help of government surplus food. But, Margaret recalls, everybody got tired of beans, oatmeal, and prunes. When Margaret's father died in

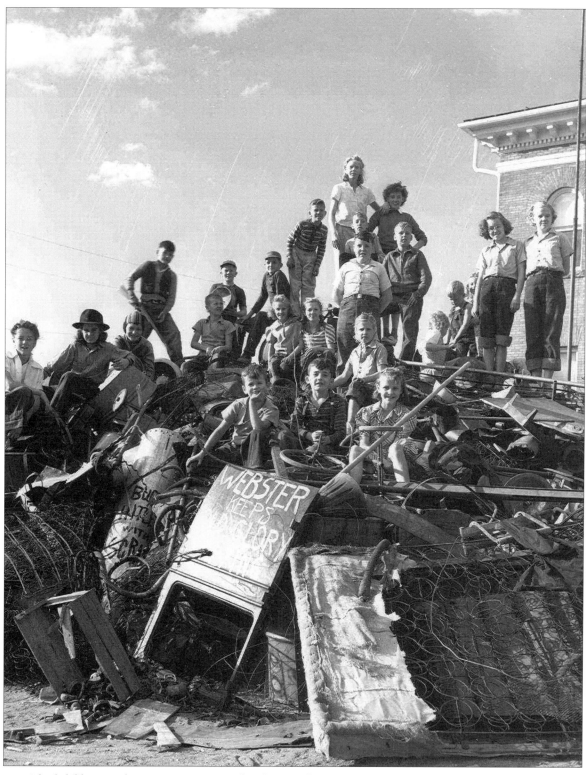

School children at salvage campaign, 1942. Photo by Russell Lee.

1933, her mother went to work in the WPA sewing room, making dresses, overalls, and quilts for people on relief. Work relief saved the Cunningham family.[45]

In addition to providing relief, the WPA also promoted the arts in Butte. The city's most well-known cultural project was *Copper Camp: Stories of the World's Greatest Mining Town, Butte Montana*. Compiled by the workers of the Writers' Program of the WPA, the project celebrated the rough-and-tumble lives of mining men. Less attention has been paid to Butte's WPA Art Center, which offered its first fine arts exhibition in the spring of 1938. Butte resident and artist Linda Cannon Burgess described the exhibit in an April 6, 1938 letter to her family:

> The W.P.A. Art Center is opening with an exhibition, part of it local talent and part a loan from other W.P.A. centers. I took six paintings up . . . the ones they have chosen for this time are the Head Frame, the one of Butte Hill, and my design for "House Beautiful" cover. Most of the other amateurs, of whom there are 77, go in for Indians. Except for one other picture, mine are the only ones of Butte . . . [46]

The exhibit, presented jointly by the Butte Art Association and the Federal Art Project, was held at the Butte Administration Building. Manoah Leide-Tedesco, an official with the U.S. Office of Education, Department of the Interior, came to Butte to preside at the opening. A noted art critic, he had this to say about the art and artists:

> This is pure art of the people who lived in a forceful molding environment, devoid of mannerism, free from extraneous influences. It is true American art of gifted Americans in Montana. One need not look for Florentine landscapes in the background, rather the Butte hill, as the onlooker is arrested by the brooding in the canvas of Linda Burgess.[47]

In the depths of the Depression a group of bold young women was coming together to address the rights of an important component of the labor force—teachers. In Chapter Twenty-six Kitte Keane Robins recounts the determined efforts of these women, her mother and aunt among them, to establish the Butte Teachers' Union. The upstart group was successful, and in 1934 the Butte Teachers' Union Number 322 received its charter from the American Federation of Teachers.

While the Depression touched the lives of all Butte residents, some members of the community were shaken by events of international consequence whose impacts reverberated from their homelands to Butte. The assassination of King Alexander of Yugoslavia in October 1934 provoked a crisis in the Balkan Peninsula, and Serbian

people in Yugoslavia and the U.S. feared loss of their autonomy. Joining women across the U.S., the Serbian women of Butte came together to promote cultural and religious traditions, Serbian language, and community solidarity. Kerrie Ghenie addresses the history and activities of Butte's *Kolo,* or Circle of Serbian Sisters, in Chapter Thirteen.

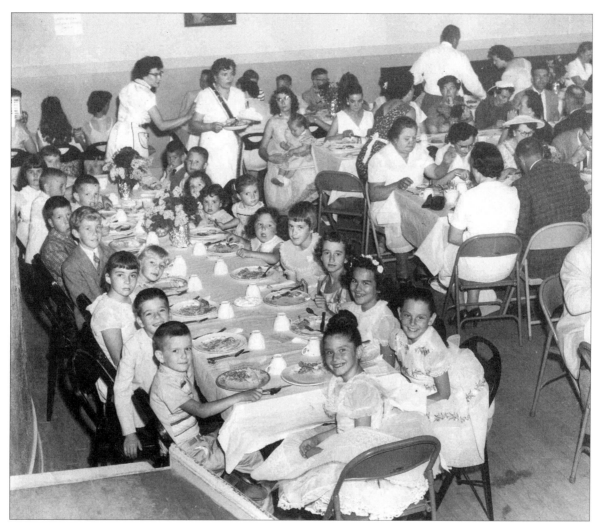

Serbian church Sunday breakfast, circa 1960's.

Economic recovery was hastened by U.S. entry into World War Two, and copper production in the Butte mines moved into high gear. The male workforce was stretched thin as some men enlisted in the armed forces while others served on the home front, keeping the war machine well-provisioned in strategic metals. Despite the chronic need for workers, women were not recruited to work in the mines. Instead, women took up other critical positions in the local social economy. Some women stepped in to run

small businesses, and others organized voluntary programs to support the war effort. For example, a small group of Butte women pioneered the American Women's Voluntary Services train program in the spring of 1942. Through the service volunteers met every train arriving in Butte that carried young men in the armed forces, providing them with care packages containing everything from cigarettes to Cracker Jacks. The volunteer corps, spearheaded by Mrs. Joe J. Kirby, began with forty members, and by April, 1943, it had expanded to 650 women. As described in the *Montana Standard*, "The Butte plan of hospitality has received recognition in leading national periodicals. This was the first town in the United States to put the train meeting project into operation."[48] Within a year, the service had been established in 48 states.

A number of young Butte women also joined the growing ranks of Cadet Nurses trained to care for combat soldiers and bolster the health care system on the home front. Ellen Crain and Andrea McCormick tell the stories of these young women in Chapter Ten. Many of these women continued their professional careers once the war ended, and they found their combat duty prepared them well for their future work in Butte's hospitals where young men's bodies bore the violence of mine accidents. A number of the Cadets went on to assume leadership in health care in Montana and beyond. Many young women turned to the nursing profession as their career choice, and while some pursued careers in hospitals and clinics, others applied their skills closer to home. Chapter Eleven presents Andrea McCormick's profile of Butte mother and nurse Rose Monahan.

POST-WAR POSSIBILITIES

Post-war promises of prosperity were short-lived in Butte as men returned to the mines only to find fewer jobs and frozen wages. A brief but violent strike in 1946 polarized the community. Some women challenged the boundaries of gender propriety as they joined men in the streets to support the strike and expose "scab" laborers. As reported in the *Montana Standard:*

> . . . The horrors which began Friday night reached a crest after dark Saturday when terrified housewives bombarded the police station and sheriff's office with calls for help. Sheriff McLeod said that some of the gangs included women and that women were reportedly the leaders in some instances of house wrecking . . . many persons passed en route to church to gaze at the debris.[49]

However, most women in mining families were growing accustomed to the haunting rhythms of mining life modulated by shift work, dynamite blasts, and three-year labor contracts. In Chapter Six, Janet Finn recounts the ways in which working-class women crafted everyday life in the post-war years, mobilizing networks of kin and friends to see the community through the hard times of strikes, lock-outs, and lay-offs. Women workers also claimed their rights to a living wage and just conditions. While the 1946 miners' strike brings back rancorous memories, the 1949 strike by members of the Women's Protective Union illustrated the possibilities of community-based unionism in garnering solidarity on multiple fronts.

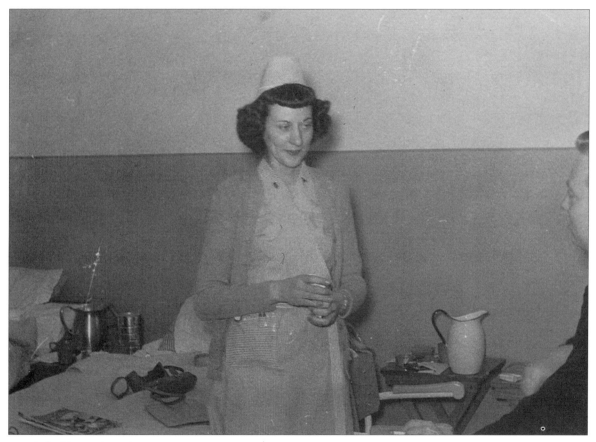

Cadet Nurse, circa 1944.

The post-war years also saw another burst of women's social and philanthropic organizing that made a lasting mark on Butte. In 1944 a group of women founded Butte's Soroptimist Club, an affiliate of the international Soroptimist organization. The club is dedicated to the betterment of professional women, civic improvement, and the promotion of international peace, sisterhood, and good will. The small group had

big plans for Butte and wasted no time in building their organization and engaging in community work. The club's history and the realization of their collective dream to build a children's receiving home in Butte were featured in *Ladies Home Journal* in 1950. Writer Margaret Hickey captures the dynamic spirit of this group of women who blended charity work and community development to create a home away from home for Butte's abused, neglected, and abandoned children. Her 1950 essay is reprinted in its entirety in Chapter Fourteen.

While some women were strengthening the social fiber of Butte, others continued to tap its aesthetic possibilities. As Mary Murphy writes in Chapter Fifteen, Elizabeth Lochrie turned her artistic eye to Butte in the early 1950s, producing a vibrant series of street scenes commissioned by the Ford Motor Company. Lesser known artists and artisans were also crafting possibilities from the raw materials of everyday life and turning their trials and tribulations into poetry. John McGinley writes of his mother Frances "Sam" McGinley, her art projects, and her creative influence in Chapter Sixteen.

TAKING A STAND AND CREATING CHANGE

Butte saw an increase in the size of its American Indian community in the post-war years. The post-World War II era ushered in a new phase of regressive federal policy aimed at the dissolution of American Indian family and tribal structure. As a result of the Relocation Acts of 1953, large numbers of Indian people were encouraged to leave their reservations and seek work in urban areas, presumably to hasten assimilation. While many Indian people migrated to growing urban centers such as Denver, Seattle, and Los Angeles, some also left Montana reservations in search of economic opportunities in Butte. Many Native American families became part of Butte's larger mining community and working-class neighborhoods, even as they maintained strong ties to their reservations. Butte's Indian community pulled together to preserve and promote cultural knowledge, values, and relationships and build local organizations by and for Indian people. Women and men shared leadership responsibility in building the collective identity and organizational capacity of Butte's Indian community. Chapter Twenty-two features the visions and values of Naomi Longfox and her experiences with other members of Butte's Indian community whose boundless energies contributed to the founding and development of the North American Indian Alliance. For more than thirty years, the Alliance has played a key role in promoting the health, education, and empowerment of Butte's Indian community.

The final push to expand mining in Butte occurred in the mid-1950s, with the beginning of open-pit mining in the Berkeley Pit. However, the promise of a copper-plated future

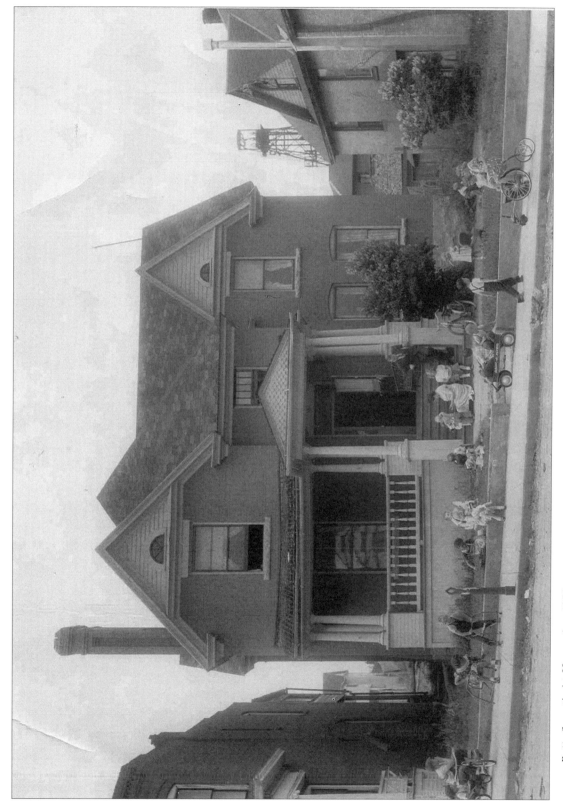

Butte Soroptimist Home, circa 1950.

was short lived. A six-month strike in 1959 devastated Butte's labor community. Many women became the sole supporters of their families during the long and difficult strike and opted to keep working after the strike ended, despite their husbands' protests. Women were making conscious choices about their economic participation, and they had grown wary and weary of the fickle nature of mining. They were not willing to count on copper alone for their survival.

The 1960s ushered in a new era of civic life and an expanded role of government in promotion of individual and community well-being. Women in Butte, as in cities across the country, claimed new ground as they joined the ranks of grassroots warriors in the War on Poverty.[50] Butte women had a keen awareness of Butte's cycles of poverty and plenty and the implications for feeding and clothing one's family. As they and their mothers and grandmothers before them had learned, the "Richest Hill on Earth" was an ironic moniker. The wealth of the hill had been significantly depleted, and the gaping pit exposed the limited future of a mining way of life. Butte's social and economic survival would be due more to federal dollars than mining wealth. So Butte women went to work, taking up the awkward government call for "maximum feasible participation" in antipoverty and community action programs. When Butte gained designation as a Model City, women joined the ranks of neighborhood councils, seeking to influence their community's future from the ground up. Women such as Corinne Shea and Gert Downey brought their leadership skills to bear in promoting social justice and community well-being through their work on the Butte-Silver Bow Anti-Poverty Council. The story of their contributions is the subject of a profile in Chapter Twenty-one.

While mining was shifting to open pit, another group of Butte women was moving its work underground. Drinking and violence have often gone hand in hand in mining communities, and women and children have often suffered the consequences. A group of women began coming together to name battering as a social problem and to move women to safe houses. Before the women's movement had gained force in Montana and before "domestic violence" was a common term, this group forged a woman-to-woman system of safety, support, and solidarity. Over time, with the dynamic leadership of Grace Sicotte, the women sought community support to create a permanent safe space for survivors of domestic violence. In Chapter Twenty Janet Finn and Ellen Crain recount the stories of Butte's women warriors who confronted problems of poverty and domestic violence and created programs to empower vulnerable members of the community.

Butte entered the 1970s in an atmosphere of uncertainty. The future of mining looked

Butte's motto, circa 1960.

bleak, and the future of the Anaconda Company was questionable. The population decline begun in 1917 had continued, and the community was now home to 40,000 residents, many of whom depended on the mines for a living. A strike in 1971 paralyzed Butte once again. During this strike St. James Hospital announced that it would accept striking Anaconda Company employees only on an emergency basis. The hospital's decision struck a nerve with Butte women responsible for the health and well-being of their loved ones. A small group of women got together and organized a picket line in front of the hospital. As one of the participants recalled, "I just did what I had to do. People were on strike and families were hurting, and it was just plain wrong for the hospital to refuse service to anyone."[51] Building on the legacy of Elizabeth Kennedy, these courageous women took direct public action, facing the wrath of some local doctors and winning the reluctant support of the men's unions. Within a few days, the women succeeded in pushing the hospital board to reverse its decision.

The 1970s marked the slow fadeout of mining in Butte. Cutbacks in the mining labor force continued, as did rumors of the Anaconda Company's precarious future. In 1977 the Anaconda Company was purchased by Atlantic Richfield Corporation. Hopes for a new lease on mining life were quickly overshadowed by cutbacks, layoffs, and increasingly tough times. Many women became the sole financial and emotional supporters of their families. Many men went in search of work elsewhere. By 1983, with the final closure of the mines, Butte was a depressed and pained community. The emotional scars on the psyches and spirits of the residents matched the scars on the physical landscape wrought by 100 years of environmental degradation. Residents were running out of hope as they saw little prospect of economic recovery. In response, a determined group of women and men joined together to form the Butte Community Union (BCU). The BCU linked the concerns and efforts of longtime welfare rights advocates with those of recently unemployed miners and their families. Seasoned community activists such as Lula Martinez brought their knowledge and skills to bear in building a formidable social action organization that took on the State of Montana to protect the dignity and rights of poor and working-class people in Butte. Laurie Mercier tells the story of Martinez's dedication to social justice, her advocacy on behalf of low-income people, and the life journey that shaped her commitment to family and community in Chapter Twenty-three.

Over the past twenty years efforts at healing and recovery have been underway, and Butte women have played key roles in the process. Women have been lead actors in the reclamation of Butte's damaged physical environment. They have also been dedicated to reclaiming Butte's memory, history, and collective identity and the contribution of women therein. Women play major political, economic, social and cultural roles in the

drama that is twenty-first century Butte. Men and women alike find inspiration for the future in the legacies of the women who molded and shaped them. *Motherlode* concludes with a series of essays reflecting on intergenerational inspirations. In Chapter Twenty-four Pat and Carol Williams remember their grandmothers and the importance of these women, not only in their own time but also, through the lives they nurtured, to the generations beyond their own lifetimes. In Chapter Twenty-five Bill Macgregor recalls his paternal grandmother, Pearl, who lost her father in a mine accident. Although Pearl's family left Butte to make a living in the Arizona mines, Pearl carried Butte with her and instilled a powerful sense of place in her grandson, Bill, who found himself compelled to "return" to Butte, a place he had never lived, and make it his home. Kitte Keane Robins reflects on the legacy of her mother, Mary Thomas Keane, one of the organizers of the Butte Teachers' Union, and the lessons she learned from her mother's commitment to the struggle for justice in Chapter Twenty-six. And in Chapter Twenty-seven Tracy Thornton remembers Dorothy and Lucile Hannifin, longtime proprietors of Hannifin's Jewelry Store, who left the rough-cut Mining City a legacy of elegance and refinement.

The process of writing and producing *Motherlode* has been inspirational. The editors and contributors share a sense of wonder and deep respect for the women whose stories are told here. And yet, the stories told here are not only of "exceptional" women. They are also the stories of our mothers, grandmothers, aunts, sisters, neighbors, friends, and co-workers. Perhaps it is best to think of *Motherlode* as a work in progress. It will be written and revised again and again in the conversations shared and the stories passed down among residents of Butte and beyond. Hopefully, the stories told will inspire and embolden the first generation of the twenty-first century as they imagine, invent, and transform what it means to be a woman.

NOTES

1. See for example C. B. Glasscock, *The War of the Copper Kings* (New York: Grosset and Dunlap, 1935); K. Ross Toole, "A History of the Anaconda Copper Mining Company: A Study in the Relationships Between a State and its People and a Corporation, 1880-1950" (PhD diss., University of California, Los Angeles, 1954); Michael Malone, *The Battle for Butte: Mining and Politics on the Northern Frontier* (Seattle: University of Washington Press, 1981); and Jerry W. Calvert, *The Gibraltar: Socialism and Labor in Butte, Montana* (Helena, MT: Montana Historical Society, 1988). For an excellent overview of Butte, the copper industry, and its environmental consequences see also Edwin Dobb, "Pennies from Hell: In Montana the Bill for America's Copper Comes Due," *Harper's* 293 (October, 1996): 39-54.

2. See Writers Project of Montana, *Copper Camp: The Lusty Story of Butte, Montana, the Richest Hill on Earth* (Helena, MT: Riverbend Publishing, 2002). First published in 1943 by the Montana State Department of Agriculture, Labor and Industry. Citations are to the Riverbend edition.

3. Writers Project of Montana, *Copper Camp*, 263.

4. Carolyn Mattern, "Mary MacLane: A Feminist Opinion," *Montana, The Magazine of Western History,* 27 (1977): 54-63; Leslie Wheeler, "Montana's Shocking Litr'y Lady," *Montana, The Magazine of Western History,* 27 (1977): 20 –33.

5. See for example Mattern, "Mary MacLane;" Wheeler, "Lit'ry Lady;" and Penelope Rosemont, ed., *The Story of Mary MacLane and Other Writings* (Chicago: Charles H. Kerr, 1997). MacLane's books include *The Story of Mary MacLane* (Chicago: Herbert S. Stone, 1901); *My Friend Annabell Lee* (Chicago: Herbert S. Stone, 1903); and *I, Mary MacLane* (New York: Frederick A. Stokes, 1917). She is the author of numerous essays as well.

6. See for example, Kim Barnes and Mary Clearman Blew, eds., *Circle of Women* (New York: Penguin Books, 1994); Eva Baron, ed., *Work Engendered: Toward a New History of American Labor* (Ithaca: Cornell University Press, 1991); Ruth Behar and Deborah Gordon, eds., *Women Writing Culture* (Berkeley: University of California Press, 1995); Ann Bookman and Sandra Morgen, eds., *Women and the Politics of Empowerment* (Philadelphia: Temple University Press, 1988); Linda Briskin and Lynda Yanz, eds., *Union Sisters: Women in the Labor Movement,* 2nd edition (Toronto: Women's Educational Press, 1985); Josefina Figueira-McDonough and Rosemary Sarri, eds., *Women on the Margins* (New York: Haworth Press, 2002); and Nancy Naples, ed., *Community Activism and Feminist Politics* (New York: Routledge Press, 1998).

7. See Mary Murphy, *Mining Cultures: Men, Women and Leisure in Butte, 1914-1941* (Urbana: University of Illinois Press, 1997) and Laurie Mercier *Anaconda: Labor, Community, and Culture* (Urbana: University of Illinois Press, 2001).

8. See Janet L. Finn, *Tracing the Veins of Copper, Culture, and Community from Butte to Chuquicamata* (Berkeley: University of California Press, 1998); "A Penny for Your Thoughts: Stories of Women, Copper and Community," *Frontiers: A Journal of Women Studies,* 19 (1998): 231-249; "The Women of Villa Paula Jaraquemada," *Community Development Journal* 36 (2001): 183-197; and "Mining Men," in *Gendered Modernities: Ethnographic Perspectives,* ed. Dorothy Hodgson (New York: Palgrave, 2001), 205-234.

9. While the introduction presents a chronological account of 20th century Butte, the chapters are thematically organized, therefore they are not necessarily mentioned in chapter order within the introduction.

10. William E. Carroll and Alex Mackel, *Revised Ordinances, City of Butte, 1914, Published by Authority of City Council of City of Butte* (Butte, MT: McKee Printing, 1914). See Murphy, *Mining Cultures,* 1-41, and Montana Writers Project, *Copper Camp,* 297-315, for a more detailed introduction to early Butte.

11. See Calvert, *Gibraltar,* on Butte's early labor history.

12. Mary Murphy, "Women on the Line: Prostitution in Butte, Montana, 1878-1917" (master's thesis, University of North Carolina, Chapel Hill, 1983), 7-8; Mary Murphy, "Women's Work in a Man's World," *Speculator* 1 (Winter, 1984): 18-25; Murphy, *Mining Cultures,* 9-10.

13. Montana Writers Project, *Copper Camp,* 18.

14. For engaging discussion of gender in early Butte see Murphy, *Mining Cultures,* Chapters 2 and 3, 42-105.

15. Murphy, *Mining Cultures,* 10.

16. Murphy, "Women on the Line," 23; Twelfth Census of the U.S., 1900, Volume 9, Silver Bow County, Butte Silver Bow Public Archives (Hereafter BSBPA); Laura Weatherly and Margaret Harrington, "Bucket Girl, Yard Girl: The Women Who Worked in Butte," *Catering Industry Employee* (October, 1975): 22-23.

17. Murphy, *Mining Cultures,* 139; Mary Murphy, *Surviving Butte: Leisure and Community in a Western*

Mining City, 1917-1941. Ann Arbor, MI: University Microfilms, 1990, 227-228.

18. Montana Writers Project, *Copper Camp*, 301.

19. Ibid, 19-20.

20. Ibid, 20.

21. Murphy, *Mining Cultures*, 19-20.

22. David Emmons, *The Butte Irish: Class and Ethnicity in an American Mining Town, 1875-1925* (Urbana: University of Illinois Press, 1989), 71.

23. *Butte City Directory, 1916, Volume XXX* (Helena, MT: R. L. Polk), 818.

24. Andrea McCormick, "Buckley Boardinghouse: Butte's Little Ireland," *Montana Standard* (Butte, MT), March 16, 1980, 18.

25. Murphy, *Mining Cultures*, 20-21.

26. Ibid, 31.

27. Robert Bigart, *Montana: An Assessment for the Future* (Missoula, MT: UM Publications in History, 1978).

28. Silver Bow County Board of Health, "Report Showing Results of Inspections of Dwellings, Hotels, Rooming Houses, and Boarding Houses and Their Surroundings," (Helena, MT: Montana Historical Society Archives (Hereafter MHSA), 1912).

29. John Astle, *Only in Butte: Stories Off the Hill* (Butte, MT: Holt Publishing, 2004), 56-57.

30. Ibid, 64-65.

31. Ibid, 59.

32. Murphy, *Surviving Butte*, 1990, 43-45; "Report of Committee Appointed by the Sixteenth Legislative Assembly to Investigate the High Cost of Living," (typescript, 1919, Montana Historical Society Library), 160-61.

33. Murphy, *Mining Cultures*, 28

34. Ibid.

35. *Butte City Directory*, 1917, Vol. XXXI (Helena, MT: H. R. Polk, 1917). Butte's population has continued to decline since.

36. Women's Protective Union Timeline, compiled by Whitney Williams, n. d., Vertical File, BSBPA.

37. Mary Murphy, "Bootlegging Mothers and Drinking Daughters: Gender and Prohibition in Butte, Montana," in *Montana Legacy: Essays on History, People, and Place*, ed. Harry W. Fritz, Mary Murphy, and Robert Swartout, Jr., 177-200 (Helena, MT: Montana Historical Society Press).

38. Murphy, *Mining Cultures*, 202-204; Montana Bureau of Child Protection Biennial Report 1931-32, Montana State Library, Helena, MT.

39. Message of Governor F. H. Cooney to the 23rd Legislative Assembly in Special Session of the State of Montana, 1933, Montana State Library, cited in State of Montana Department of Public Welfare Report to the Honorable Roy E. Ayers, Governor, for the One-Year Period Beginning March 2, 1937 and Terminating March 1, 1938. I. M. Brandjord, Administrator of Public Welfare and Secretary to the State Board of Public Welfare, Montana State Library, Helena, MT, 21 (hereafter Public Welfare Report, 1937-38).

40. "Copper States Have Big Relief Rolls," *The Eye Opener* (Butte, MT) October 13, 1935, 4. The article reports that Butte was second only to Phoenix, Arizona, in its percentage of residents receiving relief.

41. Montana Relief Commission was established in 1933, and its role was expanded in 1935 to respond to widespread need. Public Welfare Report, 1937-38, 22. See also Kinsey Howard, "Boisterous Butte," *Survey Graphic* 28 (May, 1939): 316.

42. State of Montana Department of Public Welfare Report to the Honorable Roy E. Ayers, Governor of the State of Montana, For the one-year period beginning March 2, 1938 and terminating June 30, 1940. I. M. Brandjord, Administrator of Public Welfare and Secretary to the State Board of Public Welfare, Montana State Library, 40 (hereafter Public Welfare Report 1938-1940). See also Ellen Woodward, "The Lasting Value of the WPA," http://newdeal.feri.org/works/wpa01.htm (accessed May 11, 2004).

43. Department of Public Welfare Report, 1938-1940, 41; State of Montana Department of Public Welfare Report to The Honorable Sam C. Ford, Governor of the State of Montana, For the Period Beginning July 1, 1940 and terminating June 30, 1942, J. B. Convery, Administrator of Public Welfare and Secretary to the State Board of Public Welfare, Montana State Library, Helena, MT, 29.

44. State of Montana Department of Public Welfare Report to The Hon. Sam C. Ford, Governor of the State of Montana, for the period beginning July 1, 1940 and terminating June 30, 1942. J. B. Convery, Administrator of Public Welfare and Secretary to the State Board of Public Welfare, June 30, 1942, 35. Montana State Library.

45. Margaret Cunningham, Interview with Helen Bresler, April 24, 1980, Oral History Collection, BSBPA.

46. Linda Cannon Burgess to family, April 6, 1938, Linda Cannon Burgess Collection PH054, BSBPA.

47. Manoah Leide-Tedesco, "True American Art, Free of Extraneous Influence, Found in Treasure State," *Montana Standard*, April, 24 1938, 7.

48. "A.W.V.S. Marking First Anniversary, Started with 40 Women, Now Has 650 on Staff," *Montana Standard*, April 4, 1943, Society, 1.

49. "Mobs Wreck Dozen Butte Homes," *Montana Standard*, April 15, 1946, 1.

50. This term is borrowed from Nancy Naples, *Grassroots Warriors: Activist Mothering, Community Work and the War on Poverty* (New York: Routledge, 1998).

51. Personal interview by Janet Finn, 1993, cited in Finn, *Tracing the Veins*, 166.

From the Archives

Highlights and Sidelights on the Cosmopolis of the Rockies: A Pen Picture of Butte

Mary Brennan Clapp (1923)

EDITORS' NOTE: Mary Brennan Clapp, a writer and poet, came to Butte in 1916 when her husband, Charles Clapp, was hired as a professor of geology at the School of Mines. Her essay, "Highlights and Sidelights on the Cosmopolis of the Rockies: A Pen Picture of Butte," was published in the *Anaconda Standard*, Sunday, February 4, 1923.[1] Her account paints a vivid picture of the impression Butte made on newcomers in the early twentieth century. The Clapps' economic position made their arrival much less trying than that of immigrant workers and itinerant laborers in search of a better life. Nonetheless, Mary Brennan Clapp was moved by the power of the place. Below are excerpts from her article.

THE STRANGER'S FIRST GLIMPSE OF BUTTE

I shall never forget that November afternoon several years ago that brought us on the Great Northern around behind the richest hill on earth, past the Pittsmont smelter, into the city of Butte at early dusk, to find our big "daddy" with the welcome news that after two months' searching for a dwelling commodious and comfortable enough to house three precious babies and their proud parents, he had finally bought a new bungalow just finished, away out on the slope of Big Butte.

I did not know then that Butte was a bad, bold place. I did not know that its seasons were all inclement, its faults unnumbered and its virtues nil. I knew only that my husband's work was there, in a field in which I was interested; that he had found a home for us and that we would all contribute the best that was in us to any community, which offered opportunities for service.

I had never been taught with any particular emphasis that Butte was a mining camp. I had learned from the Encyclopedia Britannica that it was the largest city in Montana, situated at an altitude of 5,700 feet, the center of the largest copper mining district in the world, well supplied with electric power, and that it put out annually (1910) almost as much copper as all of the rest of the country together.

I had learned from a Butte pamphlet that the population was over 100,000, that there were two high schools, 9 parochial schools, 23 public schools, the State School of Mines,

a public library, an Associated Charities, a Knights of Columbus building, plans for an immense Y.M.C.A. building, the Columbia Gardens, the Silver Bow Club, the Country Club, with well kept golf links, the amount of big business to be expected in a city of its size, shops, cafeterias and theaters to suit any taste, a symphony orchestra, and various women's clubs—literary, civic, musical, educational and social. It sounded good to me. So, aside from the fact that where a woman's treasury lies (in this case the salary of a college professor) there will be her heart also, I was glad to be there. We rode down hill and up hill, and still more up hill, happy in our reunion and eager to install in the new home the household gods of order, cleanliness, comfort and peace.

Such anticipation was happy, but our realization was happier. Here were oak floors and leveled plat windows that looked out to the hill and to the flats, already showing the wondrous nightly beauty that makes Butte, to those who love her, not a city of din and smoke, but of exaltation and aspiration and efficiency. Here were a wide fireplace and commodious bookcases, a built-in sideboard of simple elegance, a white-tiled bathroom, a full-length mirror in the bedroom door, a built-in tiled ice box, a southern sun porch that looked toward the Highlands, a full, finished concrete basement and an underfeed furnace. No wonder I never thought of Butte as a mining camp. No wonder I imagined that every light down the hill shone from the window of some bungalow as rich in possibilities of home happiness as our own.

I have said that I knew Butte was well equipped with electric power. What this would later mean to me was only partially imagined on that first night in our new home when I found already installed, because on account of the war domestic help was scarce, an electric range, a washer and a mangle. So began my adventures in electricity, which taught me, as nothing else could teach, the importance of the change that is coming in the lives of women. We must teach our daughters, in the light of new and wider opportunities, not less of housekeeping, but more of purpose, plan, and pleasure in their housekeeping.

That night, with no shades on the windows, lights out, and the moonlight reflected from newly-fallen snow, the house seemed full of a white glory that made all achievement possible, and put danger, discouragement and weariness far off. Big Butte, like an immense, kindly watch dog, looked in on us while we slept, and in the morning, we looked out upon a broad city vaguely outlined through violet veils of smoke from thousands of homes whose dinginess and outward homeliness were revealed very slowly and gently as the sun and wind gradually drew the long veils down the valley into the hills.

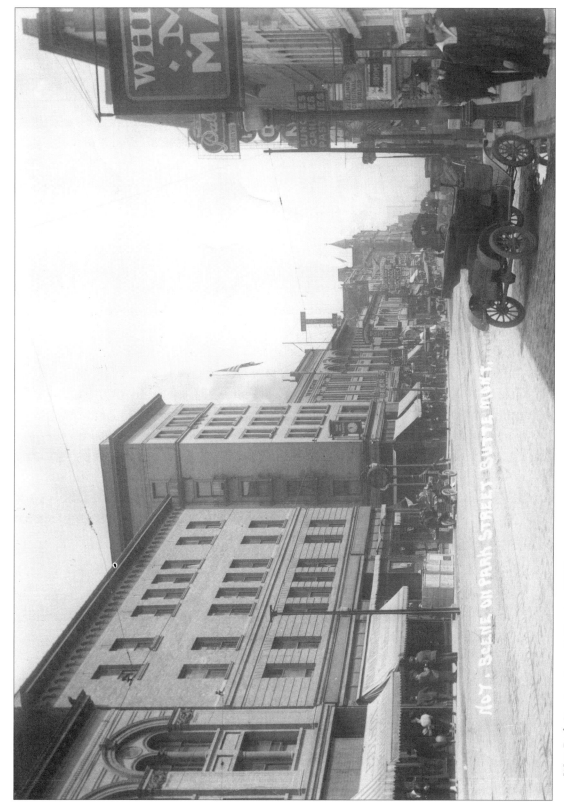

West Park Street, uptown Butte, circa 1920's.

I never thought of the mountains as being particularly barren. I was thrilled to feel that I stood near the crest of the continent and could follow with my eye the line of the Great Divide, and mark a fault above the Northern Pacific tracks where an earthquake might some day find entrance to the valley. I was thrilled to know that my house was built upon a rock, a rhyolite rock of no value as ore, never to be undermined, unless by some miracle of Nature's slow revolution the extinct volcano known as Big Butte should through long hibernation have kept one spark aglow that some internal bellows could kindle again to flame.

NEIGHBORS

I had been told that there were a thousand Sullivans in Butte. I have since found that there are, and in the light of English history for the last 800 years it does not seem strange that they should prefer Montana to Munster. We have been convinced through the Victrola that Ireland is a little bit of heaven, but those of us who have spent time in Butte sometimes feel that Butte is a little bit of Ireland. We know, too, that if it is a little bit of Ireland, it is also a little bit of England, Scotland and Wales; of Austria, of Bulgaria, Rumania, Italy and Finland, of France, Germany and Russia, and even of Czecho-Slovakia, Greece and China. I lived at the opposite side of the city from the mines. Yet I had among my immediate neighbors English, Irish, Welsh, Scotch, German, Italian, Swiss, French and Scandinavian. They were about equally endowed with the weaknesses and talents of human nature. Some had had better luck than others, and some had better health, but all, however vaguely, knew that they wanted to make Butte a better place for their children's sake. This is no reflection on Butte. It would, however, be a reflection on any city if its parent citizens did not care to make it a better place for the children's sake.

The first neighborhood call was made by three small boys, who did not know that throwing rocks onto the porch would wake the baby up. One of the boys was caught and it was several years before he called again. People in Butte do not make many calls. They meet at a club, or a café for teas, at the movies, at church, at cards. There is not much time left for calls. But if one is ill or in trouble – and this was true even before the "flu" opened all hearts to each other's anxieties – there is no lack of sympathy and neighborly kindness in Butte, nor any hesitancy in expressing it in deeds rather than in words. I had one neighbor who said she never made a call unless some one was sick. She helped rob measles and chickenpox of half their irksomeness.

NOTES

1. For complete text see Mary Brennan Clapp, "Highlights and Sidelights on the Cosmopolis of the Rockies: A Pen Picture of Butte," *Anaconda Standard* (Anaconda, MT), February 4, 1923, Part 2, 1. Volumes of the *Anaconda Standard* are available at the Butte-Silver Bow Public Archives. Brennan Clapp's husband, Dr. Charles H. Clapp, served as president of the School of Mines from 1918 to 1921. The family then moved to Missoula, where Dr. Clapp served as president of the University of Montana (then Montana State University) from 1921 to 1935. Mary Brennan Clapp continued to write while raising a family. She published her first collection of poetry, *And Then Re-Mold It,* in 1929 and her second, *Collected Verse*, in 1951.

PART TWO
WOMEN'S WORK

Sisterhood is Powerful: The Labors of the Butte Women's Protective Union

Marilyn Maney Ross and Janet L. Finn

Butte Daily Miner, Friday June 6, 1890
The Ladies Organizing
A Benevolent Association of Female Workers Formed

The ladies of Butte—God bless them!—are not going to be behind their brothers in demanding their rights. Last evening a representative assemblage of the working women of the city met at Miners' union hall and organized a protective association.

Dressmakers, milliners, waitresses, sales ladies and representatives of other occupations were present, and all manifested a strong interest in the purposes of the meeting.

P. H. Boland was there to assist the ladies in perfecting their organization, and as *The Miner* reporter was summarily fired from the sacred precincts before the meeting was called to order the public is indebted to the kindness of that gentleman for the following details.

The association is called the Butte Woman's Protective Union, and above and beyond its protective character its aims are to elevate the sex intellectually, morally, and socially, and to bring the members into closer relations with one another.

The union starts out with thirty-three members, and many more have intimated their intention to join but could not be present last evening.

Mrs. Delia Moore was elected president, and Miss Jencks vice-president of the association. A secretary, treasurer, warden and conductor were also elected, and the society was started off in good shape.

Mrs. E. M. Hughes, Mrs. Lamont, Mrs. Delia Moore, and three others whose names are forgotten, were appointed a commitee to draft a constitution and by-laws. A committee on membership was also appointed. The membership will embrace all classes of labor, and the main object of the union is to classify the wage workers, and set a minimum price on the labor of each class. The object is a meritorious one, and if the purposes of the organization are carried to their legitimate conclusions they cannot fail to better the condition of working women in this town.

Butte was a sprawling, brawling mining town in the 1880s. As the kings of the copper industry battled one another for control of the Butte Hill, miners were building their own power bases from the shaft up. Butte was becoming the epicenter of the labor movement in the West, earning the upstart city the title of the "Gibraltar of Unionism." Non-industrial workers as well as mine workers were coming together in solidarity to demand a living wage, job security, and given the dangerous nature of their labors, health and death benefits.

While mining defined Butte as a man's town, the day-to-day operations of the city were heavily dependent on the labors of women. The thousands of men who descended beneath Butte's surface around the clock had to live and eat somewhere. Rooming and boarding houses were becoming a flourishing part of Butte's social and economic life. In these spaces where the comforts of home merged with need for a service industry to support the mines and miners, women were in charge. Some proprietors had lost their husbands to the mines and faced the harsh reality of raising children on their own. Others sought to supplement their family earnings and to carve a niche in the limited economic space open to women in the late nineteenth century. From their humble beginnings, some of Butte's boarding houses, such as The Big Ship on East Park, the Mullen House in Centerville, and the Hazel Block on East Granite, became landmarks, and the women who ran them earned legendary stature[1].

Women were also earning wages on other service industry fronts in Butte, working as waitresses, hotel maids, nursemaids, "mangle girls"—who fed sheets through the massive flat work irons in commercial laundries, and "bucket girls"—who prepared thousands of lunch buckets daily for underground miners. Like their sisters across the country, Butte's working women faced restricted opportunities and meager salaries, given the diminished social value of "women's work." At the same time, Butte's working women were both witnesses to and participants in the struggles for workers' rights, wages, and safety. As they engaged with the growing miners' labor movement, their own consciousness as a collective labor force took shape. And so it was, on June 6, 1890, that a group of thirty-three working women came together to form the Butte Women's Protective Union (WPU). This chapter recounts the WPU's formation and early organizing efforts; highlights some of the union's campaigns over the course of the twentieth century; and explores some of the important themes that resonate through the stories of union activists.[2] The Women's Protective Union left a legacy well beyond secure wages and better working conditions for women workers. Its vision of a union as an instrument of social change for all workers inspired its members, and it serves as an example for all workers today.

BUILDING THE WPU

The women who gathered in the Miners' Unions Hall on June 6, 1890 were making history. They had set in motion the formation of one of Butte's oldest labor organizations and the only all-woman union in Montana. The fledgling union grew rapidly from its founding members. Its exclusively female membership soon included many restaurant workers, bucket girls, boarding house and hotel maids, laundry workers, women workers at the local tamale factory, vaudeville theater usherettes, midwives, milliners, a chimney sweep, and a fortune teller.[3] Early membership handbooks reflected the diverse categories of women's labor in Butte at the turn of the century. For example, "yard girls" plucked chickens and cleaned seafood shipped in kegs of ice to Butte's restaurants and wholesale food suppliers before modern refrigeration. Bucket girls packed lunch buckets round the clock for miners on different shifts. Feather girls worked for milliners arranging the intricate feather works on women's hats.[4]

The union was open to all working women, and focused its organizing efforts not on a particular trade or craft, but on working women as a class of people whose rights needed protection and promotion. In order to gain membership in the union, one simply had to be a woman working outside the home. From its inception, the WPU functioned not only as a site for labor organizing, it also operated as a community-based social service and action organization, along the lines of the settlement house movement, spearheaded by Jane Addams in Chicago in 1889.[5] The women saw themselves and their union as agents of social change and promoters of social justice, and they sought to improve the quality of life for all women. As early as 1892 the WPU began its own library, housing assistance program, and advocacy program to help women obtain child care, medical care, and legal services. By 1895 the union had established the Women's Industrial Institute in Butte to provide clean, affordable lodging for women workers. The union also initiated free weekly classes for women on topics ranging from job skills training to economic and political education, personal hygiene, child care, and citizenship. The women sought more than a fair wage for women workers in Butte. They also organized campaigns calling for national health insurance, unemployment insurance, and a retirement plan for all workers, nearly four decades before Franklin D. Roosevelt's New Deal.[6]

The newly formed union quickly gained strength through its affiliation with the progressive Knights of Labor. The Knights' belief in the unity of all workers and their willingness to organize all workers without regard to sex, nationality, or skill level made it a good fit for the young Women's Protective Union. The WPU's philosophy of

organizing by class rather than by trade or craft put it on a collision course with the American Federation of Labor and the craft unions.[7] The WPU supported the industrial union camp in the heated inter-union ideological and political struggles of the day. It took an active role in the founding of the Western Labor Union, a federation of industrial workers that championed the cause of industrial unionism. Later changing its name to the American Labor Union, the federation was active throughout the western United States in organizing workers by industry or class.

By the time of its affiliation with the American Labor Union, the WPU had matured into a forceful, progressive union providing strength and leadership to the industrial union movement throughout the nation. The union quickly translated its commitments into action. In 1903, for example, Butte women led the campaign for a ten-hour workday. And in 1904 they waged a victorious campaign against non-union hiring halls in Butte. The WPU remained affiliated with the American Labor Union until 1905, when it moved even further from craft unionism and toward class-based organizing by joining the Industrial Workers of the World, or the "Wobblies."[8] In retrospect, it is easy to see why the IWW's vision of one great union that embraced all workers was appealing to the women. Women workers had been marginalized and exploited both in terms of gender and class positioning. Denied the right to vote, barred from earning a living in most occupations, and denied access to the trades and craft unions, the women saw the IWW philosophy as one that recognized their struggles and valued their claims for social justice. Unfortunately, no records survive of the years of the WPU's IWW affiliation and its influence on the union and its individual members. However, given the fierce inter-union struggles that played out in Butte in the early years of the twentieth century, and the way in which IWW radicalism was viewed with fear and antagonism by more conservative unions, it is likely that the WPU also struggled both internally and with other unions over the direction of its progressive agenda.[9]

By 1907, perhaps in response to the union's isolation by the craft unions for its IWW affiliation, a strong faction within the WPU succeeded in bringing the union into the fold of trade unionism by affiliating with the Hotel Employees and Restaurant Employees International Union (HERE). However, when the WPU received its HERE charter in 1907 the union's unique character and historical significance were recognized. The women were allowed to keep their distinctive union name and to retain their female-only membership policy.[10] The affiliation with the HERE not only ended the involvement of the WPU in industrial unionism, it also established its future as a trade or craft union. In spite of this shift in organizing philosophy, the WPU continued to promote a progressive agenda for the rights of workers and women. For example, the WPU

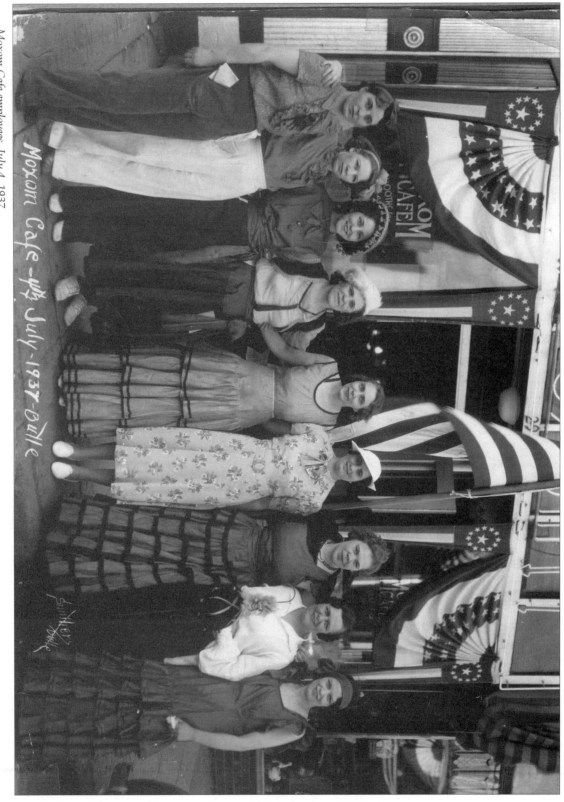

Moxom Cafe employees, July 4, 1937.

38

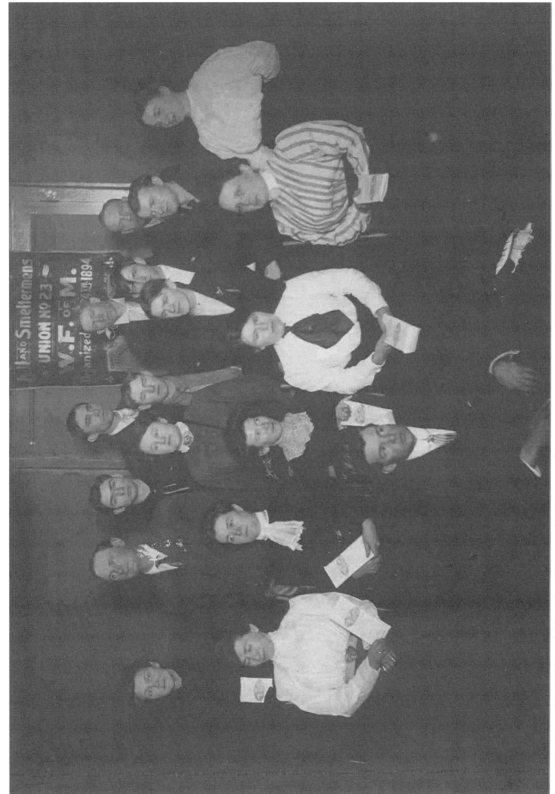

Members of the WPU and Silver Bow Trades and Labor Council, circa 1900.

welcomed its first African American members in 1907, priding itself on "not drawing the color line." The union's organizing force and powerful reputation were also recognized, perhaps begrudgingly, by Butte men. For example, in 1926, the Butte Miners' Union turned to the WPU for help, asking WPU members to pressure their husbands into getting organized. By 1929, the WPU boasted a membership of 500 and growing. By 1932 the union claimed 100 percent organization among waitresses in Butte.[11]

ORGANIZING WOMEN

Over time, a broad range of women workers would hold membership cards in the WPU, including hotel and motel maids, school and public building janitresses, hospital maids, candy-counter girls at local theaters, car-hops at drive-ins, and cocktail waitresses. Thus the legacy of valuing "women's work" in food preparation and "domestic" service remained central to the efforts of the WPU over time. The union promoted the dignity of women's labor, and formidable women organizers dedicated their lives to ensuring that the women's employers, customers, and the community at large knew just how valuable these women's contributions were. The name of Bridget Shea, a tough, no-nonsense WPU business agent, still sparks pride among women service employees in Butte. Shea walked the streets of Butte, keeping tabs on every establishment, recruiting new members to the union, making sure members were taking the union rules to heart, and taking employers to task for any misuse or abuse of their women employees. She demanded respect for WPU members as workers and as women. It was not unheard of for Shea to confront an errant employer with a broom and a good dose of public humiliation in return for an affront against the rights of her "girls." Likewise, Shea reminded members of union rules and the reasons for following them. For example, clear job descriptions meant workers could guard against exploitation by employers. Val Webster, a longtime WPU member, experienced the intimidating force of Bridget Shea first-hand. In 1929, at age 16, Webster began working as a dishwasher.[12] A year later she was hired as a waitress and then as a cook at the Union Grill. Like her mother before her, Webster joined the WPU early in her career. Webster recalls:

> Years ago they never stepped out of the boundaries . . . If you was a dishwasher, you was a dishwasher. I can't say that I didn't help dishwashers. A lot of times when I was a waitress . . . [I] wasn't supposed to, and [we'd] keep our eye out for Bridget to come in, but I loved her. One time I was working at the Union Grill and this Austrian woman, she was a real heavy woman, and she was working there. Oh, my gosh, she was a good worker. And it was suppertime. I was cooking then. I wasn't doing waitress work

then. I was a cook then. There was four waitresses and one dishwasher and myself. I was the cook for the four waitresses. And it was time for her to eat. And she said, "Oh no, I've got to get those dishes out." So I said, "Never mind the dishes. Sit down and eat." I had cooked her some pork chops and some potatoes and stuff and fixed peas. I can still see that dish sitting in front of her to this day. And I went over, and it was quiet. Everybody was waited on in front, and I said, "Mary, I'll wash your dishes up for you." "Oh, no," she said, "Bridget comes in and catches you . . ." "Oh," I said, "Bridget won't be in at this time of night." It was just about seven o'clock, and I never thought she'd come in, because she used to come in around eight or nine at night, when she'd come into catch both shifts. And I said, "Oh, she won't be in." Here I am, and I've got my head in the sink, and I'm going as fast as I can washing these dishes . . . The girls in the front were petrified when they saw her, because we were scared of her. I was just a young girl . . . And I said, "Oh, it's Bridget." "What are you doing?" [she asked]. I said, "Well, Mary's eating, and her dishes are piled up, and I thought I'd help her." "Oh, that's very nice," she said. "What time do you get off shift tomorrow?" I said, "I don't come to work 'til twelve o'clock." She said, "Come up to the union office at eleven o'clock tomorrow." "I'll be there." Well, I knew I was in for it. So I went home. I never slept all that night. My mother said, "That's what you get. If you stayed and done your own work you wouldn't have got into trouble." I never knew that Bridget had called my mother and told my mother not to worry, that she wouldn't punish me that much. So I went up at eleven o'clock to Bridget, and I said to her, "You told me to come up?" "And just what were you doing washing dishes?" I said, "I told you, poor Mary, and Mary was sick. And I just thought I'd give her a hand." She said, "You know you're a cook. You're not a dishwasher. The first thing you know, [the owners] will have you washing dishes and . . ." And I said, "Oh, no, they won't because I won't do it." "Well, you done it today," she said. And I said, "Well, that was just to help her a little bit." "Well," she said, " I'll let you go this time, and I won't bring you before the Executive Board, but if I ever catch you again, it'll be too bad." . . . But I helped that woman after, too, because she was the kindest woman . . . And I knew it was wrong, and still I thought if it was my mother washing dishes, I'd help her. So I felt that I was helping my fellow man, and I still feel that way today, especially where there are old women washing dishes. I do. I never caught one helping anybody, but I don't think I could ever punish them or bring them before the Executive Board or anything for doing it, for

the simple reason that I had done it myself . . . but if they didn't [follow the union rules] they'd be doing everything. You'd be scrubbing the floor and washing the dishes and washing glasses and silver and waiting on customers and cleaning out the toilet and everything else and peeling spuds and . . . no, if they didn't segregate your work, you'd be up against it.[13]

Val Webster herself went on to a sixteen-year career as business agent of the WPU. It is that combination of tough-mindedness and caring, as evidenced in Webster's story, that characterized the leadership and the work of the WPU over the years. The leadership advocated fiercely for the members and held them accountable to union discipline. At the same time, the union became a place of woman-to-woman solidarity and support. As membership soared, women never missed meetings. Webster remembers:

> We loved to go to the meetings. We'd have three hundred, four hundred people at a meeting. It was wonderful. It was just a joy to go and hear the business agent Bridget Shea and Lena Mattausch, the secretary, get up and tell you what they had done, how they'd go around and how our girls was abused by this one and how they'd take it up, and how they'd pick up a broom and chase the boss with the broom . . . It was very interesting to hear about them. And we would always go down to Gamer's . . . after the meeting and have ice cream. Always after a meeting we'd go there or to the Lockwood. That's where they had the best ice cream.[14]

Young women would wait for one another to get off shift, then head out together to enjoy Butte's nightlife, perhaps a dance at the Winter Garden or the Moose Lodge, or, on special occasions, a big band at Columbia Gardens.[15]

Through their experience in the WPU women saw their labor valued and validated. They took pride in their work as women and earned the respect of men in the community, especially the miners. The WPU nurtured strong bonds of friendship and a sense of family and community among its members. Moreover, many working women developed camaraderie with their customers, bringing a feeling of family and sense of community into the harsh worlds of hardrock miners. Waitresses and bucket girls might add an extra treat to the lunch of a miner they were particularly fond of. They got to know men's likes and dislikes. Catherine Hoy recalled her early work:

> I was . . . what they called a bucket girl. If the miners were nice to you, you gave them an extra cupcake or piece of cake or an extra piece of fruit or

something. But if they weren't, you know . . . I mean smart aleck or something like that, they just got their usual sandwich. And this was all made with homemade bread. The slices were about half an inch thick. You slapped the meat in there and then you put another big slice in there. They really had to use their jaws to get around that.[16]

Webster also remembered the connections and camaraderie shared among women of the WPU and their customers:

> You got so, working in the restaurant, that you knew what they wanted in their bucket, and you knew what they wanted for breakfast. When we worked at the [Union] Grill, there was two rooming houses right across the street down there on Park Street. They're both torn down now. And the Crown Bar was right next to it. And we'd see these fellows coming over. Well, we'd go into the kitchen and order their breakfast, because they always ordered the same thing, ham and eggs, or bacon or sausage or hotcakes or two boiled eggs, and we'd go and order. We had a lot of Irish fellows that ate there, and a couple of them that were very mean when they'd get up in the morning. But this one typical Irish, Mike Holland, he's dead now, God love him. And we'd know if he'd been out the night before, because we could see him coming across the street. And I'd say to Theresa, "Hurry up, put an Irish record on." We had one of those old phonographs with the horn on that you'd have to wind it up. And in between waiting on the customers we'd be winding this up. And we'd go and holler, "two boiled eggs for Mike and a boiled potato." He always wanted a boiled potato, for breakfast even . . . But we'd always put these Irish records on for Mike, so when he did open the door he'd hear the Irish music, and then everything was fine. We'd give him his pot of tea and his two boiled eggs and the paper. We always made sure that we had an extra paper for Mike Holland.[17]

Although mining employment and the overall population had begun to decline in Butte by the 1920s, the WPU continued to grow, and women continued to strengthen their position and further their rights as workers. By 1945 membership approached 1,000, and women worked eight-hour shifts, six days a week, with the right to overtime pay, sick leave, and paid vacation, benefits unheard of for service workers in most parts of the country. The union had built its power base, forged broad alliances with other labor organizations, and let it be known that it would fight for the rights of its members.

Rialto lunch counter.

STRIKE!

In 1949 the union's mettle was tested in a seven-week-long strike over contract negotiations. At the WPU Business meeting held on May 27, 1949, the regular order of business was suspended so that the officers could hear the report of the negotiating committee and learn the results of the strike vote. Vice-President Gertrude Sweet gave the result of the strike vote. Of 527 ballots cast, 421 voted to strike. As was reported in the minutes of the meeting:

> Sister Sweet stated that the vote to strike was strong enough to help the negotiating committee in their meeting with the bosses the next day. At this meeting we were offered a two-dollar a week raise, the same conditions that were offered us before, 4 time-and-a-half holidays, 2 weeks vacation after 4 years work, 1 dollar an hour for extra work for the first 2 hours. 85 cents an hour afterward, up to 6 hours, then the full shift to be paid . . . From the committee Sister Isabel Caras reported that the bosses have made it clear that there will be no more money offered. She recommended that we accept this offer. Sister Yochim reported that we have had 7 meetings with the bosses and they won't budge, and she didn't think we'd get any more. She also recommended that we accept this offer.[18]

Initially, President Bridget Shea also recommended that the membership accept the offer, noting that a strike could cause many hardships. Ballots were then passed to the members present, and the resulting vote was 170 to accept the contract and 168 to reject it. Given the near even split, a motion was made to only consider the vote as an expression of how the group was feeling and to call another strike vote at the next business meeting when all members could be present. The negotiating committee continued its efforts, but made no headway. By June 8, negotiating efforts were deadlocked, and the union decided to strike. The strike began on June 9, with the strong support of the affiliate unions of waiters, cooks, and bartenders, and without a final strike vote ever being called. Members were advised to leave their place of employment, come to the union office, and register for picket duty.[19]

The WPU continually insisted that the strike be conducted in an orderly manner, noting that "we can reach an earlier settlement if we have the respect of the bosses and the town." The strike was a difficult one, and one that brought the solidarity of the Teamsters, the building trades, and the Butte citizenry to bear in support of Butte's working women. Carpenters were immediately pulled off a job at the Finlen Hotel,

where 24-hour-a-day picketing was underway. As Sister Mattausch, the new chairwoman of the strike committee reported:

> We are not afraid. We have a right to demand a living wage. Our cooks and waiters and our bartenders and the teamsters are our true friends. They have helped and will help us in every way. We mean business and we are going to win this strike. The Finlen will get no deliveries and our maids are all out. The guests can make their own beds. We haven't even had time to make ours. Our boarding houses are all lined up 100 percent. Our miners can all eat.[20]

Blanche Averett Copenhaver, a member of the WPU Executive Board at the time, remembers spending "half her life" in negotiating meetings during the strike, where she served as Picket Captain. She remembers:

> The girls took a strike vote and the employers' association said, "Go ahead." We were supported by bartenders, cooks, and waiters. Everybody honored the picket lines. Teamsters wouldn't deliver, building trades wouldn't do any work. We kept a kitchen open and a lot of merchants and bakers donated food. The International gave us $1000 for strike benefits. We gave the pickets $2, and we passed the coffee can during union meetings. Some restaurants were open that had a signed contract, and the girls who were working would kick in. All the members had to picket or they would be fined. Our husbands were supportive. Each member would picket once a week for two hours.[21]

The strike lasted seven weeks. The business meeting minutes reflect the determined spirit of the WPU membership for the duration of the strike: "Sister Mattausch reported that the strike is getting along nicely. We have surprised the bosses who thought there would be riots on the picket line, by our orderly picketing, we are not afraid, and have shown the bosses who have tried to crush us for many years that we are stronger than ever."[22] The strike garnered broad-based community, statewide, and international union support. At weekly union meetings the WPU secretary read letters of solidarity and support pouring in from other unions. Union men relieved women on the picket lines for the night shift. The International Union sent checks to bolster dwindling strike funds. And visiting celebrities took their stand with the WPU. For example, the minutes of the July 1, 1949 regular business meeting report that, "Tommy Dorsey's orchestra had reservations at the Finlen, and when he saw the picket line, they moved on to another hotel. And the night before Bing Crosby and his chauffeur did the same thing. So the pickets are doing a lot of good."[23]

The strike also caused strains and opened fissures within the union. The WPU brought diverse groups together under the unifying umbrella of women workers. However, the union represented women who worked the gamut of service industry jobs—waitresses, cooks, maids, elevator girls, tamale girls, and school and hospital janitresses. The strike wore on, and tensions grew among the membership and leadership, as some members began to see themselves as having different interests at stake. Throughout June and July, 1949, the union leaders held both regular meetings of the membership and special meetings with the different units. Meeting minutes speak to concerns over the growing distrust within the membership, fueled by bosses' efforts to split the union and damage the credibility of its leadership. The minutes of July 1, 1949, for example, speak to concerns that the Anaconda Company was getting involved, fanning the flames of discontent and seeking to disrupt the solidarity effort.

At a special meeting on the night of July 15, the negotiating committee reported to members on the hard job they had faced in fighting for better wages and conditions. Weary from battle, Sister Averett [Copenhaver] of the negotiating committee reported that "we have gone as far as we could . . . and we were lucky to get any offer at all, what with having to fight the bosses, the ACM, and now part of our own membership."[24] Although the strike was settled the following week, resentment and distrust lingered within the union. Some members questioned the decision-making actions of the leadership. Sister Gertrude Sweet of the negotiating committee took the wayward members to task at the July 22 meeting. According to the meeting minutes, after Sweet recapped the hard work of the negotiating committee, "she talked on the move to split our union by the petitions to withdraw and join the cooks and waiters union, which were circulated through the strike by five of our sisters . . . She stated that this was sabotage and asked for the traitors to stand up and admit their guilt,"[25] which they did. Sweet proceeded to "lecture these girls severely on their treason . . . She then talked of the discord and under current in our local and asked that all officers work together and that the membership work with them to help settle this discord or the local would have to be put into receivership."[26] When a settlement was reached in July, the members of the WPU had won higher wages and modestly improved conditions, and they had bolstered their sense of dignity as women and as workers. The leadership continued to grapple with internal tensions, which took their toll on the union. As Val Webster recalls:

> It was a sad time for the union. Because the secretary and the business agent that we had—Lena Mattausch was secretary and Bridget Shea was [business agent] and there were never two finer people. But we had a couple of cats in

the union that carried tales to one and carried tales to the other and caused friction between the two of them. And they were like sisters for forty years up in that union. It was really a sad thing. And the [the International] took it under receivership and Blanche [Copenhaver] was appointed president. It's just something that I don't like to talk about. It's painful to me because they were two of the greatest union women that ever lived.[27]

MAINTAINING MOMENTUM

In 1955, membership in the WPU reached its peak at 1149 women. Throughout the post-war years, the WPU maintained its active political involvement and women's advocacy from the local to the international level. Blanche Copenhaver's personal story is intimately bound to that of the WPU. Copenhaver came to Butte in 1937 and found work as a waitress shortly thereafter. After breaking her back in a car accident, she was forced to give up waitressing. She worked as the cashier at Green's Restaurant for twenty-three years, and served in various WPU leadership positions from 1944 to 1975, including recording secretary and president. In responding to a request for an interview in 1980, Copenhaver wrote down her recollections of her years in the WPU. Copenhaver states:

> I truly loved this office (president), and put my whole heart and soul into it. I really worked at it, while holding my regular job. I held the office of delegate to the Local Joint Executive Board almost continuously until the present time. As a delegate to the Silver Bow Trades and Labor Council I have been since 1948 a delegate to all state and international conventions. I have attended seven of the latter. I have served on numerous committees of both and have been given the privilege of making the nominating speech for our Vice President at four of the international conventions.

> I was secretary of the Resolutions Committee for four years in the State AFL-CIO yearly conventions. I was advanced to chairman of the C.O.P.E. [Committee on Political Education] screening committee, a very difficult position and one which I held until two years ago, when I was elected Vice-president of the State AFL-CIO, a position I still hold. I was secretary of our State Culinary and Bartenders' Alliance for one term and State President for three terms.

> During my years as President our union made great strides in its contracts. We were the first in the state to obtain a five-day work week, the first to

Rialto Theatre candy counter.

negotiate a health and welfare provision for our members, the first to establish a death benefit for our members . . . [28]

Copenhaver and the WPU worked hard to defeat a "Right to Work" bill in the state. They helped organize a fund-raising drive for a city swimming pool and water park. During the long and difficult mine strike of 1959 the WPU joined with other members of the Silver Bow Trades and Labor Council to help meet community needs. As Copenhaver recalls:

[T]he town was in bad shape. With people going hungry and needing clothing the Silver Bow Trades and Labor Council set up a committee which

asked people from all over the state to help us. I was Secretary of this committee which really worked at the job. Truck loads of food and clothing were sent in from all over the state. Thousands of dollars were collected which were parceled out to the needy. The clothing and shoes were stored in City Hall for whoever needed them. We met regularly and gave an accounting of all monies disbursed. I felt that this bunch of dedicated people kept Butte alive and more or less stable through that long bitter strike.[29]

WPU organizers worked hard to unionize new establishments, especially chain businesses, when they located in Butte. As Webster remembers:

Our hardest problem was with these chain outfits when they came in. But still I can't say we had too much trouble with them because we had the Ramada [Inn] and the War Bonnet [Inn]. As soon as we talked to them and they agreed that they'd live up to the rules, why, that was it . . . Like Fairmont Hot Springs, I went down and talked to them people. As soon as they started building a place or somebody else was going to take over, I would go see them. But I wouldn't go alone. I'd always take some of these men from these other unions with me, and we'd just discuss everything that was going on, and tell them that it was a union town, and if they wanted to have union help, they'd have to live up to union rules. And it wasn't belligerent or nothing about it. I mean, we sat down, enjoyed a cup of coffee together and talked it over, and I never had any problems. The Fairmont was a very big deal for us, because part of it was in Anaconda and part of it was here. But the main part of it was in Silver Bow County, so we had the jurisdiction over it. So it was really a feather in my cap to get it. We got that, and now they've got Wendy's and all these places lined up. We had the Ramada and the War Bonnet, and we had the Kentucky Fried Chicken, the El Taco, and John's Taco, and the Village Inn. None of these places were union all over the state. So we were very fortunate that we were able to get them.[30]

Another WPU achievement in the 1970s was winning a battle over uniforms at Burger Crown. The restaurant backed down on their requirement that women workers wear skimpy "bunny outfits" after the WPU objected to their exploitative nature.

GOODBYE TO THE WPU

For eighty-three years the WPU was a "women only" organization. Not until 1973 when the local was merged with the Cooks and Waiters to form the Culinary and

Miscellaneous Workers Union #457 did that tradition end. With the end of the women-only policy, the distinctive name of the Women's Protective Union also passed into history. But its legacy lives on in the collective strength and pride of Butte's organized working women. The WPU is an inspiration to working women everywhere.

NOTES

1. Laura Ryan Weatherly and Margaret Harrington, "Bucket Girl, Yard Girl: The Women Who Worked in Butte," *Catering Industry Employee* (October, 1975): 22.

2. This overview of the WPU draws in part from excerpts of previously published work by Marilyn Maney (Ross). See Marilyn Maney, "Women's Protective Union," *Montana Family Union Voice* (December, 1990): 4-6. The material is used here with the permission of the Montana AFL-CIO.

3. Maney, "Women's Protective Union," 4.

4. Ryan Weatherly and Harrington, "Bucket Girl, Yard Girl," 23.

5. The Settlement House Movement, begun in Chicago by social reformer Jane Addams, sought to address the concerns of urban workers and their families experiencing the throes of immigration, urbanization, and industrialization at the turn of the twentieth century. Settlement Houses were neighborhood-based centers that actively involved residents in addressing health, education, welfare, and recreation and in promoting cultural development and civic engagement.

6. Maney, "Women's Protective Union,"6.

7. Ibid, 4. Under Samuel Gompers' leadership the AFL was committed to organizing by craft or trade. The philosophical differences between craft/trade-based organizing and industrial/class-based organizing were sources of friction in the emergent labor movement in the U.S. in the early 1900s.

8. The Industrial Workers of the World (IWW) was founded in Chicago in 1905. The union promoted the direct action of workers to overthrow the capitalist system, transform the social order, and create a cooperative commonwealth of the working class. For discussion of the role of the IWW in Butte see Jerry W. Calvert, *The Gibraltar: Socialism and Labor in Butte, Montana, 1895-1920* (Helena, MT: Montana Historical Society Press, 1988).

9. Maney, "Women's Protective Union," 5.

10. Ibid, 6.

11. See "Timeline of significant events for the Women's Protective Union," Vertical File: "Labor Union: Women's Protective Union," compiled by Whitney Williams, Butte-Silver Bow Public Archives (Hereafter BSBPA).

12. Background on Valentine (Val) Catherine Kenny Webster drawn from interview with Mary Murphy, February 24, 1980, Oral History Collection, BSBPA (Hereafter referred to as Webster interview).

13. Webster interview, 22-29.

14. Webster interview, 15-16.

15. The Winter Garden was a popular dance hall located on Montana Street. Columbia Gardens was Butte's crown jewel, a famed amusement park and gardens located in the mountains just east of town and accessible by street car. For a concise history of Columbia Gardens see Lynne Boyer, "Butte's Columbia Gardens," *Montana Historian* 8 (1978): 2-7.

16. Catherine Hoy, Interview with Caroline Smithson and Ray Caulkin, May 11, 1979, Oral History

Collection, BSBPA, 14.

17. Webster interview, 11.

18. WPU meeting minutes, May 27, 1949, Hotel Employees and Restaurant Employees (HERE) Minute Book 1948-50, 294-295, WPU file LH-002, BSBPA, (Hereafter WPU meeting minutes).

19. WPU meeting minutes, June 8, 1949, 305.

20. WPU meeting minutes, June 10, 1949, 309.

21. Blanche Averett Copenhaver, Interview by Mary Murphy, February 21, 1980, Oral History Collection, BSBPA, 3 (Hereafter Copenhaver interview). Note that she is referred to as Blanche Averett in the WPU minutes at the time of the strike and Blanche Copenhaver in the oral history and when referenced by Val Webster. She serves as the recording secretary at the time of the strike.

22. WPU meeting minutes, June 24, 1949, 318.

23. WPU meeting minutes, July 1, 1949, 322.

24. WPU meeting minutes, July 15, 1949, 334.

25. WPU meeting minutes, July 22, 1949, 338.

26. Ibid.

27. Webster interview, 24-25.

28. Copenhaver interview, transcript of written recollections, 1. This quote is from notes written by Blanche Copenhaver the day prior to her 1980 interview with Mary Murphy. The written text accompanies the oral history transcript. The Committee on Political Education is the major political action committee for organized labor.

29. Copenhaver interview, transcript of written recollections, 2. See Note 28.

30. Webster interview, 25.

Nun rethinks our education

Sr. Mary Seraphine Sheehan (1975[1])

EDITORS' NOTE: This article originally appeared in the *Montana Standard*, Sunday, August 24, 1975. It was part of a series contributed by Butte's chapter of the American Association of University Women (AAUW) for the AAUW Bicentennial Heritage Project. It is reprinted in its entirety here with permission of the newspaper.

As long as there are living graduates of the old Butte Central High School, the name of Sister Mary Xavier Davey will live in their stories and memories. She was baptized Elizabeth in a small village church in Ireland, April 3, 1866, the child of Patrick and Mary Davey. Her student days began under the tutelage of the village schoolmaster and continued later in the same discipline by the Sisters of Mercy. She entered the Sisters of Charity of Leavenworth, Kan., in 1887 after crossing an ocean and most of a continent to join an order devoted to teaching, nursing and orphan care. Her first acquaintance with the young people of Butte was in 1893, when she went from the old St. Aloysius School for Boys in Helena to St. Patrick's School in Butte.

Catholic high schools of that day were parish affairs with one at St. Lawrence in Walkerville, one at St. Patrick and a third at Sacred Heart parish, later known as Commercial College. All were staffed by Sisters of Charity of Leavenworth. It has been said Sister Mary Xavier was "faculty" at St. Patrick. Name the subject; she taught it. The range was wide, from German to the advanced class in trigonometry. In those early years she began to speak firmly and often of the need for a single high school, a larger building with more space than the few rooms allotted the high school students on the third floor of old St. Patrick. Her first class were the graduates of 1896 with formal dress, ribbons, and diplomas that attested to sixteen credits. From this class there were girls and boys who, at her insistence, went on for further study.

For Sister Mary Xavier there was no place more like her native land than the mining camp with the young people who needed every opportunity to better themselves and their families. That she had an unusual capacity for teaching was a recognized fact. That she had a particular genius in the fields of mathematics and science was something of a marvel to the more sophisticated educators who came to know and respect her ability. She had a deep and lasting devotion to her God. Her Sisters could testify to her

kindness, prayerfulness and sense of humor. There was a commonality about her that endeared her to those who lived, taught and shared rigorous Butte winters with her. The same Sisters would attest to an innate personal dignity that marked her as a private person, a clue to the kind of influence she exercised in the classroom.

Sister had an insatiable curiosity about science and invaded the sacrosanct male School of Mines to find what and how the sciences were being used there and to what end they used mathematics. The first reaction of the all male faculty bordered on astonishment as the black-garbed figure strolled their halls. Since it was impossible to go there alone, there was always some less brave Sister hovering in her shadow, listening to the conversations, and later regaling the community with Sister Mary Xavier's newest conquest.

She developed her own instruction along with the lines of material she saw used at the "Mines," and she demanded that her boys be masters of the subjects she taught. It was perhaps in this period that she became known affectionately and a bit fearfully, too, as "Zave" and she would be identified as "Zave" to the end of her teaching days.

When Sister was invited by "Mines" faculty to attend a lecture by a distinguished mathematician, she took several of her best students. It was a day they would never forget. The lecturer was competent and well prepared, and when he posed a certain equation for the assembly he expressed himself as not at all surprised when no solution was forthcoming.

The lone woman present raised her hand, and said in her deliberate voice, "Sir, I would like to try it." His was a kindly, if a bit patronizing tone as he handed her chalk and eraser. The figures went on the blackboard quickly, firmly and accurately. Amid the delighted applause of other teachers, she turned to the startled visitor saying, "Now, Sir, I would like to give you one." She did. He could not solve it, so she did. It was a triumphant moment for her students, and it was they who brought the story back. She disclaimed all knowledge of it.

Not only the School of Mines but the Hill itself became her target. Again with a timid companion in tow, she made trips to the Anaconda Mine, the St. Lawrence and the Mountain Con. She wanted to know what mining involved, what skills were needed to take her boys out of the underground diggings and what ones were necessary to make life safer in the mines. Shift bosses and superintendents grew to know her and to respect her single-mindedness, although they sometimes became uneasy with her direct questioning. As she became better acquainted with the mines, she would sally forth

with a high school girl for companion and either have a pressing question answered on the spot, or else return with materials she need for the laboratory.

Contacts with the mining personnel won her friends on the Hill and in the Anaconda offices in the Hennessy Building.[2] What she would never ask for herself, she did not hesitate to ask for her students. Her lab, though small in size and meager in funds, never lacked necessary equipment. If her students were to learn they had to put texts into experience. A call to the Hill would bring her the needed glass tubing, a priceless commodity, and the class set to work to convert it into tubes and pipettes. Copper tubing and wire were plentiful, too, but in no instance did the generous supply ever justify waste of any articles.

Sister Mary Xavier's own formal education was continuing in summer sessions. In the early 1900s she completed requirements for a bachelor, then a master degree at Creighton University in Omaha, Neb., in mathematics and science. Sister left Butte when assigned to Leavenworth, Kansas, for a year. In 1905, she was back in Helena at St. Aloysius and the following year she returned to her favorite spot, Butte. It was to the "new" Central, a converted boarding house on North Montana where she became proprietor of the chemistry lab, teacher of advanced mathematics, counselor, friend, firm disciplinarian and shaper of many destinies.

Sister Mary Xavier pushed for a program in athletics for the boys. There was no possibility of a field, locker rooms or uniforms when the team took to the gridiron for the first time. All of these would be secured in due time, for she now had "boys" who were in positions where they could help her projects. The man out in front was the priest in charge, but the force propelling the team was "Zave." Her way of evaluating poorly played games stung, and no team wanted to face her the day after a defeat. A victory was another matter or a game well played but lost.

One of the great moments for the boys and her was the finally accomplished victory over rival Butte High. The jubilant team, still in uniforms and streaked with mud from Clark Park field, headed for the convent where they could give her a first-hand account and enjoy her approval.

In a rough and tumble world, she demanded and got "ladies and gentlemen." She mourned the strikes that brought hunger and want to the town, but she defended the right of the miners to strike. She ordered a respect for the militia who patrolled the streets, and who early one school year set up a post right outside the school.[3] They were there to protect everyone she taught, and she sent out pots of hot coffee made in her lab.

One day the boys decided they could and would wear the blue denim overalls to school rather than the suit and tie required.[4] With trepidation, a segment of the group arrived for chemistry class. Sister Mary Xavier surveyed the class for several minutes while the uneasiness grew, not only among the denim clad youths but all those who were cringing under the silent scrutiny. In measured tones, she suggested: "Gentlemen to the front; bums to the rear." The shift was made in a quick scramble, the class began and not once did she acknowledge the rear of the room. No one could endure that icy calm, and at noon break the denims were abandoned. The incident never was mentioned.

Sister Mary Xavier was convinced of the value of coeducation, maintaining that boys needed the softening influence of girls while the latter were challenged to their best work by the presence of the boys. It was to her deep, personal sorrow when she heard of a decision to build a new school to house boys and incoming Christian Brothers, leaving girls and Sisters in the old school. For several years, Sister had been talking of the need for another building as the steady growth in enrollment crowded the small high school and overflowed into annexes in the county courthouse and in St. Patrick School. She had not anticipated division of students nor the advent of the Brothers. Authority had spoken in the person of Bishop John P. Carroll, and she had no further comment to make other than she thought she might remain just a "few" more years. Those "few" years were the last of coed classes in the old building. So, the legend of her preference for teaching boys was cemented.

Sister left teaching in 1926 but not active involvement. Her talents were transferred to the office areas of the community's hospitals. Her career came to a halt when a bad fall resulted in a broken hip, which never properly healed and confined her to a wheel chair until her death March 6, 1950. Sister Mary Xavier Davey's epitaph was written in a telegram from Peter Hunt, "During her years here, she did more for the youth of Butte than any one other person."

NOTES

1. Notes accompanying this essay have been added by the editors.
2. The upper floors of the Hennessy Building on North Main Street housed the Montana headquarters of the Anaconda Company.
3. The city of Butte was under martial law, with militia patrolling the streets, for extended periods of time between 1914 and 1921.
4. Blue denim overalls were the uniform of the working man in this era.

A Taste for Butte: Lydia Micheletti

Andrea McCormick

When ten-year-old Lydia Micheletti boarded a ship in 1920, she knew she was sailing to Montana. What she didn't know was that she was headed into history. Many years down a long, hard road, the name *Lydia* would be synonymous with Butte and some of the finest Italian cuisine ever offered.[1]

Lydia's cooking story began when she left home in Sasso Ferrato, Italy, with her mother, Attilia, and older sisters Connie and Mary. The family patriarch, David Micheletti, had immigrated about nine years earlier and was working a mining claim at Elkhorn.[2] Soon after the family reunited, the claim played out, and the Michelettis moved to Meaderville, on the outskirts of Butte.

The bustling Italian community filled with stores, saloons, and budding restaurants was on its way to becoming a world-famous nightspot. It was a perfect fit for the young girl who had learned to cook from her mother in the old country. "I knew how to make noodles, bread, everything at seven-and-a-half," Lydia recalled in a 1976 interview.[3]

Though her father never hit paydirt in the soil, Lydia staked a sure claim at the stove. In 1923 during Prohibition, the thirteen-year-old started cooking for Meaderville's Mike Solat, who had opened an eatery and gambling joint after losing both hands in the mines. Lydia soon moved on to larger Meaderville places where she learned to cook for bigger crowds—the White Front, La Campana, El Travatore, and Spanish Village.

Hunters Hot Springs, a resort near Livingston, Montana, followed. "Everybody wanted me then." It was at Hunters where Lydia learned to cook steaks from a chef name Spaghetti. "If you got a complaint one was too well done, you watched it the next time. Finally, you caught on."

Long hours in hot kitchens did not make for an easy life. Lydia worked seven days a week for seven years without a single day off. "The first time I had a day off was when I worked for Teddy Traparish," at Meaderville's renowned Rocky Mountain Café. On that first day off, Lydia's big brown eyes stared in amazement at a dazzling Mining City lit up at night, a sight she had missed because she always had been at work until the wee morning hours.

Lydia Micheletti, 1976.

Lydia encountered her most difficult culinary lessons at Teddy's. While her previous jobs required a larger version of the Italian cooking done at home, Teddy's also boasted private parties in which hunters brought wild pheasant, ducks, and geese to be cleaned and prepared. Lydia learned to turn out a delicious meal with whatever landed in her pans.

Once, during the big gambling days at the Rocky Mountain, a delighted customer went back to the kitchen with a handful of money, asking for the cook. "I kept on saying I was the cook, but he didn't believe it. He asked the other girls in the kitchen and they told him I was the cook. But he said I didn't look like a cook." The big spender remained unconvinced, and Lydia got only a dollar from the wad of money he put back in his pocket.

In the 1930s, after cooking many years for others, Lydia accepted an offer from legendary Butte boxer and restaurateur Sonny O'Day to become partners in Meaderville's Savoy. Although it was a gutsy move for a single woman, her sister Connie says that many

restaurants and boardinghouses were run by women in those days, sometimes with the help of husbands or male partners, sometimes not.

When the lease expired in 1946, Lydia bought a restaurant near the Five Mile from Albina Sylvain to establish the first *Lydia's*.[4] Being the boss didn't make life easier. "I cooked all the time, twelve to sixteen hours a day, seven days a week. People used to come in at midnight, and you had to stay there. There were too many places in those days. You had to keep your customers."

Sylvain had shared with her successor a recipe that would become a trademark of *Lydia's* - sweet potato salad. Serving the specialty as an appetizer along with pickled beets, salami, and cheese was a first in the restaurant business nationally, Lydia said. During her early days in business, Lydia used to make about 4,000 ravioli by hand every week. In later years, technology eased the burden by providing an electric machine to close the 40,000 ravioli produced each month.

In 1964, Lydia built an elegant new restaurant near the site of the old one. The long, hard hours and trademark Italian food moved with her, including her chicken cacciatore, Italian veal, deep-fried chicken, and homemade spaghetti sauce.

An important change brought by the passing years was in the entrees that customers preferred. Diners seldom splurged on steak during Lydia's early days at the Rocky Mountain, where a steak cost about $1.50 and a chicken dinner only fifty cents. Chicken continued to be more popular than steak when Lydia owned the Savoy. In later years, while Lydia's famous fried chicken remained in demand, steak and seafood moved up the menu as favorites.

Lydia was in her early sixties when she finally retired from the business that had dominated her life. When she died at seventy-nine, her signature restaurant was in the hands of her younger brother, David, who had been her partner throughout much of her career. *Lydia's* was known throughout Butte and the country for its savory and abundant food.

David describes his sister as a person who was gentle and mild mannered, who never flew off the handle, and who devoted her life to her labors. He doubts Lydia saw herself as a feminist or a woman ahead of her time. "All she knew was how to work and that's what she did."

Lydia had said much the same a few years after she retired. When asked if she would do it all over again, the woman who had gone from Mining City immigrant to household

name paused and then smiled, "I don't know. It was a rough life. But, the customers, they were really wonderful."

NOTES

1. This profile expands on a feature article by Andrea Ciabattari (McCormick) entitled "Lydia Recalls Busy Years at Stove," published in the *Montana Standard,* July 27, 1976, 5.

2. Elkhorn was a silver mining camp located approximately 50 miles from Butte.

3. See Ciabattari (McCormick) "Lydia Recalls Busy Years at Stove."

4. Five Mile refers to one of a series of road houses located at mile intervals south of Butte's city limits.

A Penny for Your Thoughts: Women, Strikes, and Community Survival

Janet L. Finn

> It was kind of a way of life. You'd save and save and save. If something came up, you never bought anything you couldn't pay for in three years. You figured there was another contract in three years. So you figured, every three years either a strike or a layoff. You knew, don't buy anything big you can't pay for in three years. You didn't want to get too far in debt.
>
> Miner's wife, Butte, 1991

> We had a lot of fun times, too, though, as we'd get together. We all learned early on that if you didn't laugh, you cried. You got five senses and the other one is a sense of humor. That you have to develop yourself, and we couldn't have lasted long without it. We'd see funny things in the worst situations. You had to or you wouldn't have made it.
>
> Miner's wife, Butte, 1993[1]

The story of Butte has largely been told as a man's story. Women have been cast in cameo roles as matrons of the boarding houses or madams of the bordellos. The complexities of women's lives and their determined efforts to hold the body and soul of community together during Butte's tough times have often passed unnoted. This chapter tells the stories of working-class women—the wives, daughters, and mothers of miners—and their contributions to community and family survival in the face of Butte's uncertain mining economy where strikes were a fact of life. Its focus is on women's lives and labors in the mid-to-late twentieth century, as Butte's mining economy began its decline. The chapter is based on field research I conducted in Butte between 1991 and 1994 as part of an earlier book project.[2] It also reflects a personal journey of return to my childhood home and the lessons of women's history, strength, and creativity that I learned along the way.

In 1991, I returned to Butte to learn more about working-class women's lives there and to try to fill in some of the gender gaps in the historic record. I had initially planned to record women's stories of the 1967 strike, which lasted nearly nine months and had devastating consequences for the community. I was eleven years old when the strike

Butte homes and mines.

began. It was the longest in Butte's history and the one that stood out in my childhood memories. I hoped it would be a window into stories of women's contributions to a mining way of life. What I soon found was that women did not stay on the subject of the 1967 strike. Despite my best efforts to rein in the conversation, by the third cup of coffee we had invariably shifted from the 1967 strike to strikes in 1934, 1946, 1959, or 1971, and the closure of the mines in 1983.

The women I met taught me that I had not been asking the right questions. Once I learned to listen more carefully to their stories, I realized that strikes in Butte could not be understood as a single event. Instead, strikes were a plural concept. They had to be understood as part of a larger cycle of community life modulated by three-year labor contracts. Every three years mining families faced the possibility of a strike, lockout, or layoffs, and so they learned to live in a constant state of flux among crisis, recovery, and readiness for the next strike. Women's stories revealed a shift in gender relations during strikes. While men were idled, women worked overtime, seeking out wage labor and mobilizing networks of kinship and friendship, usually behind the scenes. Women crafted a sense of the ordinary to hold family and community together during strikes. They used their material and emotional resources to create a sense of the possible under seemingly impossible conditions. They worked as community caretakers trying to ease the burden of hard times, something I have come to call "crafting the everyday." They were truly craftswomen, reworking the tools and supplies at hand to create new meanings and purpose. They struggled to transform a situation of apparent powerlessness into one in which they exerted control as caretakers. Women offered rich insights into the power of relationships among women, the negotiation of relationships between women and men, and the possibilities of community building. Their stories also illustrate the love, humor, and support that rendered their lives so much more than cameo roles. Let's turn now to their stories.

RHYTHMS OF LIFE

In Butte, thousands of lives were structured around the shifts in the mines. Once open-pit mining began in the 1950s, each day was further punctuated by the dynamite blasts in the Berkeley Pit. As one miner's wife recalls, the little things made a difference:

> Like the whistles that blew at the mines, the "hooters" my kids used to call them. The hooters blew every day at eight o'clock, noon, four o'clock, and midnight, at the shift changes. And when there was a strike, there'd be that silence, without the hooters that you got used to measuring time by. And

you just geared your life around the shift work. When his shift would change, the whole family schedule would change with it. It was hard sometimes to accommodate to graveyard. But you did it.

Strikes were a fact of life for mining families in Butte. In women's stories, it was often the memory of the personal and the particular that served as the mnemonic device for speaking of strikes. Marie, the widow of a miner and mother of five children, recalled strikes in terms of key events in her children's lives:

> There were so many strikes, the dates kind of blend together. The only way I remember them is with the kids. Michael was born during a strike. Colleen made her first communion during a strike. Tim graduated from eighth grade. Those kinds of things, those are what you remember about the strikes . . . those and the tight purse strings.

Strikes signaled a marked change from the noise and bustle of community life during times of employment. Rose, the daughter of a miner, grew up in a close-knit neighborhood near the Mountain Con mine. She fondly recalled playing on ore dumps behind her house and remembered the strikes:

> One thing I always remember about the strikes, when I was a kid, I thought it was just great because for the length of time there was a strike, this is to a child's mind, it was so peaceful and quiet. Because the damn fans were off. They hummed constantly and you could hear them, they were really loud, they were this noisy, continuous MMMMM all the time. So when there was a strike, oh God, it was so nice and quiet.

But for women like Lil, with her husband out of work and six children at home, the silence was nearly unbearable. Lil talked of a visitor asking how she ever stood it living so near the mines with all the noise of the engines and bells. She replied, "It never bothered us. The only time they ever bothered us was when they stopped. Nobody could sleep. It was horrible. Funny how it shapes your life." The powerful sensory awareness of absence and silence was not tied to dates of a single strike, but to the form and contours of a way of life.

From the mid-twentieth century, union contracts in the Butte mines were negotiated every three years. Life plans were made in three-year increments. Miners' wives built their stories of personal and community life around the tempo of union-company contracts. Women accommodated to this modulation of life through their vigilance, maintaining a state of readiness and mobilizing their resources when men were out of

work. Women planned and prepared for the possibility of a strike, but the strikes still took a toll. As Dorothy, the wife of a miner, remembers:

> I have always worked, just about always had part-time jobs. You really had to, you know. There was that three years. You did fine for three years, and then there was a contract come up. You did the best you could, and you didn't buy anything big. You got by with what you had. You learned to plan and put a little away. We planned things, you know. That was hard, you know, to have a man around the house every hour of the day. They didn't know what to do with themselves after the first three or four weeks. So little jobs, like painting, didn't cost much, and you could put a little away for it. We finished the back room one year during the strike. We'd talk about it, "Looks like it's going to go again." We made all these plans, put a little money away. Little things like painting, putting up a fence, those kinds of things. It was after the first couple of months, when the money ran out and the little jobs ran out. That's when everybody's nerves started to get jangled.

Shirley, another miner's wife, kept the "strike pot"—her over-sized coffee pot—brewing constantly to fuel the men who gathered with her husband in their garage to repair one another's cars during the strike. Meanwhile, Shirley worked graveyard shift at the hospital, sleeping during the day while her children were in school. Eleanor, also married to a miner, spoke of women keeping things going in Butte when their husbands left town to seek work elsewhere during the long strikes:

> My husband did roofing, worked in Divide, even worked in Long Island. Being proud we wouldn't accept money from my father. We were always trying to put a little away. We'd go scavenging for furniture and stuff . . . We never wanted the kids to work in the mines.

WOMEN'S WORK

As other chapters in this book address, women's paid and unpaid labors have made a significant, if undervalued, contribution to the social fabric and economic stability of Butte. Women have been the vital force behind Butte's service economy. During strikes, many Butte women sought to secure paid work outside the home or increase their work hours. Others traded their labors for the essentials needed for family survival. Some women, such as Marie, considered themselves lucky to have a part-time job and a supportive employer:

I worked and I was lucky. I always had part-time jobs. Other people had it worse. We were lucky. There was only one strike that we even had to ask for food stamps. That was I think the one that lasted ten months. We lost our house insurance, life insurance. Because you just didn't have money after three or four months. We always laughed about it. I earned twenty-five to thirty dollars a week. I'd pay five dollars to Montana Power, pay interest on the bill at Sears, pay one dollar to the water company. I paid that little tiny bit, and they were fine . . . There were a lot of women who worked at extra little jobs. Just about the whole crew at the Finlen was there because of that. We just worked part-time and it was good. The Finlen had a steady list of clients. They had a good policy. They kept us working until November, then they had a Christmas party, with lots of extras, because they knew we wouldn't be working until March. We got unemployment, then they'd start calling us back. They kept us working enough to be eligible for unemployment.

Many women recall their mothers as the financial managers of the household. While men were often at the bars, women were doing the work and the worrying. During strikes many women carried both economic and emotional burdens as the uncertainty, tension, and fear took its toll on family and community life. They variably earned the respect and the resentment of men in the process. As Shirley states, "The women had it hard because they had to figure out how they were going to keep food on the table. Women carried all of the personal burdens." Lenore, a miner's daughter, spoke of her mother's struggles:

It's ironic, here after all these years in the mines, my father is a trim and healthy man and it's my mother who suffers from health problems. The stress and worry of those years show in her body; they've consumed her health. She was the one who had to do all the worrying and make sure the family got by. If it weren't for the women in Butte, like my mother, the men would never have survived. My mother, like most the women here, took care of everybody else's needs first, and her own needs came last. She just got what was left at the end, and sometimes that was very little . . . My mother went to work nights in a restaurant. My father wasn't happy about it, but mother was a determined woman. She wasn't about to face the financial problems they'd had during some of the strikes again. After all, she knew what it had been like. She had been the one to swallow her pride and stand in line for the welfare checks. The men would never go for the welfare. It was the women who were always swallowing their pride, because

66

you can't feed children on pride and they would not let their families go hungry . . . My mother was a model of strength and determination. I learned the skills of independence from her.

For many women, family survival during strikes came down to their dogged and degrading labors, which served to spark their labor consciousness, commitment to struggle, and, at times, their resentment. Mary Lou's story is a case in point:

> I remember the tough times during the strikes . . . I don't really know how we got by. You just tried to make it day by day with coupons and strike funds and turning to your neighbors and family for help. You counted on your grocer to carry you. That was called a signover. You would just sign over your check to them once you started working again, and you never saw a paycheck. You spent your time after the strike getting caught up on what you owed. I worked cleaning apartments during the strikes. I never saw a paycheck. It just went to rent payments . . . It was hard work and I didn't like it. They gave me a list of apartments to be cleaned, and I would work until I was through. Sometimes I went by myself, sometimes I took the kids, depending on what the situation was. And I never seen a payday. It was just something you had to do. Now women today work out of the home because they want to and they get a paycheck. But there was so much that women did behind the scenes. And it was not because I wanted to but because I had to in order to survive. I don't think the men really knew.

GETTING BY

Many women managed the meager household budgets that ran in the red during strikes. Women spoke of their daily negotiations with grocers, bankers, landlords and utility companies to make minimal payments and hold off debts. They were the ones to fend off creditors and face the humiliations of debt and need. Louise recalls:

> I remember one time I was just furious. I had gone to Montana Power and made arrangements to pay. Oh, it was just a very small payment. But we had never got behind on our fuel and they supposedly had been satisfied with that payment. One day I was out in the yard hanging clothes and I saw a man at the gate and thought, "What does he want?" I went over and he was from the Montana Power. So okay, he showed me an order to shut off the power and says, "Ma'am, I have nothing to do with it." I hadn't got a

shut-off notice or anything. So he shut it off. I had to go down the next day and make arrangements to pay. I was stupid, young and stupid. If I knew then what I know now, Montana Power would still be paying me!

Holiday food baskets for miners' families, Miners' Union Hall, 1959.

Commodities were a frequent topic of women's stories. Many striking families were eligible for commodities supplied through federal programs. Nearly all of the women expressed ambivalence about receiving commodities. Some families refused any "government" assistance. Others accepted commodities or food stamps, but refused cash benefits. And some were able to see benefits as an entitlement and make use of them. For many women, there was ironic humor in their memories of commodities. But the deeper irony of living meagerly from the stockpiles of the agricultural industry while the stockpiles of the copper industry had cost them their livelihoods was not lost on them. One woman recalled the well-intended efforts of a high school economics

teacher to create new recipes to make use of powdered eggs and corn meal: "But when it comes right down to it, there's only so much you can do with ten pounds of corn meal every month." For another, strikes were accompanied by an abundance of commodities that no one in the household appreciated:

> We used to get commodities, corn meal and rice. So we'd use a little bit of the corn meal and a little bit of rice and put the rest in the basement. I used to pray every night that it wouldn't rain because the whole house woulda rose! And the powdered eggs you couldn't eat, only used them for baking. I remember one time we had a dog, a big black lab. And we weren't buying any dog food because we were barely buying our own food. So, we gave the dog corn meal. He ate corn meal and powdered eggs for a while. Even the dog hated to see a strike coming!

Commodities and other social welfare programs represent only a small part of the material support mobilized for families during strikes, and they certainly triggered strong feelings of ambivalence and took their toll on people's sense of dignity. Women developed informal exchanges among friends, neighbors, and relatives to help one another's families stay afloat until copper was mined again. Central to many women's stories were accounts of the informal giving on the part of friends and relatives, carefully couched in terms that did not obligate the receiver nor put her in the awkward position of asking for help. Families shared what meager resources they had, and they did so in ways that were always respectful of one another's dignity. Sometimes the generosity flowed from family members and other times from anonymous sources, as the following accounts illustrate:

> I had my aunts and my mother and my dad here. My one aunt was widowed, and she'd come to visit me, and when she'd visit me she'd always go, "Oh, I have all this extra fruit," because she was worried that my kids didn't get fresh fruit. She would say she had all this stuff and didn't want it to go to waste. She never would say, you know, she'd never, I don't remember any of them saying, "Do you need help." I just remember them saying, "Oh, gee, we had so much of this in our garden, how about taking some of it off our hands?" My uncle would come to visit. He'd have talked to my mother and if something weren't up to par he'd say, "Where's that faucet that needs fixing? I might as well do something. I can't just sit here . . ." Lots of indirect ways of helping, without making you feel like charity.

Shirley, whose husband later moved to a management job, recalled feeling guilty about

having an income while her friends and neighbors were struggling to get by. She would have bags of groceries delivered to families she knew to help them out. She had not forgotten the difficulty of trying to make ends meet and the importance of family support when her husband had been on strike. Shirley recalled: "We had support from my brother-in-law. Like at Christmas time, they'd buy the kids a big gift. One year it was watches. And they invited us to dinner a lot. They'd just make it an invitation—come for dinner—but it was really to help us out."

For many women, getting by often meant hard work behind the scenes in an effort to maintain routines and create security in a time of crisis. Patricia summed it up well:

> Women played a big role in the background, of saying, "Oh, well, maybe tomorrow," and not letting your kids feel you were worried, you know, about tomorrow. I don't think the strikes were done on a whim. It took a big risk, but then you have to take a risk to gain something, don't you? I think where women played a big role was behind the scenes. We'd keep things going at home, keep a routine, keep it just, you know, a way of life.

WOMEN TOGETHER

Butte women built strong bonds over time, and they pulled together during strikes, relying on one another for emotional as well as material support. They came together to laugh and cry about their predicaments. A language of "we," capturing their spirit of togetherness, permeates their stories. As Marie recalls:

> We belonged to the Fire Auxiliary in Walkerville. About 40-50% of the membership would be out on strike. We talked a lot, we had a lot of conversations. We met at the Community Hall every two weeks, and that kept everybody going. Those kinds of things helped . . . We [in the neighborhood] all knew each other well enough that if anything happened, you'd just run to one of the other houses. We've always been like that. We all went to St. Lawrence [church] . . . we helped each other rebuild our houses. Our kids are still close . . . We'd put things on lay-away, starting around the 4th of July. During the strikes the kids knew there wasn't much [for Christmas]. We all sewed, and that helped. Hennessy's and Penney's would have these big fabric sales and we'd go and buy ahead, and we'd sew all winter, and that way you had things for Christmas . . . We exchanged things back and forth. When something I made was too small for one of mine, we'd trade back and forth. We didn't throw anything away.

Women's Auxiliary of the McQueen Volunteer Fire Department, March 15th, 1962.

Women joined together to create a sense of security in the face of crisis and to create special moments despite the scarcity of resources. As Dorothy describes:

> We'd buy day-old bread, three for a dollar, put it in the freezer, that was for emergencies. Then my cousins and I, we'd all get together and we'd go out fishing, we'd stay out there, in the summer, for five or six weeks. And our kids didn't know what we didn't have. They just knew we couldn't get into town to give them everything they wanted. They just had the best time out there. They never knew they were in tough shape.

Louise recalls trips to Columbia Gardens, Butte's crown jewel park tucked in the East Ridge, as a magical escape from the grind of poverty during hard times:

> We'd make fun with what we had . . . If you didn't laugh, you cried . . . Our kids, as big as they are, still talk about the [Columbia] Gardens and how much fun we used to have. It was sad when it closed down . . . The kids all had a lovely time there. We didn't have any money to spend, so we'd head right for the swings and stuff. Coming home they could get one ride, either on the airplane or the merry-go-round, and it was a nickel on Children's Day, then they could have an ice cream cone or whatever. They had a nickel to spend on that. So they actually had a whole dime to spend. Other than that it was totally free. And we used to have fun, we had as much fun as the kids. It was a good thing that we did that. We'd have kind of gone bonkers if we didn't.

Women counted on their women friends and neighbors for support. Their close relationships not only served as means for organizing community survival, these treasured friendships were also ends in themselves. Patricia, a miner's wife, knew she could count on her neighborhood friends:

> It was people recognizing the needs and helping one another. I knew that I could go to my friends and say, "I'm out of this, can I have some of this." We traded and borrowed and handed down clothing. We had a lot of heartaches with it, but we had a lot of fun, too, and it was just something you did . . . We had so many good times. Getting older, we don't get together so much. Raising families, we didn't have all that much money to go here and go there. So we'd go for coffee. At least once a week we'd get together for coffee, and in the summertime, we'd walk every evening. The kids would be ready for bed, and all the women would take off for a stroll. Those were special

times . . . That's far from union work, but it's all part of it. Maybe if we hadn't done those things, we wouldn't have been so close. Now, see, there's a few people whose husbands weren't involved in the strikes, and they were good people to lean on. It made a close-knit bunch, the bunch of us.

Columbia Gardens playground, circa 1960s.

As many Butte women made their transition from high school to their roles as working women, marriage partners, and mothers, they formed clubs, small groups of old schoolmates and new neighbors. Through their club meetings, women set aside time and space from their obligations as wives and mothers. In the intimacy of friendships they sewed, danced, compared notes, and critiqued the blind spots of men. Mary Agnes remembered her mother's advice: "She told me to keep one club. You have to do something outside of the home, something away from your husband. Even if you get disillusioned sometimes, you have these women to fall back on." Karen remembers her mother's "club ladies" as an important resource during strikes:

My mother, during the strikes she would do a lot of sewing. She made a lot

of dance costumes. It was funny, too, she charged according to income or whether she liked you. If you lived on the West Side, you got charged way more. She took in ironing. I remember my mom mostly sewing, wedding dresses, bridesmaids' dresses, that kind of thing, mostly for friends. She never did that for strangers, other than during the strike years. She never advertised, it was through her club ladies . . . That's where a lot of the sewing came from. They would know people and say, well, my mother could use the work. She was a pretty handy person.

For many Butte women, clubs also served as a support group when times were hard. As Lil recounted:

I belonged to a club, and I was the only one whose husband worked for the [Anaconda] Company. They'd start talking about hard times, and I'd say, "You don't know hard times unless you are married to a man who works for the Company." . . . We had a card club. It started out as a sewing club, but we thought that was a little dull and we decided to play cards. For a little more excitement, we used to play for money—a dime a game . . . They weren't involved [in the strikes], it didn't seem to affect them one way or another.

For Lil, the camaraderie with women friends whose lives were not modulated by mining offered a weekly reprieve from her worries. During strikes her club friends took responsibility for hosting their activities, and they made sure she was spared any expenses when they left the card games behind for a night of dancing in Meaderville. For Shirley, her women's club was not only an ongoing source of support, it also provided a separate reality during strike time, a place where she could escape the daily tensions and uncertainty:

The year before I got married . . . there was five of us high school friends got together, met every two weeks. We still meet every two weeks during the winter . . . We're back down to five now. We don't bring any more in now. We've been friends for so long, we know each others' troubles and problems. . . . We used to just sit and talk, sometimes somebody would knit or crochet, mostly just relaxing. When it first started out it was in the afternoon, and then we had our children with us. Pretty soon we had so many kids, we decided, hey, this isn't any fun, so we changed it to evening, and our husbands babysat the kids because this was Ma's night out. And we have seen each other's children all grow up. And we've gone through I don't

know how many deaths of children. So we're still together. When my son died and my husband, they were right there. And then they were there after. These were women that were there after. They forced me to do all the things that they thought I should be doing. They are still a great bunch.

Through their clubs women carved spaces and moments outside of their responsibilities as wives and mothers. They came together as women, crafting friendship and mutual support. They drew on their pooled emotional and material resources as they redoubled their community building efforts during the strikes.

CRAFTING THE EVERYDAY

Butte women mustered their courage and creativity to craft visions of hope in the face of adversity and transform problems into possibilities. They used their multiple talents, humor, friendships, and sheer determination as they accommodated to, challenged, and changed the conditions of their lives. Marie offered a vivid memory that illustrates her skill as a craftswoman:

> There was one funny thing . . . One of the girls was getting ready for the Annual Dance at Central [High School]. The summer before we had taken that window out and put this window in [pointing to windows]. Of course, the drapes didn't fit. They'd only been up about six months, and they were blue corduroy. I took them down, and they were so good I figured we'd use them in a bedroom or someplace. They were that big wide 48-inch corduroy. So it was during a strike or right after and everybody was so broke, and she needed a dress for the Annual Dance—you remember, the one where everybody got their Annuals and nobody danced, but everybody had to have a dress? So, I thought, well, that's about my best bet. So we hauled the corduroy out and made the dress, and she loved it! It was her favorite dress! She said, "If Scarlet O'Hara can do it, Mom, so can we." You make do, you did things like that. It was kind of nutty, but we had a lot of laughs over that. We always remembered, "Remember the time we made a dress out of drapes?" It was a cute pattern. I can still see it. It was one of those cases of use what you got.

In the face of crisis Butte women crafted the everyday. As one miner's daughter described, "Women were the backbone of Butte, pulling it all together during strikes." They created a sense of the ordinary to hold family and community together during strikes. And they transformed ordinary moments and materials into special treasures.

They used the meager resources at hand to create a sense of the possible. They were artisans, craftswomen, and, sometimes, magicians, transforming hopelessness and uncertainty into hope and possibility, and the trials and tribulations of everyday life into poetry. They learned skills, courage, and determination from their mothers, and they taught their daughters the art of survival, the power of feminine strength, and the importance of humor in carving a way of life on Butte's tough masculine terrain. Their skills must be remembered and passed down so that crafting the everyday does not become a lost art.

NOTES

1. The quotes that appear in this chapter are from interviews conducted by the author with Butte women in 1991-1993. The research on which this chapter is based follows the ethnographic tradition of use of pseudonyms for individuals in telling a larger story of community. Several of the women interviewed for this research have since passed away. The use of pseudonyms is maintained here in honor of the agreement established at the time of the interviews.

2. This chapter is based in part on excerpts from Janet L. Finn, "Crafting the Everyday," Ch. 5 in *Tracing the Veins: Of Copper, Culture, an d Community from Butte to Chuquicamata.* Berkeley: University of California Press, 147 -176. Copyright 1998, The Regents of the University of California. The material is used here with the permission of the University of California Press. It also includes brief excerpts from Janet L. Finn, "A Penny for Your Thoughts: Stories of Women, Copper, and Community," *Frontiers: A Journal of Women Studies,* 19 (1998): 231-249, used here with permission of the University of Nebraska Press.

Virginia Salazar: Crafting Everyday Life in Butte

Janet L. Finn

It was October, 1951 when a young woman from Pony, Montana came to Butte to enroll in the nurse's aid-training program at St. James Hospital.[1] Virginia Jones had just graduated from high school and gotten her first taste of independence through a summer waitressing job in West Yellowstone, Montana. Gin, as she was called, found an apartment in Butte and reported for class. Nothing in her prior experience had prepared her for the shock. Gin recalls:

> They put me in the miners' ward right away. I worked in three different miners' wards. One with ten beds, one with eight beds, and one with six beds, and they were always filled. There were more wards with injured miners and there were other miners there with the 'con' [miner's consumption] who had been there for a very long time . . . It was a shock . . . I couldn't believe what I saw. I had come from a mining family. We had lived for ten years outside Norris at a mine called the Boaz, where my Dad worked, so I was very familiar with mining, but not with the accidents. Every day it seems you saw new faces, it was just continual, the accidents they had in the mines. It was quite an experience for an eighteen-year-old girl. I was surprised when I went to work there, when they put me in the miners' ward. I kept thinking, "Gee, maybe I would get the babies." I didn't know how wrong I was . . . it was on the job training. But it was interesting, and I made a whole sum of five dollars a day.

One of her patients was a charming young miner named Max Salazar. Gin was assigned to care for him as he came out of knee surgery for an injury he received in the mines. While Max flirted, Gin smoked his cigarettes, always on the lookout for the supervising nun. Shortly after Max was released, Gin went home to celebrate her birthday. While at the party, Gin managed to topple off her high heels and end up as a patient at St. James Hospital with a badly injured knee. Now the tables were turned; Gin was the patient and Max the visitor. The two were married in August 1952.

After stints in the Utah mines, Max and Gin returned to Butte in 1953 to settle down and raise their family. Children came quickly, and Gin soon found herself working

nearly round the clock to keep up with the laundry, cooking, cleaning, and care for her growing family. The Salazars welcomed fifteen children into the world in about as many years. Gin came to count on her neighbors as part of a big extended family helping one another get by. She recalls:

> Oh, boy, I worked my bones off, I'll tell you, but, across the street were the Lazzaris, and they ended up with eight children. And just on this block there were people with so many children. It really was one big family. We had a little grocery store up the hill, and then when the owners left, Carolyn Campbell, who had a grocery store up on North Main Street for several years, came and bought this one [on Granite Street]. She had a bench that she sat on in front of the store. As a matter of fact I have it on my patio now. It was just an old bench, and in the summertime when the kids would be out playing Max and I would go and sit on that bench with Carolyn. We'd just talk and visit about everybody and everything . . . There was a lot of support among the women in the neighborhood.

While Max assumed increasing responsibility in union leadership, Gin managed the home front. She honed her skills as a chef, turning out two to three turkeys a month, maintaining a constant stock pot for soups, and mastering the art of Mexican cuisine. Sleep was a precious luxury for Gin with her children so close together, and several of them born prematurely and needing special care. No matter how full the household, Gin could always make room for the neighbor children. She remembers, "I was continually baking. And different friends of my kids would come from McKinley [school] with my kids, because they knew I'd be making cookies or I'd have a cake or something for them to munch on. That's just the way it was. It was the house with the most kids, and that's where everybody's kids went after school." Neighbors returned the Salazars' generosity, especially when they were hit hard by strikes. Gin recalls one neighbor who loved to fish. His family didn't like fish so he gave his catch to Max and Gin. Another neighbor delivered bread, and he made sure the Salazars got the extra loaves.

Gin ran a tight ship at home, employing her children as the kitchen crew. She also worked outside the home as her hectic schedule would allow:

> When the kids were all in school, I would work with Carolyn for about two hours every day. The kids would come in to buy penny candy, and I mean that penny candy was a business! I worked for Carolyn off and on for a couple of years, not any long hours. And I did some babysitting too. They

Max and Virginia Salazar.

never had to worry about bringing toys or anything, and they had the kids to play with. I never did go back to nursing. I worked night shift at Martha's Café for a time, when all the kids were in school. And then I went to work for Weber's Beauty Supply, just kind of part time for a couple of years . . . I worked at the P.O. News for two years, and then returned to Weber's for five more years.

With children in nearly every class of McKinley elementary school and Butte High School for several years, Gin also was active in the Parent-Teacher Association. With a quick smile, she described how, in her spare time, she attended meetings, organized bake sales, and refurbished library books. She also served as a Girl Scout troop leader and a Cub Scout den mother for several years. A favorite field trip of her Girl Scout

troop was a visit to her neighbor Elizabeth Lochrie's home to tour her art studio and learn about the stories behind her paintings.

Gin and Max Salazar were also active in forming a Butte chapter of the Association for Retarded Citizens and establishing the community's first sheltered workshop for people with disabilities. For many years they advocated on behalf of handicapped children in the state. Their efforts began when one of their older daughters was born with a developmental disability. Gin recalls:

> One day Joan Shannon called. The phone rang and I picked it up . . . She said, "I've just been talking to Dr. Clapp"—that's who took care of the kids— "and my name is Joan Shannon, and I also have a retarded child." And I said, "You do?" I had never, ever heard of anyone else in Butte having a retarded child . . . I just couldn't believe it. So then she said they wanted to start organizing, and we set up the first meeting. The first two or three meetings, we had them at Webster Garfield School. And I'll tell you, my mother would come and stay with the kids. And we'd go down there and we'd be there until after midnight, with all of us talking. The men and the women were there and it was great, it was really good. There was the support, and what an organization it was, I'm telling you. When we started the first sheltered workshop we didn't have a place. There wasn't a building. Max was in the union by then and he said, "Well, you know, there's the basement of the Miners' Union Hall. It's full of junk and stuff, but I'll talk to them. I'm sure we can get help to get it cleaned out. We could make sure the wiring was okay and the heating system and stuff, and I'm sure we can use it." And that's what they did . . . The very first sheltered workshop was in the basement of the Miners' Union.

And after years of hard work, the Salazars saw their dream further realized when their daughter was able to move into a group home just a few blocks from their home.

Virginia Salazar is clearly a woman of many talents, adept at inventing possibilities from the meager resources at hand. But, according to Gin, one talent she initially lacked was that of seamstress. Gin remembers:

> My mother was a great seamstress, she could make anything. She made beautiful braided rugs, she made all our clothes. So her sewing machine was going all the time, and I was never interested in sewing . . . Well, then, my mom got sick, and she said, "I want you to take the sewing machine."

And I said, "What am I going to do with it?' She said, "You can learn to sew." I brought the machine home, and I started then when my son Tim was a sophomore in high school. He was in what they call "Top Sixteen," you know, singing and dancing . . . well, for all their acts everything had to be made.

So Gin found herself on foreign turf at the House of Fabric, then in the company of her friend and neighbor Carolyn Campbell who walked her through the basics. Gin was a quick study, determined to succeed in this new endeavor. Not only did she make the outfits, she has gone on to make nine wedding dresses for her daughters and daughters-in-law, scores of bridesmaid dresses, and a whole line of "granny gowns." The machine is now fifty-five years old and on its last legs, and Gin is ready to retire from sewing. With her children grown and more "leisure time" in recent years, Gin has been able to devote time to a side career as a caterer and, more recently, to her job as a foster grandmother for Head Start.

Granite Street is quieter these days, but Gin treasures memories of the strong community that thrived there for many years. Gin is a firm believer that it really does take a village to raise a child:

> I think everyone has to work together, everyone has to have input of some kind to get a good community going . . . You just have to do your best to instill good qualities in your children, because they're the future. You just have to do whatever you can for your community.

NOTES

1. The profile is based on personal interviews with Virginia Salazar by the author in May, 1993 and March, 2004.

PART THREE
IN SICKNESS AND IN HEALTH

Young Caroline McGill.

Caroline McGill: Mining City Doctor

Connie Staudohar

In July 1910, Caroline McGill sat in a German hotel room and wrote her parents. "Dear Folks," the letter began, "I'm making the biggest fool mistake to go to Butte." She described how "such a thing never entered my head until I got a letter from Dr. Rodes asking me if I would come." After her year abroad, Caroline had planned to return to her position as instructor in anatomy at the University of Missouri in Columbia. "I could do it all so easily and live such a nice comfy life there." She continued, "Instead I'm going out into the wilderness where I'll have to work my head off to make good." She had already received "the loveliest letter" from the University encouraging her "to do just as she thought best." Caroline's letter ended: "I have no business howling for it's all my own fault that I'm going. But it's all done and I have to let her rip."[1]

Caroline squeezed a lot into the four-month period that bridged her return from Europe and her departure for Butte. She spent the fall semester at Johns Hopkins University in Baltimore before returning to Missouri to bid farewell to friends and family. She sought out hands-on learning to balance her book learning. Her previous studies, and her work as an instructor in anatomy, had taught her how bodies function. From an understanding of what was normal and healthy, Caroline had learned to tell when something was unhealthy or diseased—a specialty termed pathology. Rather than continue on to become a medical doctor, Caroline had chosen pathology. Her upcoming role as a pathologist at the Murray Hospital in Butte depended both on her performance in the lab and her performance as a member of a medical team. She spent her time at Johns Hopkins researching what was needed for a well-equipped hospital lab and observing the intricate relationships that went on between doctors and pathologists, doctors and nurses, and nurses and patients. Caroline's time at Johns Hopkins was as important for shoring up her confidence as it was for gaining practical knowledge.

Upon her return to Columbia, Missouri, Caroline's colleagues and family boosted her confidence even further. At a surprise farewell dinner given in her honor by the School of Medicine, the Dean announced that Caroline would "take up her profession in a frontier country." He also noted that she would be joining Dr. Charles B. Rodes, a former classmate of Caroline's who currently practiced medicine in Butte. His sister, Thula, had been Caroline's freshman year roommate and she, too, resided and worked in Butte. After that farewell dinner Caroline boarded the Northern Pacific's "Puget Sound Limited" in Kansas City bound for Butte, Montana."[2]

A mere forty-eight hours later, on the last day of 1910, Caroline was in Montana. The following morning, the *Butte Miner's* headline declared "Hearty Greetings for Young 1911."[3] Like a sturdy tripod, Caroline faced this New Year's Day reliant on her friends, her work, and a place to live. With these firmly in place, her diary entry that first day in Butte read simply: "Cold, snow." It was indeed cold on January 1, 1911; the thermometer had not yet reached the promised high of 15 degrees when she met up with Dr. Charles Rodes and his sister, Thula.

The friends exchanged fond New Year's greetings. Charles and Thula had plans to spend the day giving Caroline a full tour of Butte. Charles had arrived in Butte to serve his medical internship in 1908. He knew the Murray Hospital and knew the types of patients Caroline would face. It was his confidence in Caroline's laboratory skills and proficiency with diagnosis that had prompted him to encourage McGill to come in the first place. The fact that his sister had followed him to Butte to work as a teacher in Butte High School just made it a more appealing possibility. He welcomed Caroline as a colleague and family friend.

The threesome headed toward the building that served both as a mortuary and a livery stable for the doctors' driving horses. Dr. Rodes introduced Caroline, as Dr. McGill, to the stablehand who assured her that since she was on the Murray Hospital staff she had the privilege of securing a horse and carriage at any time. After a brief discussion, they decided that the first stop would be the Murray Hospital; Thula would have to wait to show off Butte High School.

As they left the stables, Caroline began to notice how different daytime Butte looked from her impressions of the evening before. The setting that had looked like a fairyland with twinkling lights was now a scene filled with steep cobblestone streets, houses crammed together, and mine shafts dotting backyards. Houses were bound to outhouses by clotheslines that held stiff sheets and frozen shirts. Black smoke belched from the stacks of the mines, indicating that work went on despite the holiday. Roughly 74,000 people lived in Butte. Charles explained to Caroline that the miners built their houses so close to the mines so they wouldn't have far to walk to and from work. The underground mines were called "hot boxes," he said, because the temperature far under the earth was ninety degrees or more. In the winter, men would work a ten-hour shift in these sweltering conditions and then be hoisted back up to the surface where the air was often below zero. Men emerged from the mines covered with sweat, hit the cold air, and then walked home with their clothes frozen to them. If they had far to walk, Charles added, they could catch a cold that might develop into pneumonia, or even more seriously, tuberculosis (TB). Then, as the miners said, "you need only one more

clean shirt," for every miner knew that TB meant sure death, that the only shirt he'd need was a clean one to be buried in.[4]

Charles continued to fill Caroline in on the medical conditions she would encounter as the Murray's staff pathologist. He knew firsthand the deaths and accidents that the miners and their families experienced. Just the year before more than fifty miners had died in Butte as a result of accidents, and over a thousand miners had suffered injuries requiring medical attention. He and the other physicians on staff had set broken legs, treated eye injuries from dynamite blasts, and amputated limbs mangled by machinery. They had also treated patients suffering from chronic disease—cancer, tuberculosis, syphilis, and liver ailments. At last the hospital itself loomed before them.

The five-story Murray Hospital building anchored the corner of Quartz and Montana Streets near uptown Butte. Its walls were of solid brick, two feet in thickness, making it both fireproof and well insulated from drafts and cold air. Electric light suffused the rooms and hallways, electric call bells and speaking tubes reverberated from room to nursing station, and an old iron-cage elevator operated between floors.[5] Two thousand patients a year visited the hospital, and an active nurses training program supplied a steady stream of competent caretakers. Both nurses and doctors lived and ate at the Murray, and Caroline was to do the same. As Charles rang the doorbell at the hospital's entrance, Caroline linked arms with Thula and let herself be ushered in by her two friends. They had carefully planned their tour: she'd see the laboratory first, and then they'd show her her apartment on the first floor.

Caroline looked carefully around the room that was to be her lab. A set of scales sat on one end of the table and a black microscope sat on the other. Shelves held rows of glass tubes and boxes of slides. The room had an air of expectancy about it and Caroline's spirits soared as she took it all in. Her job would be to conduct all the lab tests for the doctors and to help them determine, from the lab results, a diagnosis of the patient's condition. Leaving the lab, the three returned to the first floor to check out her living space. The doctors' apartments suited Caroline just fine. Her thoughts rested on retrieving her belongings and moving into her apartment at the Murray Hospital. With her lab ready, her apartment comfortable, and a reconnection established with friends, Caroline felt assured and "ready to let her rip."

The second day of January 1911 dawned clear and cold. Glancing at the newspaper headline that declared, "Mercury Hits the Toboggan," Caroline was glad that she had settled in her own apartment and had no walking to do this morning.[6] She grudgingly adjusted her corset and pulled on her heavy black silk dress. She figured she was

presentable enough for meeting the rest of the medical staff and joining them on their rounds.

Within days, Dr. McGill had become a familiar sight to the patients, nurses, and staff physicians at the Murray. All the doctors came to rely on her to perform the lab tests they needed. She prepared slides from specimens and spent hours bent over her microscope, sometimes finding corkscrew-shaped squiggles that swam across the slide, sometimes finding blue rod-shaped forms that stood out against dull brown backgrounds. On the basis of such findings, Caroline could tell the doctors what was causing the symptoms they were trying to treat. The corkscrew squiggles, for instance, meant the patient most likely had syphilis, the venereal disease that progressed slowly but steadily over time; the beautiful blue rods indicated the presence of the dreaded tuberculosis, a bacterial infection that usually settles in the patient's lungs. There were times when Caroline wished she could be doing more to help the patients than merely handing over a lab report to their doctors. But for the time being she focused on the lab orders that consumed her time and demanded her careful attention.

Week after week, Dr. McGill identified the rod-shaped bacterium on slides sent to her lab and met the hollow-cheeked people whose bodies harbored tuberculosis. Soon she was no longer content to fight the disease from her lab and joined a newly formed community group, the Butte Anti-Tuberculosis Society. The society's goal was to prevent TB from spreading and to treat those already afflicted with the disease. An alarming number of Butte citizens—166 people—had died in 1910 from TB.[7] The town accounted for almost half of all deaths caused by TB in the entire state. Dr. McGill talked to groups about hygiene and accompanied the popular public health nurse, Mary Boyle, on her home visits to the miners. They also took signs into schoolrooms that proclaimed, SPIT IS DEATH. They placed spittoons in schools, theaters, and railroads, hoping people would use them instead of spitting on the floor. However, it became clear to them that as long as the tubercular person stayed in the family home, or ate and slept in the boardinghouse, there was risk of spreading the disease to others. There needed to be a special place to care for TB victims.

One of the best alternatives was a sanitarium—a special hospital designed just for tubercular people. Jim McNally, a Butte carpenter, went to the state capital to speak for the anti-TB group. He argued to the politicians that something had to be done besides, as he said, "sending the poor devils to the graveyard." With ongoing encouragement from Dr. McGill and Mary Boyle, McNally kept on lobbying. His efforts paid off quickly. The 1911 Montana legislature voted unanimously to build a sanitarium for the treatment of tubercular miners. Now Dr. McGill felt she could rest a little more easily. She had

contributed directly to the founding of a tubercular treatment facility, and in the process, she had become deeply attached to the people of Butte.

Dr. McGill had written to her parents—long before she came to Butte—that she would have to "work her head off to make good," and in her first year and a half in Butte, she'd done just that. But in the process she had become more isolated than she had anticipated. She poured her heart out to Thula as the two old friends bent over cups of steaming tea. In a short time, Butte had definitely become her home, she admitted to her friend. She respected the hardworking miners and their families and felt she should be doing more for them. If she were a medical doctor, she mused, she could work directly with patients and still use her years of training and experience in the lab. A steady resolve to return to medical school slowly, but surely, took hold.

American medical schools had been admitting females since the 1840s, when Elizabeth Blackwell became the first woman to graduate in medicine. Although she had paved the way for other women, seventy years later, in 1910, just six percent of all doctors were women. And those women still encountered criticism and suspicion. Butte people shared this attitude toward women doctors. When Olive Brasier Cordua, M.D., came to Butte in the early 1900s and hung out her shingle, not one patient crossed her threshold in an entire year. Discouraged, she left to practice medicine in the mining camps around Boulder, forty miles to the north.[8] But Dr. Cordua's story did not discourage Caroline. "This is just the challenge I need", she thought, and with strong recommendations from her colleagues at the Murray Hospital, she applied to, and was accepted at, the Johns Hopkins Medical School in Baltimore, Maryland, in 1912.

So it was that Caroline left for Baltimore in the fall of 1912. Her doctorate and her medical training at the University of Missouri, coupled with the practical experiences she had gained in Butte, allowed her to progress with her studies in record time. What took most medical students two years to complete, Caroline finished in a single year. After passing exams, Caroline finally began working directly with patients. Assigned to work in the dispensary—the walk-in clinic—she and the other medical students performed minor operations including such things as opening boils, sewing up cuts, and removing small tumors. Because it was Johns Hopkins, the women students performed the same work as the men, asked no favors, and got none.

Work in the dispensary fascinated her, and provided her with a solid background in the art and skill of diagnosing illness. Yet, the last year of her medical training held what Caroline had been waiting for—two months of study in each of three specialties: medical, surgical, and obstetrical. During these rotations, the students worked with

the indigent poor of Baltimore. The patients Caroline saw and the problems they presented reminded her of the patients she'd seen back at the Murray. Caroline knew that what she learned from her work with the Baltimore poor would help her in the work that awaited her in Butte.

Caroline paid careful attention to the modern methods of surgery being taught her. Twenty-five years earlier a surgeon might drop instruments on the floor, pick them up, wipe them on a sleeve, and continue the surgery. Now students were taught to wear rubber gloves and sterilize their instruments.[9] Until their senior year, the students operated only on dogs. Professors taught the students to act as though their canine patients were people, including taking operative and postoperative notes, and performing autopsies in the case of a death. Intestinal suturing—the stitching together of a section of the intestines—was the main skill the doctors learned with the dogs.[10] In their senior year, they had to apply the skills they had practiced on dogs to living people. Caroline completed her surgery rotation and moved on to obstetrics.

All Johns Hopkins medical students had to learn how to deliver babies in a hospital and in a mother's home. Each senior medical student had to deliver nine babies, and they were subject to call any time of day or night. Now Caroline remembered how her mother, who had delivered babies for her neighbors, kept a bag full of supplies packed and ready to go. Caroline did likewise. She felt competent and confident by the time she finished her quota of deliveries.

Caroline had worked through her four rotations and was nearing completion of her medical studies. She had asked for and received a "Report of the City Health Office" from Butte for the month of May, 1914. Caroline had been offered an internship at Johns Hopkins and considered their offer. However, when she read that eighty-eight people had died in Butte in one month, and noted their cause of death, she knew she had to return. Fifteen percent of the deaths were from tuberculosis, and of that number 82 percent had been miners. Nine men and one woman had died from pneumonia. One woman had died in childbirth and another seventeen deaths had claimed infants up through five months of age. There had been three additional infant deaths from spinal meningitis and a death from typhoid fever.[11] These were the illnesses Caroline had been extensively working with during her long days of medical school, and she knew she could apply her learning and make a difference to the people in Butte. Within two years, she had completed all the requirements for a medical degree from Johns Hopkins University. She finished with the highest ranking in the class and was inducted into the honorary medical society in 1914. Caroline boarded the train for Montana without any of the fanfare that had sent her off in such high spirits just four years

earlier. There were no accolades this time, but neither were there any regrets: Dr. McGill was heading home.

The Butte that McGill returned to in 1914 had a population that had hit ninety thousand—it was the largest city between Spokane and Minneapolis. The primary occupation remained mining and the devastating combination of mine-related accidents and illnesses did not allow many to enjoy old age. Seventy-five percent of the population were forty-five years of age or younger and just two percent were older than sixty-five. Butte presented most of the urban and industrial medical problems McGill had spent the last few years studying, and it was clear that the city had need of her expertise.

Dr. McGill returned to the Murray Hospital to live as well as to work. With its creaky iron-cage elevator and large doctors' dining room, it felt familiar, and it was far less expensive than the room her friend, Thula, rented at the nearby Napton Hotel. Thula did have hardwood floors and her own telephone, but McGill settled for her smaller quarters. Dr. T. J. Murray, as well as her old Missouri colleagues, Dr. Rodes and Dr. Potter, welcomed her back. Dr. McGill's standing in both the medical and lay community provided her with the confidence to open a private practice in 1916. The fact that she held a staff position in the internal medicine department at the Murray Hospital, as well as opening a private practice, showed her extraordinary accomplishments. The stepping-stones that McGill had maneuvered—from being the first woman to earn a Ph.D. from the University of Missouri to her appointment to the staff of the Murray Hospital—were, in fact, milestones that few early-twentieth-century women physicians ever achieved. Yet, even Dr. McGill's exceptional energies and expertise would be tested by the demands of practicing medicine in Butte.

In 1917, a fire in the Speculator Mine claimed the lives of 165 miners—every doctor in Butte was called to the scene and rescue work continued for eight days. Many of the 245 survivors, and members of the rescue crew, were in need of medical treatment. Rescue workers, termed "helmetmen," were frequently overcome by the smoke and gas and needed hospital treatment themselves. Charles Fredericks, a helmet man, collapsed on the 700-foot level while searching for survivors. The newspaper reported that "only the most heroic kind of work at Murray's hospital saved him."[12] Nothing in Dr. McGill's experience had prepared her for a crisis of this magnitude. Her concern first focused on the emergency needs of the men who came through the doors of the Murray for the long days and nights following the disaster, but then it shifted to the tremendous needs of those left behind. Fifty-eight married men died in the fire, leaving wives and children with little support. Over eighty children lost their fathers that night. Knowing as she did that, under the terms of the state accident board, the families of

the dead miners would receive just $10 a week for four hundred weeks—$4,000 per family—Dr. McGill wondered just how far that compensation would go.

Not long afterwards, Dr. McGill saw firsthand the difficulty widowed families faced. On a home visit to a sick child, McGill learned that the Glace family, with six children ranging in age from seven months to eleven years, had ended up squatting in an abandoned three-room house next to the Belmont mine—not far from the Murray Hospital. Dr. McGill's young patient, Ruth, suffered frequent sore throats and strep infections. Little Ruth told Dr. McGill that she had recently tried to mop the floor of their small family home. She had used scalding water, which froze when it hit the floor. "It was just like an ice rink," Ruth said. After this, McGill had gone to the neighbors with a request that they "keep an eye on the family."[13] She encouraged Ruth's mother to ask for help, but she knew how hard that would be for the proud, overworked widow. It seemed that many families had already gone through so much during the Speculator Fire and its aftermath that nothing more could possibly happen. In truth, as the calendar turned from 1917 to 1918, the situation in Butte only got worse.

There were reports of influenza in Butte early in 1918, but they apparently caused little concern. That attitude changed abruptly as the disease began its rapid spread. Most of its victims were between the ages of eighteen and forty. Two young nurses at the Murray Hospital, Blanche Cook and Alberta VanVrankin, died within days of each other after contracting the disease from patients. Three hundred and five people died in the month of October alone. For the first time in Butte's history Halloween was cancelled. For many of her stricken patients, McGill assumed the role of both doctor and nurse throughout the long months that the virus ran its course.[14]

Twenty percent of all the deaths in Montana from Spanish influenza occurred in Butte-Silver Bow County. Even with the schools shut down, the establishment of an "isolation hospital" in one of the junior highs, and the medical care given in homes and in hospitals, Butte lost 1,000 people to the disease. The worst of the epidemic had played out by December 1918, but one last wave of influenza hit the city and held through the spring of 1919. By this time, Dr. McGill had moved out of the Murray Hospital and into the Leonard Hotel. Perhaps she needed to get away from her medical work and get some distance from the tragedies she had experienced over the last several years. Then too, she was approaching her fortieth birthday. She was contemplating a change.

On May 18, 1919, Caroline McGill celebrated her fortieth birthday. Hardly had the birthday candles been blown out before a rare opportunity presented itself. The four-story Murray Building across the street from the hospital came up for sale. It had served

Murray Hospital, circa 1920's.

as the Murray Hospital Laundry and Nurses' Home, but the hospital had just completed an annex to replace this older building. Common sense told McGill that the Murray Building would provide the home she sought and also be a wise investment. She knew that the Murray Building would bring in rents both from offices and from apartments and this could relieve her worry about collecting from private patients. Dr. McGill purchased the building, established her office on the main floor, and rented out the other first-floor office to her friend and colleague, Dr. Harold Schwartz. McGill also rented out the apartments located on the second and third floors, reserving the entire fourth floor for her own living quarters. A bracketed metal balcony and wrought-iron rail circumscribed the entire fourth floor providing Caroline with a 360-degree view of her surroundings.[15]

Dr. McGill's circle of friends and acquaintances grew with her acquisition of the Murray Building. The second-floor apartments were rented out to teachers, including her friend, Thula Rodes. Since neither woman cared much for cooking, Caroline and Thula went

out for dinner at least once a week. On the other nights Caroline's meals were prepared by Clem Madelena whose only complaint arose from the fact that the apartment had no real kitchen and the dishes had to be washed in the bathtub. Caroline had hardly become the "sedate old spinster," as she had at one time described herself.

Dr. McGill could have relaxed a bit at this point in her career. Like a tenured professor whose job is secure, McGill and the Murray were firmly connected. Yet, the close connection might explain why Dr. McGill began teaching student nurses at the Murray on top of her already heavy caseload. She felt responsible to train students to become licensed nurses who could independently handle many of the problems that showed up at the hospital door.

These problems were dutifully recorded in "Diary of a Night Nurse," a journal kept by Beatrice Murphy, R.N. Miss Murphy worked a twelve-hour shift at the Murray Hospital in the early 1900s. Like the other nurses, she lived at the hospital and her life revolved around her schedule. Since she worked the night shift, her dinner was always on the run: "Ate supper with feverish haste." Then, foregoing dessert, she went on to describe the rest of the night:

> Fixed up a miner with scalp wound Ditto with crushed finger Took temperatures, gave medicines, etc. Went around to all my patient's rooms Answered doorbell Admitted miner with bruised head, saved his life by performing surgical operation. Broke one needle (didn't swear) Everything done nicely Tired feet, but nothing more. Walked 200 miles all told since 7 pm. No scraps, no biffs Very uneventful night.[16]

The Murray Hospital Commencement Program of 1921 contains a cartoon that portrays student nurses begging for their diplomas from a caricatured, oversized doctor. This makes light of what must have been a demanding work relationship. Consider one of the jokes about Dr. McGill:

> Patient: "Oh what was that going down the hall? Cyclone, hurricane, or aeroplane?
>
> Nurse: "No, just Dr. McGill."

The graduate nurses, in their class will, bequeathed to Dr. McGill "speed and ability carrying out orders at once."[17] Dr. McGill hoped her teaching would produce nurses who could confidently and competently handle such emergencies and consider a night "uneventful" if it only brought scalp wounds, crushed fingers, and bruised heads.

Training nurses was of practical value to Dr. McGill, but it also served to make her feel she was contributing as much as she possibly could to help an otherwise overwhelmingly depressing environment that had pervaded Butte. So many families were destitute that the Butte Josher's Club, a volunteer group, delivered 4,000 baskets of food and treats to poor families on Christmas Day 1921. The poverty was affecting people's health, and tuberculosis rates rose. The sanitarium at Galen added a building for women patients and then, just a few years later, in 1923, a thirty-bed children's building. The "Sunshine Pavilion" housed children in separate wards—one for boys and one for girls. Governor Joseph Dixon commissioned Butte painter Elizabeth Lochrie to paint murals on the walls of the pavilion in order to cheer the young patients and make their wards seem home-like.[18] Dr. McGill sent tubercular women and children to Galen knowing that it was the best place for them to receive long-term care. Meanwhile, she continued with public health outreach and a heavy caseload of private patients.

In the midst of the demands of nursing students and practicing medicine, Dr. McGill continued to make time for her friend, Thula. The two pursued professional tracks, but while teaching was acceptable and common for women (much like nursing) medicine was not. Yet, their lives continued to overlap. Miss Rodes served as Dean of Girls at Butte High School for many years and invited McGill to speak at the Friday afternoon girls' assemblies. Dr. McGill discussed personal hygiene and encouraged the girls to take swimming classes, not to learn to swim, but rather to take advantage of the School's showers![19] After these assemblies, Caroline and Thula went out for dinner and shared stories about their busy week, knowing that they had absolute confidentiality with one another.

Dr. McGill kept a diary that revealed nothing of her work-life, but rather described excursions she took around Western Montana. "I had only a few short trips to the outdoors during the years 1911-1930," she wrote, "I was so busy in Butte my outdoors was largely short drives and walks near Butte." The entries increased in frequency and are peppered with names of friends who accompanied her, names of flowers that she recognized, and names of places she explored.

8-2-1930: "I left at 2pm for the 320 Ranch in the Gallatin Canyon.[20]

8-3-1930: "Got horse and rode alone to Ramshorn Lake fished from raft got 12 trout. Supper and back to Butte via Belgrade by 11:30pm."

8-9-1930: "Left at 3pm with friends via Skalkaho to Hamilton. Night there"

8-30-1930 "With friends to Jackson, Mt. To rodeo."

The spring of 1931 found Caroline exploring again.

 5-3-1931: "Up Roosevelt Drive. Pasque flower Yellowbells Daisies."

 6-17-1931 "Left 3:30pm. Slept in car on Skalkaho."

There were more trips throughout the summer and fall. An October entry: "Home to Missouri to Father and Mothers Golden Wedding. Whole family there."[21] Dr. McGill sought to balance her heavy workload with recreation and time with friends.

Replenished by her regular outings, Dr. McGill continued to work devotedly with her own private patients and maintained a connection with the larger health issues facing Butte. She took the time to review the coroner's record of patients she had seen in an emergency setting and those who had passed through the Murray. Several untimely deaths occurred in the fall of 1936. Most were men, and none had reached fifty-seven, McGill's own age. She read through the list: a mining accident at the Belmont claimed a young man's life; two suicides—one was a doctor she knew, the other a thirty-one-year-old man; a death from silicosis; another from a gunshot wound; a premature infant; a thirty-two-year-old man who had been run over by a train.[22] How many of these men, she wondered, left behind families? The Workman's Compensation Act had passed and helped men who were injured while working in the mines. The nature and extent of an injury determined the compensation: loss of a thumb paid $150 while loss of an eye paid $2,750. Miners had to turn to the county commissioners, or their miners' union, for help with chronic illnesses. Butte's ongoing medical needs motivated McGill to continue her practice even though she had been working steadily for twenty-five years.

Throughout her quarter-century of work, Dr. McGill maintained a professional demeanor with both her colleagues and her patients. Yet, occasionally special relationships developed with certain families. The Burgess family had a particular hold on McGill's affections. Linda and Harry Burgess had called Dr. McGill late on a Sunday afternoon in 1936 expressing concern about their nine-month old son. Without hesitation, McGill instructed the couple to bring the baby in for an exam. After a hasty drive across town, the family arrived at 58 West Quartz and were ushered into the book-lined office. Their baby had been sick and now had a temperature of 103. Dr. McGill calmed the parents and turned her attention to the baby. Baby Pierce was not listless, but he was flushed and very unhappy. His abdomen felt tight, and Dr. McGill heard more than the usual rumbles when she placed her stethoscope on his belly. A sudden shudder convulsed his little body. She squirted a dropper of medicine into Pierce's mouth and proceeded to collect supplies to administer an enema. By way of explanation, she said that Pierce appeared to have a digestive problem and needed to

have his temperature lowered. The medication and enema were the best means to do that and McGill reviewed the steps for both procedures so that Harry and Linda could administer both on their own. Dr. McGill reassured the anxious parents that although Pierce's condition was serious, it was not a crisis, and she felt he would soon be well.

Within a couple of days, baby Pierce regained his strength, and Linda Burgess finally relaxed enough to write a letter to her parents back home in Massachusetts:

> Dearest Family,
>
> Walter Pierce has been sick. Dr. McGill—one on father's list and by reputation in Butte excellent—thinks now WP is on the road to recovery. I am not afraid anymore. Dr. McGill seems like a most amazing person to me—about 50 years old, slight and extremely active. They say she can out walk any person in Butte. She's abrupt in her manner but efficient. She is such an individual that I can understand why I have heard things against her on the personal side. Have heard that she hasn't much patience to complaining people and is so abrupt at sensitive ones. I like her![23]

For her part, Dr. McGill had enjoyed meeting the Burgesses. Even though McGill was thirty years older, Linda Burgess, in particular, seemed to be a kindred spirit. The doctor looked forward to the scheduled follow-up visit.

Dr. McGill double-checked the address: Green Lane Avenue. Clear across town and down on the flats. Once there, McGill noticed a cluster of well-kept houses lined the avenue and the end house sported two columns supporting an ornate iron gate. As McGill paused at the entry, she noticed vertical letters etched into each of the columns. Despite her hurry, she smiled at their message: "WORLDS" on the left and "END" on the right. This place, a good twenty minutes from her office, did indeed feel like the "World's End." The two-story house beyond the gate held two families; McGill had been told that the Burgesses occupied the ground floor apartment.

Once inside, Dr. McGill did a quick assessment of the baby's mother and her home. Linda Burgess could have passed for any of the young Butte mothers with sick infants that McGill saw in her office daily. But just as Green Lane Avenue did not resemble workmen's houses, this house filled with books and artwork was different from what McGill typically saw. A quick introduction to teenage Ruth, "my helper," as Mrs. Burgess put it, set this family apart even more. A baby's cry interrupted the greetings and sent the women down the hallway to the bedroom. When Dr. McGill picked him up, the fussy, sick baby she had seen just a few days earlier was now lively and intent on

grabbing the tube of her stethoscope. Linda unclenched his little hand from the instrument, but he was soon right back at his pulling. Dr. McGill remarked on how "good natured he was not to fuss when he was deprived of his plaything and yet showed perseverance in keeping at it."[24] Linda fairly beamed.

Dr. McGill had reason to hear more about this family when she got together for her weekly dinner with Thula. This particular week, Thula told Caroline about a bright student at Butte High who came to school everyday in the same dress and worn out shoes. She had asked the girl to come in after school and offered to buy her new shoes. "Ruth acted offended and declined any offer of assistance," Thula said. McGill quickly realized that "Ruth Glace" was the same girl she had met at the Burgess's. She also realized she had cared for Ruth's widowed mother and siblings. Upon talking more about the girl, Thula ventured that Ruth might be willing to work after school, thereby earning money rather than receiving a handout. Caroline agreed, though she wondered if the girl could take on yet another responsibility.[25]

Dr. McGill had wanted to know more of Harry Burgess's story since she knew something of Linda's, and now Ruth's, background. She found out that Harry was an assistant geologist at the Belmont and Badger mines and that he had earned his degree at Harvard, where he had met Linda. The mines fascinated him: "In some places it's so hot and humid that your colored pencils run on the paper," he said. In a letter to his parents, Harry wrote about Dr. McGill:

> Dear Folks,
>
> I have no doubt that you think we are making a mistake in having a woman doctor. I can't see that the sex of a person has anything to do with his or her ability. And we have definitely more confidence in her than in the other doctor, male, whom we had when Pierce was sick last year. We feel that we'd not be doing the best for Pierce if we had anyone but Dr. McGill.[26]

With mutual respect for one another, and a recently discovered shared love of the outdoors, it was no surprise that Dr. McGill went beyond the confines of the typical doctor-patient relationship. When a late fall office visit confirmed Linda's pregnancy, Dr. McGill shared fully in the young family's personal happiness. Personal connections, an affinity for the outdoors, and satisfaction with her work allowed McGill to keep life in perspective despite the demands and difficulties going on all around her.

"Butte, Montana, was a hard place to call home," and the mid-to-late 1930s were particularly challenging times.[27] The Department of Commerce survey of Butte reported

that 64 percent of homes were in need of repair, 20 percent had no indoor toilets, and 30 percent had no bath or shower. Twenty-five percent of Butte families received some kind of public assistance by 1936. The population of the cemetery had become greater than that of the town.[28] These harsh realities in her daily life influenced Dr. McGill to purchase her favorite recreational spot: the 320 Ranch in the Gallatin Canyon south of Bozeman. A thriving medical practice, coupled with a frugal lifestyle, provided McGill with a degree of financial independence. She envisioned the 320 as a place of renewal for herself, for her friends and family, and for her convalescing patients.

While in Butte, Dr. McGill was caught up in the demands of her work life. Linda Burgess, hospitalized for the birth of her second baby, described the doctor in a letter home:

> I look out on Granite Street to Dr. McGill's office and see her bustling around. She visited me yesterday was thrilled with the baby. She is fond of us in her way I think because we climb and live an outdoor life. She says she thinks my next baby should be born on a mountain top.

According to Linda, Dr. McGill was "ardent for babies." On the other hand, Linda had heard that she was the only doctor in Butte who gave out birth control information. Linda felt comfortable with Dr. McGill as her doctor, and the Murray as her hospital. Another woman physician, Dr. Sarah Graff, had joined the Murray's medical team and Dr. Rodes had been named President of the hospital. Linda wrote her parents stating: "Though one is not required to stay in the hospital more than 10 days, I am going to stay 2 wks."[29] The Murray Hospital and its staff, at least for the time being, provided a haven of caring concern.

Trips to the 320 Ranch had become part of Dr. McGill's regular routine and provided a balance to her medical practice. Every other weekend she loaded her car and made the three to four hour drive to the Ranch. On May 17, 1937, the day before her fifty-eighth birthday, Caroline wrote: "Mother arrived to spend summer." By June 6th, they headed to the 320. Later, McGill noted that she looked forward to seeing her friend, Thula, and to spending time becoming reacquainted with the Butte painter, Elizabeth Lochrie, whom she had met through their mutual work at the sanitarium at Galen. "Cannot recall such a clear August," she wrote. "Mrs. Lochrie sketched all day." The following day, the two women rode horses. "Lovely autumn color," and then the standard diary entry: "to Butte."[30] Dr. McGill turned sixty on May 18th, 1939. Her life swung like a pendulum between her ties to Butte and the 320 Ranch.

Dr. McGill maintained her relationship with the Burgess family. She liked that Linda Burgess did not hesitate to share all of her impressions and experiences with her family

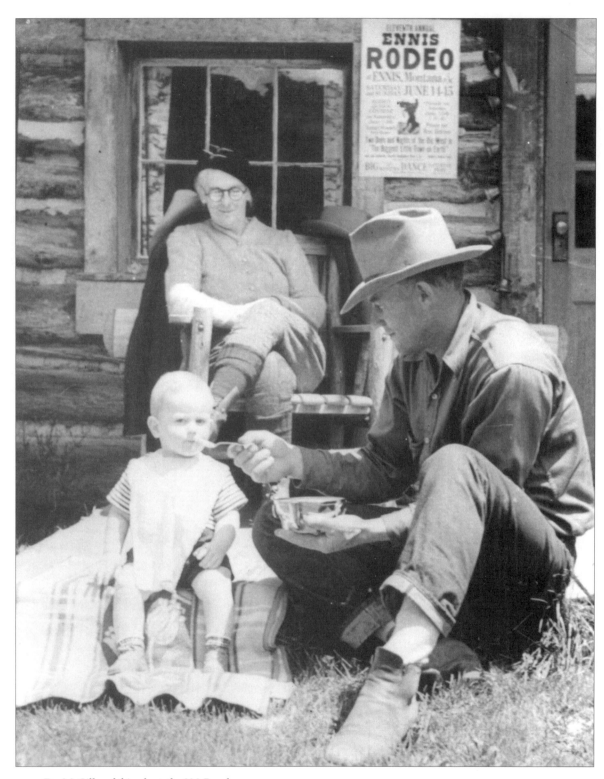

Dr. McGill and friends at the 320 Ranch.

in Massachusetts. "Harry thinks I ought not to write you about the sordid side of Butte," she wrote. "But," she went on, "it isn't Butte without this seamy side so I guess you'll just have to be exposed." Linda made paintings of her adopted city in tones ranging from soft gold to stark black. When she and Harry later left Butte, she gave up painting. "After Butte," she said, "there was nothing left to paint."[31] Butte held a similar hold on Dr. McGill, but the pull of the 320 Ranch began to gradually stretch her ties.

Dr. McGill preferred to do her socializing at the 320 Ranch. However, her mother, Mary Bonar McGill, enjoyed her visits to Butte every bit as much as her trips to the 320. Mrs. McGill accompanied her daughter on home visits and was welcomed by her patients. She helped if she could, often it was to rock a baby, or read a story to an older child. She left the doctoring to her daughter.

Doctoring in Butte continued to be demanding. The Murray Hospital building gradually became out-of-date, but the departments operating within its thick walls were the best modern medicine could offer. Yet, Mrs. Mary McGill avoided the Murray. In fact, she avoided all hospitals. She regretted that family and neighbors no longer cared for the sick in their homes and hated the thought that babies were delivered in a sterile hospital environment. So, in the summer of 1943, it was no surprise that Mrs. McGill refused to be hospitalized even though she had become frail and could no longer accompany Caroline. Dr. McGill's patients missed the old woman whom they had come to know and trust. One patient brought the doctor a photo of her mother she had snapped the summer before. She looked stern in the picture and her chin stuck out as if to say, this is certainly not my idea! Not long afterwards, Mrs. McGill died peacefully in her sleep in the apartment on Quartz Street. She was ninety-two years old.

Her mother's death had a sobering impact on Dr. McGill. Caroline felt she had grown old without noticing it. She had her aches and pains—arthritis had settled in her knees—and there were stretches when she had to use crutches to get around. She didn't seem to mind, and she admonished a friend who complained: "Aren't crutches wonderful? If it weren't for crutches, you and I would both be in bed."[32] She mastered getting in and out of the car and found that once she got on her old horse, Smoky, at the 320, her knees didn't bother her a bit. What did bother her was the death of friends, like Dr. Charles Rodes in 1947, and the closure of the Murray Hospital.

Just as she had adapted to crutches, Dr. McGill intended to adapt to the Murray's closure. In 1951, she applied for privileges as a visiting physician at the soon-to-be-opened Community Memorial Hospital in Butte. She gave the names of three colleagues as references, listed her age at seventy-two, her height at 5'2", and her weight a

Dr. McGill approaching retirement.

respectable 123 pounds. She stated that she held memberships at both the Murray and St. James Hospitals. Her colleagues' recommendations indicated the esteem with which she was held:

> Dr. Schwartz: ". . . I can say that her knowledge and wisdom in the field of medicine is excellent."

> Dr. Talbot: "Dr. McGill, in my estimation, is an outstanding internist. Her council is very sound. She is absolutely ethical and honest."

> Dr. Gregg: ". . . She is a consultant whom everyone is glad to have."

When Community Hospital opened in January of 1952, Dr. McGill had staff privileges despite the fact she was over sixty-five—the age limit applied to attending staff. The Murray Hospital closed within a few months.

With her medical career intact, and the 320 Ranch taken care of in a handwritten will, Dr. McGill began to sort through her large collection of books, magazines, and pamphlets. Like days that had accumulated into months, and months into years, the amassed volumes of books had serendipitously formed a first-rate western history collection. Almost every book held some memory or connection. She didn't have the heart to dispose of her entire collection, but she did resolve to amass her western and Native collection and give it to the School of Mines in Butte. Later each book given by Dr. McGill displayed a template with the acknowledgment: "Presented to the Library by Dr. Caroline McGill June 1953." "Dr. McGill's gift to the library," said Librarian Loretta Peck, "is an outstanding contribution to our historical collection."[34]

Many aspects of Dr. McGill's life were coming together, and yet she knew that her own retirement from medical practice was looming. A fractured hip, suffered in a fall, had made office visits difficult and home visits impossible. She tried a wheelchair, temporarily, but didn't adapt to it as she had to crutches. Then, her oldest friend, Thula Rodes, decided to marry a widower from Missouri and move back with him. With a waning medical practice, and without her friend, life in Butte seemed thin. Dr. McGill decided it was time to announce her retirement and move herself to the 320 Ranch. Yet, there were good-byes to say to both people and places.

The Butte Business and Professional Women's Club selected Dr. McGill as "Woman of the Year" in 1955. Based on her "professional achievements and her unfailing assistance in worthy civic activities," the Club singled her out as the woman they most admired."[35]

Dr. McGill felt deeply honored. The recognition gave her the perfect opportunity to say good-bye and express her thankfulness.

In September of 1956, Dr. McGill had her apartment and office packed and transported to the moving van she'd hired for the trip to the Gallatin Canyon. She took one last look around her apartment, empty and forlorn looking as it was. She moved slowly toward the door, aware that once she crossed the threshold, there was no going back. With slow shuffling footsteps, she made her way across the room, and out the door, closing it behind her with a final click. Before heading down the long curved stairway, she paused a moment longer to reflect on Butte and all that she had been part of. Forty-five years, countless patients, supportive colleagues, and a handful of close friends. She could stay and drift into a quiet retirement. Inadvertently, she shook her head and thought back to the lines she had written when she first came to Butte: "But it's all done and I have to let her rip!" She didn't look back as she descended the stairs, passed by her office, and headed for her car.

NOTES

1. Caroline McGill Collection, 1909-1958, Coll. 945, Series 1, Box 1, Folder 1, pp. 133-134, Montana State University Libraries, Merrill G. Burlingame Special Collections, Bozeman (hereafter McGill Collection).

2. "Dr. Caroline McGill to Butte, Montana," *University Missourian*, Columbia, MO, December 19, 1910 University of Missouri Archives, Columbia, MO.

3. *Butte Miner*, January 1, 1911, 1.

4. Esther G. Price, *Fighting Tuberculosis in the Rockies* (Helena, MT: Tuberculosis Association, 1943), 22-23.

5. Guy, X. Piatt, *The Story of Butte, Oldtimers' Hand Book* (Butte, MT: The Butte Bystander, no date), 84-85, Butte-Silver Bow Public Archives (Hereafter BSBPA).

6. *Butte Miner*, January 2, 1911.

7. Silver Bow County Board of Health, "Report of Investigations," Butte, Mt. 1908-1912, unpublished, SC 89, Montana Historical Society Archives (hereafter MHSA).

8. Mabel E. Tuchscherer, "Silver Bow County Medical Society and Butte, MT," in *Petticoat and Stethoscope: A Montana Legend*, ed. John A. Forssen, 1978, MHSL.

9. Charles E. Rosenberg, *The Care of Strangers*, (New York: Basic Books, 1987), 148.

10. Alan M. Chesney, M.D. *The Johns Hopkins Hospital and The John Hopkins School of Medicine*, (Baltimore: The Johns Hopkins Press, 1943), vol. 2 (1893-1905), 311.

11. "Report of the City Health Officer: Month of May 1914," Butte Health Dept. Records 1914-1917, Typescript, Box 1, Folder 7, BSBPA.

12. *The Butte Miner*, June 9, 1917.

13. Ruth Williams, interview by author, October 16, 1999, Great Falls, MT (Hereafter Williams interview).

14. Tracy Thornton, "No Laughing Matter," *Montana Standard*, July 21, 1996, section C, 6.

15. Brian Shovers, Montana Historical and Architectural Inventory: 58 West Quartz, 1985, BSBPA.

16. Beatrice Murphy, "Diary of a Night Nurse," unpublished manuscript, November 1909, SM004, BSBPA.

17. Murray Hospital Commencement Program, 1921, BSBPA, 8-9.

18. Teresa Jordan, Chronology -1920s, BSBPA; Mary Murphy, *Elizabeth Lochrie: Portraits of a People* (Helena, MT: Holter Art Museum, 1997).

19. Fran Denning, "McGill - County Benefactor," *Three Forks Herald* (Three Forks, MT), February 3, 1983, 5.

20. The 320 Ranch was McGill's property in Montana's Gallatin Valley. Its name refers to the size of the ranch, 320 acres.

21. "Before the Three Twenty," McGill Collection, Series 1, Box 1, Folder 3, 1-3.

22. Silver Bow County Coroner's Report, 1936, BSBPA.

23. Linda Burgess, to family, Cambridge, MA, undated. Private collection, Heather Burgess Pentland (Hereafter Burgess Pentland Collection).

24. Linda Burgess to family, 28 September 1936, Burgess Pentland Collection.

25. Williams interview.

26. Harry Burgess to family, 7 November 1937, Burgess Pentland Collection.

27. Mary Murphy, *Mining Cultures: Men, Women and Leisure in Butte, 1914-1941* (Urbana: University of Illinois, 1997), xiii.

28. Ibid, 210.

29. Linda Burgess to Mother, 10 June 1937; to Dearest Family, undated, Burgess Pentland Collection.

30. McGill Collection, Folder 1, 1-3, 6, 10. "Before the Three Twenty," McGill Collection.

31. Linda Burgess to family, 3 August 1936, Burgess Pentland Collection.

32. Janet Cronin and Dorothy Vick, *Montana's Gallatin Canyon*, (Missoula, MT. Mountain Press, 1992), 216.

33. Work Progresses on McGill Gift to Mines Library," *Montana Standard*, February 24, 1957, 12.

34. Dr. McGill Selected by BPW Club as Butte's "Woman of the Year," *Montana Standard*, October 2, 1955, 9.

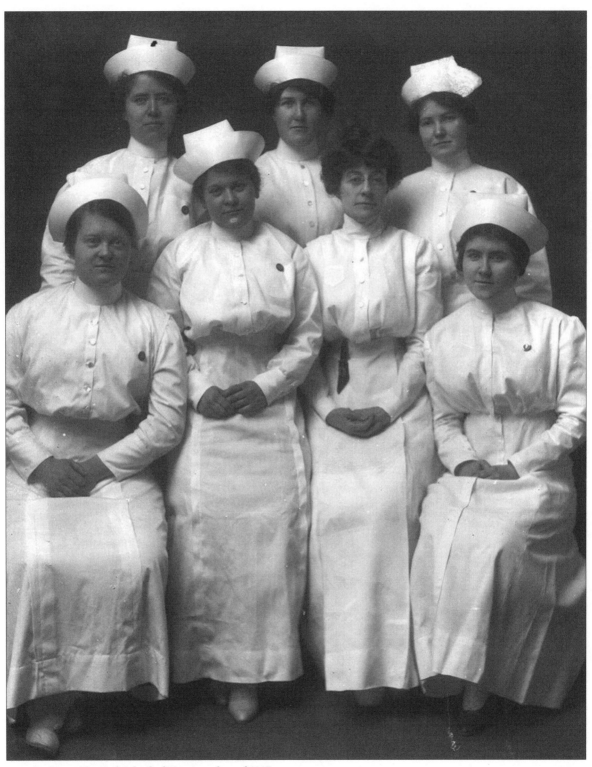

St. James Hospital School of Nursing, class of 1917.

The Sisters of Charity: Mining City Health Care Pioneers

Sr. Dolores Brinkel, SCL

The Sisters of Charity of Leavenworth (SCL) were the pioneers of health care in the mining city. During an era when women primarily were homemakers, the Sisters of Charity created a community of care for Butte's people and exemplified the role of women as advocates in shaping health care delivery. The sisters maintained tough discipline, high standards, and a commitment to the poor. They focused on the whole person, body and soul, whether that person was miner, banker, boarding house proprietress, or prostitute. Since their arrival in Butte in 1881, the Sisters of Charity have built and managed a hospital, established a school of nursing, and created innovative health care programs to meet changing community needs. Eventually the Sisters partnered with local lay staff and administrators who assumed the autonomous operation of St. James Healthcare within the Sisters of Charity of Leavenworth Health System. Their influence on Butte continues to be felt into the twenty-first century. This chapter explores the history of the Sisters of Charity in Butte and highlights their important contributions to health care.

ARRIVAL

The introduction of quartz mining in 1880 helped transform Butte City into the "richest hill on earth," with a burgeoning population and attendant social, cultural, and health challenges. Single young men, who outnumbered women three to one, flocked to Butte seeking their fortunes. They groveled in the wet underground mines for their shifts then crowded above ground in boarding houses, saloons, or brothels. Thanks to the thick layers of smelter smoke, fresh air was at a premium above ground as well as below. In addition, primitive sanitation facilities, rampant disease, and injuries from mine accidents, fights, or gunshots placed heavy demands on Butte's doctors and existing private house hospitals.[1] In short, health care conditions in Butte were bleak. Countering an inspector's glowing assessment of Butte's Workingman's Hospital in 1881, former patient G. F. Bein recalls his experience:

> They brought a patient in one evening and put him in a bed in an adjoining room. Everything was quiet until about 10 p.m. when I noticed him at the foot of my cot, with eyes shining like balls of fire, he made a lunge at me and I gave a scream and two convalescents came to my aid. One fellow hit him

in the jaw and floored him, then the other fellow helped to hold him down. Their cries brought the one attendant and they carried him back to his bed and lashed him there with a rope. I heard him ram his head against the headboard repeatedly until about 11 p.m. when everything was quiet again. In the morning a couple of the boys that came to my aid, stopped to talk to me, said you had quite a scare last night, said well he quieted down later all right, I guess I will go take a look at him. He came out in a few minutes and said, "No wonder he is quiet, he is deader than Hell . . ." I had my own blankets, with no sheet on the bed. My nose bled on the pillow slip the first night, I turned it over and it was on the bed when I left. I was lousy as was every other patient and never had even a sponge bath in the whole month.[2]

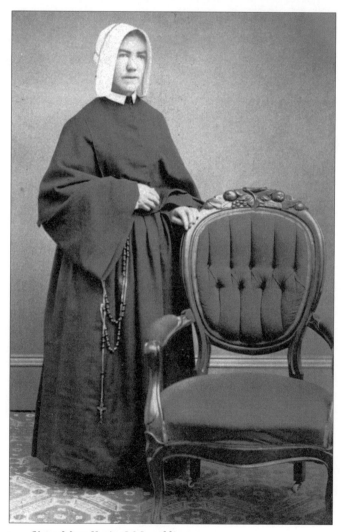

Sister Mary Xavier McLaughlin

Into these circumstances stepped the "gentle of manner, kind, soft-spoken, generous and prayerful" Sisters of Charity.[3] This band of religious women established a base in Leavenworth, Kansas in 1858, and within eleven years they had proceeded west to found St. John's Hospital and St. Vincent's Academy in Helena, Montana Territory. Dedicated to serving the sick, uneducated, and poor, they also founded a hospital in Deer Lodge, Montana in 1873 and one in Virginia City, Montana in 1876. In April, 1881, two of the Sisters at Deer Lodge were sent to establish a hospital in Butte City.

The two sisters came by wagon, bringing supplies from St. Joseph Hospital where they had served as administrator and nurse. Sister Mary Ignatia Nealon, with her expertise in business, was to obtain property and negotiate contracts, and Sister Mary Xavier McLaughlin, with her dogged determination, was to beg for funds. Sr. Mary Xavier had been in Montana Territory since 1872, and she was an experienced horsewoman. In 1877, she, along with Sister Mary Liguori Ennis, had ridden some 90 miles on horseback to nurse wounded soldiers and Indians at the Big Hole battle site in south central Montana. Four years later she rode through Butte City's muddy streets, littered with dead animals, sewage, and garbage, accompanied by Messrs. Joel Ransom and James Matthews, to beg for funds to build the hospital. Every day, they stood at the entrances to smelters and mines when shifts changed to solicit money from mine workers before it was squandered in one of the city's more than 100 saloons, gambling halls, or brothels.[4]

The sisters wasted no time in fulfilling their mission. Within six months they had raised $8,000 and had construction of the two-story hospital on Idaho Street under way.[5] They eagerly awaited the shipment of furnishings and the re-enforcement of ten Sisters from the Mother House. On the night of October 23, 1881, the stage coach from Silver Bow Junction rumbled to a stop outside the little log house on the hospital grounds that was home to the sisters. But only three new arrivals—Sisters Mary Serena O'Connor, Hilaria O'Connor, and Mary Assisium McMahon—stepped stiffly out of the coach into the cold mountain air. The rejoicing and exchange of news from the Mother House was tempered by the exhaustion from a week's train journey and the daunting task of double work duties. They began scrubbing floors, moving horse-hair mattresses onto the beds, cooking, and washing sheets and clothes in anticipation of the hospital's opening. In between they went to church and said their prayers. Three weeks later, on November 15, 1881, St. James Home opened its doors. John Hennessy, a school teacher suffering from typhoid, was the first admitted patient.[6]

A closer look at the five founding Sisters reveals their dedication and genuine care for Butte people. Two of them, Sister Mary Serena and her sibling, Sister Hilaria O'Connor,

typify the character and nursing skill of the pioneer Sisters in Butte. Sister Mary Serena, one of five O'Connor daughters who entered the Sisters of Charity in 1878 after emigrating from Ireland, had pronounced her first vows in 1880.[7] After her assignment to St. Vincent's Hospital in Leadville, Colorado at age twenty-four, she was sent to help open St. James Hospital in Butte. Unfortunately, she came down with typhoid and consequently was the hospital's first unofficial patient, a day before the doors were opened. After three weeks in bed, Sister Mary Serena began her duties as the hospital druggist. Over the next fifty years, Sister Mary Serena provided health care in communities throughout Montana and the West. A community scribe wrote that her "name suited her perfectly; she was serene, meek, gifted with remarkable intellect and sympathetic heart. However, she could be firm when principle was involved, and would never tolerate laxity, nor bend to unreasonable demands; she was always honest and upright . . . She was beloved not only by the Sisters and patients, but by the work people; she was especially revered by the clergy, who frequently recommended their intentions to her prayers, confident of her efficacious intercession with God."[8]

Her sister, Sister Hilaria, had pronounced her first vows in September, 1881, and within two months she was in Butte to open St. James. Records in her personnel file give a glimpse into Sister Hilaria's character:

> Here as nurse she won the admiration and esteem of the suffering miners . . . Always gentle and kind in her ministrations to the sick, in a motherly way, she relieved their bodily ills, and in many cases renewed their spiritual strength, by timely words and edifying manner, thus sending out some with new fervor to fight life's battles, and accompanying others with her prayers on the passage to eternity. After eleven years at St. James where the Sisters did all the nursing, the laundry, the cooking and the institutional maintenance work, Sister Hilaria transferred to St. John's Hospital in Helena, from there to St. Joseph's Hospital in Deer Lodge, then to the hospital in Leadville, and finally in 1923 to St. Ann's Hospital in Anaconda, where for six years she cared for the stricken smelter men as night supervisor making her rounds regularly and frequently. She was especially loved by those whom she had nursed at the hospital. When she celebrated her Golden Jubilee as an SCL, the high regard in which she was held was revealed by the numerous floral offerings and gifts from people of all walks of life. In the afternoon the townspeople sent cars to escort the Sisters and their guests through the city . . . Then one morning in March 1931 she surprised her superior by ending the night report with a request to be anointed in preparation for death. Naturally, the superior thought this was unnecessary, but when evening came Sister

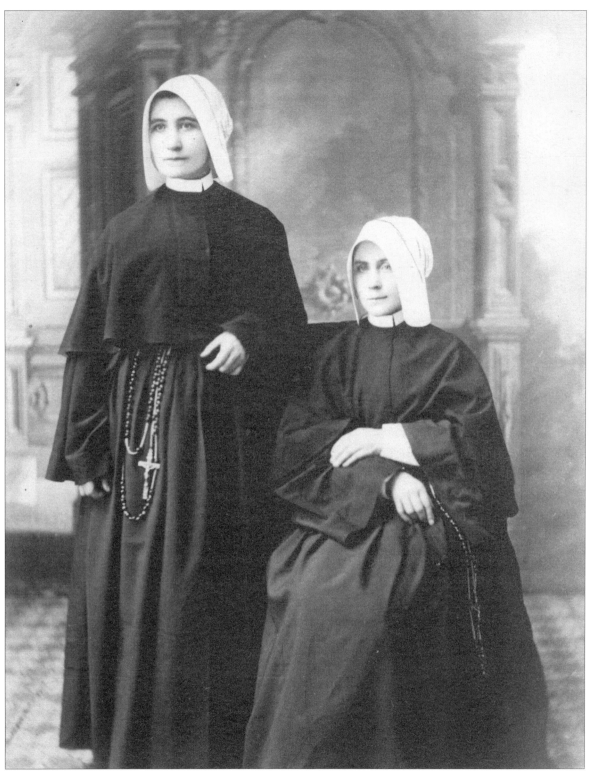

Sisters Serena and Hilaria O'Connor.

Hilaria was unable to go on duty. She received the last sacraments and anointing and without again rising from her bed, died.[9]

After two years at St. James Hospital, Sisters Ignatia Nealon and Mary Assisium McMahon withdrew from Butte and the Sisters of Charity. Perhaps both were victims of overwork and stress, or they may have decided that they no longer were called to religious community life. Sister Mary Xavier McLaughlin, the first of the five to die, continued to nurse at St. James until July 1, 1884 when after a few hours illness she passed away, much to the sorrow of the other thirteen Sister nurses and the general public. She was forty-three years old. The Butte miners asked as a favor to be allowed to sit up with the remains of the Sister beggar. According to Sister Mary Buckner, SCL, "These women had truly earned the esteem and affection of the whole Butte community. They contributed to the spiritual and temporal benefit of the people, and captivated the affection and gratitude of the sick and disabled."[10]

A COMMUNITY OF CARING

The Sisters continued to nurture the Butte community with their works, which were seldom put into print but often recounted among the Butte people who held them in affection. The compelling health needs of Butte centered on the miners. An analysis of patients admitted from 1881 to 1897 reveals that most of the admissions were from accidents, particularly in the mines. Typical ailments included: shot, fractured leg or arm or back, sprain, pneumonia, frozen feet, nerves, erysipelas [strep], consumption, rheumatism, cancer, whiskey, amputation, kidney trouble, and blasted.[11] The Sisters responded to all with a blend of skill and compassion.

St. James reserved selected areas of the hospital for treatment of miners. The miners' ward dominated the hospital, and competent Sister nurses were assigned to that duty. One of the Sisters who had a special way with miners was Sister Mary Daniel Foxworthy or "Big Dan" as she was affectionately called because of her great height and stature as well as her largess of personality and great sense of humor. A co-worker, Sister Celine Taskan recalled: "There were many times when accidents came in and there was a problem getting the patient to settle, and Big Dan was called in. She would fold her arms over her chest and then place them on the patient's chest and things would calm down, so the doctors could work with the patient."[12]

Occasionally though, the miners eluded the watchful eye of the Sister supervisor. One night:

. . . The patients in the miners' ward barricaded the door and examined the qualities of a bottle of brandy smuggled in by a visitor. The sound of raucous singing and dancing rang through the ward, accompanied by the musical strains of Tony Pasquale's accordion. The hospital staff pounded on the barred doors to no avail, while the brandy bottle circulated and the chorus sang on. By the time the frantic nurses and janitors broke into the room, the bottle was empty and most of the patients were dead-drunk.[13]

In addition to caring for miners, the Sisters at St. James also gave high priority to the poor and underserved of the community. "From the beginning, Sisters delivered food to needy families. In poor times, strikes, and panics, the Sisters in charge of the kitchen fed the hungry who came to the door on the alley. Merchants carried the hospital when funds ran low and patients couldn't pay, trusting the Sisters to settle accounts when they could."[14]

From the time that St. James Hospital opened in 1881 the Sisters contracted with Silver Bow County to care for the county poor. This care, according to Sister Emilda's letter to the County Commissioners of Silver Bow County, was "to furnish board, lodging, surgical dressing, medicine and other Hospital attention to the Emergency sick and accident cases of Silver Bow County, at the stipulated sum of $15.00 per week . . ." In addition, the hospital cared for those who were not financially able to pay. Some years, such as in 1904 and 1908, this was nearly one-third of the patients.[15] Stories abound among the Sisters of persons they befriended, reflecting both the challenges of health care and the spirit of the care givers:

> Nowhere in all these accounts [about St. James Hospital] is there a record of the Sisters being threatened in any way even when bigotry threw the town into wildly opposing factions. Not infrequently the injured from both groups were treated in the emergency room, side by side, where they could count on a stern lecture from the Sister in Charge.[16]

> One such patient who arrived via the emergency room following a close encounter with other celebrators was definitely unsure of these, as he described them "women wrapped up in yards of white stuff." He had complaints to make, but how to present these without direct approach. Ah, writ is, and he did, and the messages provided many a chuckle. Among them were: "To Sister Agnes with her big city ideas," "To Sister Mary Carmel, you who don't answer bells at night," and, "To Sister Angelina, you who interfere with my private affairs." The last was reference to Sister's asking him if he had any religious preference.[17]

Another woman arrived in the cold of winter wrapped in a big fur zipped coat. She stood in the main entrance and she couldn't speak English. She kept moaning and groaning. We got her in a wheel chair. She came in a taxi. The cabbie said she came in on a bus. So we took her down to the emergency room. Dr. Staples asked, "Is she going to have a baby?" We didn't know. He unzipped her coat and of course she was going to have a baby very fast . . . Supposedly the woman had come down from Alaska.[18]

When tragedy struck the city, the victims were taken care of by the Sisters; when disease assumed epidemic proportions, the Sisters dealt with their share of it. If they contracted the illness, then they were cared for as were the other victims. In 1918 when the city was ravaged by the flu, the mines were shut down, the schools were closed and the Sister-teachers came to spell the Sisters at the crowded hospital. Sister Mary Carlotta Butler, hospital administrator, had no funds to pay help and did not have the heart to let them go. There is no more poignant account of a death among them than that of Sister Ann Bernard McCrystal, who having spent several weeks with the sick was to have a weekend free. But it was apparent on Saturday that she had a cold; by the following Wednesday she was dead . . . She was twenty-five years of age.[19]

St. James Hospital, circa 1906.

Through the years the Sisters have maintained a charity fund to meet the emergency needs of patients and staff, a practice that continues into the twenty-first century. With

the advent of lay administrators, the SCL charity fund is overseen by the Sisters in the pastoral care office. In addition, the social service staff of St. James has budgeted funds to assist those unable to cover the costs of care. The hospital currently expends over two million dollars annually in charity care. For nearly 125 years the Sisters have truly been keepers of the community.[20]

CREATING A FUTURE FOR WOMEN IN HEALTH PROFESSIONS

In an effort to better care for patients and to meet state and national medical care standards, the Sisters sought technical training and association with other professionals. Thus they paved the way for other women who would follow in the health profession. Several of the St. James Sisters were firsts in their fields. An example is Sister Mary Gertrude Barrett who had been compounding and dispensing medicines at the hospital for several years. In 1906, with the passage of a new Montana state pharmacy law, Sister Mary Gertrude stood before the State Pharmacy Board for quizzing on chemistry, toxicology, and theoretical and practical pharmacy. She was the first woman to pass the examination, and on October 11, 1906 she became a registered pharmacist.[21]

Sister Mary Melita Walsh was a registered nurse, and in her years at St. James (1914-1919) she frequently assisted Dr. J. A. Frisbee. "One day in answering some of her many questions, he asked her if she would like to learn the x-ray. Indeed, she would, and the instruction began. She practiced her pictures on the Sisters' hands, and some braver ones allowed her to take pictures of heads as well. As a result Sister Mary Melita became the first Sister of Charity to earn admittance to the American Registry of Radiological Technicians." Sister Mary Melita continued her professional training, and in 1929 she became the first registered medical technologist among the Sisters of Charity.[22]

The Sisters of Charity were never ones to accept the status quo. In response to the growing complexity of twentieth-century medicine, the Sisters opened a school of nursing in 1906 with Sister Mary Rita O'Sullivan as the first superintendent of nurses. Four women—Marjorie Breslin, Mary A. Kelly, Florence Laughran, and Sister Mary Anacaria Sullivan—comprised the first graduating class in 1909. In 1918 the hospital, under Sister Marcella Reilly's direction, erected a home for the student nurses adjacent to the hospital. The school produced several generations of skilled nurses who went on to serve the Butte community and the state. By the 1960s nursing education was shifting from hospital based training to institutions of higher education. The St. James School of Nursing cooperated in establishing the nursing program at Carroll College

in Helena, Montana, and participated in it before the School of Nursing closed in 1970. Nevertheless, by 1967 the Butte school claimed 60 percent of the practicing nurses in southwest Montana as its graduates.[23]

One of the Sister directors of the school, Sister John Marie Pithoud, inspired and mentored many nursing students to aspire to professional growth and service. Sister John Marie spent her young years as a nurse with Dr. Louis Allard, a famed orthopedic surgeon who worked with crippled children during the polio epidemic. A columnist of the period wrote of her: "A sunny-faced woman . . . greeted them [children] as they arrived, and with a mother's tenderness and care, treated limbs malformed or temporarily paralyzed."[24]

Sister John Marie was considered by Hazel Murray, a 1943 nurse graduate, to be the most influential person in her life. Murray recalls, "She taught by concept rather than just by doing. In many ways she was a visionary because she realized . . . what nursing was to become . . . She saw the possibilities for nurses, and she certainly saw the significance of going on and getting additional education." Launched by Sister John Marie's mentoring, Murray went on to a lifelong career in nursing, first as an educator, then as chief nurse and supervisor with the Veterans Administration (VA), and later as a liaison between the VA and the American Hospital Association in Washington, DC. According to Murray, Sister John Marie was very good at identifying people who had leadership ability. Several of Murray's contemporaries who received their training with the Sisters of Charity also assumed leadership roles in nursing. For example, after serving as a Cadet Nurse during World War Two, Mary Delaney Munger went on to a significant career as an educator and as Executive Director for the Montana Nurses Association.[25] The story of Butte's Cadet Nurses who trained under Sister John Marie appears in the following chapter.

SISTERS OF CHARITY AND THE BUSINESS OF HEALTH CARE

The Sisters were astute businesswomen in times when most women were relegated to the home. In the 1880s they let contracts to construct the hospital and negotiated with the County to care for the county poor. A few years later they made financial arrangements with the mining companies to assure better care for the miners and their families. Early in the twentieth century they negotiated with the powerful Anaconda Copper Mining Company (ACM) to provide health services to miners. For much of the century they sought financial assistance from the ACM to fund hospital renovations, and in 1960 they purchased Butte Community Memorial Hospital from the company.

116

As early as 1898—nearly a century before the modern concept of Health Maintenance Organizations (HMOs) became popular—the Sisters negotiated arrangements with the mining companies to provide health services to miners. For example, a June, 1898 financial ledger shows that $3,229 was collected from seven Butte mines for miners' medical expenses. By 1914 the number of mines involved had increased to thirty-two. For its part the hospital "equipped the mines with emergency outfits. It guaranteed handling emergency cases carefully and aseptically until the arrival of the hospital surgeon."[26]

This same arrangement was formalized by the newly consolidated Anaconda Copper Mining Company when in 1915 it contracted with both St. James and Murray Hospitals for one dollar a month per miner for all the services rendered by the hospital, except for treatment of venereal disease and intoxication.[27] Miners could come in for minor injury, cold, or other ailment, stay as long as was needed, and all costs of treatment, including medications, were covered by this modest payment. By the 1940s the hospitals were losing money on the contract because of rising costs of medical treatment. However, not until the 1950s was St. James Hospital able, mostly through the efforts of Sister Mary Antonia Talle, the hospital's chief financial officer, to persuade the ACM to raise the monthly amount paid per miner. As Sister Ann Dolores Muckenthaler, then administrator of St. James, tells it, she and Sister Mary Antonia met the ACM businessmen in their offices. They sat down at the conference table, and Sister Mary Antonia with her well prepared documentation proposed a fairer rate. Surprisingly, the men had nothing to say, other than, "There's no other way to handle it."[28]

Unfortunately, the advantage was short lived. Costs of medical care continued to rise. A few years later a committee was formed to renegotiate the contract with the ACM. Committee members Drs. H. H. James and. D. L. Gillespie met with Mr. Edward McGlone, ACM vice president, to try to rectify the hospital's losing proposition. Dr. Gillespie recalled that Dr. James proposed a new figure: "I think it was $2.25 a month. With that Mr. McGlone got up and hit his fist on the desk saying, 'We'll build our own hospital.' That's how Butte Community Memorial Hospital happened to be built."[29] By 1956 the Sisters of Charity cancelled their contract with the ACM, who had built Butte Community Memorial Hospital a few blocks away. However, in 1960, after a decade of operating in the red and a long and turbulent search for new managers of Butte Community Memorial Hospital, the ACM deeded the hospital building and debt of several million dollars to St. James. These negotiations were carried out by a team of Sisters, which included Mother Mary Ancilla Spoor, Sister Mary Anselm Towle, Sister Ann Dolores Muckenthaler, and Sister Mary Antonia Talle.[30]

Although the Sisters were tough negotiators for miners' benefits, they also collaborated with the ACM in efforts to build the community, especially after the 1935 earthquake, which severely damaged the hospital. Sister Mary Linus Harrington, St. James administrator, launched a campaign to repair and renovate the hospital. She enlisted D. M. Kelly, vice president of ACM, as general chairman, and together they raised half of the amount needed for reconstruction, with the Sisters of Charity Mother House matching contributions dollar for dollar. "The ACM was a most generous benefactor in this reconstruction, paying one-third of the total expense."[31]

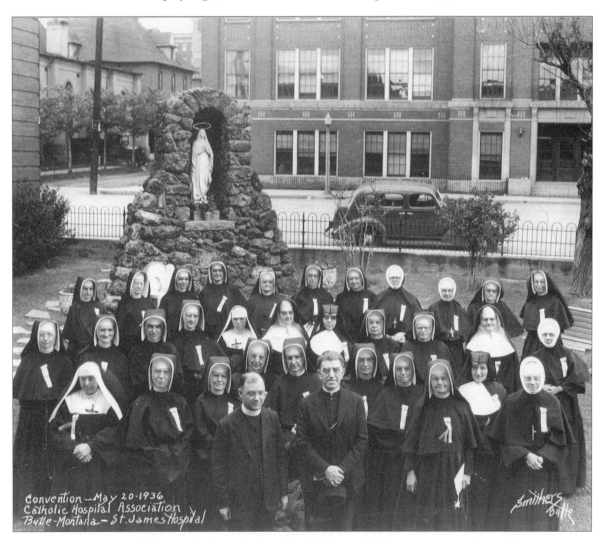

Montana Catholic Hospital Association Convention, Butte 1936.

STATE-OF-THE-ART HEALTH CARE

The Sisters of Charity were remarkable women. From Butte's beginnings they built the institutions and provided the services to meet the community's changing medical needs. As new technologies developed, such as the x-ray at the turn of the twentieth century, the sisters developed the necessary knowledge and skills to put them to use. For example, the high incidence of rheumatism among the miners prompted the installation of a hot air machine at a cost of $800 during the 1905 renovation. The sisters have also guided the hospital through the rigors of accreditation, further ensuring the public of high quality health care. When St. James Hospital celebrated its centennial in 1981, Sister Mary Serena Sheehy, hospital president, spoke with pride about the hospital's capacity to meet the full spectrum of health care needs from neonatal intensive care to neurosurgery and cancer treatment.[32]

Sister Mary Serena Sheehy was a Butte girl. She attended grade school at St. Mary's and high school at Girls Central with Sisters of Charity teachers. After entering the Sisters of Charity community she taught and was principal in grade schools in Kansas, Missouri, and Colorado. Then the Mother General asked her to study psychology in preparation for opening the Kennedy Child Study Center in Santa Monica, California. Her completion of a Ph.D. in psychology introduced her to the diverse and great problems of the emotionally and developmentally disabled. In the mid-1960s, Sister Mary Serena had an active role in assessing and providing mental health services in the Watts area of Los Angeles. After serving on the governing council of her community for twelve years, she was appointed president of St. James and returned to her native city in 1980.[33]

One of the greatest things Sister Mary Serena did was to buy St. James East (formerly Silver Bow Hospital) to house a number of health care services, such as chemical dependency treatment. One of the hospital staff, Linda Lee Holmes, remembered that she had accompanied Sister Mary Serena when she met with Silver Bow County officials to negotiate the purchase:

> It was great watching their faces, because they were expecting a little, mild-mannered lady they could put one over on. They were surprised to find pure wonder velvet—just as sharp as anyone I've met . . . I think the County thought it could get more money for it than what it was worth. But Sister was a shrewd negotiator. I don't think anyone went into a meeting with her that didn't come out of there quite amazed.[34]

At the same time, Sister Mary Serena cared deeply for the staff and patients. "Every day she'd walk up the stairs to sixth floor and come down visiting people all the way down. The people knew her and she knew them . . . She was a classy lady."[35]

BUTTE LEGACY

The Sisters of Charity of Leavenworth birthed a dream in Butte that drew together and sustained hundreds of women who in turn nurtured that dream and continue to care for the sick and poor in Southwest Montana. Albeit fewer in number today, they continue their dedication to meeting the needs of the sick and poor in the Butte Community in the twenty-first century. Grasping the situations of dwindling numbers of Sisters, complexity of health care delivery, and increased numbers and variety of trained healthcare professionals, the Sisters are also preparing lay staff to become leaders in the spiritual mission that drives the hospital. Senior hospital management participate in training focused on the history, ethical and religious values, spirituality and spiritual practices, and, most importantly, the mission of the whole system. This assures continuity of quality health care in the oldest continually operating private institution in Butte. The simple heroism of the Sisters of Charity's institution building and support services in Butte was aptly recognized by Frank C. Walker, a Butte boy and Postmaster General of the United States, when he wrote, "I have known the Sisters of Charity for so long that admiration will always be in my heart for the generous women who in poverty and hardship accomplished so much for their neighbors in Butte."[36]

NOTES

1. Drs. Cornwall & Whitford's Miners' Hospital and Drs. Holmes & Henderson's Workingman's Hospital. Mary Murphy, "Women on the Line: Prostitution in Butte, Montana 1878-1917" (master's thesis, University of North Carolina – Chapel Hill, 1983), 6.

2. Letter –"Butte, Montana Hospitals" folder, Montana Historical Society Library vertical files and *Butte Daily Miner*, November 05, 1881, 5.

3. Sister Mary Seraphine Sheehan, SCL, "St. James Hospital, Butte" (Manuscript, March 1980), 4 (Hereafter Sheehan, "St. James Hospital, Butte"), St. James Healthcare Archives (Hereafter SJHA).

4. Sister Mary Buckner, SCL, *History of the Sisters of Charity of Leavenworth* (Kansas City, Missouri: Hudson-Kimberly Publishing Co., 1898), 484 and *The Butte Daily Miner*, April 17, 1881, 3.

5. *Intermountain Freeman*, November 20, 1881, 3.

6. Sister Julia Gilmore, SCL, *We Came North: Centennial Story of the Sisters of Charity of Leavenworth* (Leavenworth, Kansas: Sisters of Charity of Leavenworth, 1961), 58-59 and Sheehan, "St. James Hospital, Butte," 1.

7. Catherine O'Connor (Sr. Mary Serena), 21 years old, entered the Sisters of Charity in 1878; Annie (Sr. Hilaria), 24 years old, entered in 1880; Maggie (Sr. Mary Veronica), 27 years old, entered in 1887

and died 1896 of an ulcerated stomach; Hannah (Sr. Joseph Marie), 27 years old, entered in 1889 and died in an accident at St. Joseph's Hospital in Denver in 1893; and Jane (Sr. Eusebia), 25 years old, entered in 1890 and died in the 1918 flu epidemic. Sisters of Charity of Leavenworth Archives (hereafter SCLA).

8. Sister Mary Serena O'Connor personnel file, SCLA.

9. Sister Hilaria O'Connor personnel file, SCLA and Gilmore, *We Came North*, 80.

10. Buckner, *History of the Sisters of Charity of Leavenworth,* 293.

11. *Patient Ledger, 1881-1897,* Microfilm 1, St. James Healthcare (hereafter SJH) Medical Records.

12. Sister Celine Taskan, SCL, e-mail message to author, May 22, 2004.

13. "St. James Commemorative Section," November 15, 1981, 4 (hereafter SJCS). Also Sister Mary Syra Keiley, SCL, "Saint James Hospital," MSS, ca. 1938, SJHA, 3 (hereafter Keiley, "St. James Hospital"). Sister Mary Syra, from the Helmville area, was the first native born Montanan to enter a religious order.

14. SJCS, 4.

15. In the three months (December 1881 – February 1882) Sisters' Hospital nursed 48 county "inmates", for a cost of $2,316.35 at a $13.50 per week rate. *Butte Daily Miner,* March 7, 1882, 8. Board of County Commissioner Proceedings, Silver Bow County, Book No. 200, 1906. The hospital offered subscription service to individuals, as well as to the mines and the railroad. *Butte Daily Miner,* January 5, 1905 and *SJH Patient Ledger*, 1908, Microfilm 2, SJH Medical Records.

16. Sheehan, "St. James Hospital, Butte," 7, also in SJCS, 4.

17. Ibid.

18. Sister Jane Ellen Furey, SCL interview with author, Billings, Montana, December 24, 1998.

19. Sheehan, "St. James Hospital, Butte," 5 and Keiley, "St. James Hospital," 3.

20. Gilmore, *We Came North*, 405. Patrick Dudley, interview with author, Butte, Montana, April 23, 2004. Sisters of Charity of Leavenworth Health System *Annual Report,* 2003, 5.

21. State Board of Pharmacy, *Minutes Record Book*, 1895-1914, 117-118, Board Office, Helena, Montana.

22. Sister Mary Melita Walsh, SCL personnel file, SCLA. Also SJCS, 3.

23. Sister Mary Jerome Kelly, SCL interview with Sister Judith Jackson, SCL, Leavenworth, KS, January 27, 2000, "School of Nursing file," SJHA. Also Sister Marilyn Podrebarac, SCL, "House History," St. James Community Hospital, 30 January 1967, 13, SCLA.

24. Sister John Marie Pithoud, SCL personnel file, SCLA.

25. Hazel Murray, R. N. interview with author, Helena, Montana, September 17, 1999 and "50th Reunion Class of 1944," School of Nursing file, SJHA. Sister Mary Domitilla Breen participated in the 1913 Montana State Association of Nursing convention in Butte; Sister Mary Thomasine O'Connor, Sister John Marie Pithoud, and Sister Gabriella Connell, were presidents of MSAN.

26. *Helena Diocese Scrapbook, 1904 – 1916*, SCLA. The pages of the SJH 1898 financial ledger were later used for a scrapbook. Financial records are readable where not covered by news clippings. Also ACM Letterpress Book, "Outgoing Correspondence," Box 388, File 3, MSHL and "1914 Annual Report, St. James Hospital," SJHA.

27. Anaconda Copper Mining Company Records, Box 369, File 5, 1915, MSHL.

28. Sister Ann Dolores Muckenthaler, SCL. Interview with author, Leavenworth, Kansas, July 2, 1999.

29. Dr. Donald L. Gillespie, M.D. interview with author, Butte, Montana, June 21, 2000.

30. Mother Mary Ancilla Spoor, SCL, to C. H. Steele, December 19, 1956. Correspondence file of Mothers General, SCLA. Deed in possession of Pat Dudley, SJH.

31. Gilmore, *We Came North*, 402-403. A patient could be exposed to 115° to 120° F for ten to 45 minutes in a hot air machine or bath cabinet. It was believed the ensuing copious perspiration would eliminate many disease toxins. Naturowatch, Principles and Practice of Naturopathy: A Compendium of Natural Healing (1925), E.W. Cordingley, "Hot Air, Steam and Vapor Baths," 3-4. http://www.naturowatch.org/hx/cordingly/10.shtml. Also Mother Mary Francesca Shea, SCL letter to Bishop Joseph M. Gilmore, February 27, 1942, Correspondence File, Mothers General, SCLA.

32. *Polk Butte City Directory* ad, 1902, 104. Also *Butte Daily Miner*, January 5, 1905, 5. Also "St. James Community Hospital Centennial Booklet," ca. 1981, 4. Also *Westmont Word*, November 4, 1981, 12.

33. Sister Mary Serena Sheehy, SCL personnel file, SCLA.

34. Linda Lee Holmes interview with author, Butte, Montana, April 23, 2004.

35. Ibid. Frances Metesh interview with author, Butte, Montana, November 17, 1999. Judy Mohan interview with author, Butte, Montana, April 23, 2004.

36. Frank C. Walsh letter to Sister Mary Celestine O'Shea, SCL, December 4, 1943, *Scrapbook 1906-1958*, SJHA.

Butte's Cadet Nurses:
Commitment to Country, Community, and Caregiving

Ellen Crain and Andrea McCormick

INTRODUCTION

America's involvement in World War II would shape the role of women in society for the next half a century. While eager young men marched off to war and shed their blood on foreign shores, women assumed new roles on the home front. America's shipyards, factories, law offices, and hospitals were being staffed by women, young and old, experienced and not. Women's organizations and clubs across the country ran war bond campaigns, rolled bandages, poured coffee, and made care packages for soldiers. In 1942, President Roosevelt called for the nation's support of the war effort:

> On the road ahead there lies hard work . . . grueling work . . . day and night, every hour and every minute. I was about to add that ahead there lies sacrifice for all of us. But it is incorrect to use that word. The United States does not consider it a sacrifice to do what one can, to give one's best for our nation, when the nation is fighting for existence and its future life.[1]

In response, women across the country gave their best without complaint. Women stayed behind and gave up butter, sugar, meat, and nylon stockings. They bought war bonds and stamps and carefully managed their ration books as part of their everyday efforts. Many came forward to offer their time and talents, juggling the demands of family time and factory time. And, at this crucial moment, the largest group of uniformed women ever to serve this country stepped forward to do battle at home and abroad: The Cadet Nurse Corps.

Drawing from archival records, published accounts, and interviews with former Butte Cadets, this chapter provides a brief overview of nursing history in Butte and explores the formation of the Cadet Nurse Corps, the creation of the Central School of Nursing in Butte, its role in Cadet training, and the impact of the Cadet Corps on the participants' lives.[2]

In no other profession in the country was the shortage of workers more critical than the medical profession. As doctors joined the armed forces and left for the war front, nurses were called into service on the domestic front. Nurses were being asked to

provide a range of services previously in the hands of doctors: delivering babies, providing full-scale medical treatment, and administering hospitals. In 1941 the Nursing Council on National Defense determined the number of nurses in America to be insufficient to meet the country's demands. The bombing of Pearl Harbor brought the nursing shortage to a crisis.

The Red Cross led the first efforts to train thousands of volunteers to take over some of the duties of nurses in hospitals. In addition, plans were enacted to recruit more young women into nursing schools.[3] The Federal Government took the initiative to meet the ever-increasing demands for nurses with the passage of the Bolton Act, which authorized the establishment of the U.S. Cadet Nurse Corps. Between July 1943 and October 1945 nearly 180,000 women took part in the U.S. Cadet Nurse Corps and helped address the worst nursing shortage in America's history. Thousands of cadet nurses were trained in Montana, many of them at Butte's St. James School of Nursing, a keystone of Montana's cadet program, as well as at Carroll College in Helena, Montana, and in hospitals in Helena and Billings. For most, what began as a patriotic and practical choice ended up as a lasting commitment.

In the winter of 2004, the authors met with six engaging women who had come together in Butte to recall those distant days when they accepted the government's offer for "a lifetime education free." The years melted away as the six women, all members of the first class of cadet nurses trained in Butte, shared their stories. Jean Waldbillig, Alice O'Leary, Mary McClafferty, Jean Haviland, Helen LaMoure, and Mary Munger were already senior nursing students at the old St. James Hospital on Idaho Street when they became part of the first cadet class in 1943. Munger, McClafferty, and LaMoure graduated from high school in Butte and registered in the school of nursing at St. James because it was affordable and available, and also because it was glamorous. Cadet nursing offered travel, adventure, independence, and a very stylish uniform. In addition to the glamour, the uniform garnered young women a level of professional respect.[4]

Waldbillig, O'Leary, and Haviland all traveled to Butte from rural Montana to attend nursing school. It was one of the few careers open to young women that enabled them to earn a living and establish themselves as professionals. All of these women had been influenced by their mothers, themselves strong, capable women. In contrast to images of mid-century family life where husbands were breadwinners and wives managed the home, these women had lived a different reality. Jean Haviland remembers her mother as her role model who graduated from college in Dillon and taught school before she married. When she became widowed, she raised her family alone while working a ranch. Such dedication and determination spurred Haviland's decision to

St. James School of Nursing, graduating class of 1943.

leave Helmville, Montana and pursue a career in nursing, which offered a more exciting alternative to teaching or secretarial work. All of the six cadets interviewed spoke with pride of their important work and their identity as nurses. In the words of Helen LaMoure, "We are damn good nurses."

NURSING IN BUTTE: A BRIEF HISTORY

There were only five trained nurses in Montana Territory until the Sisters of Charity arrived in 1870. As Sister Dolores Brinkel writes in Chapter Nine, the Sisters of Charity were pioneers in the nursing field in Montana; they built hospitals and established schools of nursing in most Montana urban centers. By 1881, the Sisters of Charity had built St. James Hospital, and by 1906, they were training nurses. In 1919, the Montana State Board of Examiners accredited the St. James School of Nursing. The initial accreditation required that entering students have at least one year of high school. A strong curriculum was developed in the ensuing years.

At the time of World War I there were fifteen hospitals in Montana offering nurses training programs to 265 students.[5] By 1919, Butte had six hospitals, two of which were training facilities—the Murray Hospital and St. James Hospital. In addition to the hospital and nursing schools, there were seventy-five private duty nurses and sixty-two physicians listed in the Butte City Directory that year.[6] All of these medical professionals were kept busy tending to the sick and injured in Butte, particularly miners. Given the dangerous nature of working conditions in underground mining in 1919—one man per week died in a mining accident, and one man per day died of tuberculosis—the medical facilities were always full. Well-trained, skilled professionals were in constant demand.

The role of the nurse in the hospital in 1919 was to provide basic care and treatment to the sick and injured by following doctors' orders. A typical nurse's day included feeding and bathing patients, changing linens and dressings, administering medications and treatments prescribed by doctors, and exercising patients. As medical research advanced and new technologies and medicines became available, the nursing role grew more demanding as well, including increased responsibilities for treatment and record keeping. Early private duty nurses in hospitals were responsible for carrying their own syringes, thermometers, and narcotics until the passage of the Harrison Narcotic Act in 1917, which controlled the distribution of opiates and prohibited nurses from carrying narcotics.

Although advances in medicine required a higher level of education for nurses, their

pay did not reflect this growing professionalism. By 1929, nurses in Butte were earning thirty to thirty-five dollars per month plus board and room in quarters adjacent to the hospital. A nurse was responsible for the whole patient, and she often was required to stay with a patient through a medical crisis, twenty-four hours a day if necessary.

The introduction of antibiotics such as sulfa in 1938 and penicillin in 1945 improved the treatment of disease. With advances in treatment, nurses were required to gain greater skill and understanding of chemistry and anatomy in order to keep up with the demands of the work. Mary McClafferty recalls how these advances shaped her nursing experience. In 1943, she helped care for the first patient in Butte to receive penicillin. Although this breakthrough medicine had come out during the war and was mainly used by the Armed Forces, a seventeen-year-old Butte boy suffering from inflammation of the heart lining had connections—his uncle was owner of Butte's wholesale drug company and was able to get penicillin after sulfa drugs failed to help. The medicine was flown in from Malmstrom Air Force Base in Great Falls, Montana, every afternoon at 4:00; it was then administered by a doctor in the first drip intravenous the nursing students had ever seen. McClafferty remembers the boy as "full of life, a cute seventeen-year-old, happy all the time." Probably aided by the penicillin, the boy lived several years before succumbing to heart disease.

WORLD WAR II

December 7, 1941, the bombing of Pearl Harbor, was a day that would live in infamy and a day that would call the young men and women of America into the theaters of World War II. In early 1942, the United States Public Health Service (PHS) called for nurses to provide care to the allied troops. Nearly 20 percent of the U.S. nursing workforce was called to the front lines. This exodus of qualified nurses to the front created a shortfall of trained nurses in civilian arenas, resulting in the closure of clinics and compromised care in small rural hospitals. The ripple effects were widespread. Many immunizations were cancelled, babies were delivered without medical help, and some hospitals were forced to close wards.[7]

In response to this crisis, the Federal Government established the Cadet Nurse Corps within the PHS in 1943. Funds were provided to create the Cadet Nurse Corps through the Labor-Security Agency Appropriation Act of 1942. This act became commonly referred to as the Nurse Training Act or the Bolton Act. The Bolton Act was named for Frances P. Bolton, a congresswoman from Ohio and great friend of nurses. The act appropriated funds to support nursing schools through the PHS and established a

Division of Nurse Education to assist nursing schools to improve their facilities and curriculum and to enrich postgraduate nursing education.[8] In exchange for a government-funded education, cadets were expected to provide military or civilian nursing services for the duration of the war. As Thelma Robinson and Paulie Perry describe in *Cadet Nurse Stories: The Call for Response of Women during World War II*:

> The Cadet Nursing Corps is accomplishing important results in civilian nursing, not merely by providing badly needed nursing care but also by replacing and releasing graduate nurses (for the war). It is estimated that students in nursing school are giving 80% of nursing care in their affiliated hospitals. The recruitment program of the United States Cadet Nurse Corps has contributed immeasurably toward preventing a collapse of nursing care in civilian hospitals.[9]

Career choices for women of that era were limited. As Helen La Moure explained, "Women could be teachers, nuns, secretaries, or nurses." Though LaMoure had never taken care of a sick person in her life, she found nursing to be the most appealing of those limited choices. "It was handy and affordable," she recalls. LaMoure's colleagues agreed that the Cadet Nurse Corps, which ran from 1943 to 1948, was one of the best opportunities the war opened up for women. Because large numbers of nurses were leaving civilian hospitals to serve in the military overseas, replacements were desperately needed. The Corps paid tuition and fees, a thirty-dollar monthly stipend, and some room and board expenses. A national campaign touted the importance—and glamour—of the job. And glamorous it was, with *Harper's Bazaar* and *Vogue* designing the uniforms and with the nurses featured in every military parade in the country. To enter the Cadet Nurse Corps was to enter the most prestigious organization of women in America. It appealed to the dreams of young women looking for a career, independence, and commitment to wartime efforts.

The Bolton Act set nationwide criteria for nursing schools for the first time in America's nursing history. For a school of nursing to qualify for the Cadet Nurse program, it had to be accredited and affiliated with a hospital approved by the American College of Surgeons, and it had to have adequate staff and facilities. However, Congress had mandated that all schools, regardless of size, were eligible for aid through the Cadet Nurse program. This meant that schools with substandard conditions were eligible for technical and financial support and field consultation to meet national requirements.[10]

With the passage of the Bolton Act, appropriation of over sixty-five million dollars in scholarships, and a mandate to raise standards at the local level, Sister John Marie

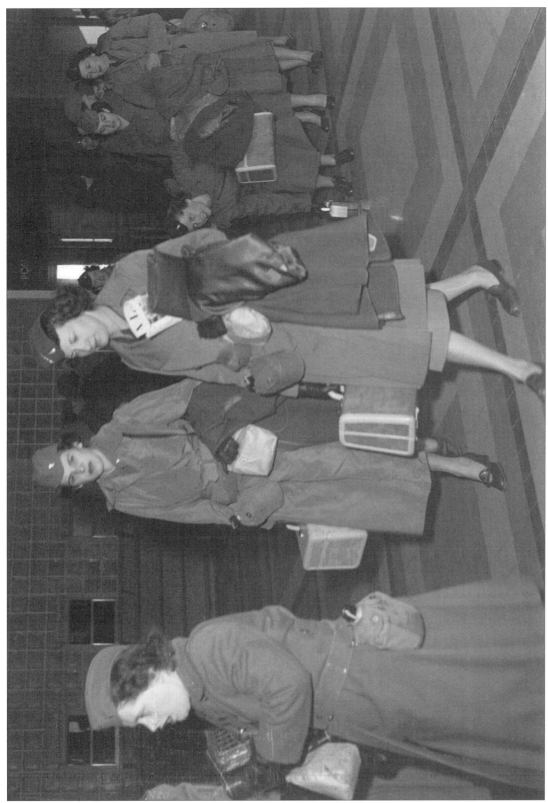

Butte cadets called to duty.

Pithoud, Director of the School of Nursing at St. James Hospital in Butte, immediately seized the opportunity to strengthen the school's curriculum. She worked in partnership with St. John's Hospital in Helena and St. Vincent's Hospital in Billings to combine the three nursing programs into a single entity—the Central School of Nursing—with its curriculum coordinated through Carroll College in Helena. According to Sister John Marie, the combined program ensured "broader educational resources for the preparation of fully qualified professional nurses."[11]

The students began their training in Helena, living at St. John's Hospital and attending classes at Carroll College. Credits earned through Carroll College could be applied toward a degree in nursing. In turn, the three participating hospitals provided clinical training, and Warm Springs State Hospital offered a psychiatric clinical rotation.[12] This combined curriculum met all of the requirements demanded of nursing schools under the Bolton Act. The Central School of Nursing offered scholarships and a living stipend to students in need, thereby taking full advantage of the appropriations made under the federal act.

The women of Butte's first graduating class remember their training with fondness and pride. They developed an intense and lasting camaraderie. They were held to strict rules that taught discipline and order—including lights out at 10 p.m., a two-hour nightly study period, a dress code that required hair to be pulled back neatly and prohibited nail polish, and a one-dollar penalty for having to re-take a test. Sister John Marie, a formidable presence as the school's director, was also a beloved mentor to them all. "She was interested in each of us as an individual," Mary McClafferty recalled.

In addition to establishing criteria for schools, the Bolton Act also established criteria for students. All women, regardless of color, qualified for the Cadet Nurse Corps if they were between the ages of seventeen and thirty-five, had graduated from an accredited high school, had earned good grades, and were in good health.[13] The Central School of Nursing held students to an even higher standard. According to a 1943 article in the *Montana Standard,* student nurses at the Central School of Nursing had to be eighteen years of age or within four months of that age, graduates from an accredited high school in the upper two-thirds of their class, of sound moral character, and fully physically qualified.[14] While the national program called for a thirty-month training program, the Central School of Nursing required thirty-six months of training. The *Montana Standard* praised this opportunity for young women:

> The Bolton Act passed and offered the young nurses at St. James an opportunity to earn a stipend and contribute to their community and their

nation in a way no other class had been offered the opportunity. The members of the class had entered the profession of nursing as civilians and would graduate as military personnel.[15]

Alice O'Leary recalled that she entered Central School of Nursing with over fifty other young women. She and her classmates rose early, by 6:00 a.m., and some attended morning mass. They reported to the floors of the hospital by 7:00 a.m. to deliver the breakfast trays. Classes started at 8:00 a.m. Lunch was spent first delivering trays then eating before returning to class. The dinner hour provided the students with their precious free time for the day. Then came 7:30 to 9:30 p.m. as study time, and lights out at 10:00 p.m. The girls had an extended curfew on the weekends until 11:00 p.m. O'Leary recalls, "There was limited time for fun and frolic. It was a treat to head over to town for an ice cream after study hour." Upon returning to their rooms from a weekend outing, they would have to enter the nurses' dormitory through the hospital, where Sister Ann checked them in. The young women could only have visitors in the parlor of the dormitory. The nurses' dormitory currently is a medical clinic, and when O'Leary goes there, she wonders how they fit two young women and their belongings into the tiny dorm rooms.[16]

By March of 1943, Mary Cherry, Nurse Recruiting Chairman of Montana, had been called upon to provide twenty-four nurses a month for army duty.[17] The majority of the nurses came through the retraining efforts of the Central School of Nursing. A companion program of the Cadet Nurse Program was the nurse-retraining program encouraged by the National Red Cross. The retraining program and the call for Home Nurses were as strong as the call for soldiers. Advertisements read: "Uncle Sam Needs You"—"Nurses and young women, brush up on your nursing skills and learn how to take care of your family, take a course to be a nurse's aide." A ten-week course was offered covering indications of illness, equipment and care of the sickroom, baths and bed making, sickroom appliances and procedures, medicines and other remedies, care of patients with communicable diseases, emergencies, and keeping a healthful home.[18]

It was the intent of the Red Cross to ensure that one person in each home could address basic health care. The organization encouraged women "with time on their hands" to volunteer at local hospitals to provide much needed relief for the on-duty nurses. Nurses who were not actively working were encouraged, and drafted in many cases, to return to their profession. They were offered refresher courses in new techniques and put to work in hospitals to fill the gap of those nurses who had gone to the front and especially to fill the medical needs in rural areas. Many retired nurses returned to duty as trainers through the Red Cross and teachers in the Central School of Nursing.

In addition to training nearly 180,000 nurses, the Corps led to significant improvements in nursing education. The Corps fostered a more academic approach to nursing rather than apprenticeship-type training. Expansion of course offerings and increases in faculty size in nursing programs can be attributed to the influence of the Corps. Circumstances created by the war helped to introduce nurse instructors as lecturers on health and disease, subjects that had previously been taught by physicians. The Corps also prompted widespread attention and federal aid to postgraduate studies for nurses.[19]

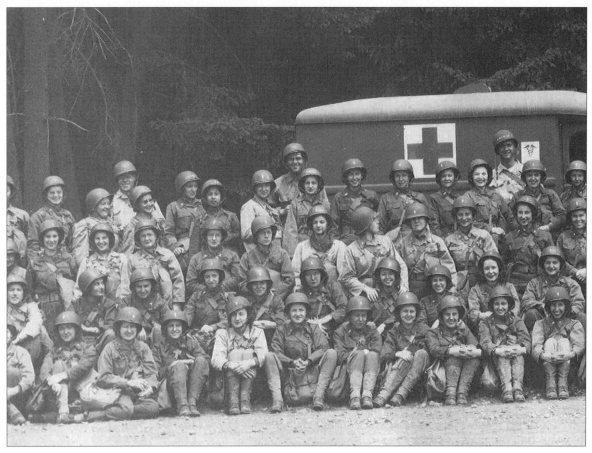

Cadet Nurses overseas, circa 1944.

SERVICE TO COUNTRY AT HOME AND ABROAD

By 1948, over 2000 Cadet Nurses had been trained in Montana. They provided critical care on both the war front and the home front. A 1951 Montana survey of 316 Cadet Nurses showed that thirty percent were single and seventy percent were married. Sixty-five percent of the married cadets and 85 percent of the single cadets were working. It appears that most of the Cadet Nurses took advantage of that 'Lifetime of Education

Free,' and they continued to work at some level in the medical field.

Each of the six cadets interviewed went on to serve their country and their communities. Alice O'Leary initially spent twelve months in the old St. Joseph Hospital in Deer Lodge when that town had no nurses. She worked alongside an elderly little nun who provided one of her most humorous memories: "Every night she'd go into her small locked closet and take out a bottle of booze. She'd give all the old fellows on the floor a good shot. I guess it helped settle them down."[20]

O'Leary later served as an Army nurse at Fort Lewis, Washington, for three years. After the war, she worked as an obstetrics nurse in Missoula until the inactive reserves were called back because of the Korean War in 1951. She spent the next two years providing care from Camp Roberts, California, and Fort Dix, New Jersey, to military bases in France and Germany. O'Leary recalls seeing signs that said "Americans Go Home" in France, but said the Americans received a warm reception in Germany, where she worked in an old barn that had been converted into a hospital. When her cadet obligations ended, O'Leary returned to Butte where her life included work at St. James Hospital, marriage, two sons, and ten years as county home-health nurse before retirement.

Helen LaMoure was a Navy nurse who, after a stint in Butte's old Murray Hospital, was stationed at the U.S. Naval Hospital in Oakland, California. After marriage and a move to Helena, she did private duty nursing and worked with veterans at Fort Harrison for thirty years. As LaMoure sums up her career, "I loved nursing from the minute I went into it. And, I was a damned good nurse."

Mary Munger and Mary McClafferty, spurred by lessons learned in the Cadet Nurse Program, left Butte to continue their education at the University of Minnesota, a premier training ground for public health nursing. Despite tight quarters that included three cadets sleeping in two single beds tied together, the experience made for fond memories. "We wore our cadet uniforms to the bus station and were treated royally, given front row seats and no fare was charged for the trip to Minnesota," the two recall. Munger eventually earned a master's degree and went on to serve as school nurse, county nurse, leader of the Montana Nurses Association, nursing teacher at Carroll College, and respected historian of Montana nursing.

McClafferty, too, devoted her life to her beloved career, first as a public health nurse in Bozeman, then as an instructor at St. James and St. Vincent's Hospitals and Carroll College, and later as director of nursing at hospitals in California and Washington. "I worked almost fifty years. When I retired at seventy-two, I came back to Butte."

Cadet Nurse Alice O'Leary (front row, first on left) and friends.

134

McClafferty's nursing fostered many memories, one of the most vivid from her training years. One morning in April 1942, a cage at the St. Lawrence mine carrying three decks of miners broke loose and fell into the shaft. McClafferty was among the young students who came to the aid of the scores of miners rushed to the hospital. The incident injured twenty-one men and killed one. According to the Coroners Inquest, "Dr. Garvey established a triage area to determine which miners were the most seriously injured. Mr. John Mehalko was clearly the worst; he had lacerations about the neck and head, and his right side was severely crushed. His right arm was pulled from the socket, and all his ribs were crushed. Efforts to save Mr. Mehalko were fruitless, and he died three day's later of pneumonia."[21]

Jean Haviland's cadet career began in Deer Lodge at St. Joseph's Hospital with O'Leary. She then went on to serve in the Army at Fort Lewis, Washington, and Camp Roberts and Fort Ord, both in California. Haviland recalls that most of her patients were young men being inducted into the Army. Her constant companion through those years was Butte nurse Mary Farren, who had joined the Army on her own. "We left on the train together and came back together" and shared all the same assignments in between. After the war, Haviland served as a nurse in Butte, New York, and Missoula. When she married and had five sons in five years, she put her nursing career to good use in her Deer Lodge home.

Jean Waldbillig put her skills to use at the Navy hospital in Oakland, and then in the public health department in Boise, Idaho. She later combined marriage with part-time work as a relief nurse in Philipsburg, Montana. Her passion became preventative medicine. "That's the part of our education that stuck with me." In later years, with the help of her husband, a county commissioner, she supported home health and well-child care programs and the Women Infants and Children (WIC) program for low-income mothers and children.

Although the Cadet program lasted only five years, Munger credits it with paving the way for today's well-educated, multi-skilled nurses. The Corps brought a more academic approach to training, encouraged postgraduate studies, and fostered training in fields such as public health, pediatrics, psychiatric nursing, and convalescent care. "It gave lots of attention to what nurses could do . . . nurses today are prepared to take on many more responsibilities than we were allowed."

All six women agreed that the work of nurses has never been adequately recognized either professionally or financially. They expressed concern about today's shortage of nurses that is as severe or worse than during World War II. Munger nodded, "Nurses

are the most important part of the health care system. They are the key to the day-to-day delivery of health care everywhere."

None of the women expressed anything but satisfaction with the career choice made long ago. "I wouldn't have had it any other way," said Waldbillig, despite days when she worked all night at the hospital and drove a tractor all morning on her ranch. The only drawback was that when family and friends took ill, "sometimes I wished I didn't know so much." Echoing her friends, Munger added, "I felt I was really helping people. It has been wonderful to be a part of such a large group doing so much good for so many."

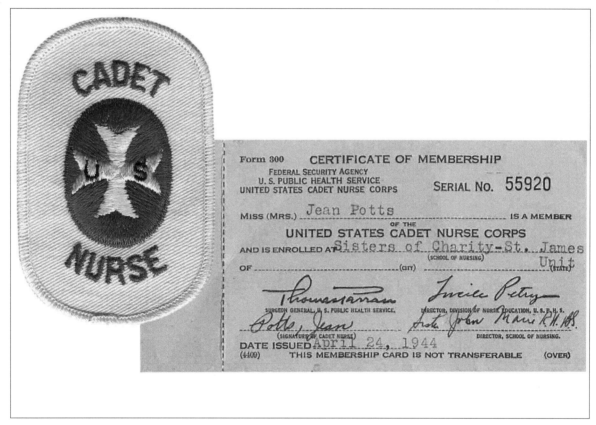

Cadet Nurse artifacts.

From 1942 until 1949 the St. James School of Nursing averaged a class of twenty to twenty-five young women graduating into the Cadet Nurse Corps. The School contributed over 140 nurses to the Corps. These highly trained women served their communities, their state, and their country during World War II. Many of these nurses were also called upon to serve their country during the Korean Conflict. These

adventuresome and dedicated young women, who began with visions of a glamorous career, have helped transform health care in Butte, in Montana, and in the nation.

NOTES

1. Thelma Robinson and Paulie Perry, *Cadet Nurse Stories: The Call for Response of Women During World War II* (Indianapolis: Center Nursing Publishing, 2001), 2.

2. "Central School of Nursing will be opened in Montana on January 30," *Montana Standard,* January 18, 1943, 1 (Hereafter "Central School of Nursing").

3. Robinson and Perry, *Cadet Nurse Stories*, 4.

4. Jean Waldbillig, Alice O'Leary, Mary McClafferty, Jean Haviland, Helen LaMoure, and Mary Munger, personal interview with authors, January 16, 2004.

5. Montana Nurses Association Committee on History of Nursing, *Nursing in Montana* (Great Falls, MT, 1961), 54.

6. *Butte City Directory 1919* (Helena, MT: R. L. Polk and Co., 1919).

7. Mark Soroka, "The Nation Responded: 1943-1948: Cadet Corps Created When 20 Percent of Nursing Workforce Called to Frontlines," University of Pittsburgh, http://www.discover.pitt.edu/media/pcc010924/nurses. Accessed March 3, 2004.

8. Public Health Service Resource, "The Cadet Nurse Corps: 1943-1948," http://lhncbc.nlm.nih.gov/apdb/phsHistory/resources/pdf/cadetnurse.pdf. Accessed November 18, 2003 (hereafter Public Health Service Resource, "The Cadet Nurse Corps: 1943-1948.

9. Robinson and Perry, *Cadet Nurse Stories,* 994.

10. Public Health Service Resource, "The Cadet Nurse Corps: 1943-1948."

11. "Central School of Nursing, 1.

12. Ibid.

13. Office of Program Coordination, Office of War Information, *Information Program for the United States Cadet Nurse Corps* (Washington, DC: U.S. Public Health Service, Federal Security Agency, Sept. 1943).

14. "Central School of Nursing, 1.

15. Ibid.

16. Alice O'Leary, Personal Interview with authors, January, 16, 2004 (hereafter Alice O'Leary interview).

17. "Student Nurses Start Training," *Butte Daily Post*, February 2, 1943.

18. Ibid

19. Public Health Service Resource. "The Cadet Nurse Corps: 1943-1948."

20. Alice O'Leary interview.

21. Clerk of the Court, Butte-Silver Bow, Miscellaneous File #115466.

War Production Board propaganda.

Rose Monahan: Nursing as a Way of Life

Andrea McCormick

Nurses have long tended Butte's sick—be they ailing miners, birthing mothers, or needy children. County nurse Helen Curtis made house calls on foot all over town, sturdy shoes on her feet, little black bag at her side. Home health nurse Dorothy Walsh joined the fledgling Head Start program in the early 1970s and remained on duty until shortly before she died some twenty-five years later. Sister John Marie was an exceptional nurse who became a Catholic convert and nun. As head of the St. James School of Nursing, she brought inspiration and knowledge to scores of students who still cherish her memory.

For some women, nursing took a more personal turn. They helped mold the future by staying close to home. Nursing was both a family tradition and a practical choice for Whitehall teenager Rose Carey when she graduated from high school in 1940. One of five sisters who became nurses, Rose recalls, "It wasn't, 'You're going to college.' It was, 'You're going into training.' "[1]

Rose received her education at St. James Hospital in Butte and expected that she was starting a lifelong career. She did, but not exactly the way she envisioned. Shortly after graduation in 1943, Rose's professional life took its first turnabout when she married a young Navy man from Butte named Edward Monahan. They said their vows at 5 a.m. in St. Joseph Cathedral in San Diego. Edward had to be on his ship at 7 a.m. He came back the next morning, but soon had to leave again. They juggled their lives around

138

Edward's assignments. Rose went to work in Vallejo General Hospital in the surgical and maternity wards, waiting for the time she could start a family. Rose and Edward would not have long to wait. Their first child, a girl, was born in 1944. They welcomed nine more children over the years.

Family became the focus of Rose's life and career. "I was so glad I had my nursing. It saved a lot of doctor calls!" If she wasn't tending one of her six girls and four boys, she was caring for relatives near and far. "I always went to help when one of the relatives was really sick. And I have a lot of relatives!"

Rose returned to professional nursing for several years after her beloved husband passed away in 1965. Then, once again, the mother-nurse was needed at home. About ten years after serving in Vietnam, her son Eddy fell victim to the effects of Agent Orange. With his mother at his side, he fought diabetes, recurring comas, and numerous surgeries. He lost his battle and died at home at age forty-two.

Rose's duty roster grew. A daughter developed scleroderma. A son had both his hips replaced and dealt with bowel cancer. Another daughter had radical orthopedic surgery on her leg. In 2000, daughter Francie, who already had battled a brain tumor, had a near-fatal bout with emphysema and bronchitis. Rose moved to Denver for two years to serve as devoted nursemaid. In 2003, a revolutionary lung transplant gave Francie a new chance at life. The road since the surgery has been long. Rose hasn't missed a step.

In reflecting on her nurses training, Rose recalled the camraderie with fellow students who were like sisters. She holds fond memories of Sister John Marie, who had saved Rose's brother from choking when he was a child and who later became her mentor at St. James. "She made you toe the line—shoes polished, uniforms a certain length. She was a wonderful woman, an inspiration." As for Rose—once a nurse, always a nurse. "It gets in your blood. I often wish I'd stayed in and done more." By her family's standards however, she's done more than enough.

NOTES

1. Profile based on author interview with Rose Monahan, January 26, 2004.

PART FOUR
WOMEN OF THE CLUB

The Pearl Club: Black Women and Community Building in the Mining City

Loralee Davenport

INTRODUCTION

Butte, Montana has been referred to as a "melting pot" for the many ethnic groups that lived within the city. Behind this melting pot image, discrimination was also at work with each wave of new arrivals serving as the target of distrust and, at times, hostility from those more established. Butte's African Americans endured discrimination not due to their ethnicity or their national origin but based on their color. For many years, black men were not allowed to work in the mines. Blacks were also barred from participation in white-dominated civic and social organizations, such as the YMCA, until the 1960s when the civil rights movement brought change across the country. In spite of this denial of full citizenship, Butte's black residents left a legacy of community involvement. This chapter highlights the civic contributions of Butte's black women to a community that did not fully accept them. It tells the story of the Pearl Club, its place in the life of black women in Butte, and its significance in inspiring their dual commitment to racial uplift and social responsibility.[1] Founded during World War I to support the war effort, the club was later instrumental in uniting black women's clubs throughout Montana. Members fought for the advancement of all black women in Montana and the nation, and they carried the struggle for equality and opportunity through the twentieth century.[2]

COMING TO THE MINING CITY

According to Stephen Ambrose, the first recorded African American to arrive in Montana was William Clark's slave, York, with the Lewis and Clark expedition in 1805. York repeatedly petitioned Clark to be freed after his service on the expedition, but he was not successful until years later.[3] The fur trappers and prospectors that followed included small numbers of blacks. These men joined the migration to the West and Montana, not only searching for opportunities, but also looking to escape discrimination and racism. African Americans arrived in Butte as early as the 1890s with the main influx occurring in the early 1900s. Their representation was similar to that of other Western mining communities, making up only about one percent of Butte's total

population. Between 1900 and 1940 the black population in the Mining City averaged about 1000.[4]

During the early part of the twentieth century, Butte was a thriving metropolis that drew diverse entrepreneurs. Black-owned newspapers and their editors offered encouragement for blacks to come to Butte. For example, J. B. Bass of Helena was the managing editor of the *Montana Plaindealer* and John Duncan of Butte served as editor of the *New Age* in the early 1900s. The papers spoke to their readership about a sense of opportunity that Montana in general and Butte in particular offered. African Americans who had come to Butte were successful in finding work, but the employment they found was often limited to service work, similar to the occupations they had left behind.[5] Better paying jobs, such as those in the mines, were not open to them. The Anaconda Copper Mining Company (ACM) did not hire blacks to work in the underground mines, claiming that the company feared for the men's safety. Likewise, the unions resisted inclusion of blacks among the ranks of miners. As Perdita Duncan, an African American woman born and raised in Butte, recalls, "Whether the black men were allowed to or not, they didn't work in the mines. Some worked at the ACM Club as waiters, ran the club, worked as valets to wealthy men, and some worked as janitors or at uptown businesses."[6] The Jim Crow laws that formalized discrimination in the South never came to life in the Mining City. However, black residents of the 1920s and 1930s recall indirect racism that shaped their everyday lives and life chances. For example, when black children played at the Columbia Gardens they would hear racial slurs such as, "Look, here comes a dark cloud full of rain," as they swung on the swings and rode the merry-go-round.[7] Parents prepared their children for the realities of racism and attempted to instill a strong sense of pride and identity. As Perdita Duncan remembers, "I learned very early that I was a colored girl growing up in a white community and that my name was Perdita Duncan. After that, nobody could crush me." Perdita describes the racism in Butte as "subtly done. You were just kept out of certain places, and by the time I was coming along, there were still certain places I couldn't go, and I just never bothered."[8]

The majority of black women in Butte were homemakers and helpmates to their spouses while also maintaining employment outside the home. They were not afforded the luxury of staying at home and raising a family. Black couples became partners in the labor of economic survival, family and community life, and the struggle for African American advancement. The majority of men and women were employed in laboring or servant positions, with only a small number working in professional positions, such as doctors or teachers.[9]

Unlike many of Butte's distinct ethnic groups, African Americans did not live together in a particular part of town. They were scattered throughout the city in apartments or in their own homes. And unlike Butte's Chinese community, who were also targets of discrimination and exclusion, the black community of Butte was allowed to purchase burial plots in any location in any cemetery. The Chinese, on the other hand, were buried only in a special section of Butte's Mount Moriah Cemetery. The cost of a cemetery plot in Butte differed very little from one cemetery to another, yet the majority of African Americans are also buried at Mount Moriah. The decision by Butte cemetery owners, intentional or unintentional, not to segregate African American burial plots allowed blacks to have a choice equal to the white community. Thus the freedom of "place," to live where one chose or to be buried where one chose, signaled possibility and encouraged black residents to believe that there was room for more advancement.[10]

BLACK CHURCHES AND COMMUNITY BUILDING IN BUTTE

As Butte's black community began to be established, churches soon became centers of social as well as religious life. For many black residents, Christian faith was a significant force in their lives, and churches were sources of hope, education, and organization. The black churches in Butte served many functions. First and foremost they helped to build and support their congregation's Christian faith. In addition, they served as community centers for social meetings, agencies for social support, and schools, teaching the importance of unity and social uplift for African American advancement. Black churches were spaces where African Americans could come together to build community. They provided a buffer against racism. They also afforded African Americans opportunities for leadership development, decision-making, and business management, which were rarely available outside of the church. Butte's black churches helped to found literary and civic improvement societies. For example, Butte's African Methodist Episcopal (AME) Church established a literary society whose goal was to "advance the intellectual environment of the black community." Churches also sponsored debates and hosted musical programs, thus providing rich opportunities for cultural development.[11]

The Schaffer Chapel, still standing at the corner of Platinum and Idaho Streets, was the meeting place for Butte's AME Church. It was used for more than worship, serving also as the site of inspirational gatherings that linked Butte's black community to a larger African American movement for racial uplift and equality. For example, in March 1913 the congregation hosted Booker T. Washington, founder of the Tuskegee Institute. During this visit the "Chamber of Commerce extended the freedom of the city" to

Booker T. Washington. Washington and his staff stayed overnight at the Thornton Hotel, noted for hosting other national figures such as Theodore Roosevelt. Yet, at the same time, black residents of Butte were barred from some of the city's prominent hotels, such as the Finlen.[12] Speaking before a packed house, Washington encouraged "colored men and women to work for themselves and the ultimate salvation of the race." His speech was covered in the *Butte Miner* on March 7, 1913, which highlighted his call for racial uplift and noted that the audience was equally divided between "white and black races." Using churches as meeting centers for both black and white community members to discuss racial issues was not unique to Butte; it was a nationwide movement. In many areas of the nation, written and unwritten segregation laws prevented blacks and whites from meeting together. Churches provided important meeting places for many progressive movements as well as for organizations such as the Pearl Club.[13]

WOMEN'S ACTION AND THE FOUNDING OF THE PEARL CLUB

Many African American women of Butte found a source of courage in their Christianity that helped them to establish other social organizations. The black churches of Butte, like those around the country, supported women's faith-based activism and encouraged members to build organizations with a goal of racial uplift and social responsibility. The first known black women's group in Butte was the Afro-American Women's Club formed in 1902. The club was organized by Armenta Jones, and the first president was Melvina Williams. The group blossomed under Williams' leadership. Williams herself attended the national convention of the National Association of Colored Women in Wilberforce, Ohio, in 1904. However, Williams' poor health took its toll and caused her to return to the south. Without her leadership the club disbanded around 1907.[14]

It is in this historic and cultural context that the Pearl Club is rooted. After the United States declared war on Germany in 1917, the Red Cross called for help with the war effort. The African American women of Butte responded by uniting into a working force. Twenty-three women organized the Pearl Unit in honor of Dr. Frank Pearl, a captain during the war. Pearl was a physician from Los Angeles and the son of Mrs. John F. Davis, a member of Butte's black community and also a member of the AME church. Davis and her husband had come to Butte some years earlier with the hopes of finding employment in the mines. Her husband was only able to find work as a porter. Nevertheless they made Butte their home and became active in both spiritual and social aspects of the black community.[15]

The work of the Pearl Unit "stood second to none in the city" under the direction of Mary B. Chappell, chairwoman of the unit. Coming to Butte about 1909, Chappell was

a graduate of the University of Atlanta in Georgia. Her husband, Arthur, was a waiter and bartender at the Silver Bow Club and later a porter at the Leggat Hotel. World War I provided Chappell the opportunity to apply her organizing skills, join with other black women in Butte, and promote mutual respect between the black and white communities. The group provided moral support to the families of both black and white servicemen through home visits. The Pearl Unit women worked some twelve months together, forming a closely bonded group.[16]

After the end of World War I, in February 1919, the Pearl Unit was ordered by the Red Cross to close their quarters and disband. The women were pleased to have the war effort concluded, but they did not want to see the end of their meetings and charitable work. On March 11, 1919, Mary Chappell celebrated her birthday with a party that included her former fellow Pearl Unit workers. During the festivities, Chappell proposed that they form a charitable service organization, supporting both black and white members of the Butte community. Her friends agreed, and Mary was elected first President of the newly formed Pearl Club. The Pearl Club met in Schaffer Chapel, and it exemplified the blending of Christian faith and racial uplift that characterized many African American women's organizations of the era. Members always opened their meetings with Christian music and devotionals. Keeping with the aims of the National Federation of Afro-American Women, these Christian activists sought to provide social services and opportunities rooted in Christianity in order to "lift people up as they climb through life." The fledgling Pearl Club saw itself as part of a broader black women's movement from the start. In 1920 Mary Chappell traveled to Tuskegee, Alabama to have the club recognized and placed on the roll of the National Association of Colored Women.[17]

Margaret Murray Washington was the founding president of the National Association of Colored Women. The Association merged many black women's clubs into a combined body throughout the United States during the early 1900s; it promoted social services and opportunities by and for black women. Washington, wife of Booker T. Washington, and the Association worked to abolish negative public images of black women.[18] Washington believed that there was a need for cooperative work among women toward the betterment of black women's lives. Mary Chappell agreed with Washington's values. After establishing the Pearl Club Chappell went on to be a leading force in the founding and development of the Montana Federation of Colored Women. In August of 1921, at Schaffer Chapel, the members of the Pearl Club organized the Montana Federation of Colored Women. Mary Chappell became the Federation's first president, setting goals that encouraged advancement through social and racial uplift. At this meeting in 1921, the women wrote a constitution and by-laws. The organization not only studied issues

that confronted black women, but supported legislation against discrimination and worked against segregation in local communities. Women of the Federation, most of whom held low paying jobs as maids and nannies, gave "substantial pledges" to the Scholarship Loan Fund. The Scholarship Loan Fund supported black college students in Montana through high school essay contests.[19]

Under Chappell's leadership, the state organization adopted the motto of "Unity and Perseverance." With the motto in mind, the Federation united the Clover Leaf Art Club of Butte, Pleasant Four and Mary B. Albert Clubs of Helena, the Phillis Wheatley Club of Billings, the Good Word Club of Anaconda, the Sweet Pea Study Club of Bozeman, the Mutual Improvement Club of Kalispell, the Dunbar Art and Study Club of Great Falls, and the Margaret Washington Club of Missoula. These clubs worked for a better understanding of black women in the workplace, recognition of African American achievements, and promotion of activities of the National Association for the Advancement of Colored People (NAACP).[20]

Chappell established the first junior club, creating organizational participation opportunities for young women and making them a part of the Montana Federation in 1926. By November 1929, twelve girls were organized and meeting at the Butte YMCA. The junior club was admitted to the state and national associations under the name of National Girl Reserves. Ironically, these young women held their meetings at Butte's YMCA at a time when blacks in Butte were still being denied membership. While they were not yet deemed "fit" for full membership, they had gotten a foot in the door. Miss Hazel Phelps was a leading member of the junior club. As a Butte High School student, Phelps was one of the Pearl Club typists. Her experience in the Girl Reserves helped Phelps develop her interest in becoming a criminal lawyer, which she pursued later in life. Other members of the Girl Reserves went on to become college graduates, real estate brokers, newspaper editors, and women who owned and managed businesses throughout the state. Members of the Montana Federation of Colored Women, such as Butte's Armeta Duncan and Janettia Brown, became inspirational role models to a new generation of women activists.[21]

A wide section of the black community participated as members and officers of the Pearl Club. For a few, the experience was the start of a lifetime of personal and professional achievement. After Mary Chappell, leadership of the club passed to Armeta Duncan, who had an elementary teaching degree and who was married to Butte's first black podiatrist, John Duncan. Duncan's daughter, Perdita, went on to assume leadership of the club. Perdita later left Butte to attend Oberlin College in Ohio, the first school to admit black women. After completing college Perdita worked as a YMCA

camp counselor for an all black camp in New York. Perdita remained in New York, and in 1935 she took a job as a social worker with the newly formed Emergency Relief Agency, which would later become the New York City Department of Social Services. She went on to take night classes at St. John's Law School and worked in the social service's legal department until her retirement in 1969. Perdita became active in Harlem social clubs, and in 1957 she became the music critic for the *New York Amsterdam News*. When she retired from her social services job, she continued in her permanent position as music critic until returning to Butte.[22]

Janettia Brown operated a boardinghouse for miners at Camp Caroline north of Homestake, located east of Butte. Janettia's father, Richard, worked at the Mountain Chief mine at Camp Caroline and went on to operate other mines in the area. Janettia's daughter, Lena Brown Slauson, first worked at the boardinghouse and later became a nanny for Jack Corette, past president of the Montana Power Company. Gurley Fenter worked as a custodian at local banks and was one of the first black members of the Women's Protective Union in Butte. Her daughter-in-law, Ophelia Fenter, became the first black teacher at Butte High School, where she taught home economics from 1969 until her retirement in 1983. Ophelia earned both a bachelor's and master's degrees in home economics at Montana State University. She was active in church work throughout her life. She was also active in the development of an NAACP chapter in Butte. These women got their start in organization and activism through the Pearl Club.[23]

The club carried on a variety of activities that were extensions of the black church into financial and political arenas. For example, Pearl Club members raised money for the Montana Federation of Colored Women through dues, raffles, and book sales. These women also purchased a $1000 interest-bearing bond representing ten shares of preferred Montana Power Company stock to support black education. A large part of the club's activities was directed toward the community at large. Their "Gift with a Lift" program, caring for the less fortunate in the community, supported many more whites than blacks. The club gave food to the Soroptimist Home for children in Butte, made clothes for young single mothers at the Florence Crittenden Home in Helena, gave jewelry to patients at the Montana State Mental Hospital at Warm Springs, and brought magazines to patients at the Memorial County Hospital in Butte. The Pearl Club contributed annually to the Veterans Hospital, the Red Cross, and the YMCA (despite its refusal to allow them membership). Members served as clerks at the polls on Election Day and studied civics and citizenship to be better informed citizens. In spite of the club's activities, social equality still came slowly.[24]

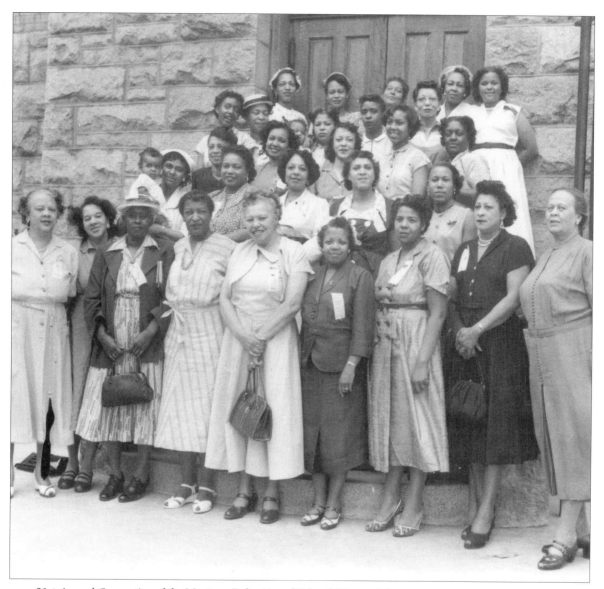

31st Annual Convention of the Montana Federation of Colored Women, July, 1952.

CONTINUING THE STRUGGLE

Ophelia Fenter recalled meeting the accomplished singer Marian Anderson in 1953 when the Pearl Club hosted her visit to Butte. In 1939 the Daughters of the American Revolution (DAR) had barred Anderson's performance at Constitution Hall in Washington, D.C. because she was African American. Eleanor Roosevelt resigned from the DAR over the incident and arranged for Anderson to sing at the Lincoln Memorial on Easter Sunday to demonstrate her support of the black community. The DAR was

not the only group to discriminate against Marian Anderson. When Anderson visited Butte in 1953, the management of the Finlen Hotel would not allow her to eat in the hotel restaurant, only to sleep there. Anderson sang to an audience of some two thousand at the Butte Civic Center. The *Montana Standard* reported that "Never in her career was Miss Anderson's voice better" than it was in Butte. After the concert she was "stormed" by her "admiring fans of all ages and persons from all walks of life seeking her autograph." Once again, the women of the Pearl Club witnessed the ironies of the Mining City wherein African Americans were at once excluded and embraced.[25]

Opehlia Fenter, 1973.

Pearl Club members also participated in other groups, such as the Butte chapter of the NAACP. In 1952 the NAACP was meeting on the third floor of the Bethel Baptist Church on Mercury Street. Pearl Club members Ophelia Fenter, Lena Brown Slauson, and Gurley Fenter helped to conduct a survey of restaurants, businesses, and public places in Butte and compile a report on discriminatory practices. The survey indicated that there were an "encouraging number of business people in Butte who do not discriminate." The committee established that the Arizona, Towey, and Tait Hotels welcomed blacks. The Acoma Lounge had open service. The manager of the Finlen Hotel made the "familiar excuse that he was forced to discriminate because of the demands of the patrons and seemed to feel quite injured that anyone would object to his policy." The manager of the YMCA, Sam Parker, turned down the committee's request to sign the NAACP petition. Parker asserted that his obligation was to the 'Y' contributors who demanded no black membership. The Chequamegon Cafe manager would serve blacks only with a "take out order." Green's Cafe and the Moxom both said they would serve only black men in uniform. Businesses signing the petition to serve blacks were: Morgan's Cafe, F.W. Woolworth, Grand-Silver, Burr's Department Store, Harrington's Ice Cream Store, the Creamery Cafe, and the S and L Ice Cream Store. The survey demonstrated that, in spite of the Pearl Club's example of service to fellow man, discrimination was still alive and well in Butte. While African Americans in Butte were able to choose where they lived and died, they still were not totally free to choose where they ate and socialized.[26] The Butte Afro-American Women's Club that met in 1902 would have been heartened that the black women of Butte had produced a new generation committed to both community building and activism. These women exemplified the Federation motto "Lifting as We Climb."[27]

THE LEGACY OF THE PEARL CLUB

The members of the Pearl Club of Butte left a lasting imprint that opened doors for the following generation. In 1902 the black newspaper of Butte, the *New Age*, editorialized that the Negro in the twentieth century had a "lack of confidence" in himself. The women of the Pearl Club must not have read the editorial, or took little note of it. There is little doubt that confidence in oneself drives positive people to actions that build unity. There is no question that the Pearl Club exemplified this. The women of the Pearl Club demonstrated and built confidence through their actions. They were faithful to their families, to their club, and to the goals of their state and federal associations. The Pearl Club women of Butte, while today largely forgotten, were an important part of the city's life. They leave a legacy that is at once sobering and inspirational.[28]

NOTES

1. See Rosetta Ross, *Witnessing and Testifying: Black Women and the Civil Rights Movement* (Minneapolis, MN: Fortress Press, 2003) for a historically grounded overview of black women's dual commitment to racial uplift and social responsibility.

2. Proceedings of the Montana State Federation of Negro Women's Clubs, Montana Federation of Colored Women Records 1921-1956, Montana Historical Society Library (Hereafter MHSL), Helena MT (hereafter Proceedings of the Montana State Federation of Negro Women's Clubs). Annual Report of the National Colored Women Association 1930-33, Thomas Finch, Second Edition Bookstore, Butte, MT. Private collection of books on the National Association of Colored Women, 1933 (Hereafter Finch Collection). Elmo Fortune, interview by Laurie Mercier, May 1, 1984, Oral History Collection, Butte Silver Bow Public Archives (Hereafter BSBPA) Butte, MT (Hereafter Elmo Fortune interview). Walter Duncan, interview by Laurie Mercier, May 1, 1984, Oral History Collection, BSBPA (Hereafter Walter Duncan interview).

3. Stephen E. Ambrose, *Undaunted Courage: Meriwether Lewis, Thomas Jefferson, and the Opening of the American West* (New York: Simon and Schuster, 1996), 80, 101-102.

4. Lucille W. Thompson, "Early Montana Negro Pioneers: Sung and Unsung." *Montana Business Quarterly* (Summer 1972): 39. *Butte City Directory* (Butte, MT: R.L. Polk, 1900-1930). Perdita Duncan, interview by Laurie Mercier, March 24, 1983, Oral History Collection, BSBPA (hereafter Perdita Duncan interview).

5. Jeffrey C. Stewart, *1001 Things Everyone Should Know About African American History* (New York: Doubleday, 1996), 127. *The New Age*, John Duncan, editor, Butte, MT, 1902. *Montana Plaindealer*, J. B. Bass, editor, Helena, MT 1907; Finch Collection.

6. Perdita Duncan interview. The ACM Club was a private club for company executives.

7. Ophelia Fenter, interview by Loralee Davenport August 5 and 9, 1999, Butte, MT (Hereafter Ophelia Fenter interview); Elmo Fortune interview; Walter Duncan interview. Neil Millen, *Dark Journey: Black Mississippians in the Age of Jim Crow* (New York: University of Illinois Press, 1990), 10-11. Columbia Gardens was Butte's crown jewel amusement park, with extensive gardens, located just east of the city.

8. Perdita Duncan Interview.

9. Ray Calkins, *Looking Back from the Hill: Recollections of Butte People* (Butte: Butte Historical Society, 1982), 2. Ophelia Fenter.

10. Carol Goode, interview by Loralee Davenport, Butte, MT, July 20, 1999. Coroner's Register, BSBPA, 1895-1935. Calkins, *Looking Back from the Hill* 2-4.

11. Benjamin Quarles, *The Negro in the Making of American.* (New York: MacMillan Publishing Company, 1987), 161-162.

12. Proceedings of the Montana State Federation of Negro Women's Clubs; Ophelia Fenter interview; Lena Brown Slauson, interview by Loralee Davenport, August 10, 1999 (Hereafter Lena Brown Slauson interview).

13. Ibid.

14. Finch collection.

15. Proceedings of the Montana State Federation of Negro Women's Clubs; Ophelia Fenter interview; Lena Slauson Brown interview; *Butte City Directory* (Butte, MT: R.L. Polk. 1912-1918.).

16. Ibid.

17. Mary Murphy, *Mining Cultures: Men, Women, and Leisure in Butte, 1914-41* (Chicago: University of Illinois Press,1997), 30. Proceedings of the Montana State Federation of Negro Women's Clubs.

18. John Hope Franklin and Alfred A. Moss, *From Slavery to Freedom, a History of Negro Americans* (New York: Alfred A. Knopf, 1988), 312. Lena Brown Slauson, interview.

19. Margaret Murray Washington (1865-1925), Alabama Women's Hall of Fame, http://www.awhf.org/washington.html. Finch collection; Ophelia Fenter interview; Lena Brown Slauson interview.

20. Finch collection; Proceedings of the Montana State Federation of Negro Women's Clubs.

21. Finch Collection.

22. Perdita Duncan interview; Lena Brown Slauson interview; William Fenter interview.

23. Lena Brown Slauson interview; Perdita Duncan interview; Ophelia Fenter interview.

24. Proceedings of the Montana State Federation of Negro Women's Clubs.

25. "Marion Anderson in Butte to Sing," *Montana Standard* March 7, 1953; "Afro-American-Women's Club," *New Age* May 30, 1902, 3; Ophelia Fenter interview.

26. Ophelia Fenter, personal collection, Butte, MT. NAACP materials 1950. Millie Marshall, interview by Loralee Davenport, Columbus, MO, September 25, 2000.

27. "The Race Problem," *New Age*, June 13, 1902, 4.

28. Ibid.

The Butte *Kolo:* The Circle of Serbian Sisters

Kerrie Ghenie

The women of Butte's Serbian Orthodox community were a remarkably active group. Despite prescription of traditional female roles through their cultural and religious traditions and the norms of the time, these strong, dedicated women challenged the status quo. With determination, religious devotion, and love of family, community, and culture, the women developed two thriving organizations: the Circle of Serbian Sisters and the Serbian Mothers Club.

The women capitalized on their individual and collective power, intelligence, and skills to benefit their church and families and the larger Butte community. In addition, they directed their energies in service to the national Serbian community, the World War II effort, and displaced persons after the war. In the process they provided each other with support, friendship, and opportunities for socialization. Their work with the Serbian women's organizations also gave them leadership experience. Many went on to use their leadership skills to benefit other groups within the Butte community and on a national level. Their inspirational story shows that a dedicated group of women, working together, can achieve almost anything.[1] This chapter tells the story of the Butte *Kolo*, drawing from published accounts, archival documents, and interviews with Sylvia Skuletich, Danica Duletich, Helen Orlich, Maryane Christie, and Rosalie Butorovich who graciously shared their history and experiences as members of Butte's Serbian community and women's organizations.

WHERE DID WE COME FROM?

To better understand the context in which Butte's Serbian women organized and worked, a brief history of the Serbian people and their cultural and religious traditions in the late nineteenth and early twentieth centuries will be explored. This exploration is by no means comprehensive. The history and culture of the Serbian people spans centuries and would take volumes to examine. This very abridged version is merely a sketch to help frame the formation of the Serbian women's organizations in Butte, Montana.

For centuries, the Serbian people of the Balkan Peninsula were under foreign rule and fought the Ottoman Turks and later Austria-Hungry for their independence. The Balkan Peninsula is made up of various cultural and religious groups that have long fought each other and foreign regimes to gain or maintain freedom and to maintain their

cultural, ethnic, and religious traditions. War and strife have been constant in this region for centuries.[2]

In the late nineteenth and early twentieth centuries, America was booming and offering immigrants a wide variety of opportunities. At the same time, life for many Serbians and others in the Balkan region was difficult. People struggled to support their families and were tired of the civil and political unrest that had shaped their lives. For some, the desire for economic security prompted their emigration to America. For others, freedom and the chance at life without conflict led them to the United States.

Many of the immigrants were young men. Some were single and worked to send money back home, others were married and worked to bring their wives and families to America, still others worked to save money and return home. Butte and other mining towns became destinations early in this Serbian immigration period due to the availability of work. Serbian immigrants could be found working in the mines, for the railroad, and homesteading the areas surrounding Butte.

With the establishment of the Serbian colony in Butte, additional Serbian immigrants found their way to the city. It is estimated that the Serbian population numbered at least two thousand by the 1930s. The majority settled in the area east of Arizona Street, west of Gaylord Street, and north of Mercury Street and extended into Dublin Gulch and Finn Town. The Serbian language was used in daily life, and many of the children of immigrants were taught Serbian along with English. Their neighborhood was home to several Serbian lodges and Serbian-owned stores, and there were at least three Serbian-language newspapers available.[3]

The Serbian immigrants became dedicated and proud United States citizens and set about building their lives as Americans. They learned the English language, obtained American citizenship, participated in local, state, and national organizations, and joined the Armed Services. In the process of doing so, however, they held true to their Serbian roots and maintained devotion to their Eastern Orthodox religion, both of which were an important part of their daily lives.[4]

To honor their Christian faith, Butte's Serbian community gave time, money, and great effort to establish in 1905 one of the first Serbian Eastern Orthodox churches in the United States.[5] The Holy Trinity Serbian Orthodox Church, located on South Idaho Street, continued the traditional practices of the Eastern Orthodox faith and the Serbian culture. The Eastern Orthodox Church maintained the Julian calendar rather than the Gregorian calendar and thus celebrated Christmas, New Years, Easter, and other holidays thirteen days later than most other Christian churches.[6] Church services were

conducted in the Serbian language, and in an effort to maintain their religious and cultural heritage, men and women tended to marry within their ethnic group. The practice of arranged marriage was used into the early part of the twentieth century.[7]

The Serbian religious and cultural traditions included strong gender roles for men and women. During worship services, men and women occupied separate sides of the church, and for those who were very traditional, the bride and her maid of honor were the only women allowed to attend a wedding ceremony. Christmas and Easter celebrations were marked by groups of men visiting home to home within the Serbian community to partake in food, drink, and fellowship. The women did not attend with the men; they stayed home to prepare banquets of food for their visitors.[8] Helen Orlich explains that the women could visit in a similar fashion the following day, but most did not. With a laugh, she adds, "The women were usually too tired from cooking and hosting their visitors the day before."[9]

The members of the Serbian community were a tight knit group. As Danica Duletich explains, "the people helped one another with living arrangements, family and social needs, and even financially when needed."[10] It was not uncommon for families to take in Serbian boarders; some did so to earn extra money while others did so to help family members and other new immigrants get started. When new immigrants arrived, the Serbian community embraced them. Danica Duletich describes how her landlady, a fellow Serb, helped her understand life in Butte when, as a new immigrant, she did not understand the new culture and could not speak a word of English.[11] Sylvia Skuletich tells of her mother, Gospava Stanisich, sharing the bounty of her garden with other Serbians. Sylvia also remembers that if a family shared the same last name, but were not related, they were treated as if they were.[12]

The Serbians were well organized and active in the community. Over the course of Butte history, there were at least five Serbian lodges, all of which had junior orders for the children. Other groups included the Serbian American Men's Club, the Young American Serbs, and organized sports clubs. Serbians also participated in groups such as the American Legion and the Red Cross. This sense of group participation and community work were hallmarks of the Serbian women's organizations as well.

ORGANIZATION AND LEADERSHIP OF THE *KOLO*

The Circle of Serbian Sisters or the *Kolo Srpskih Sestara*, as it is known in the Serbian language, is an international organization with chapters throughout the United States, Canada, and Yugoslavia.[13] Butte's *Kolo* (circle), as the women of the club frequently

called it, has a rich history, serving many purposes for its members. For some, it was a place of fellowship and community with other Serbian women, for others it was a way to support the Serbian Orthodox Church and the Serbian culture, still for others it provided opportunities for participation and activism in the larger Butte community and a place to utilize their talents for leadership and organizing.

The Butte chapter of the Circle of Serbian Sisters was formed in November of 1934, shortly after the assassination of King Alexander of Yugoslavia in October of 1934. According to Danica Duletich, who was living in Yugoslavia at the time, King Alexander united and led in brotherhood and independence the six provinces, including Serbia, that made up the diverse nation of Yugoslavia.[14] For the Serbian people of Yugoslavia and the United States, the assassination of King Alexander represented more than the loss of a leader, it also represented a threat to the independence they had struggled for centuries to achieve.

In Butte, the Serbian community as a whole honored King Alexander with a memorial service in the church. The women went even further, organizing a service group—the *Kolo* - to uphold the traditions and work of the Holy Trinity Orthodox Church, maintain Serbian language and cultural practices, and draw the Serbian community closer together.[15] The Serbian women of Butte were the first in the country to organize a *Kolo*. Shortly thereafter, Serbian women across the country organized as well.[16]

A discussion of the *Kolo* would not be complete without mentioning perhaps the most influential member of the organizing committee, Mrs. Sophie Ducich. By all accounts, Sophie Ducich, who immigrated to America at the age of twelve, was an exceptional woman and quite possibly the driving force behind the formation of Butte's *Kolo*.[17] The majority of the women interviewed for this project gave credit to Mrs. Ducich for her work in organizing and leading the *Kolo*. She was revered as a motivated, compassionate, and well-organized activist and a strong, intelligent leader who devoted herself to the projects of the *Kolo*, the larger Butte community, and the American Federation of Serbian Sisters Circles.

Mary Trbovich, in her 1987 oral history, remembers:

> Mrs. Ducich was quite a leader in her day, a very active woman. She had a lot on the ball. She thought it'd be nice to have a women's club where we would be represented everywhere. I know she went from house to house and contacted all the women. When this was organized there were, I'd say, between eighty and ninety women.[18]

157

Members of the Butte Kolo, circa 1960.

Mrs. Sophie Ducich (standing) and members of the Circle of Serbian Sisters.

Organization of the *Kolo* was formal and extensive. The women paid membership dues and elected the officers, which included President, First and Second Vice President, Recording Secretary, Assistant Recording Secretary, Financial Secretary, Treasurer, Chaplain, and a Board of Trustees complete with its own Chairman and Secretary. The *Kolo* also had Color Bearers, Honor Guards, a Sick Committee, and a Ways and Means Committee. The *Kolo* provided women opportunities to develop their leadership skills. Several women took the skills they honed in the *Kolo* and used them to benefit other community organizations, such as the Red Cross, the March of Dimes, and the Senior Citizen Center.

Kolo membership was open to women of the Serbian Orthodox community and to women who had married Serbian men. Most new members were introduced to the club through their mothers, other relatives, or neighbors.[19] Danica Duletich joined the *Kolo* at the age of twenty-two, two years after arriving in America. She remembers that other Serbian women from the community brought her into the organization.

As an immigrant, Danica left her family in Yugoslavia to be with her husband in Butte. Upon her arrival, she spoke only the Serbian language and knew little of the American way of life. It was a completely different world for her. She states that the *Kolo* became an integral part of life for the women, "It provided us a place to socialize, be active in the community and develop close, supportive relationships with other women. With its various activities, the Kolo was also fun and exciting. I couldn't wait to go to church and *Kolo* meetings, they were our life."[20] Sylvia Skuletich remembers, "The *Kolo* was a very active group, we constantly had projects underway. We organized keno games, planned community New Year's Eve celebrations, developed the Drum and Bugle Corps for the children, and marched as members of the drill team in area parades. There was never a dull moment."[21]

WORKING IN UNITY

At the time Butte's *Kolo* was formed, the Serbian church had been without a priest for almost two years. The first major project for the group was to help provide for and maintain a priest and his family. This included raising funds to build the Serbian Church Hall.[22] The women were dogged in their fund raising activities. They held bake sales; catered luncheons, dinners, and holiday events; and held rummage sales and raffles. They also held banquets for special church occasions where they prepared and served traditional meals to over 200 people. The multi-course banquets were well attended and proved to be a successful fund raising activity. The work was time and labor intensive and truly a labor of love. The women were successful in raising funds for the

church, and their financial contributions supported construction of the Serbian Church Hall in 1937.

※

MENU FOR A NIGHT OF OLD WORLD CUISINE

Salata	Vegetables
Lamb	Povitica
Klobase	Baklava
Sarma	Priganica
Cicvara	Apple and Cheese Strudel

Wine

※

The goals of the *Kolo* were to support the Serbian Church and preserve Serbian customs, but the group supported other causes as times changed. With the outbreak of World War II, the *Kolo* supported American troops and the war effort. Members served as volunteers with the USO and Red Cross, provided support to families with loved ones in the armed services, and joined together with other women's organizations in Butte to sell war bonds.[23] According to an article in *Serb World U.S.A.*, the women's organizations of Butte combined to sell $75,000.00 in war bonds to purchase a fighter plane.[24]

The *Kolo* also helped Yugoslavian orphans in Switzerland and supported the Serbian National Defense Council of America. With the end of World War II Yugoslavia became a communist state, and despite having fought along side the Allies many Serbians became displaced persons.[25] The *Kolo* contributed to national Serbian organizations to provide support for the Serbian displaced persons who had settled in the United States.[26]

In the 1940s and 1950s the women of the *Kolo* continued their work on behalf of the church and the Serbian community locally, and they also became more involved on the national level. They sent delegations to national meetings of the Serbian Sisters Federation and the Women's Congress of the Serbian National Federation.[27] Through participation in events such as these, women from Butte became active in the National Serbian agenda. In 1956 Sophie Ducich became vice president of the American Federation of Serbian Sisters Circles. From 1959 to 1966 she served as President of the Western Region of the Federation of Serbian Sisters Circles where she worked to establish the Western Region *Kolo* headquarters in Jackson, California. The headquarters, located on 173 acres, also served as a summer camp where Serbian children from the western United States could unite.[28]

By the early 1960s, the *Kolo* had a new goal. Their church had sustained damage when the land it was built upon began to recede. The recession was due to the underground mines that snaked beneath the surface of uptown Butte. Unfortunately, the damage could not be repaired, and eventually the church became unsafe. A new church and parish hall needed to be built. The parish executive board developed a Building Committee, and fund raising efforts got underway.

With their characteristic dedication, the *Kolo* made it their top priority to raise money for the new church and parish hall. The women spent hours cooking for Sarma, Povitica, and Pasty sales, catering meals for church events, and holding rummage sales, raffles, and keno nights. As Sylvia Skuletich and Danica Duletich remember, "it was a time of non-stop activity."[29] Their efforts paid off when the women of the *Kolo* presented the Building Committee with a donation of $10,000.[30] The new church, located on Butte's south side, was erected in 1965.

SARMA

1 large head cabbage	salt and pepper to taste
1 large onion	6 heaping Tbsp. rice
1 clove garlic – minced	2 eggs
1 lb. ground beef	15 oz. can of tomato sauce
½ lb. ground pork	

1. Boil water in a large pan with 1 tablespoon of salt. When water boils, cook cored head of cabbage about five minutes or until leaves soften a bit. Do not overcook.

2. Prepare filling. Fry onions and garlic in butter or bacon drippings until soft. Simmer about five minutes. Remove from stove and add ground beef and pork. Add salt, pepper, and eggs. Mix together.

3. Remove leaves from head of cabbage one at a time. Trim heavy vein on leaf with a sharp knife, but do not cut through leaf. Place a portion of meat mixture on leaf. Roll up and push ends in firmly.

4. Place a few leaves and chopped leftover cabbage on the bottom of pan. Pile rolls neatly on top.

5. Pour tomato sauce over the top (add enough water to cover.) Cover pan and simmer 1 ½ hours or until tender. [31]

BEYOND SERVICE

Although the service record of the *Kolo* is impressive, the ceremonial traditions and support functions of the group were equally important. Through *Kolo* rituals the women honored one another and demonstrated their high level of respect for their work and each other. The members of the *Kolo* took their work seriously, and their meetings reflected this. They met twice a month, drawing a good turn out. In addition to reading the minutes, discussing business, voting as needed, and planning events, the group had a secret password, and the members of the honor guard presented two flags - the American Flag and the *Kolo* Flag. When new members joined the group a formal initiation ceremony was conducted.[32] Each member had a white satin uniform with a two-sided sash; one side was black, the other side was red, blue or white, the colors of the Serbian flag.[33] The women wore their uniforms to meetings, for special occasions and ceremonies, and when they represented the group at public functions.[34]

When a member of the *Kolo* passed on, she was honored in a special way. During her wake and funeral, *Kolo* members wore their uniforms with the black sash, and six women were chosen as honorary pallbearers. The president spoke at the funeral, and the women stood on guard at the cemetery while the choir sang. An elder woman of the group carried a basket of flowers. Deceased members of the group were remembered and honored throughout the years.[35] When a member of the larger Serbian community passed on, the women cooked, cleaned, and helped in any way necessary at the home of the deceased.[36]

The women of the *Kolo* were also active participants in broader community events. The *Kolo* drill team and entries of decorated cars and floats won several first place awards in Butte's Independence Day and Miners' Union Day parades. The women also enjoyed working with the children of the Young American Serbs Club and the Drum and Bugle Corps and participating in picnics, Serbian New Year celebrations, and other social events.[37]

A meal followed every meeting and gave the women an opportunity to socialize. For many, their time at *Kolo* meetings was the only time they had for themselves. The women interviewed recall lives of hard work and responsibility. They remember themselves, their mothers, aunts, sisters, and neighbors, working long, hard hours to benefit their families, their church, and each other. Their time at *Kolo* meetings provided a break from managing a household, children, boarders, and work outside the home. Maryane Christie states, "Women with small children arranged for someone to look after them

during the meetings, and household and other chores were completed either before or after *Kolo* meetings."[38] As Mary Trbovich explains, the *Kolo* meetings provided a night off for her mother.[39]

In 1953, the women organized another group, the Serbian Mothers Club, which focused solely on children of the parish. Up to that time, the Serbian Orthodox Church did not offer a Sunday school program. The women changed that, and with the help of the priest developed and implemented a curriculum. The goals of the Mothers Club were to promote the welfare of children and youth in the home, school, and church and to procure materials for a religious education through Sunday school.[40] Helen Orlich explains that, "many members of the Mothers Club were also members of the *Kolo*. Over the years we all worked closely with the priest and held fund raising activities to support the Church and Sunday school."[41]

THE WOMEN TODAY

The size of Butte's Serbian community has been reduced over the course of time due to death, members marrying outside the Eastern Orthodox faith, and people moving from Butte.[42] As the size of Butte's Serbian community has shrunk, membership in the women's organizations has done so as well. In the mid-1980s the *Kolo* and the Mothers Club, which shared the same members, combined their meetings and began to work in unison. Maryane Christie states, "There are currently between fifteen and twenty active members that range in age from mid-forties to late-eighties."[43] Despite the reduced size, the *Kolo* and Mothers Club remain active. Rosalie Butorovich has been the group's president for the past twenty-five years. As president she strives to "build upon each year's success and make the next year more meaningful, engaging, and fun."[44]

Today, the women carry on the fund-raising traditions of their mothers, holding Sarma, Povitica, and Pasty sales, an annual craft bazaar, raffles, and rummage sales. During their recent Sarma sale, the women made and sold over 1100 Sarmas and stated they could have sold more.[45] They still cater special events that draw a large crowd from Butte and beyond. The club also works with the Serbian American Men's club to host the annual Night of Old World Cuisine, featuring traditional Serbian foods, music, and dancing for a sell-out crowd that is as diverse as Butte itself. The money raised has helped to maintain the church and Sunday school program, refurbish the parish hall kitchen, and provide clothes and food for those in need. Currently, the organizations are helping to fund the painting of the church ceiling with large, beautiful frescos by painters from Yugoslavia.

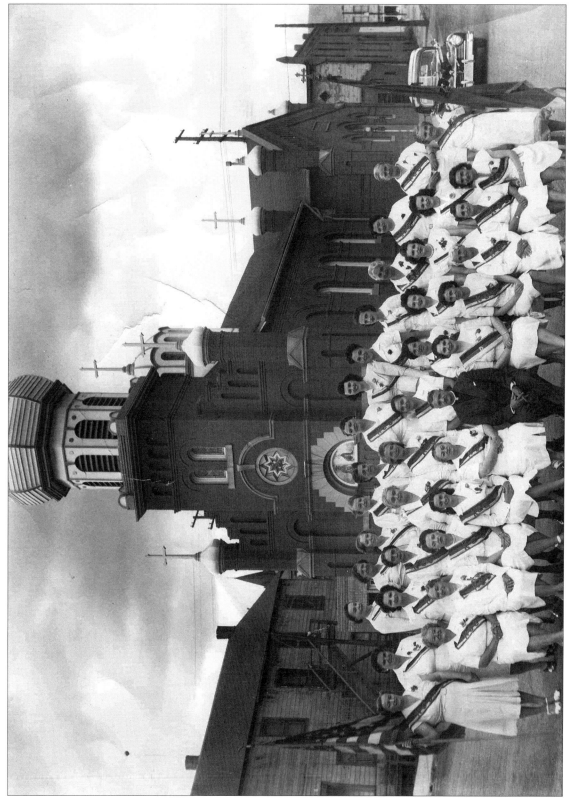

Kolo members in uniform, 1947.

165

WALNUT POVITICA

DOUGH	FILLING
12 cups flour	2 cups sugar
1 ½ cups sugar	½ lb. butter
½ lb. butter	16 oz. honey
4 cups milk	2 – 3 cans Sego milk
1 tsp salt	3 lbs. ground walnuts
4 eggs	3 beaten eggs

TO PREPARE THE DOUGH: Dissolve 3 packages of yeast in ½ cup of lukewarm milk. Beat eggs, add salt and sugar. Add yeast and butter, beat. Add milk and flour alternately. Raise in well-buttered bowl (melt butter).

TO PREPARE THE FILLING: Heat the first 4 ingredients to a boil. Add the ground walnuts. Just before spreading the filling onto the dough, add the beaten eggs.

Spread and pull dough until it is paper thin. Spread filling on dough and roll jellyroll style. Bake in greased pans at 350 to 375 degrees for one hour or until done.

With the passing of several generations, the Serbian church and the women's organizations have experienced a great deal of change. Church services and organization meetings are no longer conducted in the Serbian language. Gender roles have moderated; men and women now share the same space in the church, and women attend weddings and Christmas and Easter celebrations. The women's and men's groups work together on projects to benefit the church.

Over the many years that the women of Butte's Serbian community have organized, the church, the Serbian community, and local and state leaders have consistently recognized their work. In 1959, on the occasion of its twenty-fifth anniversary, the *Kolo* received letters of support from the Serbian Orthodox Bishop, United States Senator Mike Mansfield, Montana Secretary of State Frank Murray and Butte Mayor Vern Griffith. The *Kolo* also received warm wishes and donations from over 150 local businesses and individuals. Each year the church honors the women's efforts in its annual publication, *The Messenger.*

With the passing of elders, much of Serbian culture and history, including that of the women's groups, has been lost. In an effort to preserve this legacy, Sylvia Skuletich is

recording the life stories of elders and collecting information about the church, including women's organizations. As Sylvia states, "I want to preserve our history so future generations will understand our traditions, our lives, and the works of the older generations." She further states, "I try hard to keep the Serbian customs documented. Since many of the older generation are gone, it is up to us to do this. We are now the older generation."[46] Sylvia and her husband, Louie Skuletich, have gathered a large collection of old photographs and videotapes of church and Serbian community events. Through their work, the rich heritage of the Serbian people will be passed to future generations. The Holy Trinity Serbian Orthodox Church celebrated its 100th anniversary in 2004, and the women helped to coordinate the three-day celebration. They are proud of their church, heritage, and *Kolo*—that remarkable organization that has encircled their lives for seventy years.

NOTES

1. Information was also drawn from Mary Trbovich, interview by Mary Murphy, November 4, 1987, Oral History Collection, Butte-Silver Bow Public Archives (Hereafter BSBPA, Trbovich oral history). Archival materials from members of Butte's Serbian community were also used. Discussions with four men, Louie Skuletich, Jack Ghenie, Marko Lucich and Ed Christie provided a male perspective regarding the lives and work of the Serbian women.

2. Many books and articles have been written on the history of Serbia, Yugoslavia, and the Balkan region. Each presents its own perspective on the causes of the strife that has plagued this region for centuries. Many recent publications focus on the conflict of the 1990s. One book that discusses early Serbian history through the 1990s is Stevan K. Pavlowitch's *Serbia: The History of an Idea* (New York: New York University Press, 2002). A useful chronology of events from the 19th and 20th centuries is outlined in, "Serbia and NATO: The 1999 War," *History Behind the Headlines: The Origins of Conflicts Worldwide,* Volume 1, Gale Group, 2001. This article is reproduced in History Resource Center, Farmington Hills, MI: Gale Group, and can be accessed at http://falenet.galegroup.com/servlet/ HistRC/ - Document Number BT2309001023.

3. This information was spoken of by members of the Serbian community and also noted by a Serbian speaker at the Symposium on Ethnic Groups in Butte, held on April 19, 1974, sponsored by the Montana Committee for the Humanities.

4. The Eastern Orthodox Religion is a Christian Faith dating back to the Roman or Byzantine Empire. The Roman Empire lasted from approximately 330 A.D. to 1453. The Christian Orthodox religion has followers in many countries, each with their own national churches—Greek Orthodox, Russian Orthodox, Romanian Orthodox. The religious beliefs are the same; the difference is the national, ethnic, or cultural makeup of the congregation. Many of those interviewed for this project spoke of the Greek Orthodox immigrants and their participation in the Serbian church.

5. Marko Lucich, interview with the author March 16, 2005 (Hereafter Lucich interview).

6. Julian calendar was introduced by Julius Caesar in 46 B.C. and consisted of 365 days in each year except the fourth year, leap year, which had 365 days. The astronomer, Luigi Lilo Ghiraldi, who lived in the sixteenth century, contended that the Julian calendar was in error—the year was too long by 11 minutes and 14 seconds. This amounts to one day every 128 years. In order to correct this, Pope

Gregory XIII issued a brief in 1582 abolishing the old calendar and substituted Ghiraldi's systems of reckoning time. To amend this, October 5, 1582 was called October 18, 1582, thus dropping 13 days. The difference between the two calendars increased by one day every 1,000 years. The "new style" of Calendar is known as the Gregorgian calendar. Therefore, January 7 on the Gregorgian calendar is actually December 25 on the Julian calendar.

7. Helen Orlich, interview with author, January 30, 2004 & Sylvia Skuletich, interviews with author, April 17 and May 24, 2004. Both women spoke of arranged marriage and its practice into the early twentieth century (Hereafter Orlich interview, Skuletich interviews). According to Helen Orlich, members of the Serbian community had arranged marriages into the early 1940s, but it was much less common at that time.

8. Trbovich oral history, Orlich interview.

9. Orlich interview.

10. Danica Duletich, interview with author, May 24, 2004 (Herefater Duletich interview).

11. Ibid.

12. Skuletich interviews.

13. The American Federation of Serbian Sister Circles oversees and collects dues from most local chapters and helps to keep them connected. There are regional and national meetings each year and representatives from the local groups participate.

14. Duletich interview.

15. The mission of the *Kolo* was discussed in personal interviews and also noted in anniversary publications by the Holy Trinity Orthodox Church.

16. Lucich interview.

17. Sophie Ducich and her dedication to the *Kolo* was noted by the women interviewed and in various anniversary publications made by the Holy Trinity Orthodox Church.

18. Trbovich oral history.

19. Ibid.

20. Duletich interview.

21. Skuletich interviews.

22. Holy Trinity Serbian Eastern Orthodox Church, *Consecration July 25, 1965*, (Butte: Holy Trinity Orthodox Church, 1965), 24-25.

23. Holy Trinity Orthodox Church, *Silver Anniversary of the Circle of Serbian Sisters: 1934-1959*, (Butte: Holy Trinity Orthodox Church, 1959).

24. Mary Nicklanovich Hart, "In the Western Circle: Sophie Ducich and the Serbian Sisters", *Serb World U.S.A.*, 17, no. 5 (May/June 2001): 36-44.

25. The displaced persons elected to live freely rather submit to communist rule and therefore were forced out of Yugoslavia. Danica Duletich and Sylvia Skuletich explained that those who remained in Yugoslavia were fearful and felt great pressure to conform to the communist regime's belief system and way of life.

26. Holy Trinity, *Silver Anniversary*.

27. Ibid.

28. Nicklanovich Hart, "In the Western Circle."

29. Skuletich and Duletich interviews.

30. The money raised by the *Kolo* for the new Serbian Orthodox in 1965 was discussed with interviewees. Everyone agreed that the amount raised was significant, but the individuals interviewed had different recollections of the amount, varying from almost $9000.00 to upwards of $75,000.00. The Serbian Church noted in its 100th anniversary book that the actual amount raised was $10,000.

31. The recipes included here have been provided by Maryane Christie, the author's aunt. They are traditional recipes handed down and shared among families over several generations.

32. Maryane Christie, interview with author, 2004 (Hereafter Christie interview).

33. Lucich interview.

34. Skuletich and Duletich interviews.

35. Ibid.

36. Skuletich interviews.

37. Holy Trinity, *Silver Anniversary.*

38. Christie interview.

39. Trbovich oral history.

40. Holy Trinity Serbian Eastern Orthodox Church, *Messenger*, 4, no.7 (January – June 1985): 19.

41. Orlich interview.

42. All women interviewed spoke of the reasons for the decline in the Serbian population in Butte. Butorovich and Christie stated that in recent years the Butte Serbian church has seen an increase in non-Serbian members. Butorovich noted that people seem to like the traditions of the Orthodox Church and feel a sense of connection to the Serbian community.

43. Christie interview.

44. Butorovich interview.

45. Skuletich interviews.

46. Ibid.

Homeless Children . . . In Butte, Montana

Margaret Hickey (1950)

EDITORS' NOTE: This article originally appeared in *Ladies Home Journal* in September, 1950.[1] The article reflects middle-class assumptions about child neglect, poverty, and race that informed child welfare work at the time. At the same time, it captures the spirit and sense of possibility of the Soroptimist Club's work in an immediate way that could not readily be achieved in a retrospective account. The Soroptimist Club kept its commitment to Butte children for the long haul, continually upgrading the facility and services, and responding to changing knowledge base and needs. Changes in the field of child welfare resulted in greater use of foster homes and less reliance on receiving homes for younger children. In August, 1975, the facility changed its name to the Soroptimist Attention Home, with a focus on diverting juveniles from jail. In 1980 the Club sold the home to Butte's Sheltered Workshop. The Butte Soroptimist Club remains active today.

This is a story about a little boy who was so thin his arms were about the size of a broomstick, and so hungry that he scavenged in garbage cans like an alley cat. This is also a story about a two-year-old girl who had had so little to eat that she didn't have the strength to lift a spoon to her mouth when she got one. And the story of two children, shut in a car on a freezing night in January and forgotten by their parents. And another child, about five, with dark straight hair and big, black, Indian eyes, who was found playing in the street one midnight—and if she ever had a home, no one, not even she, knew about it.

It is also a story about a group of businesswomen who created a home for these lost and hungry children who had no place to go but jail when their parents abandoned or neglected them. The setting is Butte, Montana—but it could be anywhere. There are, unfortunately, sad-eyed and starving children in any city you wish to name. The welfare workers know it; the police know it; and when the city's civic-minded don't know it, it's because they hate the thought and won't face it.

In Butte, it was Mrs. Mary Phillips, at the Child Welfare office, who first faced it. She herself was a widow with three children to raise. Every time she saw a little tyke—and she saw many in her work—who looked hungry or ragged or scared, her heart seemed to turn over.

"What we need is a home for neglected children," she kept saying over and over to anyone who'd listen, and even to those who wouldn't. But for years people just clucked their tongues sympathetically and said it surely was a shame, and nothing was done.

Then Mary became one of the charter members of a club. She wasn't much for clubs—not that she'd been in many, but because she thought that for busy women they were a waste of time. This club, however, promised to be more than just another club. In the first place, it was composed solely of workingwomen in executive jobs who didn't have much time to waste. Secondly, it said right in the charter that if the club didn't run some sort of service program for the community, it would have to disband. Its name was the Soroptimist Club—"*soror*, for sister, *optimo*, for the highest good"—and it had a national reputation to uphold.

Mary proposed at the very first meeting that the Butte Soroptimists take on as their service the creating of a home for children. The club gave her its polite attention, as was due a fellow member, and then moved on to other ideas. Some of the other ideas, most of which weren't so ambitious, began to blossom and bloom. But not the idea of the home. It looked at first as if the Soroptimists were just as scared of a big job as anyone else.

One of the club's officers, however, wasn't scared of anything. Lois Jacobsen was just biding her time. Her husband believed that "if you want to do something badly enough you can do it"—and so did she. One day she looked Mary in the eye and said, "Mary, you're going to have your home. I've rallied enough strength in the club now, and tomorrow it's coming to a vote. You watch—Butte is about to get the finest children's home any child would need."

The club argued over the idea all the next meeting. Some said bluntly it was just too big a job. Others said they thought it was a wonderful idea, but that first there ought to be a committee appointed of those who were enthusiastic to "make a study." The pessimists pointed out that a home would cost a lot of money and if they found they could collect only half enough, they'd have had all the work of getting that in—and then they'd have to work like dogs to take it all back. There was no Butte Community Chest then to fall back on, no special funds for city projects—once started, they'd be on their own. The opposition, however, lost the day. The club agreed that: one, they'd look for a suitable house; and two, they'd campaign for the money to buy it.

In May 1947, only three years after they'd organized, they found their house. A condition of the Child Welfare Department was that it must be near schools and churches. This was; in fact, it was in one of Butte's best residential neighborhoods. A demand of the

club was that it should be big enough to hold at least twenty children. This could: its two story brick walls held twelve rooms and two baths. Moreover, it was in pretty good condition, needing only fresh paper and paint—and the cost was only $5,500.

The club set its sights for $8,000 to include furniture, and began campaigning. First they drew up a list of 10,000 names—the county's population is around 55,000—and two by two, sixteen women began ringing doorbells, badgering receptionists, writing letters. They had only evenings, lunch hours and Saturdays. But by the end of the first two weeks they'd put $500 down on their house, had $1500 in the bank and had gathered enough momentum to get radio spots, news space and a lot of word-of-mouth publicity.

Excited and enthusiastic, they then:

1. Raffled off a car;
2. Sponsored the dog races for one night;
3. Held "white elephant" raffles at every meeting;
4. Gave three rummage sales;
5. Sponsored one concert, two book reviews and a tea;
6. Threw a large charity ball (the governor led the grand march);
7. Continued canvassing all clubs, civic societies, unions and big businesses for contributions, work and donations.

By the spring of 1948, they had enough money and support to purchase the house outright, paying cash on the barrelhead, buy some Army bunks and other furniture, wangle some paint, and to start a work project.

One woman member was a plumbing executive—Faye Perry—and she checked all the plumbing. Another ran a cleaning firm and she cleaned all the donated curtains, bedspreads and clothing. Two hotel executives—Ruth Boulter and Ethel Dunstan—made two old feather mattresses into twenty pillows—and got so covered with feathers they looked like chickens. Husbands—the girls like to call them "Soroptimisters"—repaired toys, put together the Army surplus bunks, carted in donated crates of food. Work parties got together in the evening, cleaned, scrubbed and painted. The girls put on the first coat of paint; the Active Club, a men's service organization, put on the second.

To do the work, the Soroptimists not only had to recruit workers and find the time, but they also had to get union approval. Butte is practically a closed shop; even the hospitals are organized, and a merchant who puts up a shelf himself in his own store gets

picketed—fast. The girls had to go to union meetings, explain the projects, plead their case and get approval before they could do their own work—and before anyone could donate any working time to them.

But they had little trouble: the city was almost as enthusiastic as they were. The big Anaconda Copper Company, whose black rails zigzag up the hill behind the city and whose mile-deep mines work down under the city itself, gave generously. So did the big power company. Food dealers donated vast amounts of soups, baby food, crates of popcorn, chicken, ice cream and lollipops.

Old clothes poured in, in such abundance that one woman said she believed that there wasn't a person in town who hadn't sent something he'd grown out of. The doctors offered free medical examinations and treatment; the hospital offered half rates for tonsillectomies and other ailments requiring hospitalization. The mental-health clinic promised free psychiatric care. Almost every Butte merchant offered a 10 percent discount on any purchases they had to make, and practically every club offered support or money.

"We got to be the best little beggars in town—we'd beg for anything," Mrs. Jacobsen says. "Only a few held out against us. One man—a big restaurant owner—said he believed that it was just encouraging parents to desert their children to provide a children's home. A big club took the same stand—but there the individual members passed a hat and made a voluntary contribution."

By November of 1948 the house was ready for occupancy. The Child Welfare Department had found a matron—an experienced child-care worker, with three children of her own. New furniture was bought for her large front room. The Army bunks—now white with childish decals on them—were in the children's sleeping rooms. The huge old wobbly dining table someone had donated was braced and surrounded by an odd assortment of chairs. There was linoleum on the floor of the playroom, and the big refrigerator and stove left behind as gifts by the outgoing tenants were in apple-pie order. Clothes were clean, pressed, mended and in closets—and in the basement there were piles more, unsorted.

Before the first children moved in, the Soroptimists held two open houses. One was held for their own organization—when they were host to the Soroptimist Northwest Conference. In came more gifts. The club from Great Falls festooned the rooms with clothes ropes, decorated them with dishtowels, pinned on with clothespins. And the regional board presented them with 365 paper dollars, a vast feat in this silver dollar area.

The second open house was for the people of Butte and Silver Bow County. They came—by the scores. And, although it was unplanned, they gave. The Soroptimists, feeling that, after all, there *was* a limit, had planned for nothing; an early guest however, tossed a silver dollar into an ash tray. In no time all ash trays were full, and a salad bowl was called into action. That was the way people felt about the home—and still do.

The Soroptimist Receiving Home for children of Silver Bow County, Montana, opened for business November 1, 1948. Eight children were the charter residents—but by November 4 there were 15, and within two weeks there were 25. In the first year and a half, there were more than 175 small guests.

Complaints about the care of children come from anyone—neighbors, teachers, police, ministers, or even the children themselves. All, however, are referred to the Child Welfare office. For the children's upkeep, the county pays $1 per child per day. No children born out of wedlock are cared for: There is a good Florence Crittenden home nearby which takes care of these mothers and babies. A few of the parents pay the Welfare Department for the care of their children, but they are the rare ones; most of the children are from homes in such a sorry state that there is even less money than there is loving care.

The home is, of course, intended to be only a receiving home—a place where the youngsters can stay until foster homes are found for them, or their own parents can give them proper care. However, things don't always work that way; until two years ago there was almost no foster-home program in Silver Bow County, Butte's home county. Due to the efforts of the Welfare Department, there are now 17 foster homes—but even they are not enough to keep the turnover at the home as speedy as it should be. At one point this past winter there were 8 children under two at the home, and many of them stayed for months. It was grueling on the matron and her assistant; it was not good practice; but there was no alternative.

Most of the abandoned, deserted or neglected children came from homes where the problems are psychological, first, and financial, second. There is very little un-employment in Butte—it is a solidly prosperous town of homeowners, and most of its serious housing problems were cleaned up a few years back with a good-sized housing project. There are, however, many illegal gambling places, a red-light area, and more than enough bars to go around. The population is of mixed backgrounds—Finns, Indians, Mexicans, Swedes, the English, the Germans and the Irish have all pushed their way across the continental divide to the "richest hill on earth" and its progressive mining camp, the city of Butte. The home, of course, is open to all children, regardless

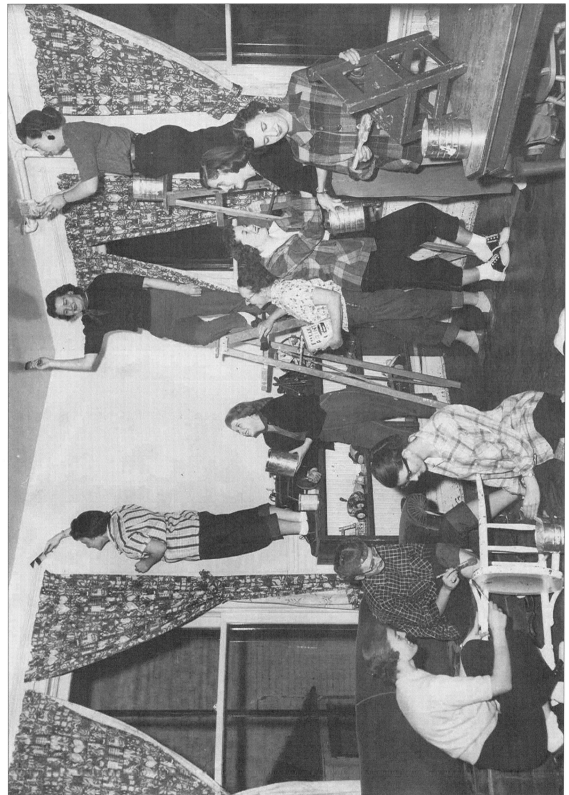

Soroptimist Club members prepare home for Opening Day, 1948.

175

of race, color or creed, and every effort is made when placing them in foster or adoptive homes to find the background closest to their own biological and religious inheritance—which sometimes may be very mixed up indeed.

To get back to the home itself and the Soroptimists, however, the club's job was far from done when the home was opened. During their campaign Mary Phillips had fallen ill and they had been without guidance. Thus, no sooner had they opened for business than they discovered that in order to secure a state license, they would have to have an infirmary and a fire escape. To add to their troubles, the matron complained—and rightly—that with so many infants to care for, she needed downstairs bedrooms, a fenced-in play yard, and a large and well-equipped laundry. The next year was spent in getting them. Fortunately, although incredibly, the club's enthusiasm was as high a pitch as ever—and there was some $2000 in the bank.

So they began again. They held more raffles, did more canvassing, wrote more letters, rang more doorbells. When the rodeo came to town and all the restaurants were on strike, they offered to take over the feeding problem of the cowboys, the handlers—and the 10,000 visitors. "We were up to our necks in hamburgers before we got through," one member says reminiscently, "but any resistance there was to us and our drive faded away then and there. We worked harder than the horses." They also imported Horace Heidt's radio show, held more raffles, gave their second charity ball—and then, when they had collected and made about $6,000 the newly formed Community Chest appropriated $8000 to the home and they were set. In February, 1950, they got their state license—and the warm blessing of the Montana State supervisor of child-care institutions, Miss Gertrude Davis. "We," she said referring to the whole State Welfare Department, "are very much impressed."

The children were impressed too. One youngster, sent back home when her parents were reunited, ran away and came back to the home. A child turned up ragged and disheveled at the police department and said he'd heard that they had all the ice cream they could eat at a home in Butte, and he wanted to live there. A baby, who, its departing mother said crossly, had never smiled in her life began to gurgle and crow with happiness. The thin one grew fat. The starved one began to creep. Five bright-eyed kids who looked and acted like young tramps when they were first removed from their disreputable home and drunken parents by the court's police became honor students—and were taken by foster parents.

Part of the home's success was due to the mere fact that it existed. But part was also due to its basically sound organization. The Soroptimists' standards and goals were

those of the professionally trained welfare department of the city, county and state. Their maintenance budget was based on a four-way plan: part Community Chest, part club, part Welfare Department and part city generosity. Their day-to-day operation was two-way—club work, plus child-care welfare workers' guidance and assistance.

Typical of its well-rounded basis was its citizen board of directors—elected by the club. This board included one welfare worker: T.G. Sivalon, State Field Supervisor of Welfare; two doctors: Dr. D.L. Gillespie and Dr. H.L. Casebeer; one lawyer: J. E. Corette; and one housewife: Mrs. L.E. Saunders, founder of many ham and cooky clubs for the home. The club's board meanwhile included all its officers (current president is Rose Shaw, a credit specialist; the treasurer is Mary Lamb) plus an advisory board.

And typical of its community contacts is the list of clubs and businesses, which work with the Soroptimists. At Christmas the power company sets up a tree and lights it in the front yard—while the Girl Scouts spearhead a drive for toys, and the candy and cookie clubs provide treats for the big Christmas party. ("All I want is something that smells real good," one little girl wistfully told the Soroptimister playing Santa Claus.) The Junior League provides all transportation needed for medical treatment (as well as paying for one of the mental-health workers in the Butte clinic). Protestant and Catholic churches alike send food and clothing, and their women's clubs do the mending. Not a union has withheld permission for special jobs done for free, or at reduced rates. The Chamber of Commerce gives office space during Soroptimist money drives. The Rotary Club, the Kiwanis Club and the Elks respond generously when called upon, and the Bucks Club contributes $25 a year to the special hospitalization fund. Anaconda Copper leased the land for a large playground at $1 a year—and put up a fence around it "high enough to stop a baseball" as a gift. The Venture Girls—the junior group of the Soroptimists—entertain the youngsters on Saturdays, and the young men's service group, the Active Club, not only painted, but helped clear out, the basement.

The local movie house lets the children in free on Saturdays. The neighborhood barber takes care of their haircuts on the house. The dietician at the hospital (a club member, Mary Kelly) plans the meals. The police send the squad car when needed to cart up a gift Turkey or any other rush donation. The Garden club is planning to landscape the home's front yard. And the pediatricians have formed a three-man club, splitting the year between them so that one of them is always on call at the home.

Not that the home has no problems. The girls are still green about what really makes a good child-care institution, as they are the first to admit. Some of the club are more house-minded than children-minded: one officer was so afraid that the children might

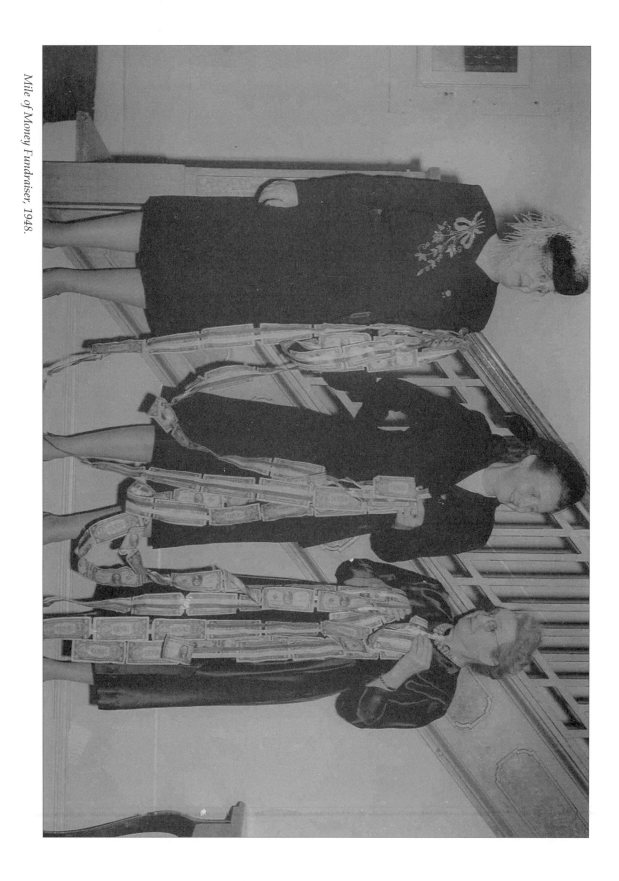

Mile of Money Fundraiser, 1948.

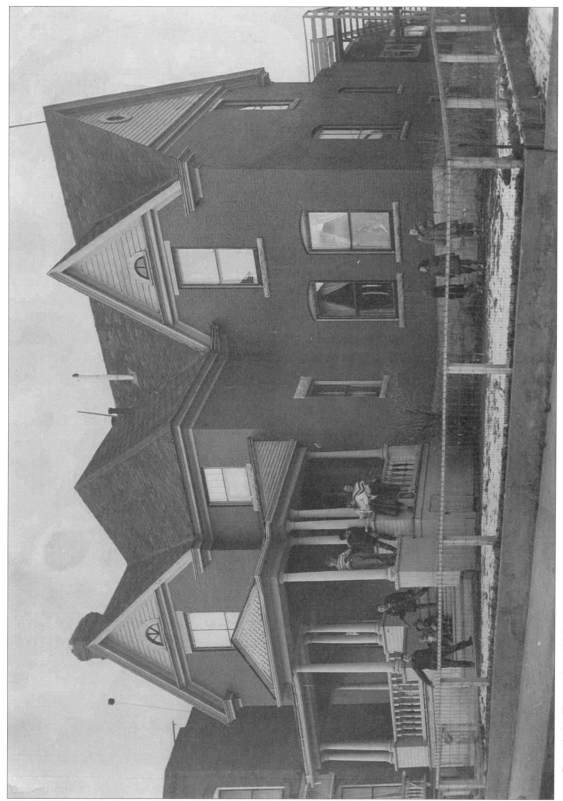

Soroptimist Home, circa 1950.

break the toys that she put them all away. There were also staff problems: the first matron left because she had too much to do—as well as taking care of the children, she was expected to do all the housework and laundry. An assistant was hired along with the second matron. But even so the job was a backbreaking one—And now the home is on its third matron who has one sleep-in assistant and one day worker to help her. Even so, she works from dawn until considerably after dusk, and rarely has the time to read to the children, or give the individual attention that the children sorely need and that she wants to give.

There are also cost-of-maintenance problems. On top of the support given them through the Child Welfare Department, there is about another $3000 yearly needed to get, and hold, the staff they want, and to get, and keep, the home in good condition. They can expect half of this to come from the Community Chest, which is solidly in back of them, and they count on two projects a year—the Charity Ball and the rodeo-feeding job—plus small extras, to raise the rest.

Weaknesses in the County Welfare Department have made other problems too: the lack of enough foster homes means that there are still too many babies and preschoolers staying too long; not enough records on the children who are cared for; a slip-up now and again on the department responsibility for medical and psychiatric examination. But that these things will be ironed out, there is not the slightest doubt—for there is an aliveness to the problems plus an eagerness to lick them in both the Welfare Department and the Soroptimists. And the club's "home committee" is visiting other institutions, studying technical and professional books and listening long and hard to the welfare workers so as to become better informed.

"We know," said one member candidly, "that we've had too much emphasis on bricks and mortar and cooking and cleaning—we know that we have created only a haven as yet—but we had to get it running first, running smoothly, before we could start incorporating into it such things as play programs and group therapy and other psychological assets. We'll get those, though, never fear; it's our dream to make it a true children's home—and as close to perfect in all ways possible."

NOTES

1. The article is reprinted here in its entirety with permission of *Ladies Home Journal*. See Margaret Hickey (Ed.) "Homeless children . . . In Butte, Montana" (September, 1950): 23-24, 227-229.

PART FIVE
VISIONS OF POSSIBILITY

Elizabeth Davey Lochrie: A Well-Ordered Life

Mary Murphy

Women have always made art in the West: pottery, baskets, and rugs, crafted by Indian women, formed the beginnings of a long lineage of western women's artistic expressions. With the advent of Euro-Americans in the West, new artistic traditions entered the region. Scores of women artists worked here; some were self-taught, others trained in the East and Europe. They taught in and founded western art schools and art departments of colleges and universities. They exhibited at county fairs, local gift shops and restaurants, and the region's most prestigious museums. Yet with the exception of Georgia O'Keeffe, most of the West's women artists remain unknown and their work unrecognized. Their obscurity is largely attributable to their gender, but also to the fact that they painted the West. With few exceptions, once painters and their subject matter moved west of the 98th meridian, they became "regional" artists and had to fight for any kind of serious recognition.[1] Women artists' struggles were compounded by the expectations of women's proper roles as wife, mother, and housekeeper. Well into the twentieth century, an independent professional woman was a rare commodity, and a woman who combined a profession with marriage, rarer still. Eve Drewelowe, who lived and painted in Boulder, Colorado, from the mid-1920s until her death in 1989, spent her entire life "struggling against the demands of domesticity." "Housewife!" she often exclaimed, "What an odious word! First! Foremost! Always! My waking thought from an embryo on was my need to be an artist!"[2]

Fortunately Elizabeth Davey Lochrie (1890-1981) enjoyed being a housewife and mother. A supportive spouse and financial security allowed her to combine domestic duties with a successful career as an artist. Elizabeth Lochrie dreamed of being a good mother and a first-rate western artist, and motherhood and painting became twined throughout her life. She once remarked, "when I was younger I was interested in painting babies, my own babies and the neighbors' babies and our beautiful Montana landscape all around us."[3] An encounter with Blackfeet Indians in 1931 ignited a passion for painting Native Americans and led to over four decades of private and public work to improve indigenous peoples' welfare. As she grew older, maternalism increasingly infused her art work and her relationship with Native Americans. She churned out portraits of native babies and children for eager clients, and raised money, collected clothing and medicine, and helped find work for the families of Indians she painted. As a clubwoman, Lochrie sought to educate her peers in art history and make a place for art in Butte's public life; as a public speaker, she brought Native American history and culture to

adults and children. When she was seventy years old, she stated, "I never wanted anything but to paint and have 10 children. My three lovely children came much nearer the perfection I dreamed of than does my painting but the dream has never dimmed."[4]

Elizabeth Lochrie was prolific, producing by her own reckoning, 2,500 large paintings, 3,000 small ones, two illustrated books, three post office murals, and a mural series at the Montana Tuberculosis Sanatorium.[5] Versatility marked her landscapes and portraits, which she worked in oil, watercolor, charcoal, pastels, and bronze bas-relief. Lochrie was best known for her dramatic, richly-hued Native American portraits, but she did not begin painting Indian subjects until she was in her forties.

Unlike many women artists and many mothers, Lochrie won considerable recognition for her work. Early in her career she exhibited in Hennessy's department store in Butte and gift shops and restaurants throughout the state. Eventually represented by the Arthur U. Newton Gallery in New York City, in her later years, she could not produce enough work to keep up with clients' demand. In 1939 a jury selected one of her paintings to represent Montana at the New York World's Fair. She was the first Montana woman artist to have a one "man" show in New York in 1952 and the first contemporary woman invited to exhibit at the Whitney Gallery of Western Art in Cody, Wyoming in 1962. When she was seventy, the Montana Press Association declared her Montana Mother of the Year.[6]

Born in Deer Lodge, Montana in 1890, Elizabeth Davey grew up in a family that appreciated art and enjoyed the outdoor attractions of Montana. In England her mother's family had been enthusiasts of the Arts and Crafts movement, and Mary Rogers Davey, an accomplished needleworker, encouraged Elizabeth's interest in art from a young age. Lochrie recalled that when her mother wanted her silence as a child, she had only to give her a crayon. Frank Stillson Davey was an inventor, amateur historian, photographer, and outdoorsman. He made his family's living as the city engineer for Deer Lodge, but he also bought wild horses and trained them to be racehorses. He taught Elizabeth and her three brothers to ride, hunt, and fish. Indeed, Elizabeth was a tomboy. She caused quite a stir in Deer Lodge when she appeared riding in a divided skirt or in her bloomer-based baseball uniform. Her mother sewed both outfits, the latter for when she played as the only girl on the town's baseball team.

In 1903, just a few weeks before Elizabeth's thirteenth birthday, Frank Davey was killed. The circumstances are obscure. The newspaper reported a tragic accident in the course of a friendly scuffle; the family claimed that the drunken teenage son of a prominent family assaulted Davey when he chastised the youth on his inappropriate behavior in

front of a group of women. The coroner's jury ruled it an accidental death.[7] Suddenly Mary Davey was left with four children to raise. She moved to Butte where she taught home economics in the public school system and established the art department in the city's preeminent department store, Hennessey's—where Elizabeth's work would eventually be sold. Until Mrs. Davey could move them to Butte, the children remained in a boarding house in Deer Lodge, seeing their mother only on weekends.

Elizabeth graduated from Butte High School and headed east to the Pratt Institute in Brooklyn, New York. She took the Normal School course, preparing to be an art teacher, but she saved her lunch money and attended Saturday classes at the Art Students League, where she could observe Robert Henri and William Merritt Chase, both of whom trained many women who eventually painted the West.[8] In later years Elizabeth pursued further art training whenever she could. In the 1920s she studied commercial art through a correspondence course; in the 1930s she spent two summers with Winold Reiss at his art school in Glacier National Park; and in the 1940s she took summer courses in fresco and mural painting.

When Elizabeth graduated from Pratt in 1911, she planned to go to Cairo. Perhaps influenced by a set of watercolors one of her favorite teachers, Arthur Wesley Dow, had made of Egypt, she signed on to teach art and the Bible at a missionary school for girls. She made a trip home to say goodbye to her family, but her plans turned topsy-turvy when she met and fell in love with a young banker, Arthur Lochrie. Canceling her trip to Egypt, she and Lochrie courted, marrying in 1913 and settling in Deer Lodge. Elizabeth's first child, Betty Jane, was born in 1914. The Lochries' second child, Helen Isetta was born in 1917 and their son, Arthur, Jr. in 1923. Elizabeth pursued a career in art while raising her young children. In 1915 she began drawing a series of cartoons for the *Deer Lodge Silver State* newspaper, humorous portrayals of local events, some with political content. She also taught art in her home. Lochrie, in fact, took private students for many years until the demand for her paintings consumed her time and ended the need for that income.[9] She once described her first two decades of combining marriage, motherhood, and art as "20 years of diapers-beds-dishes, tho I always managed to have a room or a corner for my paints and through this busy time held art classes off & on between babies."[10]

In the same year that Arthur was born, Lochrie received her first significant professional commission. The Galen Sanitarium, established in 1912 to treat tuberculosis sufferers, opened a children's building in 1924. The Sunshine Pavilion was named after the popular tuberculosis cure and series of Sunshine Camps where children received nutritious food, rest, and measured exposure to sunshine.[11] The state hired Lochrie to paint

decorative murals for the new unit. Her theme was Mother Goose, and she used her children and many Deer Lodge friends and neighbors as models to illustrate various tales. Her daughter Betty recalled that she appeared as Little Bo Peep. Lochrie painted eight scenes directly onto bedroom walls, nine murals were done in oil on canvas and then glued to walls. Each morning Lochrie placed Arthur in a basket, and accompanied by Betty and Helen, who helped carry art supplies, the family set off to paint.

In 1928 Arthur was appointed Montana's State Superintendent of Banks, and the Lochries relocated to Helena. A busy social life limited Elizabeth's painting time, but she made several posters for charity events. Two years later Arthur's work took the family to Spokane, and then in 1931 he accepted the presidency of the Miners Savings Bank and Trust Co. in Butte. The Lochries moved to 1102 W. Granite Street, which would remain their home until Arthur's death and Elizabeth's departure for California in 1975. In Butte Elizabeth created the well-ordered life that allowed her to fulfill her duties and pleasures as painter, wife, and mother. In addition, she joined numerous women's clubs and had a wide circle of women friends, including Dr. Caroline McGill, who often hosted Elizabeth at her 320 Ranch in the Gallatin Canyon, where Lochrie painted many landscapes as well as McGill's portrait. Helen Clark, another of Elizabeth's Butte friends, was a prolific journalist, who wrote frequently on western art and published several essays about Lochrie's career.[12]

In the 1930s Lochrie once again became a muralist. Submitting many proposed mural studies, she won three commissions in federally sponsored contests to decorate new post office buildings: "News from the States" was installed in Dillon, Montana; "Covered Wagon on the Oregon Trail" in Burley, Idaho; and "The Fur Traders" in St. Anthony, Idaho. "News from the States" was Montana's first mural under the sponsorship of the U.S. Treasury Department's Section of Painting and Sculpture, which encouraged artists to submit drawings that rendered the history and culture of the region and celebrated "the American scene."[13] Lochrie's Dillon mural depicts a group of assorted settlers gathered around a newspaper that has just arrived via the mail. The mural features many allusions to Montana's history and environment: a wanted poster for Henry Plummer, a variety of cowboys and Indians, a partially concealed rattlesnake, a burro laden with a miner's gear. Several of the non-Indian men hold treasured letters; all symbolize western emigrants carving a new life for themselves in Montana, yet eager for news from home.

Lochrie was a grateful employee and supporter of the federal art programs of the 1930s. She praised the federal government as "the first extensive buyer of Art that the American Artist has ever known."[14] Apart from the fact the New Deal art programs helped artists

feed themselves and their families, she said that "the approval and recognition placed on the work of hitherto unknown Artists in every region and district of the country, has so strengthened and encouraged both the creating Artist and the buying Public that Art has taken a huge step forward in National and local appreciation."[15] Lochrie saw the New Deal art programs weaning Americans away from an uncritical preference for European art and increasing appreciation for new works "that honestly depict Americans' current or early life, that show the beauties, problems, development of our individual people."[16] Lochrie wanted Montanans to create an art to match the state's other treasures. In a radio address in 1938 she noted that Montana had made its mark worldwide in terms of its raw materials: cattle, sheep, metals, grains. She hoped that Montana would "also be recognized as the cradle of a true and individual art expression."[17]

Lochrie's artistic influences and interests were many. She was an admirer of Charles Russell and Frederic Remington, as well as Renaissance painters and artists of America's Hudson River School. Like Russell and Remington, she was meticulous in her portrayal of Native American dress and ornament. As art historian Patricia Burnham has said, these were painters who used "costume details as signifiers of historical truth."[18] Lochrie was, however, far more interested in individuals than were Russell or Remington, devoting many more canvases to portraiture rather than history painting. While other of her Montana contemporaries, such as Val Knight and Isabelle Johnson, experimented with modern art, Lochrie never did. She declared representational painting was "the only way I can see beauty. . . . I like a realistic picture, something that shows something and shows it beautifully. And tells a story honestly. And that's what I try to do."[19] Landscapes and portraits were her favorite subjects. In an essay she wrote for the Montana Institute of the Arts in 1953, she described Montana as "an artist's paradise," each season presenting compelling subjects.[20] While best known for her Indian portraits, Lochrie painted many scenes of rural Montana and urban Butte, as well as a set of mural studies of Montana mining for the School of Mines, though the money never materialized to complete the project.[21] The Ford Motor Company commissioned a series of watercolors that depicted Butte's vibrant street life and diverse population to illustrate an essay on Butte in a 1952 issue of *Ford Times*.[22] Her portraiture included studies of Butte physician and founder of the Museum of the Rockies, Dr. Caroline McGill; well-known writer, James Willard Schultz; Governors John E. Erickson and Sam C. Ford. She seemed to like virtually everyone she painted, yet felt her Indian portraits were the most revealing, noting that, "White people often wish the artist to make them look better than they do, but Indians profess a delight in the actual reproduction of their appearance."[20]

Lochrie had a long-standing fascination with Native Americans, dating from her childhood when she had played with Indians in the Deer Lodge valley. In 1929 she painted a portrait of Flying Cloud, a Flathead Indian, and wrote on the back of the piece, "first Indian oil I ever painted, . . . from a 2x3 photo in black and white."[24] Two years later, in the summer of 1931, while accompanying Arthur to a banking convention in Glacier National Park, Elizabeth left the Many Glacier Hotel to sketch Blackfeet Indians who were camped on the grounds. There she met Gypsy Bull Child. The two struck up a friendship, and Lochrie painted her portrait—and jotted on it, "first Indian painted from life."[25] The encounter would change Lochrie's life in many ways. She turned almost exclusively to painting Native American subjects, and her meetings with Indians and her experiences on western reservations triggered a determination and commitment to improving Indian life by whatever means she could.

By the 1930s, Lochrie was in a position to spend the time she needed to pursue her Indian subjects. She was forty-one years old, her girls were teenagers and her son was eight. Arthur had a good paying job and the Lochries were able to afford domestic help. Years later she advised young artists, "In order to give one's uninterrupted attention to one's work, it is almost imperative to travel alone and if possible, by car. One must be free to concentrate, to stop whenever and for as long as the scene prompts, to start out or to stop when you, the artist, wish."[26] This is what she did in the 1930s. Occasionally taking the children with her, but more often leaving them in Butte with Arthur and a maid, Lochrie spent each summer driving from reservation to reservation, courting Indians to pose for her.

One story reveals her persistence. Abandoned by the trader Joe Kipp after bearing him nine children, Maria Weasel Head developed a fierce hatred of whites. When Lochrie approached her in 1942 Weasel Head spit on her and refused to pose. Lochrie spent five hours begging, pleading, offering money and gifts. Weasel Head finally agreed to allow Lochrie to paint her if Maria sat in the shade while Elizabeth sat on a nearby manure pile in the sun. Lochrie offered double pay if she relented, but Weasel Head was adamant. So Elizabeth perched on the manure pile and Maria cursed her and all whites during the session. Lochrie later wrote, "But I got her picture, Bless her poor broken heart, Medicine hat, wolfs eyes and dried apple skin and hate, and I hope that the misery that I endured while painting plus the sulphur of her hate wont turn the pigments black."[27]

Lochrie was one of a long line of Native American portraitists who believed they were capturing the last vestiges of a vanishing race. In the 1830s George Catlin feared that Native Americans might very well become extinct. A century later, Lochrie's own teacher

Winold Reiss painted the Blackfeet, drawing on the same impulse. Reiss, a German artist, who had grown up devouring the western novels of Karl May and the frontier tales of James Fenimore Cooper, first painted members of the Blackfeet nation in 1919. Beginning in the late 1920s the Great Northern purchased his work to use in their advertisements for travel to Glacier National Park. For over thirty years, Reiss's paintings appeared on Great Northern calendars, dining car and hotel menus, ink blotters, playing cards, post cards, and brochures.[28] While he needed the income the Great Northern provided, he worked from an ethnographic impulse: "What finer thing could one do for these brave fine people, who are so rapidly disappearing, than to go out to their reservations, live with them, study them and preserve their wonderful features and types."[29] Lochrie painted in the same tradition. The fact that her initial encounter with Indian models took place in Glacier National Park meant that the network of Indian families with whom she became familiar were those recruited to work as tourist attractions in the Park, meeting visitors at the train station; welcoming guests to hotels; drumming, dancing, and conducting "naming" ceremonies in hotel lobbies.[30] Both the Great Northern Railway and the Park wanted full bloods who had elaborate outfits and could represent, as one advertising manager wrote, "real Blackfeet types."[31] By the time Lochrie met Gypsy Bull Child, she and members of her family had worked in the park for many summers. Her husband George Bull Child was a good friend and model for Reiss. The Bull Childs introduced Elizabeth to other members of the tribe and this set a pattern for how she worked over the next several decades. In 1948 Lochrie lamented that at the Flathead reservation she had not found "a single old-type Indian to model."[32]

Lochrie's time with Native Americans led her, as it did many other artists and intellectuals, to adopt the cause of the Indian. She learned about Indian life from tribal members and in more formal settings. She read history and biography and sat in on anthropology courses. She immersed herself in Indian cultures, particularly Blackfeet; she mastered sign language and could converse in several Indian dialects. She garnered as much history as possible about each of the people she painted and often wrote biographical notes on the backs of her canvases.[33] In 1932 the Blackfeet adopted her and gave her the name Netchitaki, Woman Alone in Her Way. The Blackfeet had occasionally adopted into the tribe whites, whom they hoped would use their influence to advance Blackfeet interests. Euro-Americans fascinated by the culture of "a vanishing people" flocked to reservations in the early twentieth century to record stories, collect artifacts, paint portraits; they took much and gave little or nothing in return. With rare exceptions, even the most sincere came for short visits or fieldwork, then returned to distant studios or universities to write, paint, analyze. Lochrie was unusual: she was a

Montanan who never went far, whose Butte home was open to Indians, and who worked for them at the grass roots level.

Yet, she at times demonstrated a remarkable arrogance and insensitivity toward Indian culture. She once described her attempt to paint the sun dance on the Fort Hall reservation, home of the Bannock Indians. She noted, "they're not quite as friendly with the whites as some of these other northern plains [tribes] are, they still resent us very much. And as they tried to usher me off the reservation, . . . I threatened to go to the Chamber of Commerce and they said, 'Just try it.' So I went to the Chamber of Commerce and told them what had happened and asked for protection, for one of the state policemen to go with me." The person with whom she spoke asked her not to pursue her demands to paint the sun dance and offered to compensate her trip expenses if she would simply let it be.[34]

What to make of this behavior on the part of one who once wrote that "being so poor, even the finest Indian[s] . . . have to submit to the greatest indignities, to being stared at, to having their most sacred religious ceremonies profaned by the noise and clatter of groups of curious whites, who barge in uninvited to be amused by their prayers, their beautiful face painting, and significant ritual costumes"?[35] Lochrie's own commentary on her Fort Hall experience is at first confounding: "We think we have the Indian well-educated and under control, but there are spots where we have to walk very delicately. And with good reason, no doubt. And I think their reasons are justifiable. Often they've been provoked or imposed upon until they have . . . to stand up for their rights. They've been very much abused."[36] This seemingly contradictory attitude was not unique to Lochrie, but shared by many people who considered themselves "friends of the Indians." Many men and women in the late nineteenth and early twentieth centuries wanted both to help Indians and to record or preserve "traditional" Indian cultures. Theirs was a paradoxical task. Often believing that assimilation was the best way for Indians to "get along" in American society, at the same time, they mourned the passing of native languages, dances, clothing, and ceremonies. Artists, ethnographers, writers, photographers, naturalists, clubwomen, showmen, and opportunists, the friends of the Indian were a motley lot. Some diligently used their influence to benefit natives materially and politically. Others "harvested" Indian culture for their own professional or entrepreneurial purposes. Some encouraged Indians to market their arts and ceremonial life to tourists as a way to both preserve that culture and bring money to reservations and pueblos. In all cases the men and women engaged in this work trod uneasy paths between condescension and respect, hard-faced realism and romantic nostalgia, assistance and exploitation. And often, while condemning the provocations or impositions of others, because they admired Indians and had good

191

intentions, they expected themselves to be immune from resentment and to be given privileged access.[37]

Elizabeth Lochrie shared these contradictions. She believed that assimilation was the best path that Indians could take, but she also believed that white society had much to learn from natives. For over forty years, from the time she started painting Indians until her death in 1981, Lochrie worked both sides of this equation. Certainly her paintings were one way to "educate" non-Indians about native people. Yet they nearly always abstracted Indians from history. Few show any background, landscape, or context. Her subjects are pictured in outfits common to the pre-reservation period, but by the time she began painting Indians, they had been confined to reservations for decades, and their material culture decimated by poverty and repression. While many Montanans could, and did, purchase Lochrie's paintings, there were hundreds of others who learned about Indians from her through her public speaking. Around 1940 Elizabeth developed a demonstration lecture on Indian culture and her own painting that she frequently delivered dressed in a heavily ornamented Blackfeet woman's outfit. By the early 1950s she averaged at least six talks per month at schools, churches, men's and women's clubs, sororities, civic banquets. She spoke throughout Montana and the Northwest.[38] In her public lectures Lochrie sought to educate her audiences about Native Americans and to raise money and gather clothing for them. As one reporter summarized a presentation: "Butte has discovered the Blackfeet through the eyes of the banker's wife."[39]

Lochrie and the Indians she painted developed a reciprocal relationship. Initially, she gave trinkets, gas money, small sums to individuals for their portraits—what might have seemed slight recompense for the gift of their visages—but over the years she repaid their gifts with hundreds of dollars in cash, clothing, and hides, and years of care and attention. Like the trade relations that had existed for centuries between Native and Euro-American cultures, the two parties in this relationship formed a mutually beneficial bond and developed real liking and respect for each other.

Lochrie was particularly close to members of the Bear Medicine and Bull Child families on the Blackfeet reservation. She corresponded with the family women for nearly thirty years. Over the decades at least two generations wrote to her about conditions on the reservation, the lack of work and services, the sickness and all too frequent deaths, especially during brutal winters. Lochrie sent clothing, medicine, and money. She shopped for Marie Bear Medicine when Marie had money but could not find a doll buggy for her daughter in Cut Bank or pants for her sons to wear to school. She sent postage stamps to Gypsy Bull Child when she did not have the cash to buy a stamp to

send Lochrie a letter. She shipped art supplies and beads and confiscated elk and deer hides, which she arranged to get from the Montana Fish and Game Commission and the U.S. Forest Service. Lochrie paid for funerals for babies and the elderly, lent tuition money to a son who went to the university, visited a tubercular child at Galen, gave job referrals to relatives who wanted to leave the reservation. In the winters at the end of a day of painting, she worked on quilts she sent to her Indian friends. Elizabeth Lochrie most sincerely upheld the bonds of friendship.[40]

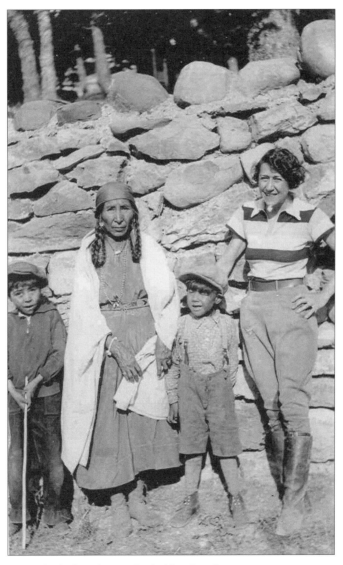

Elizabeth Lochrie with Blackfeet friends.

In addition to her work and her friendship with Indians, Lochrie also carried on a voluminous correspondence with family, friends, clients, and fans. The business of art took an enormous amount of time: supervising the packing and shipping of her work, keeping accounts of who owed what on which paintings, changing frames to suit a client's decor. Still she found time to write and deliver lectures on art history to a variety of Butte organizations. But painting centered her days. When she was at home in the winters she could not devote herself exclusively to art, still, she often spent eight or nine hours a day at her easel, converting her field sketches to paintings. Friends recalled that she would rise at 5 a.m. to scrub the kitchen floor and put the house in order so that she would have time to paint.[41]

Lochrie succeeded as a painter and homemaker in a period in which most women would have chosen one or the other, and few people expected a woman to do both jobs competently. Her accomplishment attracted comment. In 1937 she was introduced to the Butte Rotary Club as having "gained distinction as an artist without neglecting her duties as a housekeeper, wife, and mother."[42] In eerily familiar language she was praised in 1963 as "one of the most dedicated, successful and resourceful artists in the Northern Rocky Mountain region and . . . a[n] eminently successful homemaker."[43]

Elizabeth Lochrie's art and her family anchored a complicated life. She was artist, wife, mother, friend, teacher, volunteer, businesswoman, advocate. Her many roles often pulled her in opposite directions, and meeting her responsibilities posed enormous challenges. In a letter to her close friend Dr. Caroline McGill in 1957, she confessed, "I just live each day, & don't know what may develope next."[44] Yet no matter what developed, Lochrie's commitment to her art never wavered. In an essay on Rocky Mountain women artists, Erika Doss wrote, "Few Western women artists painting in the Rocky Mountain region from 1890 to 1945 chose subjects or styles that perpetuated the nostalgic frontier image of the Wild West that still pervades our historical consciousness."[45] Elizabeth Lochrie is an exception to that statement. Her history painting and Indian portraiture is more in the tradition of Charles Russell—not in style but in message. Russell did everything in his power to enshrine romantic notions of a wild west peopled by noble Indians, heroic Mounties, intrepid explorers, and tough, good-humored cowboys. Lochrie is a part of the tradition of Montana painters who immortalized a past of richly decorative characters, a past accurate in its details, but partial in its truths. Still, despite her shared commitment to the romance of the western past, unlike Russell and Remington, Lochrie included numerous Indian women and children in her oeuvre. Their presence complicates the western art tradition, and forces viewers to see a richer historical and artistic legacy of Montana and the West. It is indeed a legacy of twined painting and motherhood that Lochrie carefully composed.

NOTES

Thanks to the Holter Museum of Art for permission to use material from an early version of this essay published in the 1997 exhibit catalog, *Elizabeth Lochrie: Portraits of a People*. Thanks also to Kirby Lambert at the Montana Historical Society for making many Lochrie images available to me for study.

1. Virginia Scharff, "Women Envision the West, 1890-1945," in Patricia Trenton, ed., *Independent Spirits: Women Painters of the American West, 1890-1945* (Los Angeles: Autry Museum of Western History, 1995):1-7.

2. Erika Doss, "'I *must* paint': Women Artists of the Rocky Mountain Region," in Trenton, ed., *Independent Spirits*, p. 224.

3. Elizabeth Lochrie, "Reminiscences of Elizabeth Lochre [*sic*]," Interview by Marjorie Weeks, 197?. South Dakota Oral History Center, Institute of American Indian Studies, University of South Dakota, No. 177 (Hereafter Reminiscences of Elizabeth Lochre [*sic*]).

4. Clipping, *Great Falls Tribune*, January 10, 1960, Montana Historical Society Library, vertical file, "Elizabeth Davey Lochrie (1890-1891)" (Hereafter Lochrie vertical file).

5. Elizabeth Lochrie to Franz R. Stenzel, September 14, 1962. Elizabeth Lochrie Papers, Montana Historical Society Archives, box 4, file 6 (Hereafter Lochrie Papers).

6. The most complete biographical information on Lochrie is in Betty Lochrie Hoag McGlynn, "A Half-Century of Paintings by Elizabeth Lochrie," an essay by Lochrie's daughter. (Unpublished, provided to author by McGlynn). Unless otherwise noted, biographical information is drawn from this source.

7. *Anaconda Standard*, June 11, 1903; McGlynn, "A Half-Century of Paintings."

8. Clipping, *Great Falls Tribune*, January 10, 1960, Lochrie vertical file.

9. Clipping, *Spokesman Review Magazine*, January 6, 1952, Lochrie vertical file.

10. Elizabeth Lochrie to Diana North, January 7, 1946, xerox copy in possession of author.

11. On treating tuberculosis in Montana, see Esther G. Price, *Fighting Tuberculosis in the Rockies* (Helena: Montana Tuberculosis Association, 1943), and Connie Staudohar, " 'Food, Rest, & Happyness,' Part I: Limitations and Possibilities in the Early Treatment of Tuberculosis in Montana," *Montana Magazine of Western History* 47: 4 (Winter 1997): 48-57, and Part II, *Montana Magazine of Western History* 48: 1 (Spring 1998): 44-55.

12. The most extensive collection of Helen Clark's work is in her papers, collection #6114, at the American Heritage Center, University of Wyoming.

13. On the post office mural project, see Karal Ann Marling, *Wall to Wall America: Post Office Murals in the Great Depression* (Minneapolis: University of Minnesota Press, 1982). On Montana's post office murals, see Elizabeth Mentzer, "Made in Montana: Montana's Post Office Murals," *Montana Magazine of Western History* 53 (Autumn 2003): 44-53.

14. Elizabeth Lochrie, "The Future of Art in Montana," typescript, December 10, 1945. Lochrie Papers, box 10, file 14.

15. Ibid.

16. Elizabeth Lochrie, "American Art Comes of Age," talk presented at Butte Homer Club, January 8, 1940. Lochrie Papers, box 10, file 14.

17. Elizabeth Lochrie, "Art Development in Montana," typescript, for broadcast over KGIR, March 31, 1938. Lochrie Papers, box 10, file 13.

18. Patricia Burnham, "Paintings in the Capitol: The Politics of Art, the Art of Politics," paper delivered at the 24th Annual Montana History Conference, Helena, 1997.

19. Elizabeth Lochrie, "Reminiscences of Elizabeth Lochre [*sic*]."

20. Elizabeth Lochrie, "Montana is an Artist's Paradise," *Quarterly Bulletin of the Montana Institute of the Arts* (January 1953): 4-8, 33-35.

21. See correspondence between Lochrie and various correspondents at the Montana College of Mineral Science and Technology. Lochrie Papers, box 3, file 5.

22. R. H. Fletcher, "My Favorite Town–Butte, Montana," *Ford Times* (July 1952), 2-8.

23. Clipping, *The Montana Journal,* July-Aug 1991, Lochrie vertical file.

24. Painting in box 11, Elizabeth Lochrie Museum Collection, Montana Historical Society.

25. Ibid.

26. Lochrie, "Montana is an Artist's Paradise," 7.

27. Elizabeth Lochrie, "About Mrs. Weasle Head," n.d. Lochrie Papers, box 11, file 4.

28. C.W. Guthrie, *All Board! For Glacier: The Great Northern Railway and Glacier National Park* (Helena, MT: Farcountry Press, 2004), 76.

29. Jeffrey C. Stewart, *To Color America: Portraits by Winhold Reiss* (Washington, D.C.: Smithsonian Institution Press, 1989), 70.

30. Robert H. Keller and Michael F. Turek, *American Indians & National Parks* (Tuscon: University of Arizona Press, 1998), 57.

31. Stewart, *To Color America*, 114.

32. McGlynn, "A Half-Century of Paintings by Elizabeth Lochrie," 20.

33. Dale A. Burk, "Master from the Mining City–Elizabeth Lochrie," in *New Interpretations* (Western Life Publications, Inc., 1969): 87-92.

34. Elizabeth Lochrie, "Reminiscences of Elizabeth Lochre [*sic*]."

35. Elizabeth Lochrie, "Talk on Montana Indians," talk presented at Rotary Club, February 1, 1945. Lochrie Papers, box 11, file 3.

36. Elizabeth Lochrie, "Reminiscences of Elizabeth Lochre [*sic*]."

37. On this relationship between whites and Indians, see Sherry L. Smith, *Reimagining Indians: Native Americans through Anglo Eyes, 1880-1940* (New York: Oxford University Press, 2000) and Margaret Jacobs, *Engendered Encounters: Feminism and Pueblo Cultures, 1879-1934* (Lincoln: University of Nebraska Press, 1999).

38. McGlynn, "A Half-Century of Paintings by Elizabeth Lochrie," 21-22.

39. Clipping, Cut Bank *Pioneer Press,* July 21, 1955, 2nd sec., Lochrie vertical file.

40. See correspondence in Lochrie Papers, box 1, files 6, 8; box 2, file 13; box 3, files 2, 7; box 4, files 11, 19.

41. Clipping, *Montana Standard,* June 24, 1979, Lochrie vertical file.

42. Clipping, source unidentified, July 30,1939, Lochrie vertical file.

43. Clipping, *Helena Independent Record,* June 2, 1963, Lochrie vertical file.

44. Elizabeth Lochrie to Caroline McGill, January 28, 1957. Caroline McGill Papers, Museum of the Rockies, Bozeman, Montana.

45. Erika Doss, " 'I *must* paint': Women Artists of the Rocky Mountain Region," in Trenton, ed., *Independent Spirits*, p. 240.

The Nevada Street School of Art

John McGinley

My appreciation of art was first fostered by such things as Plaster of Paris logs formed over two tin cans welded together, colored with brown shoe polish, and adorned with ceramic frogs and leprechauns. By cutting a square section out of one of the cans and filling the can with dirt, behold, you had a small planter for vines, ferns, or pansies. My mother and her friends created such things. After several months the market for Plaster of Paris was saturated. By that time, the ladies were already off and running on some other project also involving glitter and glue.

My mother, Frances "Sam" McGinley, and her lifelong friend and neighbor, Louella "Lou" Martell, were the avant-garde of practical art forms in our neighborhood. Their influence spread from the few blocks around St. Joseph's Parish up as far as Walkerville, Centerville, into the rural hinterlands of Brown's Gulch, and as far west as Anaconda. As a two-woman school of art, they are probably most famous for their poetry. The poems they wrote were, in fact, messages back and forth to one another during their busy days when they could not even get the time to walk across the street to visit face to face. The poems bemoaned their plights as housewives, chronicled some neighborhood disaster of less than biblical proportions, and from time to time, poked holes in the inflated self-importance of stodgy and conservative husbands.

This is one such exchange between Sam and Lou:

LONG DISTANCE

Here I sit broken hearted,
The telephone and I are parted.
The line is busy so I must grieve,
Tony's asleep so I can't leave.
But as soon as the baby's awake, I'm goin'
Cause I can't stand to drink alone.
Frustrated (Lou)

* * *

DEAR FRUSTRATED

I'm sorry your visit is delayed,

Join me later for coffee or Kool-Aid.

I too feel like I'm in prison,

Mag forgets these kids are his'n.

I'd gladly leave this miserable hovel,

But to do so I would need a shovel.

Pip-pip, cheerio and all that rot.

Hurry over! I'm warming the pot.

Anxious (Sam)

* * *

My father was a very conservative man. But my mother's sense of humor would not be denied, and he found himself the subject in several of her poems. This one was written when a local priest, Father Spraycar, gave my father a live goose for Christmas, and the goose got away. My father spent the better part of an hour running through the neighborhood chasing the goose. My mother chronicled the adventure with this song. (Sung to the tune of "Wild Goose, Brother Goose")

THE WILD GOOSE

1.

Today Mag watched the wild goose fly,

Down the block 'neath the noonday sky,

He tried to grab him but it were no use

'Cause he can't fly like that wild goose.

Chorus

His heart knows what the wild goose knows,

And he must go where the wild goose goes.

Wild goose, brother goose, which is best,

A wandering foot or a heart at rest?

We stood on the porch and cheered him on,
As he ran and leaped across the lawn,
Out on the sidewalk and up the street,
I swear McGinley had wings on his feet.

Repeat Chorus

3.

A bird in the hand is worth two in a tree
Especially when you get it for free.
So while poor Mag was out there "fowling,"
We were screaming, the neighbors were howling.

Repeat Chorus

4.

The goose was flying above so high
His red ribbon brilliant against the sky,
Mag finally caught him, but I'll give you a tip,
He never would have but the poor goose tripped.

Repeat Chorus

The goose was given to our milkman and lived out its days on Elgin Dairy Farm in Elk Park, northeast of Butte.

The genius of these poems was evident not just in the cleverness of the rhymes and the day-to-day working-class subjects, but also in the way the two women involved us children in the process. It was not uncommon, on a summer day, to go into the house to get a drink of water and be handed a sheet of paper and told, "Go take this to Lou and wait for a reply." Off you would go up the street, Lou would read the poem and then sit and write a reply. You stayed with this back-and-forth exchange until it was finished. To hell with the Dodge Ball game you were playing, this was important. As you walked from Lou's to Sam's and back again, you would stop mid-street and read the poem aloud to the rest of the kids playing there. As young as we were, we understood the poems. It was a great honor to be one of the subjects of the poem, even if the poem

was pointing out some truly embarrassing thing you said or did earlier in the day. You learned you could laugh at yourself or be laughed at by others and survive it, as the following poem illustrates:

Dear Sister, H-E-L-L-L-P
Larry lost his glasses,
In itself that's nothing new.
St. Anthony I've prayed stone deaf,
Now I appeal to you.
We don't know where he left them,
He had them Friday night.
He may have left them in the church,
Or removed them for a fight.
They aren't even paid for,
They're only nine days old.
And the price they charged us for them
They can't be less than gold.
So will you please ask your children
If they know where they might be,
And in the meantime please start teaching Braille,
For Larry cannot see.

Other mothers in the neighborhood made copies of the poems, passed them along to friends and relatives and so created a hand-to-hand distribution network with copies ending up not only all over this country but even traveling as far as Ireland.

* * *

Beyond cutting and pasting construction paper, coloring in a coloring book, Church Choir, and piano lessons for the gifted few, there was very little exposure to art in the Catholic education system of the 1950s Butte, Montana. Sputnik was circling the earth, and any child with an IQ in the triple digits (or even mid-range doubles) was being groomed to be a priest, nun, or possibly a great Catholic Scientist who would go forth and meet the Red Menace face to face in the cold reaches of outer space.

Fathers taught hunting, fishing, football, and whatever other sports were available. My father worked two jobs, so we boys fished in what was aptly called Copper Creek where the mercury content in the fish was probably equal to a good-size thermometer. The advantage of fishing there was that it was in walking distance of our neighborhood. Mothers were, for the most part, the only source of any aesthetic education—with the exception of a half hour on Saturdays when you turned on the television, hauled out the John Gnagy Charcoal Set you got for Christmas, and followed along as Gnagy taught you how to draw barns. Likely as not, it was your mother who gave you the drawing set.

* * *

If I were to choose one defining project that, for me, epitomizes the creative energies of these women, it is the Great Stained Glass Window Project. I was in my first year of high school when Sam decided she would make stained glass windows for the front of the house as a Christmas display. The big front window, which was five feet by five feet, would have a Nativity Scene complete with Wise Men (my Mother and Lou said that was an oxymoron) and barn animals. The two side windows, each two feet wide by five feet high, would have angels on them.

To pull this off, Sam informed my father that she would be using three storm windows as the forms for her project. She would outline all the figures using copper wire, glued to the storm windows themselves, and then use liquid plastic to fill in the figures. Rather than use just colored plastic however, she planned on using crushed colored glass, imbedded in the clear plastic before it dried. It was her project, but like any great artistic master of old, she required a huge support team of apprentices to gather the needed materials and assist in the preparations. She began it early in the spring and recruited the entire neighborhood population of children to collect needed colored glass. She worked almost every evening in that basement for months on end.

There was no shortage of children out on the street to pull in and brief on colors of glass needed and then send out into the alleys, vacant lots, and wherever to collect it. That summer probably set a record for numbers of children with cuts on their hands. But they went out and found what she needed in Coke bottles, 7up bottles, old blue medicine bottles, broken vases (don't ask where they got those), and all kinds of odd pieces kids would find when they went to the City Dump with their parents to unload trash. When Sam ran short of light green glass, two of the neighborhood thugs offered to go to the railroad tracks and bust out all the green signal lights for her. She thanked them but declined the offer.

My aunts Margaret and Helen joined in the glass search and recruited my cousins to collect glass up in Walkerville. All through the summer and fall, people with bags of multi-colored, broken glass drove or rode buses down to our house to contribute to the effort. The project went on into the Fall and Winter and finally, three weeks before Christmas, the windows were done. My mother recruited my brother Larry and me to put the windows in place. The damned things weighed a ton. We heaved and struggled and hauled them out of the basement, past the back porch (which she had built), past the flower beds (which she had planted), and out to the front of the house where we managed to get them into place and secure them with screws. Panting and heaving, our hands nicked all to hell, Larry and I hung the windows in about two hours.

Like any stained glass window that you view from the outside in daylight, they did not seem particularly remarkable. Then the sun went down, and we turned the lights on inside the house. Even my father was speechless when he went outside and looked at them. They were primitive and awkward but undeniably gorgeous. Word spread in the neighborhood and every little kid with a scar on his or her hands came to look at the windows. And their parents came, and the Walkerville crowd came, and people from South Butte and the East Side came, and the newspaper came to take pictures, and that year she won the citywide prize for Christmas decorations. Every neighborhood kid could tell a glass story. You could proudly point to a section of the windows, at some color of glass imbedded there, and tell how and where you got that color.

The windows lasted three or four seasons. The bitter Montana winters, when the windows were up, and the hot summers, when the windows were stored in the basement, took their toll. They came apart gradually until no amount of patching would save them. Sam continued to do stained glass but on a smaller scale and in a more traditional form.

The true success of an artist, I believe, is not measured by critical acclaim or wealth but by his or her ability to involve audiences in the process of creation, granting them the chance to contribute to the work whether it is by physical contribution or by their applause and admiration as an audience. Sam, Lou, my aunts Margaret and Helen, and their many creative friends were all successful in doing just that. Sam and Lou are gone, but copies of many of their poems still circulate around Butte and among family and friends out of state. The stained glass windows are gone but somewhere in the archives of the *Montana Standard* there are probably pictures of these windows and an article about them. I hope the photos still exist and that they can be resurrected. They represent a story of creative fire, perseverance, hard work, and the ultimate success of a working artist. And I believe if you looked hard enough in a garage somewhere in

Butte or in a basement or attic, high up on a back shelf, you would, even today, find a Plaster of Paris log filled with dirt and adorned with a dusty frog.

Real art and real artists live forever.

* * *

A VISIT TO ST. NICK

Listen closely and you shall know

Of a noonday trek thru ice and snow

'Twas the 6th of December of '58

The kids all thought the idea great

To visit Santa, so off we went,

But soon our backs were bowed and bent.

Ten kids there were, no less, no more,

And soon we arrived at Hennessy's store.

Into the basement we went real quick,

For that was the lair of good St. Nick.

He looked up when he heard the thundering race,

And a look of pain crossed his whiskered face.

But he listened to each and every one

And sighed with relief when the job was done.

A trip thru toyland was next to remember

On that beautiful day of that fateful December.

Then home by taxi to round out the day,

The driver had hardly a word to say,

But the look on his face was terrible sad,

When one dozen people crawled into his cab.

Now the clerks and the cabbie and Santa I fear

Are happy that Christmas comes just once a year.

From "The Collected Works of Sam and Lou"

Seeing the Forest through the Trees: The Green Legacy of Alma Higgins

Janet L. Finn

ARRIVAL - OCTOBER, 1920

Butte was a bleak and desperate place in the fall of 1920. In April of that year hired gunmen had opened fire on striking miners on Anaconda Road in a violent effort to squelch union activism and oust the Wobblies. Mining resumed in Butte as frightened, defeated miners returned to work under the constant surveillance of military patrols. But the grinding pulse of Butte's massive mining operation was short-lived. By the following spring, the mines were idled in a corporate power play to squeeze the last resistance from an angry workforce and respond to a post-war global downturn in the price of copper.[1] A new arrival to Butte in the fall of 1920 might see fear and determination etched into the faces of working people, and dust and smoke billowing from the mine yards. She might absorb the sights, sounds, and smells of the patchwork of ethnic neighborhoods blanketing the Butte Hill. This first impression would jar the senses—a harsh cacophony that both defined and belied Butte's vision of greatness as "The Richest Hill on Earth."

But Alma Margaret Higgins saw something else in Butte in 1920.[2] Hers was a vision of aesthetic possibility on this raw and rugged terrain. Alma and her husband Warder, both natives of Deer Lodge, Montana, moved to Butte in October 1920. While her husband pursued his career as an independent mine and mill operator, Alma contemplated ways to put her passion for organizing, gardening, civic improvement, and conservation to practice in her new home. Alma had a deep appreciation for the natural world around her, an inquiring mind, and a remarkable capacity to translate ideas into action. Higgins recognized the formidable challenges Butte posed to the aspiring gardener. However, where others saw Butte as irreparably scarred and sullied, Alma saw potential—a city in need of beautification and residents willing to join in the process. She speaks with deep admiration of the pioneers of the garden movement in Butte and their dogged efforts to grow flowers "even in the days of sulfur fumes caused from the open roasting of copper ore." Reflecting on her arrival in Butte, Higgins writes:

> These were the days when Butte was advertised as the most barren place in the whole world, a place where there was not a tree or blade of grass.

Gertrude Atherton wrote a book entitled *The Perch of the Devil*. The setting for her story was in the old days in Butte. The story of the ugliness of Butte was so advertised that even as late as November (1922) at a time when there were many gardens here, Joseph Hergesheimer in a story for the *Saturday Evening Post* wrote, "The surface barrenness of Butte was incredible, as though the copper in its mountains had killed the soil of all other fertility." Evidently Mr. Hergesheimer did not leave his room at the hotel, for just a few blocks away was Broadway, a street lined with good-sized trees. Then, as late as 1926, Archie Rice of Walton, New York received $5.00 from *Liberty Magazine* for his questions, "In what American City is there no living green things, and why?" and the answer, "Butte, Montana, because of the sulphur dioxide fumes from the smelters."

Before coming to Butte to live in 1920, I, too, had some such impression of Butte—at least I thought that the Carolina Poplar, Matrimony vine, and porch box plants were all that could be grown here and that they did not flourish very well. I knew of [a] man who spent $90.00 for plants for his porch boxes, and I had heard that Mrs. D. J. Hennessy had the soil for her lawn and trees shipped from Bozeman, as good soil could not be obtained near Butte. Now when I tell you the following story of my impression of Butte in 1921, when I made a survey of the gardens, you will wonder why I felt it almost a duty to help organize the Garden Club and do my bit to eradicate the old impression of a place where now are grown some of the finest flowers in the country.

We lived in the Mueller Apartments when we first came to Butte. One morning in June I was awakened by the song of a bird. I was certain it was a robin. I awakened Mr. Higgins to help me identify the song. He said, "Go to sleep, that bird is just a sparrow." But I was not satisfied, so after breakfast we took a walk out on West Broadway, and lo and behold there was an apple tree in full bloom and a robin singing to his mate on her nest. Apple trees in Butte, what a surprise. A few days after this, when I was longing for my old garden in Deer Lodge or at least a place were I could dig, I went to the roof of the Mueller Apartments and with a pair of field glasses looked toward the mountains near Deer Lodge. Yes, I was homesick for our old garden. You may not know it, but gardening is the most wholesome, though most fascinating exercise I know of, gardening when not done to excess is an excellent tonic. In lowering my glasses, I found to my great surprise many gardens in every direction. I rushed down to the telephone and told my good friend Mrs. A. J. Christie of what I had seen. Mrs. Christie said, "Come

over and see our garden." I lost no time and that very afternoon had a treat that I have not forgotten. In Mrs. Christie's well-designed garden were blooming lovely peonies, and masses of Columbine, Iris, Larkspur, the likes of which did not grow better in Deer Lodge or Missoula. Then I said to Mrs. Christie, "It is a shame that even Montana people still think that nothing worthwhile can be grown in Butte, so if you will take me to see some of the gardens here I will ask the editor of the *Anaconda Standard* to publish an article about your gardens . . . That summer I visited 80 gardens, for after Mrs. Christie introduced me to a few and I had planned an article for the paper, I became bold and asked to visit the gardens wherever they seemed unusual. Sometime before the Chamber of Commerce flower show, Mrs. Morris asked me to meet with the committee and suggest ways to arouse more interest in growing flowers in Butte. My reply was to have pictures taken of the gardens and exhibit them.[3]

Alma did just that. She sought the assistance of photographer Charles Jenkins, and together they documented forty of the gardens she had visited. She organized a photo exhibit and description of the gardens, sparking community interest in the aesthetic possibilities ready to bloom in Butte. Buoyed by the community response, Alma launched a systematic study of gardens and gardening and a public relations campaign to promote broad-based community participation in city beautification. Alma studied photography so that she could continue her documentary efforts. In short order, she documented gardens, parks, playgrounds, and private and public outdoor art and beautification projects around Montana, produced a series of lantern slide shows (a forerunner of modern slide technology), and presented shows in major theaters throughout the state.[4] She went on to form garden clubs, participate in local, state, and national women's organizations, initiate urban garden projects, and involve school children in city beautification.

This chapter offers a window into the life of Alma Higgins, an extraordinary woman whose love of Montana's rugged alpine beauty, formidable organizing skills, and media savvy combined to nurture Montana's early conservation movement and leave beauty marks on the homely face of Butte. The chapter explores the interplay of aesthetic sensibility and political advocacy throughout Higgins' life work in gardening and conservation. Drawing from her personal journals that document her fifty-year dedication to high mountain experimental gardens, her photography, and the many published accounts of her work, this essay explores the relationship between the solitary, contemplative Higgins and the public advocate. It reflects on the passion for beauty and conservation that sustained both.

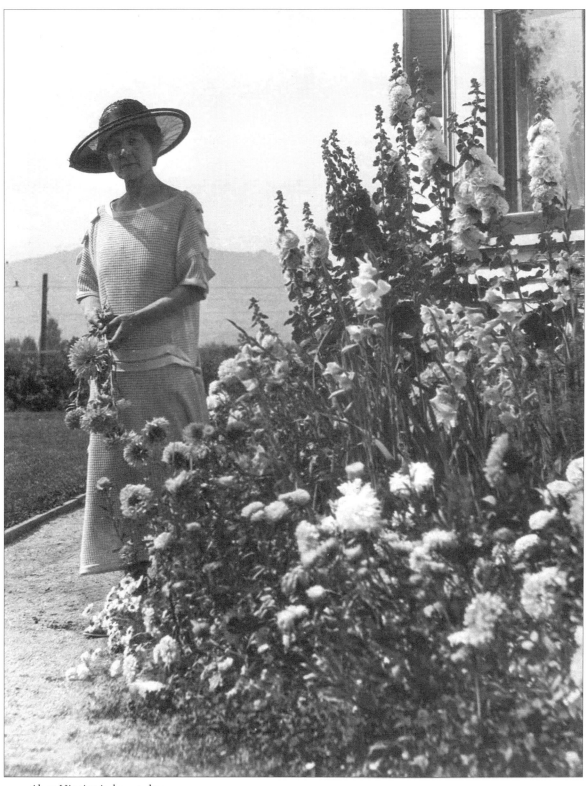

Alma Higgins in her garden.

ROOTS OF PASSION AND ACTION

Alma Higgins was born July 15, 1874, the eldest of three daughters of an established Deer Lodge family. She was a well-educated woman, having attended the College of Montana, Deer Lodge and the Visitation Convent in St. Paul Minnesota, where her interest in literature, music, and the arts was nurtured. Upon her return to Deer Lodge Alma became an active participant in local women's clubs, and began to cultivate an interest in the nascent conservation movement gaining support across the country. On December 12, 1899, she wed Deer Lodge businessman Warder I. Higgins. Their wedding was featured on the society page of the *Deer Lodge Silver State*, which described the newlyweds as "daughter and son of two of the most prominent and highly esteemed pioneer families in Montana."[5]

Alma and her new husband soon found themselves snowbound for their first Christmas together, with no possibility of getting out to cut a Christmas tree. Alma remembers, "In my window garden, I had an Araucaria growing, and this lovely little star pine saved the day for us. We decorated it with loving care and it held us enchanted throughout the yuletide season."[6] In this moment the seed of Alma's idea for a "living Christmas tree" was planted. As she contemplated the little tree gracing her window box garden, Alma began to imagine the possibilities for conserving the Western forests being rapidly consumed by the push of industry. Alma wondered, "How might public consciousness about conservation be raised one Christmas tree at a time?"

In 1902 Alma Higgins organized the Civic Improvement League of Deer Lodge.[7] She readily acknowledged her lack of experience in organizing, but that did not dampen her spirit. Alma took a systematic approach to organizing, learning from others and teaching herself along the way. Shortly thereafter, she began in earnest her campaign to engage the Montana's Women's Clubs in the conservation movement. Alma writes:

> [T]he Montana Federation of Women's Clubs certainly had something to do with pioneering the conservation movement in Montana. At the organization meeting of the Federation in Butte in 1904, I suggested that a Forestry committee be appointed, and out of courtesy to me the President appointed me chairman, although none of us knew what the duties of such a committee would be. When we adjourned for luncheon, Mrs. J. H. Owings of Deer Lodge said to me, "Alma, why did you suggest we have a Forestry committee in Montana? Don't you know we have forests to burn?" My reply was, "If the Federation of Women's Clubs of California and Pennsylvania realize the importance of having a Forestry committee, we better get started in Montana.

Unfortunately, at that time there were forests to burn in Montana, for if a fire got started in a forest it burned itself out—unless blessed rain put it out; for there were no forest rangers or fire fighters in this state in those days. In the spring of 1907 our Forestry and Outdoor Art Committee started a campaign to arouse interest in forest conservation by having Enos Mills, noted conservationist, lecture in six Montana cities. In 1907 I wrote to Senator Joe Dixon and to our Congressman Charles N. Pray at Washington asking them to urge Congress to establish a School of Forestry in Montana. We shall never know if we really initiated the conservation movement in Montana, or what influence our letters had, but in December 1908, the U.S. Forest Service was established at Missoula, in July 1909 a State Forester was appointed, and in 1912, the School of Forestry became an important part of Montana State University.[8]

Indeed, Alma Higgins and her colleagues in the Forestry and Outdoor Art Committee of the Montana Federation of Women's Clubs worked doggedly to spark public interest and participation in conservation. They engaged in dialogue with E. A. Sherman, Montana's newly appointed district inspector of the Forest Service, regarding the role of women in forest preservation, including plans to set aside a "solid block of 1,000,000 acres" in Western Montana that would be a "magnificent monument to the women's clubs of Montana."[9] They organized campaigns to "promote public sentiment in favor of forest preservation."[10] The work of Montana's women's clubs was part of a national progressive conservation movement at the turn of the twentieth century that was largely supported by the efforts of club women.[11] In her discussion of the women's conservation movement Stacy Alaimo notes:

> Although the achievements of the women's Progressive conservation movement have been largely ignored by most conservation historians, their impact was strong. They educated the public about conservation, lobbied politicians, published in conservation journals, and even promoted the "Adubonnet," an alternative to hats decorated with the feathers of endangered birds. The women conservationists brought the political pressure of the large numbers of women's clubs to bear on environmentally protective legislation.[12]

Alma Higgins was a key molder and shaper of the movement. Her thoughts on conservation were inspired by the writings of Gifford Pinchot, a progressive conservationist who established the nation's first forestry school at Yale University in 1903 and who served as the first head of the Division of Forestry, later named the U.S.

Forest Service. In January 1907, Higgins wrote to Pinchot seeking guidance on how women's clubs of Montana could be engaged in the conservation movement. Pinchot referred her to Forest Service editor Herbert Smith who promptly responded:

Your letter of January 28 to Mr. Pinchot has been referred to me. The Forest Service will very gladly cooperate with you to the fullest possible extent. The ways which occur to me in which this could be done are (1) by sending to members of the forestry committee in local clubs, or to others interested, copies of publications of the Forest Service; (2) by correspondence, if members wish to seek information in this way; and (3) possibly by outlining a program for a course of study in forestry, should any clubs wish to take up the subject . . .

Possibly you have heard from Mrs. P. S. Peterson that Mr. Enos A. Mills of Colorado is to make addresses on forestry, largely before women's clubs, in March and April. Is it possible that the clubs in your State could give him any number of engagements some time between March 5 and April 20? . . . The expense to the clubs would be simply that of Mr. Mills' local entertainment.[13]

As she noted in her reflection cited above, Higgins wasted no time in confirming Enos Mills' speaking engagement. Mills, a noted Colorado naturalist, was a champion of conservation. His talk, "Our Friends the Trees," was in demand all over the country at the time. With strong encouragement from Pinchot and President Theodore Roosevelt, Mills spoke out against the degradation of America's forests as a result of rapid industrial development.[14] Mills likely found a special pleasure in agreeing to Higgins' request to speak in Montana as he had spent various winters in Butte working in the mines.[15]

Having received such prompt and enthusiastic response from Pinchot himself, Higgins set about stirring interest in conservation among Montana's women's clubs. A consummate letter writer, Higgins sent the following missive to all clubs in the state in March 1907:

Dear Madam President:

The Committee of Forestry and Outdoor Art of the Montana Federation of Women's Clubs desires to call your attention to some of the reasons why Forestry should be studied in the Women's clubs.

The conservation of our forests is considered the most vital internal problem of the United States today, and every organization and every individual should aid the Government in creating and maintaining forest reserves in both the Eastern and Western states.

In Montana we need to arouse the people to look upon the forestry policy more unselfishly; and as women's clubs are coming to have a certain power in molding public opinion, they can make their influence felt here.

As forestry is one of the new professions, why should this subject not be taught at our Agricultural College at Bozeman, so that Montana boys can procure these much desired positions in the Service?

Besides the practical side of forestry, there is the aesthetic also. Our committee is asking for the cooperation of your club toward creating public sentiment in favor of more beautiful surroundings in our towns and cities. Why not pay a little attention to art out of doors? In the spring of the year it seems natural for individuals to think of making their home ground attractive by the planting of trees, shrubs, vines a[nd] flowers.

Will you not, as a number of individuals, a club, resolve to do something outside of your own home this spring? Will you not undertake to do at least one thing toward making your city more attractive? Are the school yards, public parks, streets and cemeteries planted with trees and shrubs, and are they properly cared for?[16]

That same year, Higgins wrote to the State Superintendent of Public Instruction calling for his support for an Arbor Day Program in schools across the state and the selection of an official "state tree." She encouraged the participation of school children in tree-selection contests and saw Arbor Day programs as yet another means of promoting the larger conservation effort.

Thus Alma Higgins launched her first of many conservation campaigns, blending a call for sound forest policy with an appeal to aesthetic sensibility. She was part of the groundswell of progressive women activists across the country linking resource conservation to home and community beautification, and in effect linking the personal and the political. This sentiment was echoed by many participants in the Women's Progressive Conservation Movement, who mobilized women's clubs across the country, published articles in *Conservation*, the official publication of the American Forestry Association with titles such as, "A Million Women for Conservation," and who turned

out in force at the National Conservation Congresses convened by Pinchot. Unlike her counterparts across the country, however, Higgins did not invoke images of "motherhood," "municipal housekeeping," or "women's work" to garner support. Rather Higgins spoke of the aesthetics of place, the possibility of beauty in unsuspecting moments and places, and the need for collective participation in creating and conserving green spaces.

Curiously, there is no acknowledgment of Higgins' dedication to forest conservation and the creation of a School of Forestry in Montana in the recorded history of Montana state forestry. For example, Gareth Moon's *History of Montana State Forestry* tells a masculine origin story, with no reference to the work of women's clubs.[17] Likewise, the biennial reports of the Montana State Forester (1910-1916) make no mention of women or conservation. Theirs is a story of markets, maps, prices, fires, taxes, production, and training. As historian Carolyn Merchant argues, when forestry came of age as a technical profession around 1912, women were excluded, and with them the "embarrassment of sentimentality" was also expunged.[18] Higgins, however, remained undaunted. She had only just begun her lifelong crusade for a green Montana and a beautiful Butte.

BEAUTIFYING BUTTE

Once settling in Butte, Higgins wasted no time in translating her visions of possibility into reality. She exhibited the photos of Butte gardens at the Montana State Fair and at the District meeting of the Montana Federation of Women's Clubs, held in Anaconda in October 1921. She transformed skeptics into hopeful gardeners and was the organizing force behind the Rocky Mountain Garden Club, founded in Butte in 1922, which soon boasted a membership of 400. Alma was as passionate about research as she was about organizing, and that same year she authored, "The Story of the Christmas Tree," a self-published work that included a brief account of the origins and symbolism of the Christmas tree and text of a Christmas pageant.

This reflection on the meaning of the Christmas tree brought back memories of the Christmas of 1899 when she had decorated the window box pine. In 1921, Higgins decided to share her idea with others. She crafted the Higgins' Christmas card depicting their living Douglas Fir. William Kelly, of Butte, editor of *Western Tourist*, encouraged her to send the card to newspapers around the country. And so her "Living Christmas Tree" campaign was launched, encouraging families and communities to celebrate Christmas by decorating a living tree as an act of conservation and community building. Higgins took her campaign nationwide, sending letters to 750 newspapers across the

country to promote the living Christmas tree concept. In order to learn where the first living tree was decorated for a community Christmas celebration, Higgins sponsored a nationwide photo contest and contributed the $5.00 prize money. In 1923, *American Forests* published an article by Higgins entitled, "A Living Tree that Tells the Story," promoting the use of living trees for community Christmas celebrations. The article sparked nationwide interest and inspired "the planting of the first national Christmas Tree on the White House grounds in 1924."[19] The White House tree, in turn, prompted families and communities to light and decorate their own living trees. Higgins' inspiration earned her the title of "Christmas Tree Lady."

Committee in charge of Butte's first Garden Week, 1922.

Butte's long cold winters may have nurtured Alma's love for Christmas trees. But, ever the optimist, Alma also had her sights on spring. In April of 1922, Alma initiated Butte's first Garden Week. While cynics might have called it a foolhardy gesture, given Butte's fleetingly brief growing season, the indefatigable Higgins seized the moment to bring gardening to the people. And with her keen organizing skills and her media savvy, Higgins became the driving force behind the first National Garden Week celebrated in 1923. A laudatory article in the *Christian Science Monitor* notes:

> National garden week is observed every spring by many organizations all over the United States, but few people realize that the idea originated and was first carried out in a city which at one time had the reputation of being one of the drabbest, most discouraging looking metropolises in the world. In the great copper-mining region of Montana is located the city of Butte. In the days when copper ore was baked in the open and fumes of sulphur which escaped from this process made the city a place devoid of vegetation, it became proverbial that Butte was a city having neither natural beauty nor acquired loveliness. It is now 25 years, however, since the processes which made floriculture difficult have been conducted in the old way. Gradually the inhabitants of Butte have come to realize that this difficulty no longer confronts them, and each year has seen new lawns and trees appear, with here and there a garden.[20]

Higgins wrote news articles suggesting strategies for promoting community participation in National Garden Week. In them she offered the following advice:

> . . . ask local garden experts to write articles for the newspaper and broadcast talks from radio stations; [include] quizzes on Freedom Gardens and nutrition; special garden page in Sunday paper, cooperation with USDA on its food production and conservation program; lectures on Freedom Gardens by horticulturists from extension services. Form Junior Garden clubs, hold contests for best vegetable gardens grown by children; establish school and community gardens. Cooperate with the General Federation of Women's Clubs in the "Seeds for Peace" project—send vegetable and flower seeds to people of foreign countries who need garden seeds. Help starving Europe feed itself.[21]

Higgins followed her own advice, directing her energies at a flurry of local and regional efforts. In May, 1922, Higgins recorded her vision for Butte. In an essay entitled, "Butte in 1930, A prophecy" she writes:

In our imagination, let us look at the city of Butte eight years from the present time. Many additions have been made for its beauty, and the comfort of its citizens that were promoted by the "dreamers" in 1922 and 1923. On every residence street there are fine shade trees, the majority having been planted under the direction of the Park Commission. Those planted during the past few years are an equal distance apart, and of uniform size. A number of small parks have been established within the city limits, school yards have been attractively planted with trees and shrubs, and every lot with a residence on it has been transformed by the planting of trees, flowers, and grass. Vacant lots are being used for children's vegetable and flower gardens, and for neighborhood experimental gardens. Butte has become known as the city where the most beautiful pansies in the world are grown. As a result of the combined efforts of a number of organizations with the U.S. Forest Service, Big Butte has been planted with native evergreens, shrubs and wild flowers, and it is now one of the most popular parks in the city."[22]

Over the next decade, Higgins dedicated herself to realizing her prophecy. She continued to document the possibilities of gardening not only in Butte but also throughout the state. She took her exhibits on the road, touring the state with lantern slide shows of Montana gardens. By 1923 she had taught herself photography and expanded her documentary photography projects to include a lantern slide show of playgrounds to promote community interest in the playground movement. Higgins was a firm believer in the adage that a picture is worth a thousand words. In her public lectures she encouraged other clubs and civic organizations to plan slide shows and conduct photo contests as a means of raising public consciousness and promoting participation in community beautification efforts. In 1924 Higgins launched a campaign to promote town forests and tree planting in public parks and school grounds. She enrolled in a course in horticulture through Cornell University. In 1925 Higgins authored an article for *The Montana Woman*, the publication of the Montana federation of women's clubs, wherein she championed the "City Beautiful" campaign. Higgins wrote:

> . . . the women's clubs, for many years have taken a keen interest in civic improvement work. Parks have been created, children's playground established, trees planted, cemeteries made beautiful, flower shows given and the bill-board nuisance abated, but we need concerted action on the parts of people in the entire community to make our cities truly beautiful.[23]

She went on to call for a statewide contest to choose the town with "the most beautiful streets, the best designed parks, the most attractive school grounds, and the finest

home gardens."[24] From Higgins' point of view, there was no reason Butte could not be the winner in all categories. In 1928, she initiated an outdoor beautification project at the School of Mines. Over the next four years, Higgins served as landscape architect on a project that transformed the campus and engaged the cooperative efforts of women's clubs, men's clubs, Boy Scouts, Girl Scouts, and Camp Fire Girls. In 1929 Higgins launched her own talk show on KGIR radio.[25] The weekly broadcast featuring garden and conservation talks ran during the spring and fall for four years. In 1933 Higgins organized the Wildflower Preservation Society in Butte. The Society worked in cooperation with the Forest Service to plant several hundred trees in Thompson Park, a recreation area on the outskirts of the city.[26]

Butte youngsters planting trees, circa 1925.

In addition to her boundless energy directed to local and statewide beautification and conservation projects, Higgins maintained her ties to national organizations. For example, in 1924, she attended the National Convention of the General Federation of Women's Clubs in Los Angeles where she promoted the planting of community Christmas trees and town forests. She served as vice-president of the American Rose Society from 1924 to 1931. Once again, Higgins connected her national stature to local practices by promoting the cultivation of roses by Butte school children. Higgins led a cooperative effort involving the Butte public schools and the Rocky Mountain Garden Club. In 1927 school children purchased and planted 1500 rose bushes at twenty-five cents each, and in 1928 they purchased and planted 2500 bushes. The Garden Club provided lessons in rose cultivation and offered prizes for the best roses grown by

children and the best essay written about their experiences of gardening. In the late 1920s and early 1930s Higgins served additional terms as President of the Rocky Mountain Garden Club. In this capacity she began to promote interest in cultivation of native alpine plants and the design of rock gardens adapted to Butte's high altitude and harsh climate.[27]

ACTION AND REFLECTION

Alma Higgins' indomitable public presence was both balanced and nurtured by her deep love for and connection to the land, be that intimate garden spaces or the craggy peaks of the Rocky Mountains. Throughout her life Higgins found solace in gardening and sought to capture and create that beauty in unexpected places. In the text accompanying one of her slide shows entitled "Art in the Garden" Higgins quotes Frederick Law Olmsted, America's preeminent landscape architect:

> A garden is an expression of an idea just as much as a painting, a statue, or a building, and like these demands aesthetic feeling, creative power, and executive skill . . . what artist so noble, has often been my thought, as he who with far-reaching conception of beauty and designing power, sketches the outline, writes the colors and directs the shadows of a picture so great that Nature shall be employed upon it for generations before the work he has arranged for her shall realize his intention.[28]

Alma sought to emulate this philosophy in her own landscape designs, from high alpine gardens to bursts of color transforming pockets of urban space in Butte. In 1933 Higgins designed and planted an urban garden alongside the Presbyterian Church on Butte's Westside. The space was dedicated to the cultivation of rare shrubs, rock garden plants, and wild flowers. In reflecting on this transformation of urban space Higgins commented, "Here a space of ugly waste has been transformed into a spot of beauty where the citizenry of Butte may pause and feast their eyes upon a creation of beauty while on a walk or on their way to work."[29]

Alma Higgins was widowed in 1935. The death of her husband seems to mark a transition to a more pensive time in her life. While Alma kept up numerous public conservation and beautification activities, she also immersed herself in research, daily journaling, and ongoing reflection about her relationship to the land, soil, and flowers she so loved. In the summer of 1935 Higgins began to develop an extensive alpine garden at her summer cabin in the Tobacco Root Mountains, adjacent to one of her husband's mills, some fifty miles south of Butte. From January to July of 1936 and 1937

Higgins lived in Los Angeles where she immersed herself in further research for her book, *The Christmas Tree, Its Origins, Legends and Symbolism of the Ornaments.*[30] She returned to Montana for the summer and fall, seeking refuge in her mountain retreat. Over the next several years, Higgins lived in her mountain cabin for as long as the weather permitted, arriving in early summer and often staying until mid-December. Her daily journal entries provide glimpses into the private Alma, the woman with a deep love of her mountain home and an aesthetic sensibility grounded in detailed knowledge of alpine floriculture. She writes:

> **September 29, 8:30, Temp. 20 . . .** So many things I planned to do have not been done. Now the plants are <u>frozen</u> that are to be put in the experimental bed. I know what is the matter—I am too fussy about the construction of the garden and the preparation of the soil, and I have given up too much time in the morning to cleaning house and writing letters. Today, just as soon as the ground thaws out, I shall work in the garden. Fortunately I have those old riding trousers that were made of heavy suiting. I must have had them since 1903 or 1904. It was not the fashion <u>then</u> for a woman to show her form so the trousers were made bloomer style at the top with heavy cuffs at the knees. They are warm and just what I need this time of year . . . My back aches, my hands hurt, and I am tired all over—but most of the plants have been placed in the experimental garden and that is a satisfaction.[31]

> **Friday, Oct 20: 6:30, Wind, Clouds, Temp. 27, Glorious dawn** . . . This morning I was awakened by a glow of rosy light in my bedroom—and when I looked out, the sky was a light rose, then in a second it became richer in color, a color beyond my pen to describe. Some of the clouds in the south were a marvelous tone of this rich rose while others were almost pure gold. The western sky was almost as vivid as a sunset. The Highlands deep bluish purple, the sky above robin egg blue, clouds, rose, yellow, mauve. This glorious spectacle was worth getting up to see. Now I am going back to bed.

> **Saturday 28 [October] 2:30, 26 degrees** . . . White clouds are swiftly rolling from west to east. Part of the time the moon is covered with a thin cloud and there is a large rosy ring about the moon. When the clouds disperse the moon shines forth in all its glory from a sky of deep midnight blue.

> . . . Being alone does not bother me, but tonight I thought of the danger of walking up and down the icy steps, and over the slippery rocks to the spring.

When I looked toward the old boarding house I thought of the days when my dear old sweetheart and I lived up here and when in 1916 he employed seventy men in the mine and mill. The old mill is demolished and the new one is over a half mile down the hill. The watchman for the property lives near the new mill. I sometimes wonder if I am just a little queer to live up here all alone. I believe I would feel sorry for any woman who would do the same thing. . .

Higgins in riding trousers at cabin.

. . . Now for a warm bath in the 16″ by two foot bathtub—right size to bathe a baby. Oh, how I would enjoy a hot bath in a big tub. It would take out a lot of muscular pain which garden work brings on. Yes, I love it up here with all its happy memories and associations. Now I am planning a lot of work— sowing seed—cleaning the seed I gathered this fall and doing some letter writing. The days are never long enough to accomplish all I plan to do each morning.[32]

Sunday, December 10 [1939] . . . I have decided to go to Butte Dec. 21 and to Deer Lodge on 23. How I hate to leave my dear little house, my place of peace and contentment, my Shangri-la . . .

. . . There is so much I want to do: mount the pressed flowers, color the pictures, write several articles on gardening—wall gardens, garden pools, etc. I also want to revise my pageant, write my Christmas story for children.[33]

Thursday, July 25, 1940. My disappointment was so great when I saw the garden, I lost interest in it, therefore have not written.

The ground hogs ate off all the campanulas, the violas, the edelweiss, and the dianthus, and ripped off all the blooms of the poppies. Jack could not find the traps so they were not set—as I had expected.

The pools near the house were both dry, and there was no water in the tank. Another disappointment.

"The worldly hopes men set their hearts upon turn to ashes." I had dreamed all winter about the beauty of the plants about the upper pool. Some of them are lovely, particularly the Allium and Fragrant Bog Orchids.[34]

Higgins was faithful in her documentation of alpine gardening, the daily labor entailed, and her deep sense of place. Hopefully, these brief excerpts provide a glimpse of the private Alma and of the finely-honed aesthetic sensibility that fueled her desire to communicate to larger audiences, spark consciousness, and effect change. Even as she sought refuge in the isolated beauty of the Tobacco Root Mountains, Alma dedicated herself to conservation and education efforts and the public relations campaigns needed to promote them. For example, as Montana joined the automobile age with major highways crisscrossing the state, Higgins found another opportunity for linking conservation and aesthetics. Writing to Montana club women in 1938, Higgins advocated their involvement in roadside beautification projects. She wrote:

Roadside beautification is closely related to gardening. However there is a great difference between landscaping a highway and landscaping a park. Our problem in roadside development is to keep the natural beauty of the old road as far as is practical. First there is the healing of the scars which have been necessarily made in the construction of the wide, safe, straight highway. The shoulders and banks must be made green again; not with artificial planting but with native trees, shrubs and flowers. These are to be planted so carefully that in a few years it will appear as though Mother Nature herself had done the work. Bank planting has proven an economy in many states, saving 50% of the cost of maintenance.

Our next greatest problem in roadside beautification is the unsightly billboard. The billboard is the only form of advertising which gives us nothing in return for our compelled attention. Newspaper advertising provides news service; magazine advertising supplies reading matter; radio advertising offers entertainment. But the rural billboard destroys our peace of mind, and spoils the beauty of our countryside.[35]

Higgins appealed to Montana women to adopt the pledge, "I favor products not advertised on the landscape," and urged club women to take up the cause.

During World War Two, Higgins promoted the Victory Garden movement. She coordinated photographic displays and promotional exhibits in the store windows of Butte merchants, featuring slogans such as, "It's Patriotic to have a Vegetable Garden" and "Food Will Win the War and Write the Peace." As the war ended, Higgins took up the call for Peace Gardens. Speaking before the General Federation of Women's Clubs convention in Portland, Oregon in 1948, Higgins argued:

In these days of national unrest and international discord, brought about in great measure by misunderstanding, we need more gardens; not alone for the food they produce for ourselves and the undernourished peoples of other countries, but because of the physical relaxation, mental poise and the spiritual inspiration they provide.[36]

Once again, Higgins linked concerns for national and international consciousness raising efforts to local actions, concluding with a call for broad-based, intergenerational participation in community gardens and garden clubs, development of city parks, and roadside beautification.

Alma Higgins continued her tireless activism until her death in 1962. Using every form

of media available to her, she promoted conservation, beautification, participation, and sustainability. With one hand on the hoe and one on the pen, Alma Higgins practiced a lifetime of passionate politics. Her legacy lives on in pockets of green bursting forth from surprising nooks and crannies in Butte, in the remnants of rock gardens at her alpine retreat, in the diverse activities of garden clubs across the state, and in the scholarship and practice of the College of Forestry and Conservation at the University of Montana, even though her name is largely unknown. Her life is testimony to the fact that one can make a difference by everyday actions. Moreover, it takes action every day to make an enduring difference. Alma Higgins was an undaunted spirit, able to see beyond the scars to the possibilities of Butte's landscape. A reflective gardener, systematic researcher, lifelong learner, and astute political advocate, Alma Higgins is a remarkable example of the power of one woman to create change. Those who continue the struggle for healing and conserving Montana's landscape into the twenty-first century would do well to embrace Alma's soul and spirit.

NOTES

1. For insightful historical analysis of this era see Jerry W. Calvert, *The Gibraltar: Socialism and Labor in Butte, Montana, 1895-1920*. (Helena, MT: Montana Historical Society Press, 1988).

2. This chapter is based on review of published documents and the personal records of Alma Margaret Higgins, PC 121, Boxes 1-4, (Hereafter Higgins Collection) Butte-Silver Bow Public Archives (hereafter BSBPA).

3. "Of Gardening in Butte," Higgins Collection, PC 121, Box 1, File 2.

4. Higgins Collection, Box 4, contains her original slides.

5. "A Brilliant Wedding," *Deer Lodge Silver State* (Deer Lodge, MT), December 13, 1899, 2.

6. Alma recounts this story in Helen Clark's article, "Christmas Tree Lady of the Nation," which appeared in *American Forests* (December, 1959): 13-14, 42, Higgins Collection, Box 2, File 1.

7. "Mrs. W. I. Higgins of Butte, Montana," *National Gardener* (May-June, 1956): 35, Higgins Collection, Box 2, File 1.

8. Text from Alma Higgins' 1948 radio address in conjunction with meeting of the Northwest Conservation League in Missoula. Dr. Kenneth Davis of the Montana Conservation Council asked Higgins to tell listeners what part the Montana Federation of Women's Clubs had in the pioneer conservation movement in Montana. Higgins Collection, Box 1, File 1.

9. "Movement by Women to Preserve Forest," *Anaconda Standard* (Anaconda, MT), June 3, 1907, 3.

10. "Club Women Assemble at Capitol," *Anaconda Standard,* June 16, 1907, 7.

11. See Stacy Alaimo, "The Undomesticated Nature of Feminism: Mary Austin and the Progressive Women Conservationists, *Studies in American Fiction*, 26 (1998): 73-97 (Hereafter Alaimo, "The Undomesticated Nature of Feminism") and Carolyn Merchant, "Women of the Progressive Conservation Movement, 1900-1916," *Environmental Review* 8 (1984): 77 (Hereafter Merchant, "Women of the Progressive Conservation Movement").

12. Alaimo, "The Undomesticated Nature of Feminism," 75.

13. Herbert Smith, letter to Alma Higgins, February 9, 1907, Higgins Collection, Box 1, File 15.

14. See Alexander Drummond, *Enos Mills: Citizen of Nature* (Boulder, CO: University of Colorado Press, 2002).

15. See Enos Mills Cabin website, "The Quotable Enos Mills from *The Spell of the Rockies*," http://home.earthlink.net/~enosmills.cbn/eamquotes/qspell.htm (accessed March 27, 2004).

16. Higgins to women's clubs, 18 March 1907. Higgins Collection, Box 1, File 15.

17. See Gareth Moon, *A History of Montana State Forestry* (Missoula, MT: Mountain Press, 1991).

18. Merchant, "Women of the Progressive Conservation Movement," 77.

19. See notes on history of living Christmas tree campaign, PC 121, Box 2, File 2, BSBPA. Higgins is quoted in Dawn Dillon, "Christmas Tree Lady of Nation," *Great Falls Tribune* (Great Falls, MT), December 12, 1958, 15. See also "Butte Woman Pens Magazine Story on Christmas Tree," *Montana Standard,* December 19, 1937, 8.

20. "Butte the Beautiful—A Civic Enterprise Led by a Woman," clipping from *Christian Science Monitor*, no date, Higgins Collection, Box 1, File 15.

21. See articles and typewritten manuscripts, Higgins Collection, Box 1, File 15.

22. Typewritten manuscript, Higgins Collection, Box 2, File 1.

23. *Montana Woman,* Higgins Collection, Box 3, File 15.

24. Ibid.

25. Higgins Collection, Box 2, File 2.

26. Higgins Collection, Box 3, File 2.

27. Higgins Collection, Box 1, File 15.

28. Higgins, in her narrative presentation, "Art in the Garden," written to accompany a lantern slide show, attributes the quote to Frederick Law Olmstead. She does not cite a source for the quote. See Higgins Collection, Box 2, File 2.

29. See typewritten manuscript with description of the garden, Higgins Collection, Box 2, File 2.

30. Despite Higgins' many efforts, the manuscript was not published.

31. Garden Journals, Higgins Collection, Box 3.

32. Garden Journals, Oct., 1939-1940, Higgins Collection, Box 3.

33. Ibid.

34. Garden Journals, Sept 1940-Sept, 1950, Higgins Collection, Box 3, File 15.

35. Higgins, "Roadside Beautification," *Montana Woman*, 1938, 16, Higgins Collection, Box 2, File 2.

36. Higgins, "Seeds of Peace," *Montana Woman,* February 1949,16, Higgins Collection, Box 2, File 2.

THE SCHOOL OF MINES CAMPUS AS WE HOPE TO SEE IT.

Landscape design for School of Mines, 1929.

Sara Godbout Sparks: Clean Up is Women's Work

Ellen Crain and Janet L. Finn

When Sara Godbout Sparks is feeling daunted by the work of environmental clean-up, the view from Big Butte offers perspective—she looks out over the remains of 100 years of mining, the scars of which etch unforgettable memories into the geography of Butte. The daughter of a boilermaker who worked for the Anaconda Mining Company, Sara sees the wounds and appreciates the human drama that produced them. She takes in the smatterings of green sprinkled like bits of confetti celebrating the possibilities of a different future on this terrain buffeted by a relentless past. Sara says with a smile:

> I used to know Butte by its bars. Now I know it by waste dumps. I don't know what that says about my life. When things get really difficult and we're in negotiations, I like to go sit up on the big M and look at the Butte Hill. And I remember what it used to look like and what it looks like today, and I say, "Thank you, God." And if I left today, I've done a really good job.[1]

Sara Godbout Sparks is the Environmental Protection Agency (EPA) Remediation Project Manager for the Silver Bow Creek/Butte Area Superfund site, part of the

country's largest EPA contaminated site targeted for clean-up. A smart, skilled professional, Sara takes a no-nonsense, no-frills approach to her work. She sees clean up as a team effort whose success depends on the talents and contributions of many players. At the same time, Sara can be hard as nails when the situation demands it, leaving no doubt that she means business.

Copper runs deep in Sara's world, as does her sense of responsibility to Butte's people and landscape. Sara is the daughter and granddaughter of men who worked on the Butte Hill, and she lost a brother in a mining accident some years ago. She recalls, "My family helped create mining problems, and I was coming back to clean them up. I was fed off mining dollars, so mining is in my blood. I see a need for it. I appreciate miners and the history associated with mining." Like Alma Higgins before her, Sara also wants to be part of making a different Butte legacy, one that heals and rejuvenates the city's battered landscape. In contrast to Alma's feminine grace, Sara approaches her work in hard hat and steel-toed boots.

Sara grew up in a world surrounded by mines and miners, playing baseball on fields that had been leveled from waste dumps. She also grew up under the influence of strong, hardworking women, and she learned about feminine strength and determination from her mother and aunts. Sara's mother worked as a nurse in Butte for more than forty years. As Sara describes:

> My mother had to work her whole life. She worked full-time as a nurse, and she also worked hard to raise six kids. She basically had to work a lot of the time just to make sure there was food on the table. She worked during strikes when my father wasn't working. I believe my mother would have loved to stay home and be "June Cleaver," but she couldn't. She was a tough woman; even when she was sick she would get up and go to work.

Sara took another path, one shaped both by her mother's role modeling of commitment and hard work and by the power and place of mines and mining among the men in her family.

> I remember when I told my parents I was going to [Montana] Tech. My sister Kathy is a teacher and Pat had a degree in psychology and a MBA, and here I come, I'm gonna go to Tech . . . When my brother was killed, he left a wife and two children, and she was only twenty years old. And I remember my father, who did not have a college education, saying to me, "you can do whatever you want in your life once you have a good diploma

from college. I will not have a daughter of mine depending on some man." So I went to Tech, and I struggled. It was hard. When I started there were very few women in any of the engineering fields. And I'll never forget, my dad—he didn't have a lot of money—and Texas Instrument had just come out with one of the first calculators. I was still using a slide rule. I remember he brought the calculator over to me and said, "I don't know why you're doing this, but if you're determined to do it at least I can buy you a calculator."

In 1980 Sara earned her degree, and she had plans. "What I really wanted to do when I came out of school was to go underground, but that was December, 1980, and the mines closed in 1981. I had spent time underground, and I really wanted to work underground as a safety engineer." Instead she worked on Butte's first Radon study, then began work on Superfund clean up. Although her work did not take her underground, it did take her into a world dominated by men, a world she learned to navigate with skill, wit, and determination. "I always remember the first time my mom came to my house and there was a pair of hard-toed boots there. She wanted to know, 'who do these belong to?' She thought I had a man in the house. 'No, Mom, they're mine.' 'Oh, my god, you're going to wear those?' 'Yes.'"

Sara continues:

Oh, my God, you know dresses have no place in my life. The best part of my job is construction. I love construction, I love design, and I love being out there with heavy equipment. One of the things I did right from the get-go, rather than being the person that was in charge or whatever, I used to go and have lunch with the men that drove the heavy equipment. I'd bring my sack lunch and we'd sit down, and they'd tell me, "If you do this on a slope this will happen," or, "This is how you do this in construction." And so, you learn a lot when you are going to school in engineering, but then on the other hand it's all book learning. And these men—I guess it was because I was willing to put on a pair of jeans and a pair of hard toes and go out there and sit right next to them—they taught me so much. They didn't look at me like, "Oh, my God, somebody from the government." It was more like, "It's the yacky blonde, she's back." That was so important; it gave me a firm understanding of construction activities. The other thing I learned as a woman, is women have to be smarter, and they have to work harder. To this day that has not changed. I go into a meeting, and it's easily twenty men and myself. Unless Robin Bullock or someone from ARCO is there, there are no women. So, I could not look at myself as being the only woman, because I would have alienated myself. I

would have made myself different. I had to fit in and be part of it. I'm tough; I'm intelligent, and I had to put out the image that I am not afraid of these men, not for one second. I will not back down.

Despite her willingness to be tough when necessary, Sara does not go it alone. She credits the success of clean-up efforts in Butte with teamwork, and she considers herself lucky to be part of such a dedicated team.

This has been a team effort. There is no way this could have been done without many parties. I see my role as a facilitator. Of course, I'm a regulator, I work under the law, and people have to do things we tell them to because it is the law. I use that authority, it's my job, but I also check my ego. I believe in compromise in dealing with people rather than forcing something down people's throats. Instead we can say if you're willing to do a little more here then let's see what we can do over here. It's a compromise, and by doing that many areas on the Butte Hill that would not have been reclaimed . . . were reclaimed. So I can't say enough about the potentially responsible parties, especially ARCO, stepping up to the plate and spending millions to tie it all together.

Sara sees compromise as key to success, and she firmly believes women are more willing to compromise than men. She credits a good deal of the success of clean-up efforts in Butte to the willingness of women in decision-making positions to work together for best results. "I see women in every phase of life more willing to compromise."

Sara brings a genuine warmth and friendliness to her work. She takes time to build relationships, to meet people for coffee, and to take an interest in people's lives beyond the issue at hand. She is known for her warmth, openness, and professionalism. "I hug people, people like to be hugged. People like to have a smile come at them. Some say it's difficult being a woman in this position. On the other hand there are times when it's very beneficial to be a warm, open woman. It opens some doors that might not otherwise be opened."

As a Butte native and resident, Sara's commitment to clean up runs deeps. Unlike outside consultants who fly in and out preparing technical reports and delivering edicts, Sara is part of the community. She lives with the consequences of her actions and faces both the praise and criticism of her neighbors. Sara finds being born and raised in Butte a benefit to her job, but it also means she takes the heat directly when her neighbors are not happy with the direction of clean-up work. Sara recalls:

I'll never forget. I was painting my kitchen and something controversial was going on. These guys from Walkerville come in, and I'm in my kitchen drinking coffee and painting. They're bitching at me about something. Finally, I said to them, "Listen, you're sitting here drinking my coffee and smoking cigarettes in my house, you might as well pick up a paint brush and help me." They did.

Sara Godbout Sparks.

Sara Sparks is part of the vibrant legacy of women's lives and labors in Butte. She tempers toughness with warmth and authority with compromise. She recognizes the power in shared leadership and community participation in the issues that affect people's lives. Armed with hard hat and steel-toed boots, a degree and street wisdom, Sara cuts a formidable figure that belies her slender frame. Sara sees herself as a stronger person for the influence of mining men and hardworking women in her life. And Butte is a better place to live today, thanks to Sara. But we ask that readers not take our word for it. Instead, take a walk up Big Butte, sit at the base of the M, and look over the city below. Count the green spaces. Remember the words of Alma Higgins, "Here a space of ugly waste has been transformed into a spot of beauty where the citizenry of Butte may pause and feast their eyes upon a creation of beauty while on a walk or on their way to work." Offer a word of thanks to Alma, Sara, and a century of women in between who have acted against the odds to make Butte a healthier place with a memorable beauty all its own.

NOTES

1. Quotes are taken from interview with Sara Godbout Sparks by Ellen Crain, June 2004.

The Art of Life

Andrea Stierle

EDITORS' NOTE: The editors contacted Andrea Stierle, artist and professor of chemistry at Montana Tech, requesting permission to include one of her drawings in *Motherlode.* The ensuing conversation offered a fascinating glimpse of this multi-talented woman and her work as both artist and research scientist. We asked Stierle if she would write a personal profile reflecting on her life and her passions for art and science. She generously agreed, contributing the essay that follows.

Drawing by Andrea Stierle.

Andrea was the third daughter of a Marine officer and his beautiful wife. He was Italian, she was German, and their union was a complex, challenging mixture of passion and violence. Andrea was a shy child, and the itinerant lifestyle of the career military family was a difficult one. Each move meant breaking into the cliques at each new

school. She was often the only "military brat" in a class populated with girls who had practically shared hospital bassinets. One of her ways of dealing with the challenges associated with constant moving was to find a quiet corner of her current world where she would write and illustrate fairy tales. Andrea actually taught herself to draw even before she could write. Her father had an illustrated biography of Leonardo da Vinci, and she remembers spending countless hours copying his sketches and paintings. Andrea's love affair with Leonardo led not only to her deep passion for art, but also to an appreciation of the intimate association and inherent connection between art and science.

Her father's last two tours of duty were in San Diego, where he retired in Andrea's senior year of high school. Andrea attended an all girls' Catholic high school where she had the opportunity to learn from teachers who truly loved to teach. She discovered speech and drama, and learned to mask her shyness competing in tournaments around the country. She would never let anyone hear her practice until the end of her senior year. One week before graduation she let her father hear her valedictory speech—two days later he died of a massive coronary.

From the time she was a little girl, Andrea passionately desired to spend her life as a healer, a medical doctor, performing miracles that would save other people's lives. Unfortunately, her desires suffered a fatal collision with reality during her junior year of college. While working as an emergency room premedical volunteer, she discovered two damning weaknesses in herself: the inability to deal with bodily fluids displaced from their natural environment, and the inability to detach herself from the people she was trying to help. Even after two years of exposure to the ER and acceptance at several medical schools, she realized that she probably was not cut out to be a medical doctor. So she modified her dreams.

Her second choice was marine biology—she would swim with the dolphins. Unfortunately, in 1980, the man of her dreams whisked her off to a remote mining town about 1200 miles from the nearest ocean. Andrea was working at the University of California at San Diego and had been accepted into Scripps Institution of Oceanography when a tall, handsome young chemist walked into her office and changed her life forever. She and Don literally fell in love at first sight. He proposed on their third date and was offered a faculty position at the School of Mines in Butte shortly thereafter. She left behind the only home she had ever really known to start a new life with Don in wild, wonderful Montana. Following a two-week honeymoon in Mexico (during which Andrea almost died of dysentery) the couple moved to Butte, Montana. A fitting climax to such a honeymoon adventure.

Butte was a different place in 1980—not quite the trendy and revitalized town into which it is slowly evolving. Decades of mining had left most of the hillsides devoid of vegetation and few trees graced the town. Many of the uptown buildings were in very bad shape and signs warning of the consequences of arson were posted in windows all over town. There were few gardens—many people just stuck plastic flowers in the ground because the long winters, cool summers and rocky soil made more "organic" gardens a little too risky. To their "California eyes" Butte was a place to endure for a year or two, but not a place to stay.

Almost in spite of themselves, however, Andrea and Don found themselves falling in love with Montana in general and with Butte in particular. The cross-country skiing and backpacking were phenomenal, and the surrounding countryside was just an extension of their backyard. Realizing that Montana was not the best place to study marine biology, and that Butte would never be a place to swim with the dolphins—despite the rising water in the Berkeley Pit—Andrea reinvented herself yet again. She decided to earn a Ph.D. in Chemistry at Montana State University, with a specialty in Natural Products Organic Chemistry. As a graduate student at Montana State University, she was able to isolate the first host-specific toxin against an important weed pest, spotted knapweed. She was also able to pinpoint the cause of a debilitating fungal infection that was destroying banana and plantain crops throughout the subtropical regions of the world. Her efforts literally saved the economic lives of people around the world.

She was ultimately drawn towards medicinal chemistry, however, and the quest for new drug-worthy compounds. Even during her four years in graduate school, Andrea began an enduring research collaboration with Don. She had always appreciated the unique dynamic of research at the boundary layers. Her specialty area was the isolation of bioactive metabolites from microorganisms inhabiting unusual ecological niches. Her first project together with Don entailed the investigation of the symbiotic microbes growing in the tissues of marine sponges (Symbionts live in very close association and can be mutually beneficial to each other—much like the Stierles themselves!). Other researchers in their field were studying the chemistry of marine organisms, including sponges, corals, tunicates, sharks, etc., for compounds with drug potential. Many exciting compounds were being isolated, but always in tiny amounts that required extensive recollection in delicate reef ecosystems. Both staunch environmentalists, the Stierles were uncomfortable with the collection philosophy of some of their colleagues. They suspected that the real chemists were microbes living within the tissues of the macroorganisms. Their hypothesis was rewarded with several interesting compounds. The most exciting of these showed activity against HIV, the causative agent of AIDS.

In 1988 Andrea and Don went to Scripps Institution of Oceanography for a combined postdoctoral appointment (Andrea) and sabbatical (Don). They returned to Butte in 1989 and have been there ever since. In 1991 the excitement over a new anticancer drug, taxol, launched a collaborative effort with Gary Strobel (Montana State University). Taxol was isolated from the bark of the relatively rare yew tree, which had been logged to the point of endangerment by the enthusiastic "harvesting" of the Pacific Northwest in the 1980s. There were only enough yew trees left to provide taxol for about three years, according to government estimates. The researchers attempted to find a fungal source of the drug, examining the fungal symbionts in the bark and needles of yew trees in Montana, Idaho, Washington, and Oregon. They found an unusual fungus in a tree near Glacier National Park that produced taxol in culture. Andrea had the honor of naming this fungus, *Taxomyces andreanae.*

Andrea and Don are equally passionate about their research and their love of teaching. They always have students in their lab. Their current research arena is the Berkeley Pit, the mile-wide, open-pit copper mine that was abandoned by the Anaconda Company shortly after the Stierles arrived in Butte. It has been slowly filling with water ever since, and it helped make the greater Butte area part of the largest Superfund site in North America. Where others saw toxic waste, Andrea saw an unusual ecosystem — one that could be easily accessed from their lab in Butte. They are currently studying microbes isolated from the acidic, metal-rich waters of the Berkeley Pit. Their preliminary data suggests that the microbial inhabitants of the Pit could be the richest "ore" produced by the Richest Hill on Earth.

In 1999, Andrea was diagnosed with ovarian cancer, and saw her hope of having children come to an end. Again, reinventing her dreams, Andrea decided that if she couldn't have children, she would help make Butte a little better place for other people's children. She shared her vision of a hands-on Children's Learning Center in Butte, Montana, that would bring to life her conviction that learning is a lifelong adventure that embraces the inherently intertwined principles of art and science. The process is slow but the Stierles have not yet given up on this latest dream for the children of Montana

When not in the lab, Don and Andrea love the outdoors, and engage in many activities including cross-country skiing, boating, mountain biking, and backpacking. Andrea paints in oils and watercolors, and both Don and Andrea love to create stained glass and pottery, although Andrea is just barely learning to center her pots. Despite all odds, Andrea has developed a gorgeous perennial garden in Butte which includes the only kiwi plant in the county. She's still working on orange trees.

PART SIX
FOR LOVE AND JUSTICE

Butte's Women Warriors: Taking a Stand Against Poverty and Violence

Janet L. Finn and Ellen Crain

The slender woman tucks a wisp of hair behind her ear with one hand and roughly smudges a tear from her cheek with the other. She takes a deep breath, sighs, then speaks softly, "You're right, the scars you can't see hold the pain and shame that just won't go away . . ." For the next hour, ten women tell their stories and comfort one another. When the weekly support group for battered women comes to a close the women gather their coats and disperse into the frigid winter air. Cloaked in a thin layer of courage and buoyed by the cautious hope of their companions, each woman faces the challenges and uncertainties of the week ahead. Some return warily to their homes, some to the home of a friend or loved one, and some to Safe Space, Butte's shelter for battered women.

Patty Boggs, health coordinator for the North American Indian Alliance, takes in the woman sitting across the desk from her. Putting the woman at ease, Patty gathers a basic medical history and explains what the breast and cervical exam involves. Patty remembers the woman from Women's Health Day sponsored by the North American Indian Alliance Women's Coalition last fall. The woman pulls the tattered pamphlet from her bag. She is thirty-eight years old and here for her first Pap test. Through public education campaigns and promotion of prevention and early intervention, the Coalition has been in the forefront of affordable and accessible women's health care.

These vignettes offer windows into the worlds of Butte women's activism and community work. Over the past forty years, as copper mining declined, women's work expanded into new social and political terrain. At times women strode into the public eye making claims on behalf of children, families, the Butte community, and, occasionally, themselves. At other times women worked behind the scenes, building clandestine networks of solidarity and support. This chapter explores differing pathways of women's community work in the late twentieth century, their moments and spaces of convergence, and the lessons learned along the way. We begin in Butte circa 1960, a key moment of community transition that reverberated from mines to marriages to City Hall.

SURFACE AND UNDERGROUND: BUTTE, MONTANA—1960

The copper strike has been underway since mid-August, and there is no end in sight. Hardship wears on faces and weighs on shoulders as folks make their way through the biting January air. The strike began with a cataclysmic bang—on the night of the Yellowstone earthquake, the night the mountain fell, damming rivers and creating the eerie Quake Lake, 150 miles from Butte. But Butte families feel as if that mountain has fallen on them. The New Year opens with headlines in the *Montana Standard* that read: "Mine-Mill Files NLRB [National Labor Relations Board] Charges—Anaconda accused of unfair labor practices." The following week's headlines report: "Butte Strike Talks Break Down." And by the end of the month the *Montana Standard* brings grim news: "County Says Relief Purse Empty," "Committee Appeals to Public as Food for Needy Runs Low."[1]

Mining families in Butte were experiencing a sense of despair and uncertainty unmatched since the days of hopelessness that marked the mine closures following World War I and, later, the great Depression. The city's population had dwindled to 46,000, about half its peak size. Nearly 20 percent of the population was living in poverty, with 10 percent living on incomes of less than $1,500 per year. By February 1960, 2,400 Butte families were receiving emergency food and clothing, with four hundred new families a day seeking assistance.[2] The Aid to the Needy program had converted Butte's Civic Center into a relief center where volunteers packed and distributed hundreds of free lunches each day. The committee was seeking permission to get slaughtered elk from Yellowstone Park as a meat source for Butte families.[3] Although the strike ended in mid-February 1960, after holding the city hostage for 181 days, its bitter aftermath lingered. There were 2,083 members of the Butte Miners' Union Local #1 at the start of the strike. 700 of them lost their jobs with the closure of the Emma and Anselmo mines and cutbacks of other underground operations. Seventeen million dollars in payroll had been lost over six months, and Butte families felt every penny of that loss. Some Butte residents call the 1959 strike "the one that broke the backs of the unions."[4] Others speak of the irony of returning to work for a nickel less than they were earning at the start of the strike. Disillusionment with and distrust of both unions and the company were running high as those men lucky enough to still have jobs returned to the mines. Butte women had managed to hold the body and soul of the community together one more time, but just barely. Many women had been the sole providers for their families during the strike—sharing night shifts at the hospital and waiting tables in restaurants hungry for business. They were reluctant to return to the home front once their husbands were earning a paycheck again—mines and mining were too fickle for that. Despite the

237

protests of their spouses, many Butte women kept on working both outside the home and within, fueled by strong coffee and getting by on precious little sleep.

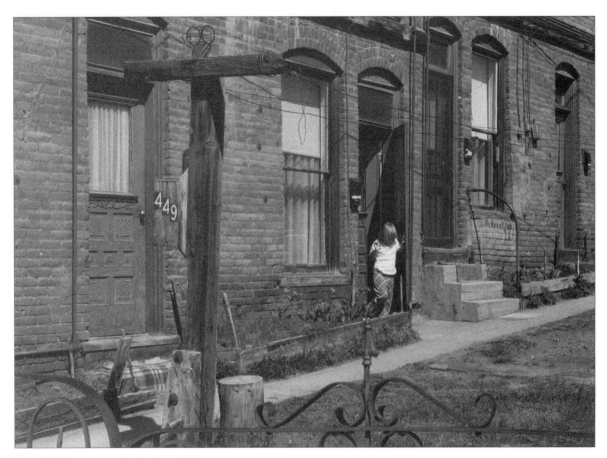

Child in uptown Butte, circa 1960.

Some women began making public claims to their right to work and challenging the local order of things. A labyrinth of formal and unwritten rules had restricted the labor of married women, pregnant women, and women with children. A wedding band had been the kiss of death for school teachers, and a female body heavy with child was not to be seen in front of a classroom or clad in a nursing uniform. But Butte women persisted and resisted. Some asserted their right to work in their chosen professions. Others questioned the wage disparities between men and women, and began to demand equal pay for equal work. Gender relations were changing in Butte, and women were the change makers.

The worlds of mining men were under siege on many fronts. Not only were the jobs fewer than in days past, the nature of the work was also shifting. Mining in Butte had long been defined by the separation of surface and underground worlds. For years

men worked "collar to collar," leaving Butte's mile-high landscape behind to enter a domain of masculine labor buried deep in the ground. Mining men in Butte created close bonds underground through their shared stake in daily survival. As one Butte woman puts it, "those mine shafts held many family secrets, and the underground walls burned with the stories of home life." Men pushed their limits underground and slid their dollars across the bar for a shot and a beer at the end of a shift, counting on women to be managing the home front. By the mid-1950s, however, that landscape of labor was changing. As the Berkeley Pit, Butte's massive open-pit copper mine, began to consume Butte's east side, miners found their old rules giving way, and their underground worlds exposed and upended. By 1960, underground mining was losing ground to the gaping pit, which was also consuming close-knit ethnic communities in its path. Men's relations to landscape, labor, and loved-ones were in flux. Teamster strikes in July and September, 1962 sent waves of fear through the community, as Anaconda company officials warned of the serious consequences, including the loss of 2,000 more jobs, that could result.[5] Work resumed in a matter of weeks, but tensions lingered. Contract negotiations in 1964 provoked more doubt about Butte's copper-laden future. Journalist Hunter S. Thompson captures the mood among men on a trip through Butte in 1964:

> Once Butte was one of the wildest, richest boom towns in the West. But now there is an atmosphere of age and tiredness about the place, a feeling that the very earth you walk on is worn out from too much mining, that the air you breathe has gone stale from too much steam and ore dust, and that even the people are running low on energy . . .
>
> I arrived in Butte in the middle of a "wildcat" strike that shut down the hill for three days. Groups of men in dirty work clothes stood around on downtown street corners or sat at the long wooden bars of the city's myriad taverns, drinking 10-cent beers and looking bored and depressed and very much like stage versions of surly, out-of-work Irishmen.[6]

Butte women empathized with the plight of mining men, but they were taking no step backward. Women were coming together with neighbors and friends to discuss the unions, the company, and the blind spots of men. They examined the situation, and they saw things differently, from their positions as women. From those positions they began to envision new courses of action and new possibilities for women's work and lives. Some women moved into new public spaces as volunteers and employees of the federally-funded anti-poverty programs emerging in the 1960s. Other women were moving first underground and then into the public eye to protect women from domestic

violence and to challenge ingrained beliefs and values that made battering of women tolerable. In the process these "grassroots warriors" were redefining women's work and community work and expanding their political and economic possibilities.[7]

FIGHTING THE WAR ON POVERTY—EXPANDING THE TERRAIN OF WOMEN'S INFLUENCE

By the mid-1960s the American Dream of getting ahead seemed ever more elusive as Butte families found it harder and harder to catch up after each successive strike. The reality of widespread economic vulnerability could not be denied in Butte. Likewise, the nation as a whole was coming face to face with the shameful reality of widespread poverty in the land of plenty. Movements for civil rights and social justice were making links to economic injustices dividing the nation. In 1964 President Lyndon Johnson led a national call to arms to fight the War on Poverty. The Economic Opportunity Act, cornerstone of the War on Poverty, was signed into law in August 1964. It launched the founding of community action programs across the country that called for "maximum feasible participation" of community residents, especially those adversely affected by social and economic conditions. This was to be a new sort of civic process, informed by the expertise of those whose voices were all too often silenced, including women. Sociologist Nancy Naples, in her insightful account of the multifaceted ways in which the Economic Opportunity Act and the resulting community action programs influenced women's lives, explores women's pathways to participation and ways in which women "built political houses" that linked their longstanding commitment to community work with new forms of political decision making.[8] Naples looks at the ways in which women's paid and unpaid work was often blurred as they expanded efforts at community building. She considers how women's race and class background shaped their entry into the war on poverty and the ways in which calls for "maximum feasible participation" were sometimes undercut by notions of professionalism that shut out the views and voices of working-class women. Naples describes women's work in the war on poverty as "activist mothering" whereby women drew on the strategies and skills of community work they had developed as mothers. At the same time, as they expanded the political nature of their community work, they began to re-examine the politics of home and family. Overall, Naples suggests, women saw the holistic needs of the community and sought ways to challenge the limits of categorical funding that divided problems and programs into discreet pockets. While Naples focused on women in major metropolitan areas such as New York and Philadelphia, a number of her themes also resonate with the experience of Butte women.[9]

As other chapters in this book address, Butte women have had a long history of collective work for community survival and well-being. However, as the poverty rates rose and the relief funds dried up, it was apparent that local efforts had been nearly exhausted and a stronger safety net was needed. Some were eager to see federal dollars bolster community action plans, and others were eager to find work. Corinne Shea went to work as a secretary for Butte's newly minted anti-poverty program in 1965. By 1970 she was the assistant director, and she went on to assume directorship of the organization—by then known as the Human Resource Development Council—in 1981, serving as the first woman director in the state. Corinne's story and that of her colleague and friend Gert Downey, who succeeded her as director, are highlighted in the profile in Chapter Twenty-one.

President Johnson's War on Poverty was part of his larger social and political vision of the Great Society. The anti-poverty programs were geared to address the interlocking impacts of poverty in a comprehensive way. They opened up opportunities for improved housing, health care, job training, child care, nutrition, senior services, and youth development. By 1968 Butte had established a Community Action Program, created the Silver Bow County Anti-Poverty Council, and opened a neighborhood service center offering a range of programs to address community concerns, including Head Start, Neighborhood Youth Corps, Legal Services, and the center for a six-county Concentrated Employment Program.[10]

In addition, the Johnson administration envisioned comprehensive urban renewal as a way to move beyond the war on poverty to the realization of a great society that embraced social and economic justice and created cities that were magnets for opportunities rather than receptacles of social problems. With this utopian vision in mind, the Model Cities Program was launched through the authorization of the Demonstration Cities and Metropolitan Act of 1966. Butte political leaders quickly got on board to bring the Model Cities Program to their community. In 1968 Butte became one of the first seventy-five cities in the country to be awarded a one-year planning grant. With federal funding of eighty-seven thousand dollars, the board launched a comprehensive study of the city's economic, social, and physical problems. The first planning board was made up entirely of men. By 1970, however, women had gotten a foot in the door and two seats on the twenty-member board.

The planning group identified the "model neighborhood" that would be the focal point of Butte's revitalization efforts. The designated neighborhood encompassed Walkerville, the central business district, and south Butte to Front Street.[11] The neighborhood population was 18,000 and the majority of the residents were working-class families,

Woman forced to move from Pennsylvania Block, uptown Butte, circa 1970.

242

many dependent on the mines for a paycheck. The planning group proposed a governing structure for the program that would involve local government and draw on the expertise of resident neighborhood councils. The group also appointed ten study committees who began to systematically address issues related to youth, education, employment, health, economic development, social services, physical environment, senior citizens, housing, and recreation in the Model Neighborhood. Although women remained in the minority, they gained membership on every committee. The study groups began to appreciate the structural rather than personal nature of poverty affecting Butte families. They considered how the realities of poverty came into conflict with a community ethic that placed a high value on independence and helping one's own, which made it difficult for people to seek assistance. They began to explore the web of social problems and family struggles from delinquency to neglect and violence that seemed to be exacerbated by conditions of poverty.

The efforts of the local study teams were under way just as Butte was reeling from another long and financially catastrophic strike. Their research resulted in a grim demographic profile of Butte: They found that Butte/Silver Bow had the state's highest unemployment rate, largest welfare caseload, lowest median income, most severe health problems, highest general and infant mortality rates, highest birth rate, and largest aging population.[12] The caricature of miners' hardy independence and the historical patterns of family-to-family and neighbor-to-neighbor supports in meeting social welfare needs were not enough to sustain Butte. Further, their economic analyses pointed to the flagging force of mining. Technological changes dating to 1920 had been transforming the nature of mining, such that fewer and fewer workers were needed to produce the ore. The study committees predicted that the copper market would experience more fluctuations over the next forty years, with each depression being longer and more severe. They spoke to the connections between the disintegration of the copper market and the weakening of the social fabric of the community, connections that Butte boosters did not necessarily want to hear. They mapped the physical infrastructure of Butte, documenting the decay that permeated the central business district. And they spoke to a taboo subject in Butte, the prevalence of alcoholism in the city.[13] A paycheck, a shot, and a beer had gone together since Butte's raucous early days. Butte was the celebrated city that worked hard and played hard. Bars were extensions of the community and places where the dirt and danger of life underground gave way to song and story. Drinking was a key part of community culture and history. And by 1970 alcoholism was beginning to be recognized as a social problem whose power and pain infiltrated the intimate spaces of family life throughout the mining city.

Through active participation on the board and the various neighborhood councils representing subsections of Butte, local residents began to have a voice in the ways in which federal initiatives translated into local programs meeting local needs. Although women were in the minority, they were nonetheless present and making their voices heard. The closer the process came to the grass roots of the community, the greater women's representation and participation. For example, women made up 10 percent of the planning board, but 30 percent of the North and Southside Neighborhood Councils. Meeting minutes document women's participation and the ways in which they made connections among interlocking issues affecting children, families, and neighborhoods.[14]

As the Anti-Poverty Council reflected on the multiple forces impacting family life, they sought a comprehensive approach to intervention. They proposed the creation of the Human Resource Council to act as the formal coordinator of services and supports and as a site for community education and advocacy. In addition, the group proposed the development of a family service center, envisioned as a one-stop center offering a holistic approach to family support, advocacy, and development, and establishment of a day care center with capacity for fifty children. By 1970, the thirty-three member Human Resource Council was up and running, a family service center had opened its doors, and the day care had enrolled its first thirty children, the majority from single-parent families. These programs were of significance to the community at large and to Butte women in particular. First, women who had experienced Butte's hard times had been represented in the planning process, and had a say in setting priorities for community action. Second, new employment opportunities were opening to women through these programs. And third, these programs were recognizing and addressing concerns of children and families as public issues that need the support of public resources. As the welfare of vulnerable children and families became recognized as social as well as personal concerns, Butte women, like women throughout the country, expanded their domain of influence in public decision making. In addition, neighborhood councils created spaces for women to champion civic improvement and social justice efforts that directly impacted their families, neighborhoods, and social groups. For example, Sam McGinley, a mother of five, used her position on the Southside Neighborhood Council to advocate for the demolition of abandoned buildings that posed a safety hazard in her neighborhood. Naomi Longfox used her position on the Southside Neighborhood Council as a platform from which to address Native American concerns and advocate for the establishment of the North American Indian Alliance.

The utopian visions of model cities were cut short when the Nixon administration failed to appropriate additional funding in 1972. However, forty years after the passage

of the Economic Opportunity Act, a host of programs supporting children, families, and seniors remain a vibrant part of the community, and women are active in all levels of their operation, from volunteering as foster grandmothers to directing the Human Resource Council. Over the years Butte women, like their counterparts in New York, Chicago, and Philadelphia, have blurred the boundaries of paid and unpaid community work and called attention to the health and well-being of individuals, families, and communities as *public* issues. They continue to remind us of the value of "women's work," the work of caregiving that has too often gone unnoticed and unpaid. They have staked their claims to participation and expanded women's political influence. Building on the legacy of Elizabeth Kennedy and the Housewives' League discussed in the Introduction, women of Butte continue to take a stand personally and publicly when the health and safety of children and families are at stake.[15]

FROM UNDERGROUND TO SURFACE: BUTTE WOMEN'S ACTIONS AGAINST BATTERING

While anti-poverty programs brought many women into public decision-making arenas, early efforts to address violence against women were underground. Over the years, people often looked away from the abuse of women at the hands of their partners. The tolling of nine bells warned the Butte community that a man had been hurt underground, but no bells tolled to signal injury to a woman in her own home. Personal memories and stories passed along in hushed voices woman-to-woman reveal the anguish many women tried to hide. One Butte woman states that alcohol and violence have long gone hand in hand in Butte. She recalls one of the members of her mother's club who endured terrible beatings. The woman got embalming fluid from a local mortician to try to cover the bruises. Another woman tells of a friend who was married to an abusive man. She was a talented craftswoman, weaving rugs from the rags, scraps, and remains of clothing that were part of her life and the lives of her children. Each rug was unique, and each contained the stories and memories connected to the bits of fabric woven in. The rugs became scrapbooks of her life, laden with the memory, history, and emotion of a family too often silenced by violence. Their creation was her solace and respite, acts of love and fragments of joy that disrupted the loneliness and fear in her marriage.

A Butte woman tells a story of the ways the risks of mining were woven into the very substance of intimate family ties:

> Mining was dangerous. My grandfather died in the mines. My mother and grandfather used to tell me, "Never let your husband leave for work mad."

No matter how angry you were, no matter what had happened, you had to put it behind you and tell him that you loved him and kiss him goodbye because you never knew but what it might be the last time you saw him. No problem or fight should ever be so big as to stop you from kissing him goodbye and telling him you loved him. Because no woman wants to live with the guilt of having seen her husband for the last time when she was filled with anger. Don't miss the chance to make amends.[16]

Her words suggest the intimate power that kept many women tied to sometimes loving, sometimes violent relationships. Many women found their efforts to break free of violence stymied by feelings of shame and guilt as well as economic dependence. Alcohol, violence, and tradition-bound expectations of women fused together in problematic ways that left women trapped and vulnerable.

In the early 1970s a few Butte women began to do something about violence against women. Working quietly behind the scenes, they began to organize their own version of an Underground Railroad, crafting woman-to-woman networks, identifying safe houses, and moving women to safety. Grace Sicotte was the driving force behind these clandestine efforts. The daughter of an independent news publisher from Butte, Grace had learned early on to critically examine what others took as "acceptable" practices and to follow her conscience. Grace married young, raised three children, and worked in a variety of non-traditional jobs. When she divorced in 1970 Grace faced the challenges of a single working mother, and she began to dedicate more and more of her time and energies to women's concerns. Grace worked as a dispatcher, taught exercise classes for women, and began a women's resource center in conjunction with the YMCA. In each of these settings, Grace encountered women who were experiencing abuse. She began talking with other women engaged in community work and found they were witnessing similar problems. Grace began to build a network of safe homes for battered women. The work was risky, and the privacy of the homes was carefully guarded to protect the woman who had been battered and those moving her to safety. Grace served as a main contact person, and she worked closely with a nurse from the St. James hospital emergency room and a handful of other dedicated volunteers. In time, the network extended from Butte to Helena and Bozeman.[17]

As Grace and her collaborators witnessed the extent of domestic violence in their community and appreciated the danger of the work they were doing, they focused their efforts toward public education and the creation of a permanent facility to provide safety and support for battered women. Grace's passion for women's issues soon filled to capacity her Women's Referral Center, tucked away in a small space at the YMCA.

She provided literature on women's health and rights and the realities of violence against women, and she invited women to come together and share their stories. After years of working behind the scenes, Grace began to speak out publicly, taking advantage of every forum open to her—women's clubs, church groups, garden clubs, and voluntary organizations. She launched self-help groups for women and found herself learning more about the plight of battered women as participants began to break the silence and give voice to their experiences. By 1976 she had been elected to the board of directors of the Montana Women's Resource Network, dedicated to providing information on women's employment and rights and setting up women's groups. Grace reached out to women throughout the community and region, mobilizing an action group with the goal of establishing a shelter. Marilyn Maney Ross was one of Grace's early recruits. Marilyn recalls:

> Grace was the motivating person. Her concern was that in order to provide safety and any kind of services to battered women and children we had to have a place, we had to have bricks to do this. So that was the big challenge . . . to get a building where we could set up a shelter. There was a lot of reluctance in those years for people to become directly involved with it.[18]

Community beliefs and traditions run deep, and the women found themselves up against walls of resistance when they broached the subject of violence against women. A core group of activists, that also included Claudine Micone, Diane Manning, Reverend Dallas Doyle, Reverend Bob Craver, and Sister Madeline Burns, began planning for a shelter and lobbying community decision-makers for support. Marilyn remembers:

> There was reluctance to get involved with what people saw as domestic situations—don't stick your nose in another man's business. We ran into some resistance from some of the preachers. They thought we were encouraging women to divorce their husbands. We met some resistance with, "why are we airing Butte's dirty laundry in public", and the old, "well they probably deserved what they got". . . It was a real chore finding people who would serve on the board of directors.[19]

The group persisted. They began to formalize their plans under the auspices of a newly formed non-profit group called the Butte Christian Community Center, founded in 1980. As the organization's initial articles of incorporation reveal, public recognition of domestic violence and the need for a shelter was still a taboo subject. They couched their plans in less 'controversial' terms. Article III, describes the organization's purpose:

(1) To form a community center to be used for Christian purposes on a non-denominational basis, to promote the following concepts: a) A place where senior citizens share fellowship; b) children come after school to study, get help with homework or rap; c) quiet room for people to read, listen to music, (and pray); d) Help harried or harassed parents with emergency baby-sitting and to talk over frustrations; e) Have soup-pot, all day, every day; f) Have safe house (temporary) for young children, victims of abuse, and young runaways; g) Outlet for the need people have to help each other.[20]

Virtually no mention of the center's primary purpose was made. As Marilyn recalls, "We just threw in there whatever we thought might appeal to a certain commissioner at the time. Kids were always a good issue. But domestic violence was still a gray area where people had some strong feelings. So to get the building we got very creative with our articles of incorporation."[21]

After two years of organizing, the Safe Space shelter for abused women and their children was opened in Butte in the summer of 1981. The group had purchased a small building containing two apartments with funding from the Department of Housing and Urban Development that had been approved by the Butte-Silver Bow Community Development Office. Grace Sicotte served in a volunteer capacity as the shelter's first director. In a 1981 *Montana Standard* article, reporter Andrea McCormick brings Grace's behind the scene's work on behalf of battered women to public attention. She writes:

Although many do not understand the problems of abused women, Sicotte knows them well. At a recent women's meeting in Bozeman, she was introduced as the 'grandmother of abused wives in the state of Montana.' Sicotte, who works in the county traffic office, has traveled around the state for 15 years, talking on women's centers and wife abuse. The past five years she has spent countless hours finding emergency havens in private homes for area victims of abuse . . . Sicotte says many battered women do not seek help. "Many are afraid or ashamed to speak of what they have suffered. Many are unaware of how to initiate civil or criminal proceedings against a husband, boyfriend, or relative. Many cannot support a family on their own. Most painfully of all, many are incapable of taking any kind of action to improve their situation because constant abuse and harassment has drained and demoralized them."[22]

Safe Space's first home was filled to capacity on a regular basis, and Grace's cubbyhole at the YMCA served as the organization's office. The group worked hard to raise funds,

expand awareness campaigns, and provide crisis intervention and support services. A number of dedicated women have assumed the directorship of Safe Space in its nearly quarter century operation, each with a sense of gratitude for and awe of the founding mother, Grace Sicotte. In 1985, Safe Space moved to a larger facility to better serve and protect battered women and their children. By 1990, the home was providing shelter to 120 women a year. In 2002 Safe Space responded to over 2100 crisis line calls, provided services to 269 women and children, offered 619 nights of shelter, and educated over 3,800 community members about the realities of domestic violence.[23]

Space Safe continues its important work under the able leadership of women working both in the public eye and behind the scenes. Intergenerational patterns of pain and violence, too often fueled by alcohol, are hard to break through. But the dedicated staff and volunteers persevere; they bring women together to share their stories, question the power of violence over their lives, challenge the blame and shame, and renew faith in their power to act and hope in another possible future.

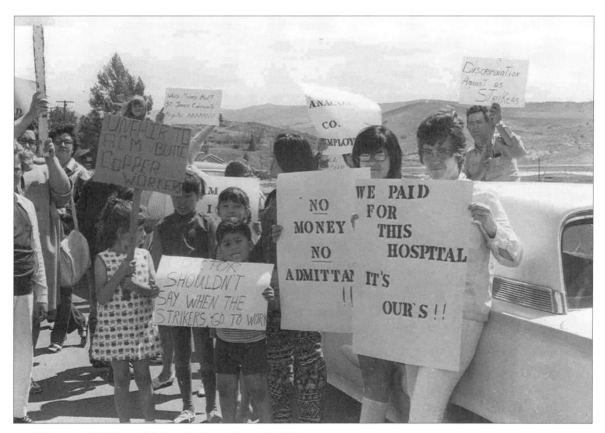

Women and children picketing St. James Hospital, 1971.

Butte women continue to work publicly and behind the scenes to defend the rights

and dignity of all members of the community. They have "built political houses" both literally and figuratively. They have demanded that the health and well-being of women, children, families, and neighborhoods be addressed as public issues. As a new generation carries the torch of activism into the twenty-first century, they are fueled by the passion, grace, and wisdom of Butte's indefatigable women warriors.

NOTES

1. "Mine-Mill Files NLRB Charges," *Montana Standard,* January 1, 1960, 1; "Butte Strike Talks Break Down," *Montana Standard,* January 7, 1960, 1; "County Says Relief Purse Empty," *Montana Standard,* January 27, 1960, 1; "Committee Appeals to Public as Food for Needy Runs Low," *Montana Standard,* January 19 1960,1.

2. *Butte Model Cities Comprehensive Demonstration Plan: Part I, Problem Analysis* (Butte, MT: Office of the Mayor and the Community Development Association, 1969) (hereafter *Butte Model Cities Comprehensive Demonstration Plan),* 118; "2,400 Butte Families Receive Emergency Food and Clothing," *Montana Standard,* February 2, 1960, 1; "More Surplus Food Arrives: County Allotment Increased," *Montana Standard,* February 3, 1960,1.

3. "City Will Continue to Give Food and Clothing to Needy," *Montana Standard,* February 6, 1960, 1.

4. "Ratification Ends Copper Strike—Workers Are Returning to Jobs," *Montana Standard*, February 16, 1960, 1. Personal Interviews by Janet Finn 1991, 1993.

5. See for example, "Butte Mines Closed by Strike," *Montana Standard,* September 18, 1962, 1.

6. Hunter S. Thompson, *National Observer,* June 1, 1964, 1.

7. "Grassroots Warriors" is the term used by Nancy Naples in her insightful analysis of women's activism, *Grassroots Warriors: Activist Mothering, Community Work, and the War on Poverty* (New York: Routledge, 1998).

8. Naples, *Grassroots Warriors.*

9. Ibid.

10. *Butte Model Cities Comprehensive Demonstration Plan: Butte Model Cities Program, Second Year Action Plan* (Butte, Montana, April 1970).

11. See map of neighborhood, *Butte Model Cities Comprehensive Demonstration Plan,* 7.

12. Ibid., 117.

13. Ibid., 9-16, 119-120.

14. See minutes of the Neighborhood Council Joint Board of Directors, October, 1970 – February, 1971, Model Cities Records, Box 1, File 2, Butte-Silver Bow Public Archives (hereafter BSBPA).

15. See Introduction for discussion of Elizabeth Kennedy and the Butte Housewives' League.

16. Personal interview, Butte, 1993. Quoted in Janet L. Finn, *Tracing the Veins: Of Copper, Culture and Community from Butte to Chuquicamata* (Berkeley: University of California Press, 1998), 142.

17. Based on news articles, personal interviews with Grace Sicotte by Janet L. Finn, 1993 and interview with Marilyn Maney Ross and Ellen Donohue by Ellen Crain and Janet L. Finn, 2004.

18. Personal interview, Butte, 2004.

19. Personal interview, Butte, 2004.

20. *Articles of Incorporation of Butte Christian Community Center*, signed May 27, 1980, Butte Montana. Safe Space records.

21. Personal interview, Butte, 2004.

22. Andrea McCormick, "Abused Women to Have Shelter," *Montana Standard,* March 1, 1981.

23. Safe Space press release for National Domestic Violence Awareness Month, 5 September 2003. Safe Space records. Thanks to Ellen Donohue, former Safe Space director, for participating in an interview and sharing organizational documents with us.

Making a Difference: Corinne Shea and Gert Downey

Andrea McCormick and Ellen Crain

Corinne Shea.

Gert Downey.

Corinne Shea went to work for the Butte-Silver Bow Anti-Poverty Council when it started 1965. Twenty years later, when her boss, Gary Gorsh, decided to retire, the board of directors began looking for a man to oversee the burgeoning agency. It didn't occur to them that a woman would want the job. Corinne did. With a profound sense of compassion and resolve, she accepted the torch of leadership. It has been carried by women ever since.[1]

Gary Gorsh gave Butte's low-income people a powerful early voice. Corinne Shea and her successor, Gert Downey, stand alongside him as pioneers against poverty. Both started out as secretaries. Both were devoted mothers with large families. Both were widowed in mid-life and found the strength to carry on. Both left their mark as steel magnolias who cared deeply and then did something about it.

Corinne was about forty when she became a secretary for the new anti-poverty agency shortly before the birth of her sixth child. She had worked in one job or another since

leaving high school. When applying for one position early in her career, she announced that she wanted to get paid what a man got for doing the same work. The boss refused. Corinne walked away.

Of all her jobs, the Anti-Poverty Council was the best fit for the Centerville native whose grandmother had opened her doors to anyone in need during the Depression. "You don't ask—you give," was Corinne's motto with her family and herself. Corinne reached out and often lent money to family and friends in need. "Her whole life was about taking care," says daughter Ann Shea.

For years, Corinne assembled a large number of food baskets at home around the holidays. The family assumed it was part of her job. Although the Anti-Poverty Council did distribute food, the Sheas later learned those baskets prepared in their home were from Corinne, not the agency. One of the few times Ann ever saw her strong mother cry was while packing her private offerings. "There never will be enough," she said sadly.

During Corinne's years with the Anti-Poverty Council, she wrote the grant that brought Head Start to Butte. She worked on low-income energy assistance, set the stage for a senior citizen center, and helped provide jobs for low-income youths and adults. As director, she managed all departments and all their budgets. When it was time for raises, Corinne didn't do it by percentage. "She took the amount that was available and divided it up so everyone got the same exact raise," Ann said.

Corinne cared even when it wasn't her business to do so. When the county food stamp office was located in her building, Corinne saw a worker close up at 4:00 despite a long line still waiting. "My mother called the state and said, 'that will never happen in my building again.' "

Ann, a lawyer who has worked on many social issues herself and now helps her siblings care for their mother, credits Corinne with teaching the family compassion, generosity, and understanding. "She was a brilliant person. It was admirable what she did without a college education." As for her mother's role in helping fight poverty in Butte, "It was something that was her life's mission. She found her niche, and she really belonged there."

When Corinne decided it was time to leave that niche, she passed it on to a ready successor. Gert Downey had started out with the Anti-Poverty Council as a secretary at the Neighborhood Center in 1966. She shared Corinne's passion for helping make life a better place for others. She regarded Corinne not only as a friend and co-worker,

but also as a mentor: "Corinne was a great woman. She was brilliant. She could see the issues clearly. She really cared about people. I grew to love her."

Gert had followed her own path to the Anti-Poverty Council helm. The Butte native came from "good, honest people," who made a simple but happy life for Gert and eleven siblings. As a teenager, she worked at Woolworth's to help pay the five dollars a month it cost to attend Girls' Central. A high school secretarial course eventually opened the door for a job as stenographer at Metropolitan Life Insurance Company (Met Life). There, Gert encountered one of her first professional women role models, office manager Nellie Kelly: "Every place else had men bosses. She made us all go through training and learn all the jobs." Even though all the agents were men, "it was a progressive company. Those were good days."

Unlike many companies of that time, Met Life did not force Gert to quit when she married and became pregnant with her first child. She left of her own accord five months before her child was due. "I thought I should be a stay-at-home mom. I was bored stiff."

Her boredom quickly faded with the birth of her child—and nine more after that. It wasn't until her oldest son was ready for high school and the family budget couldn't manage the cost of Boys' Central that Gert went back to work. Her first part-time job involved weekend work. When she heard about an opening with the new Neighborhood Center in the old St. Mary convent, Gert applied. At the job interview, Gert explained that she wanted a weekday job so she could be home with her family on weekends. "The board (of directors) thought that was a great reason. They gave me the job."

The job that suited home soon commandeered heart. Over the years, Gert took part in a gamut of Anti-Poverty Council programs and cooperative efforts with other agencies: Annual assessments of low-income people's needs, start-up of the Big Brother program, literacy training for parents, summer youth employment, initiation of the school lunch program, training and employment for low-income adults, programs to give opportunities and education to single and teen moms.

Gert saw Head Start grow from a small summer offering into one of the most successful federal programs in history. She wrote grants during the Nixon era "when they were going to close everything down. We could only plan from year to year." She saw funding shift from the federal government to state block grants.

Along the way, Gert left the Neighborhood Center to become a clerk for the Concentrated Employment Program, the Anti-Poverty Council's administrative

assistant, assistant director under Corinne from 1981-91, and finally director from 1991-95. As director, Gert says some of her proudest moments came from joining with other local agencies to help the homeless. "We knew families were being tossed out in the street. At the office, we could see people living in a run-down station wagon with three or four kids. You could see they were desperate." Families were holed up in empty buildings or paying sky-high rent for deplorable conditions. "It made you sick to see people there."

Changing this bleak picture was not easy. It went from setting money aside to help people in emergencies to seeking a federal grant to build transitional housing in Butte's uptown. Emotions ran high when Gert went to the local urban revitalization agency (URA) for help. Neighbors were angry and didn't want the project in their area. "We won URA support by one vote," Gert recalls. She later proudly cut the ribbon for the Homeward Bound Program on North Main Street that has assisted countless homeless adults and families to find work and get back on their feet.

Low-income senior housing was another of Gert's deep concerns. She was part of the process that gave rise to the Rosalie Manor senior housing. She also started the long road of grant-seeking that culminated in construction of the Continental Gardens for senior citizens after her 1995 retirement.

Gert looks back on her years with Corinne and the Anti-Poverty Council with quiet pride. "I was fortunate to have a wonderful husband and family and a stable home. I saw so many dysfunctional families caused by poverty and alcohol . . . This was way more than a job for me. I hope I was there to open some doors for people. Give them the opportunity to improve their lives and the lives of their children. Move to better and safer housing. See education as a key . . . I hope I was there to give them hope."

NOTES

1. This essay is based on interviews with Gert Downey and Ann Shea by the authors in March 2004.

Naomi Longfox and the Power of Native American Women in Butte

Janet L. Finn

For more than thirty-five years American Indian people have developed and maintained strong community-based organizations to promote the health, welfare, education, and empowerment of Butte's Native American population. However, the presence of Indian people in Butte has a much longer history. Long before white occupation, native peoples regularly traversed the backbone of the continent. Blackfeet Indians are the first recorded miners of the region, using elk horn to extract ore from the ground. In the late 1920s and early 1930s a group of Chippewa Cree people settled in the Summit Valley south of Butte, living on the margins of the city. Over the years, more tribal members followed, making the Chippewa Cree the largest tribal group represented in Butte. Members of other regional tribes also came to Butte as shifting federal policies further limited their abilities to make a living and maintain their homelands and cultural autonomy. Throughout the mid-twentieth century large numbers of Indian children continued to be removed from their families and placed in boarding schools as part of government efforts at forced assimilation. In 1949, the Hoover Commission on the Reorganization of Government recommended the termination of the federal-Indian trust relationship. And in 1950, Dillon Myer, Commissioner of Indian Affairs, supported the termination of the trust relationship, a program of relocation and urbanization of Indian people living on reservations, and incentives for migration to cities as a means of assimilation. In 1953, Congress passed the Termination Resolution, which provided for the end of the special federal relationship with many tribes. And in 1956 the Relocation Act was passed, the purpose of which was to push Native Americans off reservations through offers of job training in urban areas.

This pressure for urbanization of Indian people played out in Montana as the push of hardship and the pull of employment possibilities drew tribal members from Montana's seven reservations to the state's largest industrial center—Butte. Melba Azure, a member of the Little Shell band, joined her father in Butte in 1948, when she was fifteen years old. Leaving boarding school in South Dakota, Melba moved into the hotel where her father and grandfather were living while they worked in the mines. Melba's mother had died when Melba was very young. Melba came to Butte to take over the household responsibilities for her grandfather and father. She recalls a sizeable Native American community emerging on East Mercury Street as more and more Indian people arrived in Butte. Debbie Azure was two years old when her family moved to Butte in 1957. Her

father, Robert Azure, left the Fort Belknap Reservation to find work in the mines. They, too, joined the East Mercury community.

Naomi Longfox.

Naomi Longfox and her husband Charles (Chappy) came to Butte from Fort Belknap in 1956 to visit Charles' sister and her husband, with plans to stay for a week. Instead, Butte became her home for the next forty-nine years. Naomi's story resonates with those of other Indian women who left Montana's reservations in search of new opportunities in Butte and who gave tirelessly of themselves over the years to create opportunities for others. Naomi recalls her arrival in Butte:

At the time I just had one daughter. We came on a weekend to visit, and all we had with us was a week's worth of clothing. While we were here, my brother-in-law asked my husband if he would like to go to work. He said, "Sure, I'm willing to work." And [my brother-in-law] said, "Well, you'll come into the mines as my partner." So we busied ourselves around and he told us what all my husband would need to go to work in the mines. And here it is, 2004, and I'm still here working. We stayed with my sister-in-law for a couple of weeks until we saved enough money to get our own place. We never did go back to get the remainder of our things that we owned. We just stayed and made a home here with what we came with. That was in 1956.[1]

The Longfox family soon moved to Butte's East Side, near the Belmont mine in an area that was home to Butte's Hispanic community. It was not until Naomi's mother came to live with her in 1957 that she began to develop ties to the larger Indian community in Butte. Naomi recalls:

There were a lot of Native Americans here in those years. They had a relocation program from our reservation. With this relocation program what they did was give people a certain amount of money for you to leave the reservation and find work. Well, a lot of people chose Butte because there was work here and it was a mining town. There were a lot of people from my reservation here in Butte, but they were older people, so I didn't really know them until my mom moved here.[2]

Like many Native Americans of her era, Naomi had been educated in boarding schools. Unlike many of her peers, however, Naomi cherishes fond memories of her boarding school experience in Flandreau, South Dakota. Far from home and family, Naomi built ties of kin-and friendship with other girls and with the boarding school matrons. Though she was a small and somewhat frail child, Naomi developed a sharp sense of humor and a reputation as a practical joker. One time, Naomi recalls, she began marching very officially across the school grounds. She managed to convince a few other girls to start marching behind her, appearing equally serious and official. Soon the entire schoolyard population was marching behind her single file, first around the grounds and then directly into the cafeteria, where they were promptly shooed outside by the cook and warned not to return until suppertime. Naomi begins to giggle as she recalls the jokes she and her friends pulled on the dormitory matrons:

It was a big thing if you could sneak out and get back in without being caught. A whole bunch of us girls would just run out and then run back in.

There was this one old matron, and she was kind of crabby, but I just loved her to death. She was having room checks, and I was just coming down the hall. I was one who had run out. We just ran out across this big field and then back again, but if you were caught, you were severely punished. So she was having room checks, and I had just got back into the building. And the alarms went off, and they would start this big search. So I ran into a room that wasn't my room, and I asked the girl for help. So I come out of her room like I had been there all along, and here is the crabby matron coming out of my room. And she said, "Oh, there you are Naomi. I knew you sure wouldn't be one of them out running around." So there she was taking down names of everybody but me.

In boarding school, Naomi learned a lot about health, illness, and resilience, themes that have framed lifelong commitments. She suffered from chronic health problems as a child and spent considerable time in hospitals. Those early experiences offered important lessons in the meaning and power of compassionate care and respect for the dignity of the patient. During her extended hospital stays, Naomi discovered sources of inner spirit and strength as well: "I made it a goal each day to write a poem. And that's what I did. I wrote a poem every single day I was in the hospital. I used to have a big thick tablet of them. I wish that I had kept them." While Naomi has not kept writing poetry over the years, she has maintained a commitment to reflection on the possibilities each day offers.

Naomi had always envisioned having a large family but was only blessed with three children. However, she and her husband helped raise several nieces and nephews. Naomi and Charles strongly valued education. They put aside money for their children to go to Catholic schools, and also offered their children the option of attending boarding school. While her eldest child opted to follow in her mother's footsteps and attended boarding school, the younger children attended Catholic schools in Butte. At times money was very tight. Naomi went to work to help support the family.

I had my two boys here. I waited until my youngest boy was six years old and then I started to work. I went into restaurant work, and I've worked ever since. I was always used to real hard work because of growing up in a large family. We always had to help with the outside chores and the inside chores and the younger siblings. So, I probably chose restaurant work because it was hard work and I enjoyed it. I knew all that type of work from my experience in boarding school in South Dakota. So I worked seventeen years at the same restaurant. At the time it was Fred and Millie's, and then

it changed to Ray's Place. I worked in all parts of the kitchen. I cooked, I did back-up work and dishwashing. The only thing I didn't do was waitressing because I was never interested in that . . . For several years I worked as the graveyard cook . . . I felt that I worked with about the best people that you could in town.[3]

Naomi speaks of her boss and co-workers as an extended family with whom she shared a strong bond. Over the years the restaurant also became the stage for her practical jokes. Naomi shakes her head and smiles as she remembers her boss, who constantly fell for her gags:

> I shared a whole lot of laughter, even with my boss. I would play jokes on him and he would always fall for them, especially on April Fool's day. That was my favorite day. I'd April Fool him so many times, and we'd just laugh, and he'd take off his glasses and tears would be running. You know I would probably say things to him that no other person would ever think of saying to him . . . I've always thought that humor is the best thing.[4]

Humor and laughter became valuable antidotes to the trials and tribulations of everyday life. However, Naomi turns serious when she reflects on challenges of a mining way of life. Naomi's husband worked as a contract miner for many years. Naomi remembers:

> So my husband continued to work in the mines. And while he was working in the mines we would always be faced with strikes. So it was sometimes just my salary that we were able to live on. I still have this thing [when I go to the store.] I still stock up on a lot of food if there's something on sale. [If there is] something that I use a lot, I don't usually buy one, I buy several. And that's something I've done since the old days and I brought it over to now. At the time we were coming from the reservation. I think a person was never extravagant. There were things you stocked up on. I've always been the kind of person who, you know, if you come over and say 'could I borrow five pounds of sugar,' I'll have 20 pounds in my cupboard. And, you know, I still do that. It was hard, but in the neighborhood I lived in we all had small children and if we were out of something, we always borrowed from a neighbor, and we always paid back whatever we borrowed.[5]

Naomi and Charles lived with the dangers and uncertainties of mining. Sometimes, during the strikes, the family would return to the Fort Belknap reservation. Other times, they relocated to small towns around the state, where her husband found temporary work. Naomi recalls their temporary moves to Glasgow and Shelby, Montana as being

particularly hard on the family. Naomi was there to support her husband through the strikes and during the dark days after the mines closed. She is relieved that her husband left the mines with his health after twenty years underground. Naomi remembers:

> My husband's partner was killed in a mine blast, and they brought Charles home. He had been hurt a lot of times, a piece of metal in the eye, cuts, things like that, but nothing serious. They had to get him out of there this time. He was like a wild man. The shift boss brought him home. He wanted tea and wanted me to sit with him. They had been partners for nine, ten years. That day is fixed in my mind. He couldn't sleep after that. He just kept reliving the moment and the blast and frantically digging, trying to get to his partner. But he made himself go right back to work. He knew he had to go back. He told me it was like being in a car accident, and if you didn't start driving again right away the fear would paralyze you. It was dangerous work and lots of times I was scared. If the phone rang late at night, I had that fear that something happened in the mines. But his belief was, "If the Good Lord wants you, that's it." He knew the dangers of mining. We talked about it and we prepared for the contingencies. But the loss he had that day, that stands out more than anything. After that, I used to talk to him about leaving, but he would say, "Well, the Lord didn't want me, he chose Joe."[6]

Naomi's husband had transferred to the Berkeley Pit when underground mining closed down, and he lost his job when those operations shut down in 1983. That day is etched in her memory:

> I remember the day he was laid off. He came home and said, "Well, I finally got my slip. I don't know if they aren't doing me a favor." At least he came out of it with his health after twenty years as a contract miner. He didn't know whether to be happy or sad. It was a difficult time for him. His work had been very important to him, and it was hard for him to be around the house while I was the full-time breadwinner. He had always helped out. I tried to humor him to ease the pain. I'd tell him how much I liked coming home to a home-cooked meal after a hard day's work. After about a year of feeling depressed and at loose ends, with no possibility of mining in the future, he decided to run for tribal council.[7]

Naomi recalls the depression of those days that enveloped the entire community: "It was a time of mourning for people. People were talking in quiet voices, and there was a feeling of mournfulness in the community."

261

Naomi responds thoughtfully to a question regarding the racism she and her family experienced in Butte over the years. She states, "Maybe I did experience it, but I'm the type of person that if someone—if I am at the store or at the bank—if another person, regardless of their color, tried to get ahead of me in line or be waited on before me, I'll say, 'Pardon me, I was here first.'"[8] She taught her children to rise above the hurtful remarks directed at them, and she countered those remarks with messages of dignity and respect. Naomi tried to not allow herself to be affected by racism. She recalled that being ill as a child and spending considerable time in the hospital, she learned to be assertive, despite her natural shyness. As she asserted herself and asked that her needs be met, she gained confidence and a sense of her own worth. Naomi recalls another time in the hospital, this time as an adult in Butte. One of the nurses was reluctant to care for her because of her race. Naomi confronted the woman, told her she was paying for her care, had worked all her life, had never accepted government assistance, and that she wondered why this woman would think she could not touch Naomi. With her determination and directness Naomi confronted the nurse and informed her supervisor, letting her know this was not merely a single incident but a symptom of a problem that affected the health care of Indian people. The hospital administrator contacted Naomi and asked what she felt should be done to address the problem. Naomi was later invited by the supervisor of nursing to speak to nursing students who were about to complete their training. She was asked to address the students on "How Indians Want to be Treated." Naomi began by challenging the theme itself and the separation of "us" and "them" upon which it was premised. Instead, she described her personal experience in the hospital and challenged the audience: "Now, you come to me to ask me how I want to be treated. I want to be treated with the same respect and care that you would want to be treated yourself. How do you want your own mother or father or son or daughter to be treated? That is the standard of care and respect that I expect and no one should expect anything less."[9]

It is that sense of quiet strength and enduring determination that Naomi brought to bear on behalf of Butte's Indian community over the years. Naomi and Charles joined with other members of the community, such as Caroline O'Neill, Ozzie Williamson, Robert and Mona Azure, Eddie Flamand, Aaron Perry, Jimmy Main, and William Johnson to begin building an organization by and for Indian people. O'Neill and Williamson started the effort and invited others to join them. At first they met in one another's houses to talk about what was needed for Butte's Indian community. O'Neill and Williamson were working as alcohol counselors, and they educated others on the need for access to addiction treatment and support services for Indian people. Others had begun going into the prison and working with the Native American Indian League,

an advocacy group established for inmates. They began to discuss the realities of discrimination and the lack of Indian presence in the community, especially in arenas of education, health care, and public decision-making.

As they listened to and learned from one another, the group became both determined and inspired to act on behalf of Indian people. Change was in the air in Butte at the time. The War on Poverty was being waged, and the federal government was encouraging local communities to come together as frontline warriors in direct action to challenge and change poor economic and social conditions. A group of Butte movers and shakers was developing a proposal for Butte's designation as a Model City, and in the process was turning a more sympathetic ear toward sectors of the community who had been largely left out of public decision-making.

The small group who had been meeting in Ozzie Williamson's living room seized the moment and developed a strategy to bring concerns of Indian people to the Model Cities forum. The group wanted to create a social space for Butte's Indian community where people would be comfortable. They envisioned a one-stop center for information, support, and advocacy, a place where people could come with any problem, where issues of discrimination in schools, the workplace, and the community at large would be confronted, where families could find support and resources, and where people could access opportunities for health care, education, and employment. The team went to work gathering the information and support needed to champion their cause. Some members went door to door to get an accurate count of Butte's Indian population and to encourage their support of Indian candidates for the Model Cities board. Others met with people struggling with alcoholism to learn from them what they needed and wanted in treatment. The group was ahead of its time in using what we now call "focus groups" as their research strategy. They learned that men wanted to see male counselors, women wanted female counselors, and all wanted Indian counselors, in whom they felt a greater sense of trust. The group began writing grants to seek funding for a culturally responsive treatment program that would become part of the new center they envisioned.

Naomi ran for a seat on the Southside Neighborhood Council so that she might be better positioned to bring concerns of Indian people to the community. The council seat also provided her a platform from which to lobby for support of an Indian Center as a Model Cities project. As Michelle Robinson, past director of the North American Indian Alliance recalls, "When it came time for Model Cities to make a decision on programs to fund, they dropped the Indian Center and wanted to fund a dog pound instead. But many Indian people went to the meeting and challenged their decision.

The Model Cities Board backed down and funded the center." Robinson, a dynamic young activist, had recently arrived in Butte. She quickly became involved in the efforts to build the center and soon found herself serving as its first executive director.

From its beginnings the collective effort to establish a center for Butte's Indian community was a model of gender equality. Men and women joined forces and shared leadership responsibilities. Naomi was one of the founding board members when the center was officially incorporated in 1971. The small but resourceful board worked tirelessly to secure support and expand possibilities for its constituents. The board wrote grants to secure funding for alcohol treatment, health care, job training, and early childhood education programs. A revolving loan fund was established to promote social and economic development. Indian youth were engaged in the "Pride in Indian Heritage" program. But the group did not rest on their laurels. The troubling statistics that spoke to the plight of Indian people—unemployment rates, infant mortality, poverty, incarceration rates—and the laws and practices that spoke to the power of racism—prohibitions against two or more Indians congregating, refusal of service in public places—fueled their commitment. Moreover, the group was determined to bring the voices of Indian people to bear in community decision making and increase their presence in professional and public roles.

Once the Indian Alliance had opened its doors, the board and staff dedicated themselves to program development. They started small, learning the skills of grant writing as they prepared small seed grants to launch counseling and education programs. Each small success encouraged the next possibility. Naomi recalls the energy and excitement of those days as the center provided the catalyst for community building:

> Back in those days when we first started planning our organization, it was such a strong community. When we would have a meeting or we would have voting there would be hundreds of people. We would have no less that 375 people that would come to vote. And when we had our potluck meals there would be anywhere from 300 to 500 people. We were housed down here on Galena Street, at the old St. James Hospital. They would let us use the old St. Joseph's gym for our potlucks . . . Back in those days there were so many people that were just so eager to get everything started. There was so much enthusiasm and so much volunteerism, everybody was real anxious to see something get started . . . Back in those days there was so much money out there that a person could apply for, and we had a lot more programs.

The Indian Center also garnered the support of the larger community over the years.

For example, Naomi recalls a difficult period in the early 1980s when funding for the center was running short. She and her colleagues were desperate to find more affordable space so they could keep their programs going. Dolores Barsanti, director of the Neighborhood Center, provided them with office space, charging only a minimum amount needed to cover the cost of utilities. The health, employment, and training programs of the Indian Alliance called the Neighborhood Center home for two years. Since the mid 1980s, the Indian Alliance has also received annual support from United Way of Butte. Naomi speaks with pride and appreciation of the long-term cooperation between the Indian Center and the non-Indian community in Butte to meet the needs of low-income people.

While Naomi played an active role on the board throughout the 1970s she also lent her energy to community building efforts that supported both Indians and non-Indians. She joined Grace Sicotte and others in organizing woman-to-woman networks to move victims of domestic violence to safety. Naomi recalls:

> Well, long before there was Safe Space, I would take a woman that didn't have a place to go or was running from her husband or whatever with the children, I would take them into my home and give them a place to stay until we got the situation taken care of. A lot of times I would go to the house by myself and see really what the situation was and what we could do to alleviate the situation. Long before there was ever United Way, the other ladies in the organization [and I] would feed people or bring them food if they didn't have anything to eat in their homes. We'd bring them food from our own homes. Or if somebody was passing through we would bring sandwiches to get them on their way. We brought clothing from our homes before there was ever a giveaway of clothing . . . One day my one son and I were talking and he said, "God, Mom, you were giving away things long before they ever had Salvation Army."[10]

Naomi sums it up with a smile, "I served on the first Safe Space board, the Habitat for Humanity Board, the Hospice board, every board but Salvation Army!"

In 1979 Naomi was hired for a paid staff position with the North American Indian Alliance, and she has worked there ever since. Over the past twenty-five years, Naomi has dedicated her efforts to expanding the education and employment opportunities for Indian people. Naomi has worn many hats in the process. As she puts it, "I've done just about everything but write a will. I'm part counselor, lawyer, judge, parole officer, coach, friend, and teacher." She has nurtured relationships with and a sense of

community among the young people who pass through her office. Over the years, Naomi has run support groups and sponsored coffee time for minority students attending the College of Technology. She believes in creating spaces where they can support one another and express their frustration. Naomi is also a forceful advocate for the rights of Indian students. She has worked hard to help young people see the value of education, and she takes pride in the accomplishments of the many students who have passed through the center.

> I'm so proud of people, even if they make a goal to go out and get a GED [General Education Degree]. I talk all the time with new people coming in the center. Some come in with such negative thoughts. I ask them to give me one positive thought . . . I just had a student come in who was my student ten years ago. He is now getting his pilot's license and he stopped by and let me know he would be in Butte twice a week, and he's got a job with the Forest Service . . . From time to time, in the ten years he was gone, he would call me. So I have become close friends with a lot of my students.[11]

Over the years, Naomi worked side by side with Caroline O'Neill, who ran the health programs through the center. Since Caroline's retirement in 1982, Naomi has worked with Patty Boggs, who, at age twenty-one, moved from the job of receptionist to health program coordinator. Naomi speaks with pride in seeing a new generation of women's leadership emerge through the center. Patty has overseen the development and expansion of culturally responsive health care that includes a diabetes program, a breast and cervical cancer screening center, and the services of a nurse practitioner on staff. The center has launched a women's health coalition, conducted surveys to identify the health care concerns of Indian women, and organized women's health fairs.

Butte's Indian community is smaller these days, but the Indian Alliance remains its epicenter. Funding is harder and harder to come by, but each day committed women bring their talents and energies to bear to promote individual and collective healing, growth, and advocacy. Enjoying a rare moment for reflection in their busy schedules, Naomi Longfox, Michelle Robinson, Melba Azure, Inez Bagley and Michelle Dennis took stock of where the Indian Alliance had come and what they hoped for the future. The women talked of the importance of knowing one's history, maintaining respect for elders, and keeping the spirit of sharing and generosity alive. They hope their children and grandchildren will embrace the value of education. And they envision the North American Indian Alliance continuing as a key part of the community and crafting a sense of belonging, dignity, power, and confidence among Indian people as it has done since 1971.

NOTES

1. Naomi Longfox, interviews with author, February and March 2004, Butte. (Hereafter Longfox interviews, 2004).

2. Ibid.

3. Ibid.

4. Ibid.

5. Ibid.

6. Naomi Longfox, interview with author, May, 1993 (Hereafter Longfox interview, 1993).

7. Ibid.

8. Longfox interviews, 2004.

9. Longfox interview, 1993.

10. Longfox interviews, 2004.

11. Ibid.

"We're All *Familia*": The Work and Activism of Lula Martinez

Laurie Mercier

> We're all *familia*. We're all one big family. Until people realize that . . . we come from the same tree of life, until they realize that, we'll never be able to relate to each other or really love each other the way we should because people don't relate that way. But we're all one big family.
>
> Lula Martinez

After the shutdown of Butte's mines, when most people were contemplating leaving, Lula Martinez came back to her native home. She felt some ambivalence about returning—prompted by her second husband's death in Portland—because she did not have fond memories of the city and the poverty and racism that she experienced in her youth. Yet Lula's life history, filled with a commitment toward love, justice, and the lives of women and the poor, was shaped by her early years in Butte and later by Chicano and farmworker activism in Oregon, Washington, and Idaho.

This sketch of Lula's life is based on an oral history interview I conducted with her in 1987, deposited with the Montana Historical Society. Additional contextual information is supplied by my interviews in 2004 with Robert McCarthy and Sister Kathleen O'Sullivan, and a 1986 interview with Lula and her sister Angelina Costello by Teresa Jordan, deposited with the Butte-Silver Bow Public Archives.

Like most narrators, Lula wove together the threads of her life as a seamless blend of influences, observations, and experiences, not in any particular chronological order, which led her to a life of commitment to social justice. Over the years she volunteered and served on boards for the Idaho Migrant Council, community health clinics, Oregon Legal Services, food banks, senior citizens programs, domestic violence shelters and programs, and the Butte Community Union. She explained why she was drawn to helping out: "I've worked more hours in volunteer work than I have ever worked for salary. . . . because there's so much that people need. . . . I think of all the people that need and that's why I keep going, I suppose. . . . Everywhere you go people need someone. People need someone and there's not very many people that can give of themselves."

Lula left Butte again in 1988, and she spent her final years in Portland, where she passed away among loving friends and family on February 18, 2000. Lula remained a close

friend, and I saw her often when I moved to Portland-Vancouver in 1995. Just days before her death, I had taken her to see the play *The True History of Coca-Cola in Mexico*, staged by the Milagro/Miracle Theatre. Despite her health problems, she insisted on topping off the evening with a margarita at a nearby pub. Always great fun, Lula had a bawdy sense of humor and critical intellect. She read widely and was consistently compassionate and generous, even in her final years with fellow residents in her senior living high-rise. In her accounting of her life, I sometimes wondered how much was real or imagined. But then I would come across a corroborating piece of evidence that supported some of these stories that once seemed a bit far-fetched. At her funeral, in discussions with her daughter and son Lucia Peña and Ben Martinez, we realized we knew Lula in different ways as children and friend.

Unlike most oral narratives of Butte that depend on people who have remained in the city and love it despite its flaws, who are attached to the place and see it through that lens, Lula's story represents one of the many who left. Although she returned for a few years in the 1980s, she retained her ambivalence about Butte. It was never a place, in Lula's mind, that was friendly to the poor.

<p style="text-align:center">* * *</p>

Petra Ortega and Fidencio Acebedo left Mexico as teenagers and married and found work in Texas, moved north with railroad work, and had their first daughter, Lula, in 1922. She describes how her parents settled in Butte and her first memories of the mining city.

> My mother and father came to Butte because Dad got a job on the [railroad] when it was being built from Texas up here and they contracted whole families to help build a railroad and they had these family railroad cars. . . . And when they finished on the railroad, they finished somewhere close to Butte so they stayed here and he went to work in a mine. But he didn't work a year before he was killed in a mine. My mother . . . had five children when he got killed . . . so she stayed, but my mother couldn't read or write English, she was only Spanish. She remarried in a year, another Mexican from Mexico who couldn't read or write English, and had more family. Then he died from the result of the mine, also. She stayed, raised her children here. I suppose one of the reasons why she stayed was because of the fact that she couldn't move. With eleven children you don't. . . .
>
> We lived on the east side, at 839 East Galena. And all I remember is we were all surrounded by copper dumps. Waste dumps . . . but then we called them

the copper dumps. And the ore bins were a little ways down from where we used to live where a little car used to come from the Belmont Mine and dumped the waste or the ore into the bin, and we could hear that at night . . . And then at 6:00 in the morning there was a train that came with cars and they would dump the ore from the bins . . . load it onto the train cars and the train would pull it away. And it would whistle while it went, that's why I remember. . . . And I also remember that we were surrounded by different nationalities. We had Vankoviches and Joseviches and Biviches and we had Serbians and we had Chinese. We had *italianos, españolas*, and Mexican people. We had the whole United Nations around on the east side.

There was a lot of Hispanic people. At that time I think most of the people were from Texas and Mexico. Now they're from New Mexico and Colorado, most of the people, but then most of the people were from Old Mexico and from Texas. . . . In Texas and places like that there are barrios but in Butte there was never a Mexican barrio. The only town that I remember is like Finntown. . . . And very few blacks. I think there was about four or five black families that lived in Butte that I can remember when I was going to school. . . .

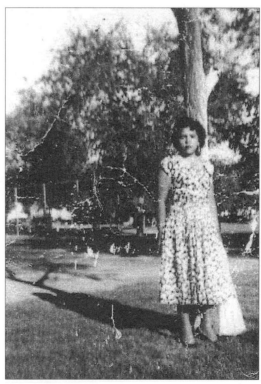

Young Lula Martinez.

Although in later decades Butte's Mexican American community had a *Centro de la Raza* cultural group that brought together people for meetings and events, there were no formal ethnic associations that Lula could remember from her youth. She explained that she retained her cultural identity as a Mexican American woman because she moved away from Butte and lived and worked with *mexicanos* and Mexican Americans in the irrigated farm communities of the Pacific Northwest. Nonetheless, during the 1930s Mexican American families in Butte continued ethnic traditions informally through celebrations, family gatherings, foods, and preserving the Spanish language.

> When they'd baptize families we'd have a dance or a party or a dinner. . . . When the girls turn fifteen we'd have a *quinceañera,* and when they got married of course we'd have a dinner, and when they got engaged or things like that, we'd have a dinner, we'd call 'em a *comida*, because they were at home. . . . But that's how we had our cultural things. And we had our music, records and stuff like that. . . . We always kept our own food. We always cook our own food, on the holidays we always have our traditional tamales and enchiladas. . . . So we keep our tradition alive and we talk Spanish.

Despite this ethnic diversity in Butte, Lula learned early as a child that society imposed a racial and class hierarchy that made life for people of color more difficult. Her experience with discrimination influenced her later activism.

> As children we didn't know there was a difference so we got along fine. It was when you're already between the ages of ten and eleven and going to school when the teachers started to say, "well you gotta sit over there. All the Mexicans sit on that side." And in those days they did, and then we found out that there was difference. . . . When I grew up in Butte and was going to school, there was a lot of discrimination. . . .
>
> I suppose that is what makes a person decide what you're going to be in later life. It made a difference to me in what I chose to do as an activist. I was very active in trying to change the attitude of the people that were serving people. I always felt that if you were given a job to serve people within a community, especially social workers or people that were taking your money, like people at the light company, that I had to go pay lights for my mother because she couldn't afford to pay the whole bill and I had to explain, as a girl. Eleven-year-old girl going into a place and talking to a lady that your mother couldn't pay the whole bill and the lady saying well she has to or the light'll go off. When you got to go home and tell your

mother who hasn't got any more money to pay, and tell her that she's gotta sit in the dark with a whole room full of children—you just don't tell your mother those things. And they are very sadistic because they didn't turn the light off but you sat there wondering when they were gonna come and turn it off and not being able to tell your mother because you didn't want to tell her that.

Lula credited her mother as a big influence and inspiration for her own determination to seek justice for others. As a widowed woman, Petra Aguilar took in boarders during the 1920s and 1930s and only accepted what money they could afford to pay. She made big pots of soup and beans and generously fed others in the neighborhood and "bums" who came through on trains. "Mama never turned anyone away."

> She never gave up. At the time that my dad got killed in the mine, she got a pension from the mine. . . . She fed all her children around her. . . . Whenever any children came and there were blocks around that came to play with us, she'd feed everybody. She'd make big pots of stew and feed all the kids. . . . But my mother influenced me by seeing, by my seeing her that she never judged. She just went day by day, and I suppose that was [my] first influence.

Her mother also reinforced traditional gender roles by stressing education for the boys and housework for the girls. As the eldest daughter, Lula had a great deal of responsibility, and she also developed a strong will to overcome gender restrictions as well as racial discrimination.

> She was very supportive of the boys, but the girls had to do a lot of housework. We had to do a lot of the work and there was . . . always three or four babies in diapers. And we had a lot of work to do at home and it could never interfere with anything. So we had to get up real early in the morning and to this day I get up at 5:00 in the morning. But either that or you just didn't do school work. . . . She did push the boys to do a lot of schoolwork. But one great thing came about. The girls all had good careers and the boys didn't! So you see there is a moral.

Like her mother, Lula married as a teenager, and she and her husband left Butte to toil in the irrigated agricultural fields of the Pacific Northwest. Lula believed her work ethic and feminist consciousness—a belief in the equality of women and a desire to obtain it—contributed to her successful marriages and determination to work for justice.

> When I left Butte I was seventeen and we went to Washington first. . . .

Never picked apples in my life, was raised in Butte. Never worked in the fields. I picked it up right away and I liked it. I liked the idea of working in the fields because if you're not lazy you can put everything up for the winter. You get everything with your picking free and from a person who was raised that you had to buy everything in the store if you had the money. If you didn't you didn't and here it was all free just for you to go to work and pick it. To me that seemed like God put me in a paradise because here all these orchards were full of fruit, which you don't buy in Butte without a lot of money. . . . And to me it was so strange because I'd never been out of Butte before. So I worked twice as hard and learned twice as much and so I never came back because of that.

I've always been [a feminist] but I didn't even know it, and I think you will find the majority of women are but they don't know because they've never really knew what [feminism] was. . . . I had a good understanding with my first husband. And my second time, when I got married, I just laid it on the line the same way, you know, and we got along fine, really good. . . . I think as far as marriage is concerned, I think it's great but I think that a complete understanding beforehand is due because I'm this way and I'm not going to change for nobody because I'm me.

The social movements of the 1960s and organizing activity in the Snake River Valley inspired Lula to become involved in an effort to locate health clinics in the small communities where most farmworkers lived. But this successful effort in the 1960s was not her first organizing experience. Lula learned early on that families could achieve more success by approaching people in power as a group rather than as individuals, and she organized groups of women to obtain food and social services. Despite their "double day"—working in the fields and managing their households—Lula believed that Chicanas and *mexicanas* had special endurance and made time for organizing work that promised a better life for their families. "A woman knows that her man's got two strikes against him," she noted. "He's poor, he's a Mexican, and this is what he has to do. So she does what she has to do and lives accordingly. A woman is the strongest [in the family]."

My first experience in organizing was in the migrant field when we would organize to go to the Welfare Department to get the . . . food commodities. At that time, they were commodities, not food stamps, for people. That was my first organizing. I didn't even know it was called organizing. I just got people together to go to different stores to bargain for the things that were

left for people that needed food. There wasn't food banks then but I would go to the Safeway, to the corner grocery stores and everything and ask 'em for day old bread and things like that to give to people that were coming in that didn't have anything because a lot of migrant people would come in without any money to eat on or anything until they worked. So we'd hit a lot of these stores and that's what I would call organizing now. . . . I always had a group ready or a car ready if somebody got sick because it was . . . thirty-two miles was the closest to get 'em to a hospital or somewhere. . . .

[Social service agencies] couldn't be bothered to give [migrants] help because they weren't going to do all that paper work for them just to give them money for one month. So, as a group, we'd go in and talk and it's harder for them to say no to a group because we were prepared with all the things that I thought or that we collectively came up with. . . .

Most of my groups were women. Most of the groups that I worked with that got community health clinics started were women. . . . Because it's women who know how much they need when their children get sick. It's women who know that without a good health clinic or good doctor, they're the ones that suffer. Their children suffer. If the man gets sick of the family, who will they call. . . . To be a man it's great. All you have to do is just go to work for eight or ten hours and come home and you got it made. But a woman works ten hours out in the field and comes home and works another twenty-four at home. Their work is never done. . . . So they knew what they needed, so they were going to fight harder, and so when I wanted something done and I knew who to go ask for help. . . . Even if they didn't know how to speak English, they were there. Even if just for support. If we had to write letters they would write letters in Spanish.

After her second husband's death in Portland, Lula returned to Butte in 1984 and became involved in the Butte Community Union (BCU), formed in 1982 on the heels of the closure of the Anaconda mines. As families struggled to survive the deindustrialized economy, the state restricted benefits to the unemployed. The BCU formed to advocate for and organize Butte's low-income citizens. Lula was surprised to find Butte social workers "still stereotyping" and "pushing people around." She felt little had changed in the social service system since she left Butte in 1940. Robert McCarthy, founding director of the BCU, recalled that he met Lula through her sister Angelina Costello, who was active in many community groups, including *El Centro de la Raza*. McCarthy hired Lula as an organizer. Her "beat" was Silver Bow Homes, central Butte's public

Lula Martinez, seasoned advocate for social justice.

housing, where she spent her days going door-to-door discussing issues with tenants. Out of those discussions, BCU and tenants lobbied for a playground. The housing director of Silver Bow Homes finally conceded, saying that he'd like to "bury the Butte Community Union" under the new playground.

Sister Kathleen O'Sullivan, a BCU board member, credited Lula for being her "mentor" as well as the "wisdom person at BCU". The pair developed a close friendship, despite their differences—one estranged from the church, the other a member of a religious order—and their different class upbringing led each to see the world differently. "She always amazed me as someone who could sense injustice," O'Sullivan recalled. "I grew up middle class and wasn't aware as she was." On Lula's skills as a persuasive organizer, O'Sullivan noted that "she spoke truth, not trying to convince people, but would say something that would focus the discussion, draw your attention to the essence of something." O'Sullivan remembered that Lula always seemed to recognize the importance of an issue when others did not, and was ready to act, such as the time when a bill affecting low-income residents was up for discussion at the state legislature. Lula jumped in her car and drove to Helena in record time to convince lobbyist Louise Kunz, of the Montana Low Income Coalition, to head off passage of the bill. Thanks in part to Lula's work, BCU became a place where people in need routinely dropped in for assistance, but her "bullshit detector" enabled her to determine if someone was in real need or not. She frequently took migrants into her home, let them shower, and directed them to a friendly farmer she knew in Idaho who would provide temporary work.

Lula felt that the most important issues BCU tackled were fighting to retain general assistance benefits and developing an affordable heating plan for the poor. BCU also generated the Central Butte Plan to address the problem of subsidence of homes in the center city, surveying the condition of every house in the neighborhood and the status of people living there.

> Butte Community Union is the only program in Butte that is really concerned with people as people. Not because they're a class but because they're people. They're low-income people. They're poor people. They're street people. Anybody can walk into the Butte Community Union and get some help . . .

> A lot of people have lost [their homes] because their homes are tilted, the foundations gave under it and they're cracked. Big holes in their yards. The subsidence is bad, terrible in Central Butte. That should be an issue that should be carried over and fought for really hard because now it's starting

to settle more because of the pit. As that water danger gets higher there is a bigger danger and now people know that . . .

I think the BCU is managing to stay alive by being a thorn in their side that's never going to go away . . . That there is a substance to it and that it had a good start, a good beginning and nothin' that had such a good beginning is easy to get rid of.

As Lula's health declined and she decided to return to Portland to be with family, she reflected on her work with the BCU:

Besides making a lot of good friends and having a lot of good arguments, I think that I invested my time very wisely. Because anytime you make friends, long-lasting friends, you've won and that's what you really should look at. I've learned a lot by being here these last years, more about Butte than I did before I left because I was young to where I formed a hatred period before I left, and now when I came back I worked with people and I know that it's not the same. The hate isn't there but it's still not a love because it's still . . . not a love of Butte. It's the love of people.

PART SEVEN
INSPIRING GENERATIONS

The Legacies of Our Grandmothers

Carol and Pat Williams

Our grandmothers were brought by men to the turbulent, bawdy, mining city of Butte, Montana. Emma Richards Bartlett, Carol's great-grandmother, left England from Southampton and arrived in Butte on the arm of her husband John in 1887, two years before Montana achieved statehood. As a twenty-three-year old mother, Emma left her friends, family and the grave of her firstborn in Cornwall, England. She and John, along with an infant daughter Beatrice, joined her brother's family in Burlington near the Blue Bird mine west of Butte. Both her brother and husband were from a long line of Cornish contract miners who, along with thousands of others, had been recruited by American mining companies.

Lizzie Hagan, Pat's grandmother, arrived in Butte with her father, Jim Hagan, in May of 1905. She was thirteen; her father was thirty-eight. They were Irish, the family having moved from Ireland to Cleator Moor, England, some years earlier. Lizzie and her father departed for America from Liverpool, traveling with 2800 other passengers on the steamship Cedric of the White Star and Dominion Lines. The Hagans made the journey with the 2500 third-class passengers. All her life she would remember and retell stories about the crossing, including her own constant seasickness: "I would lie on the deck, sick, my head hanging over the edge of the ship. It's a wonder I wasn't tossed into the sea."

Just as Emma left behind the grave of her son, young Lizzie Hagan would never again see "my wonderful Mommy." Within two years Mary Ann Hagan would die of pneumonia and her remaining four children were scattered to other family members. During the rest of her life Lizzie would see only one of them, her younger sister Nellie, fifty years later in an emotional reunion which unexpectedly took place on Lizzie's small front porch in Butte.

IT TOOK A VILLAGE TO MINE THE COPPER

The difficult, tragic, but hopeful context of Emma's and Lizzie's entry to the "New World" forged their resolve to cope and improve. Among the challenges they and many other women faced was the need to help make Butte more than a fleeting mining camp. The deep, rich veins of copper lacing The Hill provided the promise of jobs and salaries and, for a handful, unbelievable wealth. The realization of those promises, however,

required more than financial investment, mining technology, and workers by the tens of thousands; also necessary was the often overlooked but critically important element of community stability, without which a reliable work force would have been impossible.

The essential difference between Butte and other mining camps was not only the richness and abundance of the ore veins, but also Butte's women who raised families and, with genuine determination, labored toward, nurtured, and created community. The city, although raucous, had civilizing elements, each tied to the other. Ethnically diverse, Butte established social enclaves and associations that celebrated its international character. Rushing headlong into tomorrow, the people, often Butte's women, took time to remember and preserve the past through the creation of notable groups such as the Butte Pioneers Club. The bleak landscape was not conducive to the ease of neighborhood living, so garden clubs and beautiful beds of flowers were maintained in the city. The shrewd wives of the city's miners convinced the executives of the Anaconda Company to begin staggered paydays, thus avoiding the "one big party" that was degrading the stability of Butte's families.

It took a village—a city—to mine the enormous amounts of copper and the other valuable metals which laced the world's richest hill. It could not have been accomplished by itinerant miners seeking only a good payday or two and then moving on. The difficult and dangerous task of underground mining saw an incredible turnover of miners—20 percent each month. An experienced and stable work force was essential and that, in turn, required community. It was provided by women: Emma, Lizzie, and thousands of others with the wisdom, determination, and the imperative to make it happen.

A CITY OF MEN

Butte was masculine. The muscled sinews of the gallows frames, the boarding and flop houses, the seven belching stacks of the Never Sweat Mine, the granite hill with its veins of rough metal. The city of Emma's and Lizzie's early years was virile, macho, powerful, brawny, daring; it was male—or so it seemed.

Where and how would a woman, a girl, find her place in that strapping city? For most American women of the time, the making of a family was paramount. Unlike them, however, the women of Butte had to overcome the burdens laid down by the city's activities. Butte was a microcosm of the West where men had stirred the dust, and determined women settled that dust and with it, the West.

In Butte the living was high. Men exchanged their paydays for raucous nights. The city

in those early years was about hard work and hard play. Men gave scant thought to family stability, neighbor, or community.

Women lay claim to the homes; they fussed, cajoled, demanded civility, raised the families, and diminished the impudence. In Butte, the feminine imperatives of organization and nurture were tested to a degree perhaps greater than in any other American city. Our grandmothers, along with thousands of others, met the test.

Despite fatigue, disappointment, and expectations that too often failed, women succeeded. By meeting the daily challenges, by simply living their lives in determined, organized ways, they went about being homemakers, mothers, grandmothers, and organizers in a manner that did justice to the critically important but seldom told drama of women in the mining city. Surrounded by the artifacts of a man's world, they not only steadied and righted the topsy city but by example and design they sent their children and grandchildren off as legacies of their own discipline, kindness, and quiet leadership.

EMMA RICHARDS BARTLETT

Carol's great-grandmother left an ancient culture behind when she departed Cornwall, England. The earliest human construction in her homeland dated back 6,000 years. The ancients built their monuments in stone, which Emma remembered seeing and at which she marveled. That land whose people spanned the Neolithic, Bronze, and Stone ages was home to Romans, missionaries, kings, chieftains, and — the Cornish proclaim — King Arthur himself. Emma Richards grew to womanhood knowing that rich history of her homeland, and for her first two decades she lived in those lush surroundings washed by sea breezes and a pleasant climate. Throughout the 1800s the men of Cornwall had mined the nearby deposits of tin and copper. The deep location of the metals so near the sea made the Cornwall mines dangerous and costly because of the constant requirement for drainage. High costs, dangers, and resource depletion combined to end the mining boom in the area. Cornwall's men, including Emma's husband John, began to seek ways to reach America and work in its mining enclaves.

When Emma, her husband, John, and their baby daughter Beatrice arrived in Butte, they found a landscape, climate, and history far different than home. The community, lying high in the Rockies, was in the throes of its growing pains—undeveloped and disorganized. Butte seemed cold, desolate, and dry to the twenty-three-year-old bride and mother. Sponsored by Emma's brother Marshall Richards, a motorman on Butte's

Emma Richards Bartlett.

street cars, the immigrant family lived initially with the Richards in the tiny settlement of Burlington a few miles west of Butte.

To Emma's eyes Butte was tumultuous. Most of its people lived within the several square blocks of the city's teeming downtown. Throughout the area there were soon more than fifty hotels and thirty restaurants. Although there were a dozen churches, there were more than 100 saloons and dance halls.

In 1894, Emma learned that her mother was ill, and she insisted that the family, which by then had grown to two more daughters, briefly return to Cornwall. Emma often spoke of that arduous trip. She would jokingly recall years later that, "I left Butte with rheumatism but returned cured."

One of the new daughters was Carol's grandmother, Elizabeth. Despite being only five years old during the Cornwall visit, she talked lovingly all of her life of the beauty of the Cornish landscape and most particularly its gardens. This interest in gardens was life changing for Elizabeth, who would become a talented gardener. In a city with few role models, she experimented with her plants and trees in the shadow of the Belmont Mine and would become a founding member and officer in the Butte Garden Club.

Upon their return from Cornwall in 1894, Emma and John began the construction of their new home at 1016 East Galena, where they would live for the rest of their lives and which would be home to three generations of Bartlett women. Emma not only devoted herself to her own family but also dedicated herself to the care of others. When her children were able to care for themselves, she began to work outside the home. She worked as "nursemaid" to many children whose fathers were executives of the Anaconda Copper Mining Company. She took a bus or street car from East Mercury Street to the West Side and the various homes of her employers.

In addition to her childcare duties she also took in laundry and boarders. She became a midwife for many of Butte's women, including some of her own daughters, and she took great joy in delivering several of her own grandchildren. She worked alongside many Butte physicians to provide care during delivery and after. She used to say when she had someone close to delivery that she was waiting for a full moon and the baby would "come just around the corner."

In 1913 when her daughter Elizabeth married Weston Griffith the family added a second story to the home for the newlyweds. And a generation later, on February 3, 1943, the house, 1016-1/2 East Galena, became Carol's home for the first five years of her life. The joy of having two grandmothers to spoil a little girl in addition to two doting parents,

Celeste and Vern, was every child's dream. Although some memories are difficult to distinguish from those infused by listening to conversations of elders, Carol recalls, "My great-grandmother's laundry was her primary income." Tubs and a professional laundry mangle were in the basement. The mangle, now in the laundry display in Virginia City, Montana, competed with the noises of the nearby Belmont Mine. Carol remembers:

> I can still recall the aroma of the bars of Fels Naptha soap, the bluing agent, and starch. There were wash tubs and wash boards, and in the corner stood the large mangle for pressing the linens and clothes. For our family's laundry there was a large galvanized tub and well-worn washboards. On the back porch hung a cloth bag filled with dozens of clothespins. Stretching thirty feet into the back yard were row upon row of clotheslines upon which frozen white ghosts would dance on the winter wind. The laundry would go from tub, to line, to mangle and miraculously be folded sparkling and clean, tied with string, ready to be picked up or taken to the always satisfied client.

To the children and grandchildren of those women, hard work and overcoming difficult circumstances became the norm. Through her determination, Emma taught three generations the necessity and value of hard work . . . and she was doing it in one of the hardest-working towns in the world.

Now fading photographs depict the celebrations and parades of the Butte Pioneers Club. There on the parade wagon stands Emma with six or eight other women and two men. The women are wearing the formal clothes of twenty years earlier: high boots, riding coats, exquisite dresses, and grandly plumed hats. Emma was a founding member of the club in 1928; membership was open to any resident of Butte, (scandalously, any "white resident"), who had lived there for at least twenty-five years. Emma spoke often of the social events of the Club: picnics, holiday dances, the "Apron and Overalls Ball." One of Carol's most precious possessions is the entire outfit Emma is wearing in one of the photographs.

Active in other community groups, including the Daughters of St. George and the Women's Benefit Association (WBA), Emma was also a devoted Methodist and sang in the church choir. The WBA was an outgrowth of the Maccabees, which was the first benefit association managed solely by women for the benefit of women. Its purpose was to assist women and orphans when tragedy would strike. Each member contributed a small amount of money each month, and if a death or disabling injury occurred, the needy family would receive funds to tide them over. The maximum benefit was $1,000.

It was an early day insurance company that was later incorporated as a mutual insurance company.

When Emma died at the age of ninety, she had outlived her husband by thirty years and left six children, twenty grandchildren, and twelve great-grandchildren. They all were blessed by her life and her understanding that our beginnings, our history, our labor, and our community mattered. She continues to reach generations not yet born.

ELIZABETH HAGAN KEOUGH

At 13 years of age, the young Lizzie Hagan, Pat's grandmother, had barely reached her teens when she and her father James stood on a dock at Liverpool and said their goodbyes to their mother and wife Mary. A half century later Lizzie would tell and retell the story to her grandchildren. "My mommy saw daddy and me off. She took a shawl from her shoulders and put it around mine. 'There you are Lizzie in case you get cold on the boat.' Then, patting me on the head but looking at daddy she said, 'Now don't forget: when you get to the new world, don't stop in America. You go straight to Butte, Montana.' "

Upon their arrival in Butte, they moved into the home of young Lizzie's aunt, Mrs. Elizabeth Fitzpatrick. Her new home was located on Gagnon Street just east of St. Mary's Church off North Main Street. The Fitzpatrick home was small and crowded, and it was soon decided that Lizzie would live there while her father and uncle moved to a boarding house until permanent lodging could be found. Jim Hagan quickly found work in the mines, and Lizzie, a Catholic, attended St. Mary's and later St. Patrick's grade schools and was a regular communicant at the nearby church.

Butte, as it was when Emma Bartlett arrived a decade and a half earlier, was teeming with activity. The fierceness of the war of the Copper Kings was matched by the struggles for employment and recognition of various ethnic groups. The Hagans and the Fitzgeralds, despite having departed from England, were Irish, and they clung to a few associations such as the Ancient Order of Hibernians (AOH) and, of course, the labor unions.

On the working front, although the Butte Miners' Union had secured the per-day miners' wage of an unheard of $3.50 at the time of the Hagans' arrival, unions had previously cooperated so closely with the companies that their independence was in doubt. However, issues of wages, working conditions, the eight-hour day, steady employment,

and work place authority soon became matters of fierce and sometimes violent confrontation between mining labor and company management.

Elizabeth Hagan Keough.

As a young girl Lizzie listened as her father, his friends, and relatives discussed the necessity of the solidarity that unions provided, but she also heard the angry words about which unions and which philosophy were best for Butte's workers. She saw dark disagreements overtake the faces of those she trusted to help and protect her in this place so far from her home. Her young mind understood that although the workers

had common objectives, friendships were being strained by the disagreements about how to reach the goals of appropriate salaries, benefits, and safer work conditions. She watched as her father and others strove, sometimes unsuccessfully, to remain friends despite the critically important disagreements about the various union ideologies. She saw the attempts to heal fresh wounds and deaden the pain caused by harsh words hurled in the heat of argument: a good natured slap on the back, the well timed wink, the argument closing handshakes.

For the remainder of her life Lizzie would show sympathy and support for workers and their unions, but she knew the dangers of the internecine and often violent confrontations among the unions. Years later she would urge her grandchildren to "stay in with your enemies for your friends will do you no harm."

Jim Hagan was working to bring his family to America. However, his wife died of pneumonia less than three years after those goodbyes at that Liverpool dock. Lizzie never spoke of it except to say, "I never saw my Mommy again." Within three years, her father, too, was dead of tuberculosis.

Lizzie was only eighteen and working at housecleaning and laundry. She was also a maid at the home of Dr. and Mrs. W.E. Dodd. The optometrist was an early friend and benefactor of a young lawyer—Burton K. Wheeler, who went on to become a respected United States Senator from Montana. Senator Wheeler would later regale his senate colleagues with humorous stories about the young, funny, Irish maid Lizzie Hagan. One of the most highly prized possessions in the home of Carol and Pat is a vase which President Franklin D. Roosevelt gave to Senator Wheeler and asked that he present it to Lizzie, by then a mother of five children, in remembrance of one of those humorous stories. Asked to retell those stories, Lizzie would say, "Oh, I can't remember. I suppose I was such a greenhorn that the Dodds and Wheelers simply enjoyed the turn of my young Irish tongue."

At twenty-one Lizzie married Pat Keough in 1912. She later talked about his good looks and Irish charm. He was ten years older than she and, like her father, an immigrant miner. Blessed with an Irish wit, her husband Pat was a storyteller, artist, and a practical joker who could "throw his voice," often to both the consternation and laughter of those who worked alongside him deep in the darkness of the earth. Pat found audience and friendship in Butte's bars, detracting from his home life at 204-1/2 W. Woolman Street. "A street angel and house devil," was Lizzie's description of him. As with too many of his companions, the difficult work and rancid air of the underground shortened his life. Dead at 56 years, Pat left five children, four of them in their teens.

To support herself and the children, Lizzie took employment as a cleaning lady and later as a candy maker. She often told frank, funny stories, about her exploits in "stealing kindling wood from the company to burn in my stove and keep us warm in the middle of the winter." She "mopped floors and shined brass doorknobs on the fifth floor" of the Anaconda Company headquarters in the Hennessy Building on North Main Street. Working through the night hours, she found great pride in doing her best and often delighted her grandchildren with lively stories that gave her work stature and a heroic nature. One such story filled her grandchildren with both fear and wonder as she told of being a cleaning woman in the Rialto Theater on Park Street. She and another woman would work all night cleaning the entire theater following the last movie or live show. One evening, moving backward while vacuuming the center aisles of the balcony, Lizzie fell over the railing, did a full somersault in the air, and landed on her feet in the center aisle of the floor below. She quickly returned to the balcony to continue her vacuuming; doing so, of course, to the astonishment of her fellow worker and herself as well.

Lizzie came to know virtually every family living within a square mile of her home on Woolman Street. Walking to Butte's downtown with her, normally a fifteen-minute walk, often took an hour . . . a most interesting hour. She met her friends coming and going, and with a smile and a joke, she inquired about their family members, always by name. She not only knew the names of all the members of the families and extended families, but she also recalled the places in Ireland or England from which they or their families had departed. Her wealth of personal knowledge helped others to appreciate their own importance and their own place in the society. Throughout the years Lizzie was a gold mine of family information for politicians and their supporters who would arrive at her house searching for the necessary information that would mark them as the candidate in touch with the people.

The sad irony, unknown to anyone, was that Lizzie never voted. She could not because, for some unknown reason, she never received her citizenship. Late in life she confided that secret to her grandson Pat and insisted he not tell anyone because "they will send me back." It is sad now to consider her near-constant fear that one day some government authority would knock on her door, confiscate her meager possessions, and ship her back to what she always called "the old country." Lizzie loved America, revered its presidents—Democrats as well as Republicans—even when alone at home she would stand at attention with her hand over her heart during the playing of the National Anthem on the radio. That allegiance was witnessed on a few occasions when she didn't realize anyone saw her. Yet this immigrant who instilled love of country in others lived her own life frightened at the oversight of not having received her citizenship.

Lizzie understood the value of organized labor and its solidarity to the betterment of her own family and community. She and her daughters were members of the Butte Women's Protective Union as, by the way, was Carol's great-grandmother Emma. During the funeral for Lizzie's husband, an event occurred that was often retold by those who witnessed it. On the third and final day of the funeral at Duggan's Funeral Home on North Montana Street, the time had arrived in the ceremony during which the pallbearers were to carry the coffin out to the hearse for the trip to the cemetery. Lizzie was informed that the ceremony would be delayed because one of the pallbearers she had selected wasn't present. Lizzie asked the proprietor of the funeral home, Larry Duggan, to select someone from among those in attendance. Unfortunately, he inadvertently chose a person who a few years earlier violated the cherished union solidarity by crossing the picket line to work in the mines despite a worker supported "strike."

The pallbearers, with the newly chosen substitute, walked solemnly down the crowded room's center aisle toward the casket. When they passed the front row on which sat the widow and her five children, Lizzie glanced up and, seeing the stand-in pallbearer, recognized him as a strike-breaker. She rose, faced the packed room of friends and called out to Mr. Duggan, "Larry, would you have that lad at the organ quit playing for a moment, please?" Once the music had ceased, she calmly told the startled crowd, "I don't want to make trouble; each of you understand that I have enough of that in my life now, and I certainly don't mean to unnecessarily embarrass anyone. But I must tell everyone this—no scab is packing my Pat. Boys, let's go back to my house; we can bury Patty in the morning."

Many of those mining friends often related that story in later years, noting that they carried Lizzie on their shoulders for the four-block march from Duggan's to the Keough home on Woolman Street. In death as well as life belief in one's cause was paramount.

LEGACY

Not only did women such as our grandmothers persevere, but they also left personal legacies in their children and grandchildren. The nine children of Emma Richards Bartlett and Lizzie Hagan Keough each became caring, delightful, accomplished adults. They were small business owners, craftsmen, entertainers, mothers, and fathers.

One of Emma's grandsons and the father of Carol became mayor of the city of Butte, Vern "Hanna" Griffith. The legacies of determination, daring, commitment, and concern have also reached through the decades to the grandchildren of Emma and Lizzie: one

of whom, Sister Toni Harris, became the Prioress of the International Catholic Order of Sinsanwa Dominican Nuns; another is the renowned motorcycle daredevil Robert "Evel" Kneivel; Carol Griffith Williams has been a member of both houses of Montana's State Legislature and the Democratic nominee for Montana's Lt. Governor in 2000; Pat Williams was Montana's United States Congressman for nine terms.

Emma Richards Bartlett and Lizzie Hagan Keough are only two among the throngs of women who, at the turn of the twentieth century, had the boldness to cross an ocean and begin life anew at the urging of a husband or father. Combining marriage, motherhood, and careers into single avocations, they created community, changed the lives and fortunes of others, and passed on valued legacies to succeeding generations.

Pearls from Butte

Bill Macgregor

The threads of stories of women surviving and thriving in Butte are often woven around a central tragic loss of a male family member to the dangers of mining. Sometimes that loss is covered over by the years, sometimes it is made survivable by distance—physical or emotional—from the event, but it tends to remain a key to understanding what might otherwise remain inexplicable sequences in a family's history. Demographics in some of the workers' neighborhoods surrounding and supporting mines on the Hill tell part of the story—a high percentage of households in Dublin Gulch, for instance, were run by widows. The lives these women built following such losses affected attitudes of all family members about women's roles. Boys growing to manhood in such households often learned that women's traditional roles might be matters more of opportunity than destiny. Grandsons hearing these stories from across the generations gain new awareness of the forces that shaped the character of the family's women.

COMING HOME

From the University of Hawaii, where I had been teaching, I was flying to Butte, where I was scheduled to interview for a faculty position at Montana Tech. In the hazy light of a late afternoon in July 1984, I experienced my first face-to-face encounter with Butte. Earlier, I had lived a decade in the Rocky Mountains in Colorado, so the airborne approach that skimmed mountain ridges didn't seem strange. The topography and dry summer air were familiar enough, reminding me of my years spent on the edges of the Sonora and Mojave deserts. What first struck me as strange, and remains strange to this day, was the summer light. At 10 p.m. the day of my arrival, there was still no sign that night—real darkness—was getting ready to fall. The lingering summer twilight, the mild dry air, the mountains looming at the edge of town—all these brought me out onto the hotel room balcony to take in what impressions I could detect of this place that I was thinking of moving my family to.

The hotel was on a commercial strip that could have been in L.A., Houston, or Detroit—generic, safe, and familiar. But the view from the hotel balcony was profoundly *un*familiar: before the light faded and the lights of the city began to emerge, the outlines of the city on the hill to the north—the feature that gave the town its name—struck a familiar chord, but it reminded me of nothing I had ever seen while traveling or living

292

in the West. I went to bed wondering what that outline reminded me of—and in the middle of the night I awoke with a start. I knew why the outline seemed familiar: I had once seen the same piles of dingy brick factories, industrial warehouses, bygone-era hotels, and assertive civic structures while looking across the Delaware River from Philadelphia at the decayed industrial heart of Camden, New Jersey. Like Camden, this place had seen much better days, but unlike any towns or cities of the same age that I had known throughout the Rocky Mountain West, the architectural history that told of those better days was still visible in the city's profile.

What struck me as well, during that first exposure to Butte, was the curious sense of coming full circle—of completing a circuit that had been broken nearly ninety years earlier when my father's mother (then nine years old) left here in 1898 after her father, my great-grandfather, was killed in the Leonard Mine in January of that year. This sensation was not a feeling of *déja vu*, because the strangeness of the place gave me no inkling that I had been here before; instead, the feeling was one of making a connection with a part of my family's history that before this time had existed only as stories told on special occasions, or while looking at old photo albums. My entire visit was permeated with this queer sense that I was returning—but to a place I'd never been before. My recent study of T.S. Eliot's work lent an eerie, almost scholarly objectivity to this experience. I remembered his allusion to unknown ends and remembered beginnings in *Little Gidding* from his *Four Quartets*:

> *We shall not cease from exploration*
> *And the end of all our exploring*
> *Will be to arrive where we started*
> *And know the place for the first time.*
> *Through the unknown, remembered gate*
> *When the last of earth to discover*
> *Is that which was the beginning*

In the twenty years since my arrival in Butte, this mysterious sense of homecoming—or of "arriving where I started"—has caused me to reflect continually not only on Butte's history, but on the unique character of the community and its strange and contradictory influences on my family—as carried down through the memories and the character of my grandmother, Pearl.

Ironically, apart from my grandfather, the central man in her life through all the years that I knew her, was a memory, a potent and fecund image of an absence, a tracery of loss around which she had to construct a pattern for her real life. Moreover, these

293

reflections about this child of Butte have over the years led me to a sense of belonging here, to a sense of ownership of my family's history, and through its connection to the place, to a sense of ownership and responsibility to develop and sustain Butte's communal memory—and thus its understanding of its present identity. In my mind, my grandmother's story has grown inextricable from the story of Butte.

PEARL'S FROM BUTTE

Born in Western Washington in February 1889 to Charles and Diana Lemon, Pearl Amanda Lemon (which she sometimes spelled LeMonde following the un-Anglicized form of her father's Louisiana surname) lived most of her first nine years in Butte, where her father worked as a contract miner and her mother was a registered nurse. A month before Pearl's ninth birthday, and on the day of her mother's birthday, her father was killed instantly when explosive charges he had "spitted" (lit the fuses with his candle) in the drilled "breast" (the wall of rock being mined) at the 800-foot level of the Leonard Mine exploded prematurely. Within a year, Diana, Pearl, and her sister, Garnet had left Butte behind and moved to Bisbee, in southern Arizona where, as in Butte, copper mining had spawned a small but prosperous community.

Pearl Amanda Lemon.

This is the story carried through life by all members of Pearl's extended Arizona family. My own memories from childhood of family conversations about Butte include murmurings about mysterious plots involving Wobblies and Pinkertons and The Company. In those conversations the festering grief and resentment about my great grandfather's violent and untimely death always seemed associated with suspicious behavior—on the part of the mine owner, the other miners, or "social outcasts" in the community: anarchists, revolutionaries, foreigners. Given that Butte from the 1890s on was known for the warfare among competing mining interests and that it was populated largely by such "suspicious types," the family mythology about Butte survived and fed upon itself, contributing to a xenophobic strain in both my grandparents' and my father's generation.

* * *

A gift from my grandmother that I brought to Butte when I set up house here was a lithograph of the Battle of the Boyne, when "King William crossed the water" and subdued one of those "foreign" groups, the Irish. Knowing little at the time of the depth of Butte's identification with the Irish struggles against England, I put a nail in the plaster wall, and proudly hung the picture in my study—as an heirloom. On the eve of the first St. Patrick's Day I viewed in Butte, the nail came out of the wall, dropped the picture to the floor and broke its glass covering. Unnerved, but undaunted, I restored the glass, repaired the frame, and reattached the picture to the wall. Early the next spring the picture fell again, this time when the frame itself came apart. Somehow, I haven't been able to convince myself in the 18 years since then to repair the picture again in order to display it on my wall.

* * *

Hovering behind my direct awareness of my grandmother as I was growing up in the southwest was the image of her own mother, Diana. My dim, early memories of her are of a craggy woman who always dressed all in black, though I can find plenty of photos showing her dressed in bright and dapper styles in contradiction of those memories. Perhaps the cragginess of her features recorded in these photos evoked my childhood memories of a stark severity that wasn't there. The menfolk in the family treated her with respect and a bit of awe; in an age when highly educated women were far from the norm, she held both a college degree and medical certification as a nurse. More than twenty years after leaving Butte, Diana went back to school to add medical training as a chiropractor to her list of certifications (at her graduation ceremony, she joked self-deprecatingly that the speaker at the ceremony addressed the graduates as "Doctor so and so" as they walked across the stage. I guess her pride in her achievement remained shadowed by her cultural training that told her only men were to be addressed

as "Doctor.") In the later twenties and thirties she had become financially secure enough to offer my father generous financial support as he worked through the process of earning his mining engineering degree from the University of Arizona in Tucson. By that time, Diana had outlived two more husbands—stepfathers to her two daughters. Yet in all the years I knew my grandmother, I never heard her speak of those stepfathers—only of her mother and her long-dead father.

By the time my father had completed college, Pearl had assumed the stature she was to carry through the later years when I knew her. For one thing, her stature was a literal fact: she stood half-a-head taller than my grandfather, and only a couple of inches shorter than my six-foot-one father. For another, her steady, confident influence was felt by all those around her. Following the family's emergence from the Great Depression, she came to be regarded as the stable core around which the family revolved. She was the reliable correspondent, maintaining close ties with family members all across the continent, from Canada to Mexico; the engaged and engaging member of various civic and fraternal groups in Nogales, the Arizona border town she called home from 1923 until shortly before her death in 1985; and the embodiment of the term "homemaker"—not the occupational title, but the real thing, the spirit of the household.

ONE LIFETIME LATER

In the summer of 1985, a few months before she died, Pearl was treated by my father to a grand tour of the places of her childhood, and Butte was an important destination on that tour. I had lived in Butte for a year and was eager to take her to some of the local sites I knew and to have her show me places she might remember from eighty-seven years earlier. At that point in her life, she required a wheelchair to get around, and gravity had begun to take its toll on her body—instead of becoming more and more frail, she had become heavier and more earthbound as she aged. Yet her mind and spirit were as perceptive and aware as ever. When she met us at our house she was full of almost girlish eagerness and curiosity about her first return to Butte since 1898.

Pearl had buried my grandfather, her husband of more than fifty years, and many of her oldest friends; so it was not surprising to me that her first request was to visit her father's grave. When we arrived at Mount Moriah Cemetery we had to pass by many more recent headstones, and as we did so she gave out a gasp of pleased surprise. The section where her father is buried is surrounded by graves and monuments of his Masonic lodge brothers, and she seemed relieved to know that. The monument for Charles Lemon seems surprisingly opulent for someone whose identity in the Butte

City Directory was merely "miner"—a seven-foot-tall carved column of polished black granite. Upon first seeing the monument, I had been filled with questions: How had the family afforded such a luxury? Who, if anyone, had helped? What did this monument say about the differences between myself today and my forebear and his time? And though I pressed her for answers to these questions, the memories she shared were those of a traumatized nine-year-old girl—vivid, intense, and fragmented.

Pearl's response to the gravesite visit was a curious mix of stoicism and tenderness: she nodded approvingly when she first saw the stone still standing as it had when she had last visited the grave. She stared around at other graves from the same time period and scanned the thousands more, marking lives that had ended in the subsequent century. She asked Dad to push her chair closer, and when he had maneuvered her over the rough ground to the gravesite, she tentatively reached out and touched her father's name on the stone. In my imagination, at that moment, she was there with us, and somewhere else, far beyond any of our knowing. As the moment passed and we bundled her back into the van, I had the sense that she had been waiting her whole life to stand here again, if only to simply extend her hand and touch a cold stone that restored to her something irrevocably lost.

The remainder of her visit involved a series of slow-driving processionals up and down the streets of uptown Butte, to see what sights might be familiar to someone who had last seen the streets and buildings eighty-seven years earlier as a ten-year-old. As we drove around she told us that after her father's death, the company that owned the mine had given her mother a boarding house to manage as a source of income. She described standing on a balcony in a building where she had lived and looking down on endless crowds of people passing on the streets below. She recalled parades loud with bands and performers and bright with elaborate moving displays. But she couldn't point to a single place and positively recall seeing it before; her sense of streetscapes that were intact in memory were confused by the fragmentation of those scenes by eighty-odd years of continual change in the city.

She told one story that evoked several dimensions of the reality of the time. When she was seven or eight years old, her mother had given her some money and told her to go down to the bakery that was a few blocks away to buy some bread. "But," she was told, "don't buy that raisin bread they have there." Curious, when she got to the bakery, she asked to see their raisin bread, and when they said they had none, she ordered "plain white bread, then." Her mother later explained that the number of flies that sometimes were baked into this shop's loaves made them look like raisin bread. Pearl still laughed about her mother's little joke about living conditions in Butte and the

homemaker's duties to protect her family from being cheated by careless or unscrupulous shopkeepers.

It was a lesson Pearl learned well. When I used to accompany my grandmother on shopping forays into Nogales as a child, she invariably knew all the merchants by name, and she always took care to ensure that the meat and produce she selected were fresh and clean, and the groceries were fairly priced. If she was dissatisfied, she would quietly (but obviously) set aside the unsuitable items, pay for the rest, and drive across the street to the competing market to buy the remainder of what she needed. They usually got the message: more than once I remember a store manager greeting her and assuring her that *today* they had good, fresh tomatoes (or pork chops, or peaches).

Like Pearl and her mother, Diana, Butte's women have often had to take on this kind of role, and in some cases it has moved beyond the level of the nuclear or even extended family to accommodate mutual protection of families' welfare throughout the community. Mary Murphy's *Mining Cultures: Men, Women, and Leisure in Butte, 1914-41* recounts the assertiveness and relative success of the Butte Housewives League in combating price gouging by Butte merchants at the end of World War I.

Pearl died a few months after this visit; I never saw her alive again. But in her few days in Butte she convinced me that she was onto something important and profound in seeking to reconnect to her dead, to awaken again memories, images, places, people, and events that somehow brought her life full circle, filled it up, and completed it.

PERSISTENCE OF VISION: LOSS AND RECOVERY

In thinking about the story of Pearl, Diana, and Charles Lemon—my own Butte dead— I find myself pondering paradoxes that reflect more broadly on Butte's story. My discovery of my Butte ancestors' struggles parallels my understanding of Butte's survival as a community. Born as a member of the dangerous and transitory species of communities known as mining camps, Butte's uniqueness isn't merely in the number of miles of tunnels beneath its streets, or in the (now dated) magnificence of its uptown District, but rather in its staying power as a communal entity in the face of horrendous losses of the lives and health of its men to the mines.

The last birthday card Pearl received from her mother, Diana, was sent in January 1950, just two weeks before Diana's own eighty-seventh birthday, and five weeks before her death. The note—just a torn scrap of paper—trails off with the following poignant thoughts:

*　*　*

I'm thinking of Feb 2nd

it will be lonesome

for me. Had your

dear PaPa. now alone

& old. but must

have no regrets. its

gone. love

dear girl

*　*　*

Every birthday after the one in 1898 must have been intensely bittersweet for Diana: every opportunity for celebration clouded by the memory of Charles's death. So half a century later, she still grieved, felt the loss, and then sucked up her regrets into some hidden store of strength: nothing heroic or mighty—just a stolid and steady willingness to acknowledge her loss and move on with her life. And as her life came to its close, the loss still keenly felt, the temptation to descend into self-pity was stopped by the necessity of dealing with the here and now, and ultimately by the connection to family: "love/ dear girl."

When I first arrived in Butte twenty years ago, knowing this story, or parts of it, I couldn't have written about it; I felt it was too private and personal. In the intervening years, so many students and friends from Butte have shared similar stories of loss and perseverance that I now recognize it not as merely my family's story, but Butte's story.

As a longtime resident "from away" I have often puzzled over Butte's survival in its primary identity, as "the mining city." My experience of living throughout the Rocky Mountain West brings comparisons to mind of once-booming mining camps with similar potential aspirations of urban prominence and stability that are now just ghost towns or tourist attractions—and not merely because the ore reserves were used up— towns such as Cripple Creek, Central City, and Blackhawk, Colorado; and Jerome, Tombstone, and, yes, Bisbee, Arizona. Why did their communities dissolve, their buildings crumble, and their civic life die out, while Butte endured?

My experience among lifelong Butte residents has convinced me that Butte's persistence lies primarily in the family-centered, neighbor-centered, community-centered character of its people—much like the character and attitude revealed in Diana's last letter to Pearl. Beyond that, I have come to recognize a set of seemingly contradictory coping skills apparently learned across generations in this culture. And because of the high mortality rates among men in the mining profession, I associate these skills primarily with the women of Butte, who, like my grandmother, and her mother before her, formed the glue that has held families, neighbors, and community together.

Butte's families have learned to live with powerful social and economic forces, as embodied in the Anaconda Company's (ACM) domination of every aspect of community life for most of the last century. They have learned that this can provide a pathway to economic stability. But they have also learned that their acceptance of this situation can cost them their homes and their entire neighborhoods. Memories and feelings remain strong among former residents of Meaderville, McQueen, and Dublin Gulch, to name a few, whose settled lives were uprooted by decisions of the mining company—to expand or alter operations in such a way that neighborhoods were buried or moved, and neighbors dispersed.

Steve Luft's *Digital Reconstruction of McQueen,* a 2004 graduate project at Montana Tech, brought together photographic records, a three-dimensional model of McQueen in its Butte-area setting, and an interactive kiosk enabling users to visit the lost community through various lenses. The public announcement of his show prompted an overwhelming response from former residents of McQueen, and their reactions to the *Reconstruction* of their lost neighborhood were both revealing and emotionally powerful. The exhibit evoked expressions of intense grief over the losses these people had suffered —several women broke down in tears at large-scale photos showing the Holy Savior School being crushed by waste rock from the growing Berkeley Pit. Yet they were there; they had come together for this experience, reconstituting for the moment their lost neighborhood. And the original values underlying their social bonds were still intact— when a very aged former teacher from the community showed up late and took the seat offered her, all small talk stopped and everyone sat up and paid attention, as if they were back in her classroom.

This virtual reconstruction of their lost neighborhood allowed the people of McQueen to revisit the neighborhood as it was; to renew neighborly bonds in that context; and to expand their understanding of the loss that had occurred in their lives. More pointedly, however, the experience allowed them to embrace and accept their loss and move on, by reminding them that the loss was a shared one, and that though the original

community was attenuated, dispersed, and displaced, it was not utterly destroyed.

My family's displacement from Butte following the death of my great grandfather is echoed in the experiences of many others in the community. It is probably the most commonly told story about Butte. For many the loss and reason for departing may not have been a death, but *merely* the loss of a job, a career, and a livelihood. For others, the loss may have been the physical destruction of homes and neighborhoods in the name of progress and profit by the ACM or its antecedents, and while many such displaced residents relocated to other parts of town, many others left Butte entirely. But still others, like my great grandmother, left because the loss of a family member to the dangerous work in the mines, combined with opportunities to start over elsewhere, and a hope to leave the loss and grief behind in Butte.

Yet like other stories of dispersal and loss, Butte's has its redeeming side. The stories of Butte and the attendant life-lessons I learned at my grandmother's knee as a child in Arizona left me receptive to making a kind of sense of what I find in Butte today: a city whose decaying infrastructure and stagnant economy make it an object of occasional scorn and contempt by other Montanans; a community whose identity is in constant contest; a community that cares passionately about its history—often, it seems, because it matters so much to residents *whose history* of Butte is being told; a community whose economic hopes remain largely tied to mining—an industry for which the underlying premise is the exhaustion of the primary resource that makes its form of industrial prosperity possible.

Thus, the facts of life in Butte are built on the inevitability of loss and the necessity of human persistence in the face of such loss. Pearl's wisdom was in the acceptance of these facts. It was a legacy her mother and her life in Butte left her. My vision of Butte now is part of my inheritance from Pearl. When viewing the city from the same perspective I had the first time I was here, it isn't Camden, New Jersey that comes to mind, or Cripple Creek, or Bisbee, or any other strange place I've known. It's Butte's own unique succession of losses I see, and the human community that endures those losses and goes on.

Teaching Inspiration: Building the Butte Teachers' Union

Kitte Keane Robins

When I was a young teacher in 1968, I was having a conversation about the civil rights movement with a black teacher at our school. She sighed and said, "Well, my mother always said, 'Freedom isn't free.'" It was just the kind of thing my mother, one of my aunts, or one of their co-workers might have said. When I told Mother about the conversation she said, "That lady is absolutely right. Personal, political, or economic freedom it isn't free."

Mother would know about struggling for rights. In 1933, in the depths of the Great Depression, my mother, Mary Thomas (Keane), her sister Catherine Thomas (O'Neill), and their colleagues Ruth McGee and Marie Leary were elementary school teachers in their mid-twenties. The women began a conversation that would lead to the formation of the first viable teachers' union in the state of Montana. On May 22, 1934, the Butte Teachers' Union No. 332, a chapter continually active to the present, received its charter from the American Federation of Teachers.[1]

This chapter tells the story of the formation of the Butte Teachers' Union (BTU) and the young women who served as its catalysts. It is based on conversations with my mother prior to her death in 1992, review of my mother's personal papers, and archival research on the union's history.[2]

Teaching was one of the few professions open to women in the 1930s. Mother's personal notes for a speech she gave about the founding of the BTU recall the situation for teachers in 1933:

> We were in line at the county court house, not to pay income tax, but to file because we had earned a yearly salary of slightly over a thousand dollars. Three years earlier, we had been hired at $140 a month for the nine months of the school year, or $1260 per year. The next year we were cut to $126 per month, and in 1933 we were cut to $112 or $1008 per year. If two sisters were employed in the school district they were cut to $80 per month each.[3] [The rationale was that sisters would be single women, usually living in their parents' home, so they didn't need the full salary.] Marie Leary had a four-year degree, and she was teaching first grade. At that time most elementary teachers had a two-year degree from the state normal school, with some having little formal education beyond high school. Marie's salary

was twenty dollars a month lower than the teachers in high school with the same degree. The four of us decided to meet and see if anything could be done to prevent further salary cuts, and try to get fair compensation for teachers who spent time and money studying to better themselves professionally.[4]

My mother's colleague Ruth McGee had similar concerns. As John Astle writes, "A young elementary teacher in the Butte system had started her seventh year as a teacher and the second year in a row with a salary decrease. Her name was Ruth McGee, and she was to be the first president of the Butte Teachers' Union. Right now other problems were on her mind."[5] Ruth had started teaching in Butte in 1927, also at a salary of $1,260 per year, after graduating from Montana State Normal School (Western Montana College) and teaching two years outside of Butte. She had been promised a raise after two years in Butte, but she received no increase for five years. Instead she saw her salary cut. Astle describes the situation in the early 1930s:

> During these years, the school board reserved the right to cancel a teacher's contract at any time if they found it necessary to close the schools. Teachers' salaries could be advanced on the existing schedule only upon the recommendation of the District Superintendent. There was a period of about eight years from 1927 that only teachers who had friends on the School Board received any advancement in salary. And, in spite of the financial crisis that was being mentioned by the School Board, no employee of the school district, except teachers, had received cuts in pay.[6]

In response to the situation, my mother and her three young colleagues contacted other teachers and asked them to meet at the American Candy Shop to discuss what could be done. They began to identify the issues that affected their lives and work. The vast majority of teachers at this time were young women. At that time a woman teacher lost her job as soon as she got married. This led to quite a few secret marriages, where couples would be married, but continue to live in their parents' homes. Sometimes even the parents would not know about the marriage. When the husband found sufficient employment to support his wife and the school year was over, the couple would then announce that they had been married. Some couples went through a second wedding with only the bride and groom aware that they were already married. If the women became pregnant, this was quite a problem. The first marriage certificate would be promptly produced to prove they were already married. The embarrassment of admitting they were "keeping it quiet" so the woman could keep teaching, was less than the embarrassment of a pregnancy without a marriage.[7]

In a 1984 article by Carmen Winslow in the *Montana Standard* Ruth McGee spoke to some of the effects of the marriage rule. Ruth felt she could not marry her beau. "Ruth was supporting her mother, brother, and sister with her teaching wages. Had she married, her husband would have been responsible for them all. 'I couldn't ask him to do that,' she said. Ruth never married. With pride Ruth said, 'It was the union that negotiated the marriage rule out.' "[8]

In the 1930s new teachers were often about nineteen or twenty years old, and the marriage rule created significant turnover. For an individual teacher to take legal action would have been unheard of both for economic and cultural reasons. Women had only been allowed to vote in Montana since 1914 and nationally since 1920. For these reasons and the dire economic conditions of the Depression, school boards and communities could, and did, have a "take it or leave it" attitude regarding teachers' pay and teachers' benefits.

The struggle to found the Butte Teachers' Union was especially courageous, given the harsh economic conditions of the Depression. At this time copper, the economic lifeblood of Butte, was four cents a pound, and demand, even at that price, had dwindled. About one in four Montanans was without work or on welfare. Some thought the teachers should be grateful because, after all, they had jobs.[9] But the heart of the matter was that these young women realized their contracts were not worth the paper they were written on. They also knew that as individuals they had no power to change the situation. Cuts in salary were arbitrarily made with no end in sight. There was no organization through which a teacher or group of teachers could present their grievances to a school board and ever expect to be heard.

Anger over the continual pay cuts, the disparity of pay for teachers doing the same work, and the lack of increased pay for additional education fueled the women's impetus to organize. My mother found the pay cuts that sisters were forced to take especially unfair. Sisters working in the school system were doing exactly the same work as the teachers next to them. Yet, because sisters took their salaries to the same household, their pay was radically cut. Many young teachers, like my mother and aunt, had dated the men they would eventually marry for many years. Because of the Depression, many men did not have jobs, or if they had jobs there was little job security. Often people lived in their family homes through their twenties, saving money until they could eventually marry or leave home. Some teachers were supporting parents, and, at times, the entire family. With the constant pay cuts these hopes to marry and leave home were pushed farther into the future.

Looking through Mother's old papers, there seemed to be little talk about benefits as a primary reason to form the union.[10] The original motivation was to secure better pay for teachers, and to make their contracts mean something. In time, however, the benefits fought for and won by the BTU were a great source of pride for all of the original union organizers. They knew they had made a significant difference in changing teachers' lives for the better.

These are some of the conditions in the early 1930s that my mother noted:

> Not only could your pay be cut, there was no job security. There was no tenure. You could lose your job at any time if it was necessary to close schools. You were also fearful that you would lose your job because someone's friend needed a job. Most teachers had no way to defend themselves against a breach of contract, because they could not afford lawyers and there was no organization that would come to their defense. Teacher's pay could be arbitrary.[11]

Moreover, there were no rules as to how large classes could be. "Classes were usually about forty to forty-five pupils, but they could be larger."[12] There was no real teachers' retirement.[13] There was no medical insurance, no time off for any medical problem, and no sick leave. Mother described what happened if a teacher got sick. She reminded us that at that time antibiotics were not available. Diseases like influenza and pneumonia could be fatal.

> You were daily with large groups of children, so you were exposed to everything. Convalescence from disease was often long. If you were too sick to go to school, you had to find your own substitute and pay them out of your own salary. If you could find someone who would substitute for you by phone, that was a bonus, but since many people didn't have phones, you might have to actually go knocking on doors.[14]

I asked her how you could do this if you were sick. Her answer was, "Always make sure you have good friends." Since her sister Catherine was a teacher and they both knew most of the elementary teachers, they could help each other find substitutes. Most of all she said, "You usually didn't admit you were ill even to yourself. You would just go to work sick." Personal leave was something no one could even conceive of in 1933. The truly amazing thing is that conditions in Butte were probably better than in many places. There was great competition to get a teaching job in Butte.

After identifying the struggles they faced and committing themselves to seek change,

the young women were ready to organize. However, they were inexperienced and not sure how to proceed. As Ruth McGee recalled, one woman suggested that they circulate a petition. Ruth pointed out that a petition would not provide contract guarantees.[15] Others suggested bringing their case to the parents of their students and asking for help from parents' groups. The women turned to their own parents for advice as well.

Mother and her sister Catherine had been complaining about their situation at home. Their father, Joe Thomas, an Irish immigrant, would say, "You won't change anything by just talking to each other." Joe Thomas had immigrated to the coal mining area of Pennsylvania from Donegal in the late 1800s because of the desperate economic situation in that part of Ireland. In Pennsylvania the coal companies owned the towns and controlled the grocery stores and the medical facilities. No matter how hard the miners worked, they were usually in debt to the company. Often they would receive no money at the end of the pay period. Their wages would end up just being credit at the company store. The miners were virtually serfs. The extended family sent Joe Thomas off to look for a better place to live. In Colorado he heard of a fantastic place, Butte, Montana, where one could earn $3.50 a day working in the mines "free and clear." He arrived to find a bustling city with lots of Irish and less of the prejudice against his people than he had seen in the east. There were many churches, bars, and opportunities. Probably because of his experience in the Pennsylvania mines, Grandfather Thomas was very interested in labor issues, and he encouraged his daughters to get organized.

Grandfather Thomas was sure they would have no success getting better wages, and real contracts, unless they started a teachers' union. The young women told him that the idea had come up, but reminded him that once before when local teachers tried to form a union they were all fired. Grandfather suggested they seek help from the Butte Trades and Labor Council, which later connected them to the Teachers' Union in Chicago. They followed his advice, and the initial group of four teachers soon expanded to include fifteen others, eleven women and four men: Margaret Lowney, Margaret McGellic, Marjory Gillick, Raymond Bundy, Angiline Golubin, Charles Davis, K. L. Julson, Stanley Griffiths, Ann O'Brien, Mae Toy, Catherine Prendergast, Olga Kanarski, Margaret Clark, Agnes Murphy, and Mary Sullivan. These nineteen people became the charter members of the Butte Teachers' Union. Whether by chance or by plan, the charter members were teaching in schools throughout the system. Two of the men taught in the high school, and the other two men were manual training teachers. And the 15 women were teaching in 11 different elementary schools.[16] The Butte teachers received their charter on May 22, 1934, from the American Federation of Teachers, which was associated with the American Federation of Labor. On October 3, 1934, the first officers were elected and installed.[17]

Carmen Winslow writes about the risks these women faced: "Ruth McGee recalled her mother being worried about her daughter's involvement in unionism. 'Aren't you afraid you'll lose your job?' her mother once asked. 'I don't care if I do,' Ruth replied at the time, 'because I can scrub floors and make the same as I am teaching.' "[18] Mary Thomas was twenty-five years old, Catherine Thomas was twenty-six, Ruth McGee was twenty-nine, and Marie Leary was twenty-eight when they became charter members. Recalling this period, Mother always laughed saying, "You have to be young to be a revolutionary."[19]

Like so many worthwhile actions, forming the union was much harder than the women ever imagined it would be. Many teachers objected to the union. The young organizers were shocked at the opposition to what they thought was a good idea. Serious rifts developed among various groups of teachers. Some teachers opposed the fledging union's proposed salary schedule that would encourage hiring teachers who had earned at least a two-year diploma. In 1935 over one third of teachers in the Butte school system lacked a two-year diploma. Others resisted the union's support of basic standards such as registration of transcripts and teaching certificates with the County Superintendent of Schools. In addition, there were opponents who said that teaching was a profession and having a union would diminish a teacher's professional status. They didn't think it was proper to be "unionized" like trades people.[20]

The opposition from teachers was disheartening for the organizers. My mother said, "I just felt terrible. Before we tried to organize a union we got along with everyone. Now we had real enemies. People were angry with us."[21] They were called naïve, young radicals. People said they were just foolish girls who didn't know what they were doing. Mother described walking into a lunchroom and being shunned by some teachers. Former friends and acquaintances wouldn't talk to her. People would leave derogatory poems where the union organizers would find them. She was deeply hurt. But once they began recruiting teachers to join the union, there was no turning back. As Mother said, "If you started something you just had to push through until you succeeded or failed. The idea of quitting in the middle was unthinkable."[22] Also, if the union failed, they felt it would let down all the other people who were trying to organize labor, and Butte was a hotbed of labor issues and labor organizations. Although Mother was a forceful orator, and could stand up for herself and her opinions, she was also very sensitive. By 1984 when the union celebrated its 50th anniversary the organizers received almost universal praise and accolades. Yet, for some of the organizers there were remembrances from these early years that brought back memories of real personal pain and turmoil.

Mary Thomas Keane. *Catherine Thomas O'Neill.*

By late 1934 the core group was growing. The union had garnered serious supporters. The active participation of charter members Chuck Davis, Raymond Bundy, K. L. Julson, and Stanley Griffiths added immensely to the union's credibility. The organizers were no longer considered just a group of "naïve, young women"; male teachers were now also involved. New members were screened and initiated. The dues were 50 cents a month.

The BTU presented its first contract to the school board in early March, 1935. The provisions included a recognition clause for the BTU; a single salary scale for all teachers, which meant teachers would be paid according to their education and experience not according to the grade or subject they taught; and advancement would be made strictly in accordance with the new salary schedule. Educational credits for advanced training would be rewarded. If economic conditions prevailing in School District No.1 warranted a salary adjustment, representatives of the union would be called in to negotiate such an adjustment. The school board would be willing to hear grievances of union members when presented in writing.

The pro-labor Independent Party held a majority of the school board seats at this time. But according to Ruth McGee, even these board members said that there was not funding available to pay the teachers the new salary scale.[23] "A sympathetic county

treasurer, Mervin Dempsey, tipped the teachers off on county financial books. It was there that the teachers found $500,000 in the school district's 'sinking fund'. We said, 'yes, you can pay us more.' And the trustees did."[24] The contract was accepted on March 26, 1935, by a vote of 4 to 3, to become effective July 1, 1935. The union teachers were amazed and overjoyed at what they had accomplished. It seemed to be too easy, almost too good to be true. And it was. In a little over a month they would find all their gains lost.

The April 6, 1935 school election changed the make up of the school board. Two members of the People's Party, which did not support the pay increase for teachers, defeated two members of the Independent Party.[25] The new school board did not approve the raises, and it rescinded the single salary schedule and the contract that had been negotiated only a month earlier. The union members were shocked and angry. They, along with the Silver Bow Trades and Labor Council representatives, spoke to the school board. They pointed out that overturning the contract violated the National Recovery Act. They also reminded the school trustees they might be called "unfair" and people supportive of labor would boycott their businesses. According to Carmen Winslow, the People's Party trustees who did not support the union contract included a grocer, undertaker, and a truck driver for Montana Hardware.[26] When the school board tabled a letter sent by the Silver Bow Trades and Labor Council asking them to reconsider their action on the contract, the trustees were placed on the Council's "unfair" list. This meant that all union members and their families throughout Butte boycotted the businesses. There is a story that is told where the body of a deceased family member was taken to the undertaker, who served on the school board, for burial. When another family member found out that this undertaker was on the "unfair" list and why, he went to that mortuary and took the body to another undertaker. By June, the impact on their businesses forced the school board members to ask the BTU to reopen discussions on the salary schedule and contract. The negotiations dragged on through the fall. According to Mother, as winter approached the engineers who ran the school heating plants applied pressure by threatening to stop the heat supply to the schools. The final agreement and contract wording was finalized on December 11, 1935 retroactive to September l, 1935.

Butte teachers were the first teachers in the United States to negotiate an agreement between a teachers' union and a school board through a process of collective bargaining. They now had one of the first single salary schedules in the country. They had created an organization where their shared grievances could be aired. And they had made it known that these polite, gentle ladies in dresses and hose, proficient at giving teas and

making mints, adept at dinner conversation and writing pep songs, were a force to be reckoned with.

Little did my mother know in 1933-34 the profound effect the union she helped organize would have on her own life and the lives of her children. In September 1948, my father, Robert Keane, died of heart disease at the age of 41. His early death came as a complete shock. His job, like so many at that time, was not covered by social security. The medical insurance covered only a small part of his final illness. Mother returned to teaching at the Blaine School two weeks after my father's burial to support her children who were nine, six, and four years old. By the time Mother retired in 1972, she had taught in the Butte schools for a total of thirty-three years.

Looking back, my brothers and I had a truly wonderful life. We had economic security and medical coverage, and our mother could be home with us during the summers. Our lives were full of her delightful friends, most of whom were teachers. Some were married, some were single, and some were widowed. They were all able to support themselves and their families on their teachers' salaries. There was a banquet celebrating the first 50 years of the Butte Teachers' Union in 1984. Representative Pat Williams came from Washington D.C. to give a speech. His father had owned the American Candy Shop where the Union organizers first gathered. Pat had been a teacher before he became a congressman. His presence at the event meant a great deal to the early founders and organizers. As with so many events in Butte, life had come full circle.

My mother also gave a speech that night. In it she told some of the history of the BTU and stories from the early days. At the end she said, "I never dreamed at twenty-five the effect our good and strong organization would have on so many families and children. In the end everything we do has an effect on all of our children. We hope that all of what we did and continue to do benefits the following generations." My brother and I couldn't look at one another. We would have cried. Our life, the security of a warm house, good food, and medical insurance, the chance to go to college, our mother's security in retirement, all started in the American Candy Shop with a determined group of women who said, "We can do better than this. Life can be more fair. We can and will stick together and make a difference."

NOTES

1. Though the State University of Montana at Missoula had an earlier chapter number, it was dormant until revived in 1937, largely through the efforts of Mike Mansfield. The Butte Teachers' Union was formed only 18 years after the American Federation of Teachers was founded in Chicago in 1916.

2. Of particular significance is John Astle's "History of the Butte Teachers' Union: The First Fifty Years" (1984), which provides source material for this essay (Hereafter Astle, "History"). A copy of the history is on file at the Butte-Silver Bow Public Archives. Mary Keane's personal papers, containing notes and speeches about the Union's formation, also provide valuable source material.

3. Mary Thomas Keane, personal papers, which include scrapbooks, contracts, and notes from speeches (Hereafter Mary Thomas Keane personal papers).

4. Ibid.

5. Ruth McGee served as president of the union from 1934-36 and 1961-63.

6. Astle , "History," 3-4.

7. From conversations with my mother and others who were teaching at this time.

8. Carmen Winslow, "Teachers' Union Finds Start in Candy Shop," *Montana Standard*, November 4, 1984, 18. (Hereafter Winslow, "Teachers' Union").

9. Mary Thomas Keane personal papers.

10. Ibid.

11. Conversations with Mary Thomas Keane.

12. Mary Thomas Keane personal papers.

13. A true retirement system was not in place until September of 1937. The bill establishing a retirement system for Montana teachers came about through the efforts of the Butte Teachers' Union, supported by the lobbying efforts of organized labor. See Astle, "History."

14. Conversations with Mary Thomas Keane.

15. Winslow, "Teachers' Union," 18.

16. See "All School Teachers Are Re-employed at Present Salaries at Board Meet," *Montana Standard* April 30, 1935, 2.

17. The first slate of officers included five women and two men. Given the times, the presence of men added prestige and credibility to the newly formed union.

18. Winslow, "Teachers' Union," 18.

19. Conversations with Mary Thomas Keane.

20. Astle, "History," 7-11.

21. Conversations with and personal papers of Mary Thomas Keane.

22. Ibid.

23. Winslow, "Teachers' Union," 18.

24. Ibid.

25. Astle, "History," 7 – 11. The People's Party supported a market economy and sought to lower taxes.

26. Winslow, "Teachers' Union," 18.

Dorothy and Lucile Hannifin: Gems of Butte

Tracy Thornton

While the number of women in Butte's work force was growing in the 1930s and 1940s, not many were running their own businesses. Dorothy Hannifin was an exception to the rule. Dorothy, with the help of her sister, Lucile, was a successful businesswoman in the Mining City, running Hannifin's Jewelry on North Main Street for nearly forty years. Dorothy and Lucile were true gems of Butte who left a legacy of elegance and beauty that touched many lives.[1] Residents from all walks of life were transported to another realm as they entered the exquisite store, perhaps to admire the sparkle of a crystal goblet, select wedding china, or purchase a very special gift, be it a diamond pendant or a small figurine. As Zena Beth McGlashan recalls, "I will not forget, as long as I live, the massive mahogany cases that lined the walls displaying crystal, china, and silver . . . It was, I think, one of the most elegant places I was ever in . . . and I've been a lot of places!"

Dorothy Hannifin had not envisioned a life in the jewelry business. An aspiring scholar, Dorothy attended Reed College in Portland, Oregon, and in 1932 at age twenty-two she became the second woman to earn a law degree at Montana State University (now the University of Montana). She returned to Butte and began her professional career in the legal department of the Anaconda Copper Mining Company. However, her legal pursuits were short-lived. Upon the death of her father, Dr. John Hannifin, in June 1935, Dorothy took over the struggling business of Towle-Winterhalter & Hannifin Jewelry and began her career as a businesswoman.

"Dorothy was a pioneer in the business world," recalls longtime friend Sheri Broudy, who met the Hannifin sisters when she was a girl. According to Broudy, the jewelry business Dr. Hannifin had co-owned for forty years was not doing well as a result of the Depression. "Dorothy just stepped in and learned by trial and error. She pulled that business up by its boot straps." "The business was in very poor financial condition,'" recalls another family friend, Ann Simonich, who also worked for a time at Hannifin's. "For the first five years after she took over Dorothy did not take any salary. [She] just felt it was her duty to help out."

Making sacrifices for family was typical of Dorothy. After all, she and Lucile had been molded and shaped by their mother, a strong, smart woman who had worked hard

early in life to support her own family. Mary Moran Hannifin grew up in Pennsylvania and came West as a young woman. She began her teaching career in Butte in the 1890s. Times were hard, and part of her meager salary went to support her family back East. As was the expectation of the times, she "retired" from teaching when she wed John Hannifin, a successful young optometrist about to launch his new business venture. Going against the grain, however, Mary Moran Hannifin later returned to teaching and served a distinguished career as principal of Monroe School in Butte. As the Hannifins pursued their professional careers they also instilled in their daughters the value of education, a strong Catholic faith, and a refined sense of taste.

Both Dorothy and Lucile followed their mother's example of leaving home to pursue their education and immerse themselves in the possibilities of a larger world. Dorothy headed first to Oregon then returned to blaze the trail for women lawyers at Montana State University. Lucile graduated from Immaculate Heart College in Los Angeles with a degree in music. She worked as a secretary at the Montana State Children's Home before responding to a call of faith and joining a Catholic religious order.

In December 1942, the illness and subsequent death of their mother would bring Lucile, then a postulate in an Oregon convent, back home. She never returned to the convent. According to Simonich, Lucile remained in Butte at the request of her sibling. "Dorothy told me she was very lonely," recalls Simonich, "and asked Lucile to stay home." So began the partnership of 'Dot' and 'Luie,' nicknames the sisters had given each other.

With Dorothy at the helm the sisters ran Hannifin's Jewelry for the next thirty-two years. The business became well known throughout Montana. Cheri Foss, who worked in the store as a teenager in the mid-1960s, recalls the store's beauty: "It was filled with many items I'm sure I would never have seen or heard of if I hadn't been able to work there." According to Foss, the Hannifin sisters loved their store, "They were so friendly, caring, knowledgeable, and willing to spend time with customers and employees."

While Dorothy was largely responsible for the business end, Lucile lovingly brought the soul of an artist to the store. "Dorothy was the cog in the wheel," explains Simonich. Broudy recalls that Lucile, who was an accomplished pianist, would help out and work part-time in the store. Lucile arranged elegant window displays, often featuring religious themes that blended her artistic sensibility and deep faith. In addition, Lucile took care of the family home the sisters shared and prepared their meals.

The sisters, who were virtually inseparable, were also a study in contrasts. While Dorothy has been described as strong and confident, Lucile has been characterized as a playful spirit. Foss fondly remembered both sisters. "Dorothy was efficient, organized,

and expected the same of her employees." On the other hand, Foss describes Lucile as the more "flamboyant" sister who "loved to talk, tell stories, and laugh." Both sisters loved a good joke, and Dorothy often urged Lucile to tell stories that would send them both into peals of laughter.

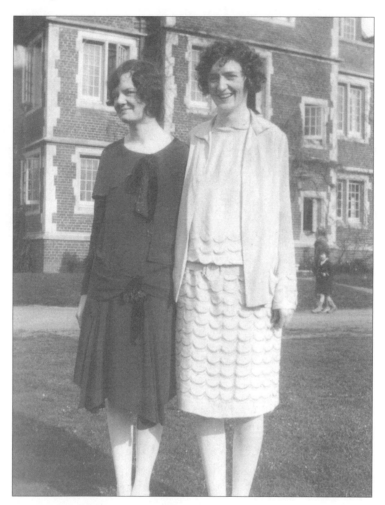

Lucile and Dorothy Hannifin.

While business was a top priority for the Hannifin sisters, the desire for adventure was a close second. The siblings traveled extensively throughout the United States, Europe, and even to Thailand, absorbing cultural knowledge along the way. According to Martin Burke, a University of Montana law professor who gave the eulogy at Dorothy Hannifin's funeral, "Dorothy filled the store with exquisite items which she discovered in her various travels. She loved fine art and craftsmanship and had a great eye for it. She featured in her store the works of great silversmiths and goldsmiths of Florence;

she stocked the shelves with the finest china and silver. She introduced the people of Butte to some of the finer things in life." Ann Simonich remembers Dorothy as an excellent photographer who documented their travels then shared their adventures through slide shows. "She would narrate everything and make you feel like you were right there with her."

The Hannifin sisters were women of dedication and devotion—to their family, business, community, faith, and one another. The sisters retired in 1977, but remained active in civic organizations and St. Patrick's parish. Their closeness was never more evident than in the early 1990s, when Dorothy began to develop signs of senile dementia. It was then Lucile's opportunity to be strong as she took on the role of her sister's caregiver and protector. Lucile died on July 10, 1997. Dorothy followed her sister in death on Feb. 2, 1999, and was buried with Lucile in the family plot at St. Patrick Cemetery. Martin Burke sums up the sentiments of many as he describes the sisters as family to him:

> Dorothy and Lucile understood family in a much broader way than just blood relationship. The good Lord's plan for Dorothy and Lucile did not include traditional family of husband, children, and grandchildren. Instead, God planned a much broader family for Dorothy and Lucile. Indeed, their definition of family embraced everyone whom they loved—and these sisters loved and nurtured a lot of people. There's an old saying that home and family are where the joys are shared and sorrows lessened. How true that was with Dorothy and Lucille—they celebrated important moments in the lives of their friends—baptisms, first communions, graduations, weddings. And they were always at the bedside of a dying friend—keeping vigil with that person and his or her family . . . they taught me by word and example about what it means to be family, about the love and support that should exist among brothers and sisters, about having the courage to be a trailblazer and an explorer, about the importance of laughter in our lives, about beauty, and most importantly, about faith.

NOTES

1. This essay is based on an article entitled "Women of Substance: Hannifin Sisters Leave Their Mark on Butte's Business World," by Tracy Thornton, which was published in the *Montana Standard* January 23, 2000, C1, 6. This expanded version includes supplemental background on the Hannifin sisters from the Hannifin Family record, Vertical File, Butte-Silver Bow Public Archives. Quote from Zena Beth McGlahsan is from correspondence to Ellen Crain; quotes from Martin Burke are from the text of his eulogy for Dorothy Hannifin. Both documents are part of the Hannifin Family record.

AFTERWORD

Janet L. Finn and Ellen Crain

As the stories in the preceding chapters attest, women have truly been Butte's mother lode. With courage, grace, and humor, women have built and sustained community in good times and bad. They have persevered for the sake of individual, family, and community survival, and they have taught us the value of commitment for the long haul. From bedsides to boardrooms, women have exerted their influence to build a healthier, safer, more just world. Women have made the connection between personal struggles and public issues and between acts of love and acts of justice. They have stepped forward to serve their community and challenge those who would seek to silence them or render them invisible. And they have found and created beauty on harsh terrain.

In the face of powerful and, at times, hostile forces, women have taken bold action for change. Some dressed in silk skirts and others in steel-toed boots, Butte women have stepped forward, questioned the status quo, and made their voices heard. Women have crossed boundaries, challenged assumptions, and changed the course of history in Butte and beyond. In so doing, they have inspired future generations to take a risk, envision possibilities, and make a difference. We are grateful for the opportunity to bear witness to these stories and to make them part of the public record. It is through the sharing of these stories that the *Motherlode* legacy lives on.

ABOUT THE EDITORS

Every single contribution in *Motherlode* has genuine merit. That each found its way into this essential volume is due to the profound efforts of Ellen Crain and Janet Finn. Throughout, you sense their abiding presence: encouraging, cajoling, listening, researching, collecting, and organizing, all directed toward bringing valuable truths to life. After all, even though the story of Butte as told by women has been largely obscure, the raw material has always been there, it's just that someone had to know where it was, assemble it, and expose it to the light of day. In this case, it turned out to be two someones.

One has to wonder whether anyone other than Ellen and Janet could have accomplished such an extraordinary volume. It seems unlikely. Like all great recipes, this one is simple yet precise, requiring sharp minds, stout hearts, steady hands, and bravery, all ruled by compassion and sensitivity. Something else mattered too, and that is good old fashioned plain hard work. And complete mutual trust didn't hurt anything either.

Since 1990, Ellen has been the director of the Butte-Silver Bow Public Archives, a position she has clearly handled with great skill, earning her the respect of everyone, lay and professional alike. Janet has been equally active. She is a professor of social work at the University of Montana, and, using her Ph.D. in cultural anthropology and social work as a base, has spent years in the field trying to understand the theory and practice of social justice. These two capable and indefatigable women have devoted their lives to righteous causes wherever and whenever the opportunity arose, in the process becoming models for anyone interested in conscientious reform, and the search for what is right and good. In this remarkable work, they are triumphant.

ABOUT THE CONTRIBUTORS

SISTER DOLORES BRINKEL, SCL, a native of Broadview, Montana, and a Sister of Charity of Leavenworth, currently serves as the archivist for the Catholic Diocese of Helena. Her experience as archivist for St. James Healthcare in Butte enabled her to access records essential to telling the story of the pioneer health care Sisters of *Motherlode*.

With undergraduate and graduate degrees in history from St. Mary College in Leavenworth, Kansas and Loyola University in Chicago, she first taught high school and college students. Then as a registered lobbyist in Kansas she furthered the efforts of a Criminal Justice Ministry office for the Archdiocese of Kansas City in Kansas. Later she administered a national Rural Ministry Education Institute, and edited publications for the National Federation for Catholic Youth Ministry. Sister Dolores has researched and subsequently published three family histories heralding her own Montana pioneer family in Yellowstone, Stillwater, and Sweet Grass counties.

ELLEN SHANNON CRAIN, a Butte native, is the Director of The Butte-Silver Bow Public Archives, a position she has held for the past fifteen years. She holds Bachelor of Arts Degree in public policy. She is the coordinator for the Butte Anaconda and the B.A. & P. RR Labor History Landmark Program and also sits on the Regional Historic Preservation Planning Committee for Butte and Anaconda. Ellen is active in a number of other groups, including the Montana Committee for the Humanities, and the Montana Cultural and Aesthetic Projects Advisory Committee, of which she is the chair. Ellen is married with three children.

LORALEE DAVENPORT was born in Butte, Montana, graduated from Butte High School, and earned a B.S. from Western Montana College. Loralee went on to earn her Master's and Ph.D. in History from Mississippi State University. Loralee's published articles include: "The Mississippi," in *The Encyclopedia of Geology and the Earth Sciences* and "The Mississippi Flood of 1890," in the *Encyclopedia of Natural Disasters*. She co-authored the *Road to Yellow Creek: High Technology and High Politics in Rural Mississippi* with James C. Haug. She also served as a panelist on "The African–American Experience," a Presidential Forum on Turning Points in History. Loralee is retired from academic life and currently teaches history at Butte Central High School.

JANET L. FINN was born in Missoula, Montana and grew up in Butte. After working as a social worker in Montana for several years, she returned to school at the University of Michigan, where she earned a Ph.D. in cultural anthropology and social work. Janet

is a professor of social work at The University of Montana-Missoula and author of two books, *Tracing the Veins: Of Copper, Culture, and Community from Butte to Chuquicamata* and *Just Practice: A Social Justice Approach to Social Work* (co-authored with Maxine Jacobson). Janet received the 2004 Montana Committee for the Humanities Fellowship to support work on *Motherlode*. When not in the classroom, Janet divides her time between western Montana and Chile, documenting struggles for social justice and stories of women's lives.

KERRIE GHENIE was raised in Butte and currently resides in Missoula. She is a graduate of the University of Montana and Walla Walla College with degrees in social work. Kerrie is a faculty member of the University of Montana School of Social Work. Kerrie is married and has one child.

BILL MACGREGOR has lived in Butte and worked as a faculty member at Montana Tech since 1984. Prior to coming to Butte he taught at major state universities in Hawaii, California, and Colorado (he earned his doctorate in English from CU-Boulder). His early years exposed him to mining camps and mining culture in Arizona, Colorado, and California. His professional and personal life in Butte has become ever more entwined with the stories of the people, places, and events that lie hidden behind the surface of the community's contemporary identity. He engages students from a variety of classes in work that helps recover, rebuild, restore, and reinterpret Butte's complex story.

ANDREA CIABATTARI MCCORMICK grew up in the historic Butte neighborhoods of Meaderville and McQueen, the granddaughter of Italian immigrants who arrived in the Mining City in the early 1900s. She attended Butte schools and graduated from Saint Mary College in Leavenworth, Kansas, with a degree in English. During and following college, she spent 10 years as a reporter, feature writer, and feature editor for *The Montana Standard* in Butte. She wrote hundreds of stories on a wide variety of subjects, her favorites being Butte's fascinating history and people. She also wrote several articles and helped gather Italian recipes for the popular *Butte Heritage Cookbook*.

One of Andrea's subjects in *Motherlode*, Lydia Micheletti, was a close Ciabattari family friend. During the years when Lydia first came to Butte and was launching her famous career, the Michelettis lived next door to Andrea's grandfather and his family in Meaderville. Andrea, who is married to Butte native Jack McCormick, has continued to write over the years while pursuing other interests and raising her two sons, Gabe and Tony. She currently works for KXLF-TV in Butte.

JOHN MCGINLEY was born and raised in Butte and graduated from Boys' Central High School in 1966. John is currently a working artist living in Sacramento, California.

LAURIE MERCIER is Associate Professor of History at Washington State University, Vancouver and was oral historian at the Montana Historical Society from 1981 to 1988. She is the author of numerous publications about women, labor, working-class and ethnic communities, and oral history, including the prize-winning book *Anaconda: Labor, Community, and Culture in Montana's Smelter City* (University of Illinois Press 2001) and co-editor of the anthology *Mining Women: Gender and the Development of a Global Industry, 1670-2005* (Palgrave 2005). She was co-director of the IMLS-funded *Columbia River Basin Ethnic History Archive* http://www.vancouver.wsu.edu/crbeha/. Mercier is completing a book about Montana women based on oral history interviews conducted during the 1980s.

MARY MURPHY, Professor of History at the Department of History and Philosophy, Montana State University-Bozeman, teaches and writes in the fields of U.S. women's history and the history of the American West. She is the author of *Hope in Hard Times: New Deal Photographs of Montana, 1936-42* (Montana Historical Society Press, 2003), which won the 2003 Montana Book Award. She is also author of *Mining Cultures: Men, Women, and Leisure in Butte, 1914-41* (University of Illinois, 1997) and she edited, with Harry Fritz and Bob Swartout, *Montana Legacy: Essays on History, People, and Place* for the Montana Historical Society Press in 2002.

KITTE KEANE ROBINS was born in Butte Montana, and spent the first 21 years of her life there. The early stories her extended family and their friends shared during picnics, family dinners and other occasions in Butte, made the history of the Great Depression, World War II, and the New Deal come to life. In 1965 Kitte and her husband, Pat Robins, left Butte to further their educations. She graduated from the University of Wisconsin-Milwaukee in 1967 and taught in elementary schools in Milwaukee, Wisconsin and Seattle, Washington. Pat and Kitte Robins returned home to Montana, settling in Missoula in 1974. Kitte taught in the Missoula County High School Adult Education program from 1989 to 2000. She is the mother of three daughters and one son, and has been involved in a variety of community organizations and activities.

MARILYN MANEY ROSS is a third generation Montanan who has made her home in Butte for more than thirty years. She served for twenty years as Chairman of the Board of Directors of the Butte-Silver Bow Public Archives and was instrumental in the formation of the Labor History Collections housed at the Archives. She has published articles about Butte's labor history, especially the women trade unionists in many labor publications and has been a contributor to the George Meany Labor Archives. During her working life she served as Director of Butte's Safe Space and the Montana State AFL-CIO Dislocated Worker Program, and at the time of her retirement was serving as Director of the Butte Food Bank.

CONNIE STAUDOHAR is an independent scholar who holds a bachelor's degree in nursing from the University of Washington and a master's degree in history from Montana State University, Bozeman. She is an Anaconda native who has a long-standing interest in the industrial health of early-day mining populations and wrote her master's thesis on "Miner's Consumption in Butte, MT 1900-1928." A broader study, "Limitations and Possibilities in the Early Treatment of Tuberculosis in Montana," was published in *Montana: The Magazine of Western History*, Winter 1997 and Spring 1998. The chapter on Dr. Caroline McGill is based on research she did at the Butte-Silver Bow Public Archives as a Ray Calkins Memorial Research fellow in 2000.

ANDREA STIERLE is a research scientist who firmly believes that the most interesting aspects of life can be found in the boundary layers. She studies biology using chemical tools and chemistry using biological perspectives. She is blessed to live, work and play with her dearest friend, her husband Don. They share their Montana lives with an assortment of cats, Osa the golden retriever, and several hundred plants.

TRACY THORNTON, a Butte native, is the daughter of Ann and Emmett Thornton. She comes from a traditional Irish Catholic family of 11 children, and was raised in Butte's Corktown. Tracy is the historian for *The Montana Standard* newspaper and is the mother of three children, Rory, Kylah and Drennan, and grandmother to Aidan.

CAROL GRIFFITH WILLIAMS is one of four children of Vern "Hanna" Griffith and Celeste McCall Griffith. Carol, a former teacher and community activist, received a Bachelor of Science degree from Western Montana College. She was a founding board member and director of Peace Links, an international organization to promote understanding among women in the world, most specifically in the former Soviet Union and the United States. She represented Missoula in the State House of Representatives in 1999 and 2000, was nominated for Lt. Governor in 2000, and was elected to represent Missoula County in the State Senate in 2003.

PAT WILLIAMS is the son of Shelton Williams and Elizabeth "Libby" Williams, restaurateurs from the 1930s to the 1970s. Virtually growing up on Butte's Park Street, Pat refers to himself as "a downtown kid." Williams has taught from grade schools through university graduate schools. He served in the Montana House of Representatives for two terms: 1967 and 1969. Elected to the United States Congress in 1978, Williams served 9 consecutive terms, longer than anyone in the state's history. He is Senior Fellow at the University of Montana's O'Connor Center for the Rocky Mountain West.

ABOUT THE DESIGN

When constructing this book, it seemed important that it should in no way resemble an ordinary textbook, even though we hope schools adopt it for their social studies programs as they should. That is why this first printing consists largely of the less expensive perfect bound paperbacks, the fewer Smyth sewn hardcover books being an accommodation to libraries, not one of which should be without this benchmark edition.

In order to accommodate the enormous amount of material assembled herein, we decided on a larger than normal format, with the stated goal of being careful not to mislead anyone into thinking this might be just a coffee table book, which it most assuredly is not. While the women on the cover may be laughing, it is as saving grace counterpoint to the darker things in their lives, because this collection represents a dead serious testament for the ages. The important thing then, was to somehow invest it with an appropriate architectural simplicity and authority, giving it a handsome dignity with its own form of beauty, yet one which never bleeds over into prettiness. We wanted a physicality as powerfully generous as the topic of the book itself.

When we were arranging to print *Mile High Mile Deep*, we informed the manufacturer that this book would be coming along within the year, and they ordered enough Finch Vanilla Opaque text stock for us to accommodate both jobs, only instead of eighty pound, we scaled back to seventy for this larger volume. Too, we were unable to identify any typography better than what was used in *Mile High Mile Deep*, and so we stayed with Palatino Linotype.

PHOTO CREDITS

Contents "Butte Fire Department, currently home to Butte-Silver Bow Public Archives."
BSBPA, Miscellaneous Photo Collection

Page 5 "Uptown Butte mining neighborhood, 1981."
Butte-Silver Bow Public Archives (BSBPA), Historical Architectural Engineering Record
(HAER) Project Collection

Page 9 "Juggling employment and child care, circa 1930s."
BSBPA

Page 13 "School children at salvage campaign, 1942."
Photo by Russell Lee, Courtesy of Library of Congress, Reproduction
Number LC-USW3-009702-D

Page 15 "Serbian church Sunday breakfast, circa 1960s."
Courtesy of Sylvia Skuletich

Page 17 "Cadet Nurse, circa 1944."
Courtesy of Alice O'Leary

Page 18 "Butte Soroptimist Home, circa 1950."
BSBPA, Soroptimist Home Collection

Page 21 "Butte's motto, circa 1960."
BSBPA, Miscellaneous Photo Collection

Page 29 "West Park Street, uptown Butte, circa 1920s."
BSBPA Miscellaneous Photo Collection

Page 38 "Moxom Café employees, July 4, 1937."
Courtesy of World Museum of Mining Photo Archives

Page 39 "Members of the WPU and Silver Bow Trades and Labor Council circa 1900."
BSBPA Labor History Collection

Page 44 "Rialto lunch counter."
BSBPA Labor History Collection

Page 49 "Rialto Theater candy counter."
BSBPA Rick Crnich Collection

Page 58 "Lydia Micheletti, 1976."
Courtesy of the *Montana Standard*

Page 62 "Butte homes and mines."
Courtesy of the BSBPA Labor History Collection

Page 68 "Holiday food baskets for miners' families, Miners' Union Hall, 1959."
BSBPA Labor History Collection

Page 71 "Women's Auxiliary of the McQueen Volunteer Fire Department, March 15th, 1962."
Courtesy of the World Museum of Mining Photo Archives

Page 73 "Columbia Gardens playground, circa 1960s."
Courtesy of Jerry Bugni

Page 79 "Max and Virginia Salazar."
Courtesy of Virginia Salazar

Page 84 "Young Caroline McGill."
 Courtesy of the Museum of the Rockies

Page 93 "Murray Hospital, circa 1920s."
 BSBPA, Murray Hospital Collection

Page 100 "Dr. McGill and friends at the 320 Ranch."
 Courtesy of Montana State Historical Society, Helena, Call Number PAC 79-37

Page 102 "Dr. McGill approaching retirement."
 Courtesy of Montana State Historical Society, Helena, Call Number PAC 79-37

Page 106 "St. James Hospital School of Nursing, class of 1917."
 Courtesy of St. James Health Care Archives

Page 108 "Sister Mary Xavier McLaughlin."
 Courtesy of Sisters of Charity of Leavenworth Archives

Page 111 "Sisters Serena and Hilaria O'Connor."
 Courtesy of Sisters of Charity of Leavenworth Archives

Page 114 "St. James Hospital, circa 1906."
 Courtesy of St. James Healthcare Archives

Page 118 "Montana Catholic Hospital Association Convention, Butte, 1936."
 Courtesy of St. James Healthcare Archives

Page 125 "St. James School of Nursing, graduating class of 1943."
 Courtesy of Alice O'Leary

Page 129 "Butte cadets called to duty."
 Courtesy of Alice O'Leary

Page 132 "Cadet Nurses overseas, circa 1944."
 Courtesy of Alice O'Leary

Page 134 "Cadet Nurse Alice O'Leary (front row, first on left) and friends."
 Courtesy of Alice O'Leary

Page 136 "Cadet Nurse artifacts."
 Courtesy of Jean Potts Haviland

Page 138 "War Production Board propaganda."
 Courtesy of the *Montana Standard*

Page 149 "31st Annual Convention of the Montana Federation of Colored Women, July, 1952."
 Courtesy of Montana State Historical Society, Call Number 92-25.11

Page 151 "Ophelia Fenter, 1973."
 Butte High School Year Book, 1973, Courtesy of Butte High School

Page 158 "Members of the Butte *Kolo*, circa 1960."
 Courtesy of Sylvia Skuletich

Page 159 'Mrs. Sophie Ducich (standing) and members of the Circle of Serbian Sisters."
 Courtesy of Sylvia Skuletich

Page 165 *"Kolo* members in uniform, 1947."
 Courtesy of Sylvia Skuletich

Page 175 "Soroptimist Club members prepare home for Opening Day, 1948."
 BSBPA, Soroptimist Home Collection

Page 178 "Mile of Money Fundraiser, 1948."
 BSBPA, Soroptimist Home Collection

Page 179 "Soroptimist Home, circa 1950."
 BSBPA, Soroptimist Home Collection

Page 193 "Elizabeth Lochrie with Blackfeet friends."
 Courtesy of Montana Historical Society, Helena, Call Number 79-37.

Page 207 "Alma Higgins in her garden."
 BSBPA, Alma Higgins Collection

Page 213 "Committee in charge of Butte's first Garden Week, 1922."
 BSBPA, Alma Higgins Collection

Page 216 "Butte youngsters planting trees, circa 1925."
 BSBPA, Alma Higgins Collection

Page 219 "Higgins in riding trousers at cabin."
 BSBPA, Alma Higgins Collection

Page 224 "Landscape design for School of Mines, 1929."
 BSBPA, Alma Higgins Collection

Page 228 "Sara Godbout Sparks."
 Courtesy of Jean Cannada

Page 229 "Drawing by Andrea Stierle."
 Courtesy of Andrea Stierle

Page 238 "Child in uptown Butte, circa 1960."
 BSBPA, Miscellaneous Photo Collection

Page 242 "Woman forced to move from Pennsylvania Block, uptown Butte, circa 1970."
 BSBPA, Miscellaneous Photo Collection

Page 249 "Women and children picketing St. James Hospital, 1971."
 Courtesy of the Montana Standard

Page 252 "Corinne Shea ."
 Courtesy of Corinne Shea Family

Page 252 "Gert Downey."
 Courtesy of Gert Downey Family

Page 257 "Naomi Longfox."
 Courtesy of the Montana Standard

Page 270 "Young Lula Martinez."
 Courtesy of Angelina Costello

Page 275 "Lula Martinez, seasoned advocate for social justice."
 Courtesy of Angelina Costello

Page 283 "Emma Richards Bartlett."
 Courtesy of Pat and Carol Williams

Page 287 "Elizabeth Hagan Keough."
 Courtesy of Pat and Carol Williams

Page 294 "Pearl Amanda Lemon."
 Courtesy of Bill Macgregor

Page 308 "Mary Thomas Keane."
Courtesy of Kitte Keane Robins

Page 308 "Catherine Thomas O'Neill."
Courtesy of Kitte Keane Robins

Page 314 "Lucile and Dorothy Hannifin."
BSBPA, Hannifin Collection

Cover "Butte Women."
Courtesy of World Museum of Mining Photo Archives

Front End Sheet "Main Street, Butte, 1928."
BSBPA, PH002 Collection

Back End Sheet "Butte Parade Float."
BSBPA, PH002 Collection

Back Cover "Ellen Crain and Janet Finn."
Editor Photograph by Russell Chatham

INDEX

320 Ranch, 95, 99, 101, 103, 187

Acebedo, Fidencio, 269

ACM Club, 143

Active Club, 172, 177

Activist Mothering, 240

Addams, Jane, 36

African Americans, 10, 37, 142-153;
Advancement, 143-44

African Methodist Episcopal Church (AME),
144-45

Afro-American Women's Club, 145, 151

Aguilar, Petra, 272

Alaimo, Stacy, 209

Allard, Dr. Louis, 116

Ambrose, Stephen, 142

American Association of University Women
(AAUW), 53

American Candy Shop, 303, 310

American College of Surgeons, 128

American Federation of Labor (AFL), 37, 306

American Federation of Labor-Congress of
Industrial Organizations (AFL-CIO), 48

American Federation of Serbian Sisters, 157

American Federation of Teachers (AFT), 302-
11

American Forestry Association, 213

American Hospital Association, 116

American Indians (*See also* Native Americans),
18, 174, 184, 256

American Labor Union (ALU), 37

American Legion, 156

American Registry of Radiological Technicians,
115

American Women's Voluntary Services, 16

Anaconda Copper Mining Company (ACM;
Anaconda Company), 22, 47, 55, 74, 116, 118,
143, 172, 177, 204, 224, 232, 237, 239, 281,
284, 289, 295, 300-01, 312

Anaconda Standard, 6, 27, 205

Anaconda, Montana, 50, 197, 212

Ancient Order of Hibernians, 236

Anderson, Marian, 149-50

Anselmo Mine, 237

Anti-Poverty Council, 253-55

Anti-poverty programs, 241, 243, 245, 253-55

Arbor Day Program, 211

Arizona, 294, 299

Armed Forces (Army, Armed Services), 15,
123, 127, 135

Art Students' League, 186

Arthur U. Newton Gallery, 185

Association for Retarded Citizens, 80

Astle, John, 9

Atherton, Gertrude, 205

Atlantic Richfield Corporation (ARCO), 22,
226-27

Austria-Hungary, 30, 154

Azure, Debbie, 256

Azure, Melba, 256, 266

Azure, Mona, 262

Azure, Robert (Bob), 255, 262

Baby Pierce, 96-98

Badger Mine, 98

Bagley, Inez, 266

Balkan Region, 14, 154-55

Bannock Indians, 191

Barrett, Sister Mary Gertrude, 115

Barsanti, Dolores, 265

Bartenders, 45-46, 48

Bartlett, Beatrice, 280-91

Bartlett, Emma Richards, 280-91

Bartlett, John, 280-91

Bass, J. B, 143

Bear Medicine, Marie, 192

Bein, G. F., 107

Belmont Mine, 92, 96, 98, 258, 270, 284-85

Berkeley Pit, 11, 20, 63, 231-32, 239, 261, 300

Bethel Baptist Church, 151

Big Butte, 27, 30, 215, 224, 228

Big Dan, 112

Big Ship, 7, 33

Bisbee, Arizona, 293

Biviches, 270

Black Churches, 144-45

Black Residents (*See also* African Americans),
142-53

Black Women, 142-153

Blackfeet Indians, 184, 189-90; reservation, 192

Black-Owned Newspapers, 143

Blackwell, Elizabeth, 89

Blaine School, 310

Blue Bird Mine, 280

Boarding houses, 1, 2, 4, 7, 35-36, 46, 59, 61, 107, 272, 281, 284
Boaz Mine, 77
Boggs, Patty, 236, 266
Boland, P.H., 34
Bolton Act, 124, 127-28, 130
Bolton, Frances, P., 127
Boulter, Ruth, 172
Boycott, 10
Boyle, Mary, 88
Bozeman, Montana, 205, 248
Breslin, Marjorie, 115
Brinkel, Sister Dolores, 6, 107,126
Broudy, Sheri, 312
Brown, Janettia, 147-48
Brown, Richard, 147
Brown's Gulch, 197
Bucket Girls, 35-36, 42
Buckley, Mary, 8
Buckner, Sister Mary, 112
Bucks Club, 177
Bull Child, George, 190, 192
Bull Child, Gypsy, 189-90
Bullock, Robin, 226
Bundy, Raymond, 306, 308
Burgess, Harry, 96-98, 101
Burgess, Linda Cannon, 14, 96-99, 101
Burke, Martin, 314-15
Burlington, Montana, 280, 284
Burnham, Patricia, 188
Burns, Sister Madeline, 247
Burrs Department Store, 151
Business Girls' Club, 8
Butler, Sister Mary Carlotta, 114
Butorovich, Rosalie, 154, 164
Butte Anti-Tuberculosis Society (See also tuberculosis), 88
Butte Business and Professional Women's Club, 7, 103
Butte Business College, 8
Butte Cadet Nurses (See also Cadet Nurses), 123-137
Butte Central High School, 53-56, 75
Butte Christian Community Center, 247
Butte City, 4, 107, 109
Butte City Directory, 126, 297
Butte Community Memorial Hospital, 101, 116- 17
Butte Community Union (BCU), 22, 268, 274-77
Butte Daily Miner, 34

Butte High School, 2, 55, 79, 86, 95, 98, 147, 148, 186
Butte Hill, 4, 14, 35, 54, 204, 224, 227, 280, 292
Butte Housewives' League, 10, 245, 298
Butte Josher's Club, 95
Butte Kolo, 15, 154-69
Butte Miner, 86, 144
Butte Miners' Union (Local No. 1), 40, 80, 237, 286
Butte Pioneers Club, 281, 285
Butte Rotary Club, 177, 194
Butte School Board, 303-311
Butte School District No. 1, 303-311
Butte Sheltered Workshop, 110
Butte Soroptimist Club (See also Soroptimist Club), 17
Butte Teachers Union Local No. 332 (BTU), 302-311
Butte Trades and Labor Council (See also Silver Bow Trades and Labor Council), 306
Butte Women's Council, 10
Butte Women's Protective Union (See also Women's Protective Union (WPU), 6, 34-51, 148, 290
Butte Workingman's Hospital, 107
Butte Workingman's Union, 104
Butte-Silver Bow Anti-Poverty Council, 20, 252
Butte-Silver Bow County, 92, 241, 248, 252
Butte-Silver Bow Public Archives, 267, 317
Cadet Nurse Corps, 123-37
Cadet Nurses, 16, 116, 123-37
Camp Caroline, 148
Campbell, Carolyn, 78, 81
Candy-Counter Girls, 40
Caras, Sister Isabel, 45
Carey, Rose, 138
Carroll College, Helena, Montana, 115, 124, 130, 133,
Carroll, Bishop John P., 56
Casebeer, Dr. H. L., 177
Catholic Church, 177, 200
Catholic Schools, 53-56, 200, 259
Catlin, George, 189
Centerville, 197, 252
Central School of Nursing, 123, 130, 132
Centro de la Raza, 271, 274
Chamber of Commerce, 177, 191, 206
Chappell, Mary B., 146, 147
Charity Ball, 180
Chase, William Merritt, 186
Chequamegon Café, 151

Cherry, Mary, 131
Child Welfare Department, 170-80
Children's Day, Columbia Gardens, 72
Chinese Community in Butte, 143
Chippewa Cree, 256-67
Christian Brothers, 56
Christie, Maryane, 154, 163-64
Christie, Mrs. A. J., 205-06
Chuquicamata, Chile, 3, 317
Churches, 144-46, 155, 161, 200
Circle of Serbian Sisters, 15, 154-69
City Health Office, Report of, 90
Civic Improvement League of Deer Lodge, 204, 208
Civil rights, 10, 142, 302
Civil Works Administration, 12
Clapp, Dr. Charles H., 27
Clapp, Mary Brennan, 6, 27
Clark, Helen, 187
Clark, Margaret, 306
Clark, William, 142
Clark, William Andrew, 8
Cleator Moor, England, 280
Club Women, 6, 73, 142-53, 170-80, 208-17, 245
Columbia Gardens, 28, 42, 72, 143
Commissioner of Indian Affairs, 256
Committee on Political Education(COPE), 48
Community Action Program, 241
Community Chest, 171, 176, 180
Community Memorial Hospital, 101
Concentrated Employment Program (CEP), 241, 254
Conservation, 11, 204, 206, 208-09, 211-12, 222
Constitution Hall, Washington, D.C., 149
Consumption, 10, 112
Cook, Blanche, 92
Cooney, Governor F. H., 11
Cooper, James Fenimore, 190
Copenhaver, Blanche Averett, 46-49
Copper, 4, 11, 15, 20, 27, 55, 68, 69, 201, 204, 224-25, 232, 237, 239, 243, 269, 280, 294, 304
Copper Camp, 2, 14
Copper Industry (See also copper), 4, 10, 68, 205
Copper Kings, 4, 8, 286
Cordua, Olive Brasier M.D., 89
Corette, J. E., 177
Cornish, 282
Cornwall, England, 4, 280-82, 284
Costello, Angelina, 268, 274
Craft Unions, 37

Crafting the everyday, 63, 75-77, 266, 282
Crain, Ellen, 3, 16, 20, 123, 224, 236, 252, 316
Craver, Rev. Robert, 247
Crazy Mary, 2
Creamery Café, 151
Crosby, Bing, 46
Crown Bar, 43
Culinary & Miscellaneous Workers Union Local No. 457, 51
Cunningham, Margaret, 12, 14
Curtis, Helen, 138
Czecho-Slovakia, 30
Daly, Marcus, 4
Daughters of the American Revolution (DAR), 149
Davenport, Loralee, 10
Davey, Elizabeth, 185
Davey, Frank Stillson, 185
Davey, Mary Rogers, 185-86
Davey, Sr. Mary Xavier, 6, 53-56
Davis, Chuck, 306, 308
Davis, Gertrude, 176
Davis, Mrs. John F., 145
"Dear Frustrated," 198
"Dear Sister, H-E-L-P," 200
Deer Lodge Silver State, 186
Deer Lodge, Montana, 109-10, 133, 135, 185-89, 204-08.
Demonstration Cities and Metropolitan Act of 1966, 241
Dempsey, Mervin, 308
Dennis, Michelle, 266
Depression Era, 1, 11-14, 237, 252, 272, 296, 302-04
Dillon, Montana, 124, 187
Discrimination, 142-44, 147, 151, 254, 262-63, 271-77, 303
Dishwasher, 40-42
Dixon, Governor Joseph, 95, 209
Doctors and nurses, 123-32, 173, 177, 230, 284, 295
Dodd, Dr., 288
Dodd, Mrs. W. E., 288
Domestic service, 4, 6, 284
Domestic violence, 20, 239, 245-50, 265, 268
Dorsey, Tommy, 46
Doss, Erika, 194
Dow, Arthur Wesley, 186
Downey, Gert, 26, 241, 252-55
Doyle, Rev. Dallas, 247
Drewelowe, Eve, 184

Drum and Bugle Corps, 160
Dublin Gulch, 155, 292, 300
Ducich, Sophie, 157, 159, 161
Duggan, Larry, 290
Duggan's Funeral Home, 290
Duletich, Danica, 154, 156-57, 160, 162
Duncan, Armeta, 147
Duncan, John, 143, 147
Duncan, Perdita, 143, 147-48
Dunstan, Ethel, 172
East Side, 202, 239, 258, 269
Easter, 155-56
Eastern Orthodox Religion, 155
Economic Opportunity Act, 240, 245
El Travatore, 57
Elevator Girls, 47
Eliot, T.S., 295
Elk Park, 198
Elkhorn, Montana, 57
Elks Club, 177
Emigration to America, 107, 155, 187, 280, 286
Emma Mine, 237
Emmons, David, 7
England, 30, 185, 280, 289, 295
Ennis, Sister Mary Liguori, 109
Environment, 14, 22, 224, 230,
Environmental Protection Agency, 11, 224
Erickson, Gov. John E., 188
Eye Opener, 12
Fairmont Hot Springs, 50
Family service center, 244
Farren, Mary, 135
Feather Girls, 36
Federal Arts Programs (*See also* Works
 Progress Administration), 187
Federal Emergency Relief Act, 11-12
Federal Government, 124, 127, 263
Federal Writers' Program (*See also*
Works Progress Administration), 2, 14
Feminist, 2, 59; feminist consciousness, 273
Fenter, Gurley, 148, 151
Fenter, Ophelia, 148-51
Finlen Hotel, 45-46, 66, 145, 151
Finn Town, 155
Finn, Janet L., 3, 6, 11, 17, 20, 34, 61, 204,
 224, 236, 256, 316
Finns, 174
Fitzpatrick, Elizabeth, 286
Five Mile, 59
Flamand, Eddie, 262
Flathead Indian People, 189

Florence Crittenden Home, Helena,
 Montana, 148, 174
Ford Motor Company, 18, 188
Ford Times, 188
Ford, Governor Sam C., 188
Forestry, 210-11
Fort Belknap Reservation, 257, 260
Fort Hall Reservation, 190
Fort Harrison, Montana, 133
Foss, Cheri, 313-14
Foster grandmothers, 245
Foster Homes, 174, 176, 180
Four Quarters, 295
Foxworthy, Sister Mary Daniel (Big Dan),
 112
Fredericks, Charles, 91
Freedom Gardens, 214
Galen, Montana (*See* Montana Tuberculosis
 Sanatarium, Galen)
Gallatin Canyon, 95, 99, 104, 187
Gallows Frames, 281
Gamer's Café, 43
Garden Club, 17, 177, 205-06, 214-16, 247,
 280, 284
Gender, 1-3, 19-12, 16, 61, 98, 154, 166, 238,
 264, 272
Germans, 174, 190, 229
Ghenie, Kerrie, 15, 154
Gibraltar of Unionism, 4, 35
Gillespie, Dr. D. L., 117, 177
Gillick, Marjory, 305
Girl Scouts, 79, 177, 216
Glace family, 92
Glace, Ruth, 92, 97-98
Glacier National Park, 186, 189-90, 232
Gnagy, John, 201
Golubin, Angeline, 306
Gorsh, Gary, 252
Graff, Dr. Sarah, 99
Grassroots warriors, 240
Great Depression (see Depression Era)
Great Falls, Montana, 173
Great Northern Railway, 190
Green's Café, 48, 151
Gregg, Dr., 103
Gregorian Calendar, 155
Griffith, Celeste, 285
Griffith, Elisabeth, 284
Griffith, Vern "Hannah," 285
Griffith, Weston, 284
Griffiths, Stanley, 306, 308

Hagan, Elizabeth (Lizzie), 280-91
Hagan, James (Jim), 280-91
Hagan, Mary Ann, 280
Hagan, Nellie, 280
Hannifin Sisters, 312-15
Hannifin, Dorothy, 23, 312-15
Hannifin, John L. Dr., 312-15
Hannifin, Lucile, 23, 312-15
Hannifin, Mary (Moran), 313
Hannifin's Jewelry Store, 23, 312-15
Harper's Bazaar, *128*
Harrington, Sister Mary Linus, 118
Harrington's Ice Cream Store, 151
Harris, Sister Toni, 291
Harrison Narcotic Act, 126
Haviland, Jean, 124, 126, 135
Hazel Block, 35
Head Start, 138
Health care, 1, 6, 8, 16, 107-37, 241, 262, 266
Helena, Montana, 187
Helmville, Montana, 126
Hennessy Building, 55, 289
Hennessy, John, 109
Hennessy, Mrs. D. J., 205
Hennessy's Department Store, 70
Henri, Robert, 186
Hergesheimer, Joseph, 205
Hickey, Margaret, 18, 170
Higgins, Alma, 11, 204-23, 225, 228
Higgins, Warder I., 204-05
Holland, Mike, 43
Holmes, Linda Lee, 119
Holy Savior School, 300
Holy Trinity Serbian Orthodox Church, 155, 166
Homer Club, 6
Hoover Commission on the Reorganization of Government, 256
Hotel Employees and Restaurant Employees International Union (HERE), 37
Hoy, Catherine, 42
Hudson River School, 188
Hughes, Mrs. E. M., 34
Human Resource Council District 12, 241, 244-45
Hunt, Peter, 56
Hunter Hot Springs, 57
Idaho Migrant Council, 268
Immigrants, 4, 155, 160, 280-91, 306
Indian Culture (*See also* American Indians), 174, 184, 188-92, 194, 256-67

Industrial Workers of the World (IWW), 37, 295
Ireland, 4, 8, 30, 110, 200, 280, 289, 306
Irish, 7, 43, 174, 239, 280, 288, 295, 306
Irish widows, 7
Italians, 229, 270
Italian cuisine, 57-60
Italy, 11, 30, 57
Jacobsen, Lois, 171-73
James, Dr. H. H., 117
Jencks, Miss, 34
Jenkins, Charles, 206
Johns Hopkins University Medical School, 85, 89-90
Johnson, Isabelle, 188
Johnson, Lyndon B., 240-41
Johnson, William, 262
Jones, Armenta, 145
Jones, Virginia (Gin), 77
Jordan, Teresa, 268
Joseviches, 270
Julian Calendar, 155
Julson, K. L., 306, 308
Junior League, 177
Keane, Mary Thomas, 23, 302-311
Keane, Robert, 311
Keane Robins, Kitte, 23, 302-311
Kelly, D. M., 118
Kelly, Mary, 115, 177
Kelly, Nellie, 254
Kelly, William, 212
Kennedy, Elizabeth, 10, 22, 245
Keough, Elizabeth Hagan, 280-91
Keough, Pat, 288-91
King Alexander, 14, 157
Kipp, Joe, 189
Kirby, Mrs. Joe J., 16
Kiwanis Club, 177
Knievel, Robert "Evel," 291
Knight, Val, 188
Knights of Columbus, 28
Knights of Labor, 36
Kolo, 154-69
Kolo Srpskih Sestara, 156
Korean War, 133, 137
Kunz, Louise, 276
La Campana, 57
Labor history, 34-52, 286, 290, 302-11
Labor-Security Agency Appropriation Act of 1942, 127
Ladies Home Journal, 170

Lamb, Mary, 177
Lamont, Mrs., 34
LaMoure, Helen, 124, 126, , 128, 133
Laughran, Florence, 115
Leary, Marie, 302-311
Lee, Russell, 13
Leide-Tedesco, Manoah, 14
Lemon, Charles, 294, 296, 298-300
Lemon, Diana, 294-95, 297-99
Lemon, Garnet, 294
Lemon, Pearl, 294-301
Leonard Mine, 293-94
*Little Gidding,*293
Little Shell Band, 256
Living Christmas Tree, 208, 212-13
Livingston, Montana, 57
Lochrie, Arthur, 186-87, 189
Lochrie, Arthur Jr., 186-87, 189
Lochrie, Betty Jane, 186-87
Lochrie, Elizabeth Davey, 79, 95, 99, 194-96
Lochrie, Helen Isetta, 186-87, 189
"Long Distance," 197
Longfox, Charles (Chappy), 257, 279-60
Longfox, Naomi, 18, 244, 256-67
Lowney, Margaret, 306
Luft, Steve, 300
Lydia's, 59
Macabees, 285
Macgregor, Bill, 23, 292-93
MacLane, Mary, 2
Madalena, Clem, 94
Main, Jimmy, 262
Mangle girls, 35
Manning, Diane, 247
Mansfield, Senator Mike, 166
Many Glacier Hotel, 189
March of Dimes, 160
Marian White Arts and Crafts Club, 6
Martell, Louella "Lou," 197-99
Martinez, Ben, 269
Martinez, Lula, 268-77
Masonic Lodge, 296
Mattausch, Lena, 42, 46-47
Matthews, James, 109
May, Karl, 190
McCarthy, Robert, 268, 274
McClafferty, Mary, 124, 127, 130, 133, 135
McCormick, Andrea, 7, 11, 16, 57, 123, 138, 248, 152
McCrystal, Sister Ann Bernard, 114

McGee, Ruth, 302-311
McGellic, Margaret, 306
McGill, Dr. Caroline, 8, 85-105
McGill, Mary Bonar, 101
McGinley, Frances "Sam," 18, 197-203, 214
McGinley, John, 18, 197, 20203
McGinley, Larry, 202
McGlashan, Zena Beth, 312
McGlone, Edward, 117
McKinley Elementary School, 78
McLaughlin, Sister Mary Xavier, 108-09, 111
McMahon Sister Mary Assisium, 109, 111
McNally, Jim, 88
McQueen, 300
Meaderville, 57-58, 74, 300
Mehalko, John, 135
Merchant, Carolyn, 212
Mercier, Laurie, 3, 22, 268
Messenger, 166
Methodist, 285
Mexican Americans, 268-77
Mexicans, 269-71
Mexico, 230, 269, 296
Micheletti, Dave, 57, 59
Micheletti, Lydia, 11, 57-60
Micone, Claudine, 247
Million Women for Conservation, 211
Mills, Enos, 209-10
Mine-Mill Union, 237
Mine-related accidents and illnesses, 77,86-87, 90-92, 96, 107, 110, 112, 126, 135, 246, 261, 269, 288, 293-94
Miners, 2, 6-7, 61-76, 86, 89, 90-92, 110-117, 224, 239, 243, 256, 260, 280, 286, 297-98
Miners Saving Bank & Trust, 187
Miners' Union Hall, 36, 80
Mining, 54, 188, 224-25, 231, 237-38, 246, 269, 286; mining economy, 6-7, 10 15, 18, 20, 22, 43, 61, 99, 204, 224-26, 237, 239-40, 243, 262, 268, 286-87, 301, 304; mining families, 7, 17, 61-76, 78, 135, 224-28, 257, 260
Mining Camp, 28, 714
Mining City, 6, 23, 35, 57, 59, 142-43, 150, 312
Missoula, Montana, 206, 209
Model Cities Program, 20, 241, 263-64
Monahan, Eddy, 139
Monahan, Edward, 138-39
Monahan, Rose, 16, 138-39
Montana Catholic Hospital Association, 118
Montana Department of Fish and Game, 193
Montana Department of Public Welfare, 12

Montana Federation of Colored Women, 146-49

Montana Federation of Women's Clubs, 208-212, 215

Montana Historical Society, 268

Montana Institute of the Arts, 188

Montana Low Income Coalition, 276

Montana Nurses Association, 116, 133

Montana Plaindealer, 143

Montana Power Company, 66-68, 148, 173, 277, 271

Montana Relief Commission, 12

Montana School of Mines (*See also* School of Mines), 6

Montana Standard, 16, 53, 130, 150, 202, 237, 304

Montana State Board of Examiners, 126

Montana State Children's Home, 313

Montana State College, 211

Montana State Forester, 212

Montana State Hospital at Warm Springs, 130, 148

Montana State Legislature, 11, 88

Montana State Normal School (Western Montana College), 302-03

Montana State Pharmacy Board, 115

Montana State University, 148, 231-32, 312-13

Montana Tech (*See also* School of Mines), 188, 210, 216, 225-26, 229-30, 292, 300, 318

Montana Territory, 109, 136

Montana Tuberculosis Sanatorium (Galen, Montana), 95, 99, 185-86, 195

Montana Woman, 215

Montana Women's Resource Network, 247

Moon, Gareth, 212

Moore, Mrs. Delia, 34

Morgan's Café, 151

Mothers' Pension, 12

Mount Moriah Cemetery, 144, 296

Mountain Chief Mine, 148

Moxom Café, 38, 151

Muckenthaler, Sister Ann Bernard, 117

Mueller Apartments, 205

Mullen House, 35

Munger, Mary Delaney, 116, 124, 133, 136

Murphy, Beatrice, R.N., 94

Murphy, Mary, 3, 10-11, 18, 184, 298

Murray Hospital, 85-96, 101, 103, 117, 126, 133

Murray, Dr. T.J., 91

Murray, Frank, 166,

Murray, Hazel, 116

Museum of the Rockies, 188

Myer, Dillon, 256

Naples, Nancy, 240

National Association for the Advancement of Colored People (NAACP), 147-48, 151

National Association of Colored Women, 145-56

National Federation of Afro-American Women, 146

National Girl Reserves, 147

National Labor Relations Board (NLRB), 237

National Recovery Act, 12

Native American Indian League, 262

Native Americans (See also American Indian People), 11, 18, 184, 188-90, 192, 244, 256-67

Nealon, Sister Mary Ignatia, 109, 111

Nevada Street, 197

Neighborhood Center, 241, 253-54, 265

Neighborhood Council, 244

Neighborhood Youth Corps, 241

Netchitaki (Woman Alone in Her Way), 190

New Age, 143, 150

New Deal, 36

New Deal Art Programs, 187-88

New York Amsterdam News, 148

Nickel Annie, 2

Night of Old World Cuisine, 161, 164

Nixon Administration, 244, 254

North American Indian Alliance, 18, 236, 244, 256-67

Northern Pacific Railroad, 4, 9, 30, 85

Nurse Training Act (see Bolton Act), 124, 127

Nurses, 123-36, 225

Nursing, 123-36, 138-39, 246

Nursing Council on National Defense, 124

O'Brien, Ann, 306

O'Connor, Sister Mary Hilaria, 109-111

O'Connor, Sister Mary Serena, 109-111

O'Day, Sonny, 58

O'Keeffe, Georgia, 184

O'Leary, Alice, 24, 131, 133-34

Olmsted, Frederick Law, 217

O'Neill, Caroline, 262, 266

O'Neill, Catherine Thomas, 302-311

O'Sullivan, Sister Kathleen, 268, 276

O'Sullivan, Sister Mary Rita, 115

Orlich, Helen, 154, 156, 164

Ortega, Petra, 269

Owings, J. H., 208
Parker, Sam, 151
Pasquale, Tony, 113
Pathology, 87
Pearl Club, 142-53
Pearl Harbor, 124, 127,
Pearl Unit, 145-46
Pearl, Frank Dr., 145
Peck, Loretta, 03
Peña, Lucia, 269
Penney's, 70
People's Party, 309
Perry, Arron, 262
Perry, Faye, 172
Perry, Paulie, 128
Peterson, P. S., 209
Pfeiffer, Amanda, 8
Phelps, Hazel, 147
Phillips, Mrs. Mary, 170-71, 176
Phillipsburg, Montana, 135
Picket Line, 45-46, 249
Pinchot, Gifford, 209-10
Pinkertons, 295
Pithoud, Sister John Marie, 116, 130, 138
Pittsmont Mine, 27
Plummer, Henry, 187
Pony, Montana, 77
Poverty, 20, 113, 170, 192, 236-51, 252-55, 257
Povitica, 164, 167
Pratt Institute, 186
Pray, Charles N., 209
Prendergast, Catherine, 306
Presbyterian Church, 217
Prostitution, 4
Public Health, 8, 88, 90, 95, 127
Public health nurse, 88
Racial Uplift, 10, 142, 144, 146
Racism, 10, 142-44, 150, 170, 189, 191, 262, 271-72
Ransom, Joel, 109
Ray's Place, 260
Red Cross, 124, 131-32, 145, 148, 156, 160
Reilly, Sister Marcella, 115
Reiss, Winold, 186, 190
Relocation Acts of 1953, 18, 256-58
Remington, Frederic, 188, 194
Reservations, 190-93
Rialto Theater, 49, 289
Rice, Archie, 205
Richards, Emma Bartlett, 280-91
Richards, Marshall, 284

Richest Hill on Earth, 1, 12, 20-21, 27, 107, 174, 204, 232, 281
Robins, Kitte Keane, 14, 23, 302-311
Robinson, Michelle, 263-64, 266
Robinson, Thelma, 128
Rocky Mountain Café, 57-59
Rocky Mountain Garden Club, 212, 216-17
Rodes, Dr. Charles B., 85-87, 91, 101
Rodes, Thula, 86-89, 91-95, 98-99
Roosevelt, Eleanor, 149
Roosevelt, Franklin D., 36, 123, 210, 288
Roosevelt, Theodore, 143
Ross, Marilyn Maney, 6, 34, 247-48
Rotary Club, 177
Rothstein, Arthur, 62
Russell, Charles, 188, 194
S & L Ice Cream Store, 150
Sacred Heart Parish, 53
Safe Space, 236, 245-50, 264-65
Salazar, Max, 77-80
Salazar, Tim, 81
Salazar, Virginia (Gin), 77-81
Sarma, 162
Saunders, L.E., 177
Savoy Restaurant, 58-59
Scabs, 16, 290
Scandinavian, 30
Schaffer Chapel, 144-46
School of Forestry, 209, 212, 222
School of Mines (see also Montana Tech), 27, 54, 103
Schultz, James Willard, 188
Schwartz, Dr. Harold, 93, 103
Seeds for Peace, 214
Senior Citizen Center, 160, 253, 268
Serb World U.S.A., 161
Serbia, 154-69
Serbian American Men's Club, 156, 164
Serbian Church, 154-69
Serbian Community, 14-15, 154-69, 270
Serbian Mothers Club, 154, 164
Serbian National Defense Council of America, 161
Serbian New Year, 155, 160, 163
Serbian Sisters Federation, 161
Serbian Women, 15, 154-69
Shannon, Joan, 80
Shaw, Rose, 177
Shea, Ann, 253
Shea, Bridget, 40-42, 45, 47
Shea, Corinne, 20, 241, 252-55

Sheehan, Sr. Mary Seraphine, 53
Sheehy, Sister Mary Serena, 119
Sherman, E. A., 209
Shoestring Annie, 2
Sicotte, Grace, 20, 246, 248, 265
Silicosis, 96
Silver Bow Club, 28, 146
Silver Bow County, 11-12, 50, 113, 119,
Silver Bow Creek, 3, 224
Silver Bow Homes, 274, 276
Silver Bow Trades and Labor Council, 39, 48-
 49, 306, 309
Simonich, Ann, 312-13, 315
Sisters of Charity of Leavenworth (SCL), 6, 53,
 107-22, 126
Sivalon, T. G., 177
Skuletich, Louie, 166
Skuletich, Sylvia, 154, 156, 160, 162, 166
Slauson, Lena Brown, 148, 151
Social justice, 20, 22, 241
Social responsibility, 144, 253
Social services, 274
Social uplift, 144
Social workers, 271
Solat, Mike, 57
Soroptimist Club, 19, 170-80
Soroptimist Home for Children in Butte, 148,
 171-80
Soroptimist Receiving Home, 174
Soroptimisters, 172
Southside Neighborhood Council, 202, 244,
 263
Spanish Village, 57
Sparks, Sara Godbout, 11, 224-28
Speculator Fire, 91-92
Speculator Mine, 91
Spoor, Mother Mary Ancilla, 117
Spraycar, Father, 198
St. Ann's Hospital, Anaconda Montana, 110
St. James East (formerly Silver Bow Hospital),
 119
St. James Health Care, 107
St. James Home, 107
St. James Hospital, 77, 103, 110-114, 117-19,
 124-26, 133, 138, 246, 262, 264
St. James School of Nursing, 106, 115, 124-25,
 130, 136, 138
St. John's Hospital, Helena, Montana, 109, 130
St. Joseph's Hospital, Deer Lodge, Montana,
 110, 133, 135
St. Joseph's Parish, 193, 197, 264

St. Lawrence Church, 53, 70
St. Lawrence Mine, 133
St. Mary's Church, 286
St. Mary's Convent, 254
St. Patrick's Parish, 315
St. Patrick's School, 276
St. Vincent's Academy, Helena, Montana
 Territory, 107
St. Vincent's Hospital, Billings, Montana, 130,
 133
Stanisich, Gospava, 156
Staudohar, Connie, 8, 85
Stierle, Andrea, 11, 229-32
Stierle, Don, 229-32
Strikes, 16-17, 20, 22, 45-52, 61-75, 176, 225, 237,
 240, 245, 260-61, 290
Strobel, Gary, 232
Sullivan, Mary, 206
Sullivan, Sister Mary Anacaria, 115
Sunshine Camps, 186
Sunshine Pavilion, 95
Superfund, 11, 224, 226, 232
Swedes, 174
Sweet, Gertrude, 45, 47
Switzerland, 161
Sylvain, Albina, 59
Talbot, Dr., 103
Talle, Sister Mary Antonia, 117
Taskan, Sister Celine, 112
Taxol, 232
Teaching (see Butte Teachers' Union), 238, 302-
 11
Teamsters, 45-46
The Butte Irish, 7
The Perch of the Devil, 205
"The Wild Goose," 198
Thomas, Catherine (O'Neill), 302-311
Thomas, Joe, 306
Thomas, Mary (Keane), 302-311
Thompson, Hunter S., 239
Thornton, Tracy, 23, 312
Three-Twenty Ranch (see 320 Ranch)
Towle, Sister Mary Anselm, 117
Towle, Winterhalter & Hannifin Jewelry, 312
Toy, Mae, 306
Traparish, Teddy, 57
Trbovich, Mary, 157
Tuberculosis (TB), 86, 88, 95, 186, 288
Tuskegee Institute, 144
Tuskegee, Alabama, 146
U.S. Forest Service, 209-10, 215

Underground Mining, 1, 8, 20, 35, 86, 107, 226, 298

Union Grill, 40, 43

Unions, 17, 34-51, 172, 177, 204, 239, 286-88

United States Public Health Services (PHS), 127

United Way of Butte, 265

University of Missouri, Columbia, 85, 89, 91

University of Montana, 222, 312, 314

Vankoviches, 270

VanVrankin, Alberta, 92

Venture Girls, 177

Veterans Administration (VA), 116

Vietnam, 139

Victory Garden, 221

Virginia City, Montana, 109

"Visit to St. Nick," 203

Vogue, 128

Waiters, 45-46, 51, 143

Waitresses , 35, 40-41, 47

Waldbillig, Jane, 124, 135-36

Walker, Frank C., 120

Walkerville, 53, 197, 202, 228, 241

Walkerville Volunteer Fire Department Auxiliary, 70

Walsh, Dorothy, 138

Walsh, Sister Mary Melita, 115

War bond campaign, 123

War on Poverty, 20, 240-41, 265

Warm Springs State Hospital (see Montana State Hospital at Warm Springs)

Washington, Booker T., 144-46

Washington, Margaret Murray, 146

Weasel Head, Maria, 189

Webster Garfield School, 80

Webster, Val, 40-43, 47, 50

Welfare Department, City-County, 174, 177, 180, 273

West Side Shakespeare Club, 6

Western Labor Union (WLU), 37

Western Region *Kolo*, 161

Western Tourist, 212

Wheeler, Senator Burton K., 288

White Front, 57

Whitney Gallery, 185

Widows, 7, 290

Williams, Melvina, 145

Williams, Carol Griffith, 23, 280-91

Williams, Pat, 23, 280-91

Williamson, Ozzie, 262-63

Winslow, Carmen, 304, 307, 309

Wobblies (see Industrial Works of the World), 37, 204, 295

Women Infants and Children (WIC) Program, 135

Women Workers, 6, 7, 10, 17, 20, 34-52, 57-60, 65-67, 127, 132-36, 224-28, 229-32, 259-61, 268-77, 280-91, 302-311, 312-315

Women's Benefit Association, 285

Women's Club of Butte, 6, 177, 187, 192, 208-09, 247

Women's Commercial Club, 6-7, 8

Women's Health Day, 236

Women's Industrial Institute, 36

Women's Progressive Conservation Movement, 209-11

Women's Protective Union (WPU, *See also*

Women's Referral Center, 247

Butte Women's Protective Union), 10, 34-52, 117, 148

Working class, 6, 8, 10, 18, 34, 61, 63, 199, 204 240

Workman's Compensation Act, 96

Works Projects Administration (WPA), 12, 14; WPA Arts Center, 14; WPA Writers' Program of Montana, 2, 14

World War I, 9, 10, 126, 142, 146, 237, 298

World War II, 15, 18, 116, 123, 127, 136, 137, 154, 161

WPA Art Center, 14

Yard girls, 36

Yochim, Sister, 45

York, 142

Young American Serbs Club, 163

Young Men's Christian Association (YMCA), 28, 147, 148, 151, 246-49

Yugoslavia, 14, 157, 164

"Zave," 53-54